D0049468

JAMES
ABBOTT
McNEILL
Whistler

A LIFE

JAMES
ABBOTT
McNEILL
Whistler

A LIFE

G.H. FLEMING

St. Martin's Press
New York

Library of Congress Cataloging-in-Publication Data

Fleming, Gordon H.
 Whistler : a life / Gordon Fleming.
 p. cm.
 "A Thomas Dunne book."
 ISBN 0-312-05995-7
 1. Whistler, James McNeill, 1834–1903. 2. Artists—United States—
Biography. I. Title.
N6537.W4F57 1991
760'.092—dc20
 [B] 90-29331
 CIP

First published in Great Britain by The Windrush Press.

First U.S. Edition: August 1991
10 9 8 7 6 5 4 3 2 1

For Clayton

Contents

THE FINAL YEARS

Preface

In 1978, my book *The Young Whistler* was published. It covered the first 32 years in the life of James Whistler and was to be the first of two volumes. I then became preoccupied with other matters until 1985, when I returned to Whistler.

Because I had uncovered new facts about his childhood and youth, and because I found that some of my opinions had changed, I could not easily have resumed the narrative where I had left off. And so I returned to square one and started a complete study, from birth to death.

While researching and writing, I wasn't guided by any thesis. I didn't have an axe to grind; I wasn't trying to prove anything. I just wanted to present an accurate portrait of James Whistler. Because of legends, myths, rumors, exaggerations, after-the-fact recollections, and conflicting reports, this wasn't easy to do. But, relying heavily on contemporary sources, I have tried to beat a path through this maze of material and to separate the wheat from the chaff.

It was once said that if you wanted to find out how many teeth were in a horse's mouth, you could do one of two things: look into the horse's mouth or look into Aristotle. If I may be permitted a shift of metaphor, in preparing for this volume I tried at all times to look into the horse's mouth. I may have been the first writer on Whistler to do this.

The new material would in itself, I think, warrant another biography of Whistler. But beyond that, he was a captivating, contradictory person who could be, and has been, seen from numerous frames of reference. And he was an important artist who has attracted, and goes on attracting, a body of commentary. He was someone, it would seem, who deserves an occasional book-length reinterpretation of his life and work.

Author's Acknowledgments

It would be impossible for me to acknowledge all of my sources. The standard Whistler bibliography, by Robert Getscher and Paul Marks, runs to 377 pages and contains about 2000 entries. I have read almost everything listed in this volume, along with more recently published works, unpublished manuscripts, and peripheral materials, and all of it has in one way or another been helpful. There are two titles, however, that I should like to mention by name. Although its authors are biased, and it contains inaccuracies, the two-volume *Life of James McNeill Whistler*, by Elizabeth and Joseph Pennell, the closest friends of their subject during the last decade of his life, is the single most basic reference for any student of Whistler. An almost equally essential tool is the catalogue raisonné of Whistler's paintings compiled by Margaret MacDonald, Robin Spencer, and the late Andrew McLaren Young.

From start to finish, I wrote this book in Chicago's Newberry Library. I cannot too strongly express my gratitude to everyone at the Newberry, the most congenial place in which I have ever worked. Three staff members whom I should like particularly to single out for thanks are Karen Skubish Sattler, Jennifer Becker, and Amy Henderson.

The principal Whistler holdings are at the Library of Congress and the University of Glasgow, and during my several visits to both institutions I was always treated hospitably. I have also used the facilities of other libraries: the Art Institute of Chicago; the Bodleian Library, Oxford; the British Library, in the British Museum; the British Newspaper Library, Colindale; the Fitzwilliam Museum, Cambridge; the Freer Gallery, Washington; the Guildhall Library, London; the Henry Huntington Library, San Marino, California; the Humanities Research Center, the University of Texas, Austin; the Kensington and Chelsea Borough Libraries, London; the Louvre Archives, Paris; the Maryland Historical Society, Baltimore; the Metropolitan Museum of Art, New York City; the Newington District Library, Rotherhithe, London; the New York

Public Library, New York City; the Pierpont Morgan Library, New York City; the Royal College of Surgeons Library, London; the United States Military Academy archives, West Point; the University of Paris Library of Art and Archaeology; the Victoria and Albert Museum Library, London; the Witt Library of the Courtauld Institute, London.

Several individuals, in one way or another, were particularly helpful: the Rev. James Birdsall, Christ Church, Pomfret, Connecticut; Ann B. Gray, the Stonington Free Library, Stonington, Connecticut; the late Raeburn Miller, University of New Orleans; Kenneth Rapp, West Point; and the late Nancy Strode, Amersham, England.

A note on translations and diction

Some materials, published and unpublished, have been translated from French by Martha Lamb and Christy Beck, under my direction, explicitly for this volume. Whenever one of these specially translated passages appears, it is followed by an asterisk.

The diction is generally American. The 'third floor' of a building, for example, would be the British second floor. And occasionally there may be an explanation which readers on the eastern side of the Atlantic will find self-evident.

Picture Credits

Acknowledgement is given below with thanks to the museums and art galleries which have given permission to reproduce the following works: Front cover picture, *Self Portrait*, James Abbot McNeill Whistler (Arrangement in Gray: Portrait of the Painter, c.1872) © The Detroit Institute of Arts, Bequest of Henry Glover Stevens in memory of Ellen P. Stevens and Mary M. Stevens. Back jacket picture, Caricature of James Whistler by 'Spy' *Vanity Fair* 12 January 1878.

Plates

1. *Wapping on Thames* National Gallery of Art, Washington; John Hay Witney Collection.
2. Edward Poynter: Pencil Portrait of Whistler, 1858, (04.78) Courtesy of the Freer Gallery of Art, Smithsonian Institution, Washington, D.C.
3. Henri Fantin-Latour: Portrait of Whistler, 1865, (06.276) Courtesy of the Freer Gallery of Art, Smithsonian Institution, Washington, D.C.
4. *At the Piano* Taft Museum Cincinnati, Ohio, USA. Bequest of Mrs Louise Taft Semple.
5. *La Princesse du Pays de la Porcelaine* (03.91 – American painting by James McNeill Whistler (1834–1903); Rose and Silver: The Princess from the Land of Porcelain (1863–1864); Oil colour on canvas: 199.9 × 116.1 cm (78¾ × 45¾"). Courtesy of the Freer Gallery of Art, Smithsonian Institution, Washington, D.C.
6. *The Little White Girl* The Tate Gallery, London.
7. *Old Battersea Bridge*, 1863, oil on canvas, 25½ × 30½", 1928 .55, gift of Mr Cornelius N. Bliss © Addison Gallery of American Art, Phillips Academy, Andover, Massachusetts. All Rights Reserved.
8. *The Coast of Brittany*, Wadsworth Atheneum, Hartford. In memory of William Arnold Healy given by his daughter Susan Healy Camp.

9. *The White Girl*, National Gallery of Art, Washington, Harris Whittemore Collection.
10. *Symphony in White*, The Barber Institute of Fine Arts, The University of Birmingham.
11. *Miss Cicely Alexander*, The Tate Gallery, London.
12. *Portrait of the Painter's Mother*, © Réunion des Musées Nationaux.
13. *Portrait of Thomas Carlyle*, Glasgow Museums and Art Galleries.
14. *Old Battersea Bridge*, The Tate Gallery, London.
15. *Harmony in Pink and Grey: Valerie Meux*, Copyright the Frick Collection, New York.
16. Maud Franklin as Whistler's *Young American* Courtesy of the Freer Gallery of Art, Smithsonian Institution, Washington D.C.
17. *Portrait of Miss Rosa Corder* Copyright the Frick Collection, New York.
18. *Portrait of Mrs Frances Leyland* Copyright the Frick Collection, New York.
19. Etchings *Miss Annie Haden* Hunterian Art Gallery, University of Glasgow.
20. *Black Lion Wharf* and 21. *San Biagio*, New York Public Library Print Collection, Miriam and Ira D. Wallach Division of Art, Prints and Photographs, Astor, Lenox and Tilden Foundations.
21. *Nocturne in Black and Gold, the Falling Rocket* © The Detroit Institute of Arts, Gift of Dexter M. Ferry, Jr.

THE EARLY YEARS

1

Boyhood in New England

[1834–43]

James Abbott Whistler was the most combative, contentious, contradictory artist of the nineteenth century (perhaps of any century). From start to finish, his career was marked by one dispute after another.

He couldn't even enter life without making a fuss.

He was in fact born on 11 July 1834 in Lowell, Massachusetts, the first child of George Washington and Anna Mathilde Whistler. He had two half-brothers and one half-sister whose mother had died in 1827.

This sounds simple and non-controversial. But not to Whistler. 'I shall be born where I want,' he once testily responded to a stranger's observation that they shared the same birthplace, 'and I do not choose to be born at Lowell.'

Rarely as an adult did he so choose. Nearly always when asked, he would name one of several other cities as the place of birth.

When challenged on this by a relative, he insisted that he was free to say anything he wanted because he had been born in Lowell 'only by accident.'

The accident was a link in a chain of events that began when teenaged John Whistler, James's paternal grandfather, born in 1756 into a comfortably situated family in Ulster, Ireland, impetuously joined the army, fought against the American revolutionists, and, following the defeat at Saratoga, was incarcerated in a Boston stockade before returning in a prisoner exchange.

After less than a year at home, John Whistler eloped with the daughter of one Sir Edward Bishop, and, perhaps to elude Sir Edward, also perhaps because John liked what he had seen, the newly-weds sailed across the Atlantic. When the war ended, John Whistler became an American soldier, rose within the ranks, and as an engineering officer was assigned to construction projects on the frontier.

In 1800, when Whistler, a first lieutenant, was stationed at Fort Wayne, in what is now Indiana, his wife gave birth to a son named after the first President.

As a child, George Washington Whistler moved about with his parents in the Midwest, and on 31 July 1814, when his father was a major in charge of

3

Newport Barracks, Kentucky, he enrolled as a cadet at the United States Military Academy.

* * * *

The Academy is on the west bank of the Hudson River, 56 miles above New York City, and because it juts out, it has always been called West Point. When George arrived, it was in its thirteenth year, without entrance examinations, age limits, or a prescribed system of instruction. This would soon change, but the guiding principles would remain fixed for the rest of the century. Obviously a training ground for army officers, it was also a preparatory school for engineers, and for decades its graduates drew boundary lines, improved rivers and harbors, and built roads, bridges, and canals.

In 1819 George Whistler graduated twelfth academically in a class of 29. In one subject, drawing, he was first, and because of his talent a classmate considered him 'too much of an artist to be an engineer.'[1] Actually he became a topographical engineer, mainly engaged in drawing maps, maps that highlighted roads, streams, hills, trees, rocks, bridges, buildings and embankments. For nine years he did this, except for five months in 1822 which he spent as a West Point drawing instructor.

On his return to the Point, Whistler was an expectant father. He had met his future wife, Mary Swift, when he was a cadet. Her brother Joseph – twenty years older – was the Academy's superintendent, and another brother, William, was Whistler's classmate.

Mary was beautiful, spirited, vivacious – and very young. On Whistler's graduation day she was fourteen.

Through letters and visits to her home in New London, Connecticut, the second lieutenant kept so closely in touch with the schoolgirl that her father, a doctor, and her older brother were uneasy about the relationship. (Her mother was dead.) In a conference on 21 January 1821, Lieutenant Whistler assured them that he and Mary would never marry clandestinely. Five days later they eloped.

It was not a good match. Those who could have voiced an opinion on it were tastefully silent in their correspondence, except once. William Swift's letter to his brother on 9 August 1825 contains two tantalizing sentences: 'Whistler has been *beastly drunk*. It is said that he has been driven to it by the conduct of his wife.'[2]

Two years later, William wrote more ominously. Mary had had 'an attack of bilious of a serious nature.'[3] Within three months, she was dead, aged 23, mother of three children.

* * * *

'They are my all,' Whistler told Joseph Swift in May 1828, lamenting that his

job kept him from seeing his sons and daughter, living with their maternal grandfather.[4]

He was also unhappy because he was 'tired of playing third or fourth fiddle,' and looked for 'duties other than making pictures.'

Retired Major General Swift exerted some influence, and in September 1828 Whistler got an assignment which would alter his life.

The year of 1825 had marked the beginning of an era. In England the railroad came into being, and building rails was now an international obsession. The American pioneer was the Baltimore & Ohio, chartered in 1826. An act of Congress empowering the President to authorize army officers to build canals and roads for private companies was construed to include railroads, and in July 1827 three officers were sent to Baltimore to begin a survey for the B. & O.

One of the three, Captain William McNeill, known as a 'boy wonder,' had at the age of twelve entered West Point with George Whistler. He graduated and was commissioned in 1818, a year ahead of Whistler; he became a first lieutenant in 1821, and in 1823 he was promoted to captain. After a few months in Baltimore, he was put on the board of directors for the project.

From time to time others joined the enterprise. One of them, arriving in September 1828, was George Whistler.

On 1 November, McNeill and Whistler, along with another West Pointer, Jonathan Knight, and a civilian locomotive builder, Ross Winans, were sent by the B. & O. to England for five months to study its railroads. Upon returning to America, Whistler, after ten years in the army, became a first lieutenant. He and McNeill would henceforth work exclusively upon railroads, the B. & O. and several other lines.

On 3 November 1831, their relationship took on a new dimension. William McNeill's sister Anna became the second Mrs George Washington Whistler.

<p style="text-align:center">∗ ∗ ∗ ∗</p>

The father of William and Anna was a Scottish physician, Dr Daniel McNeill, who, after his wife's death in the late 1780s, emigrated to America, leaving behind two daughters to be raised by relatives. He went to Wilmington, North Carolina, where his brother, an amateur Shakespearean actor who enjoyed playing Hamlet, had settled. He established a medical practice, married the town beauty, and fathered six children. Anna, the fifth, was born on 27 September 1804.

It would be hard to imagine someone more unlike Mary Swift than Anna McNeill. When she became Mrs Whistler, she was eleven years older than Mary on *her* wedding day, a plain-featured, austere, humorless religious fanatic.

After his marriage, Whistler carried on with his railroading, usually as his brother-in-law's subordinate. In 1833 McNeill became a major, but Whistler was still a lieutenant, at a salary of $1152. Because civilians earned three times

that amount, many junior officers had been resigning. Whistler didn't want to do this, but his hand was forced.

In December 1833, after almost fifteen years of service, he asked for his first leave of absence, to spend thirty days with his family. On 26 December he was granted a leave – until the end of the year. He angrily submitted his resignation, expecting it to be declined. The War Department responded with one sentence: 'Your resignation as first lieutenant of Artillery is accepted to take effect on the 31st December 1833.' This reply, he told Swift, 'mortified me more than I have been willing to admit.'[5]

Luckily, army officers who had resigned easily found employment. Lieutenant Whistler was hired by the Shore Line Railway, building a road between New London and New Haven, in Connecticut. He would be paid $4000 a year, but because he had to travel a great deal at his own expense he left after two months to accept an offer of a $3000 salary and a rent-free unfurnished home from the Boston and Lowell Railroad, which was constructing a 26-mile line from Lowell to Boston. He would supervise the machine shop, where locomotives were assembled.

In March 1834, the Whistlers moved to Lowell, into an attractive two-story colonial house on what is now Worthen Street, about fifty yards from a tributary of the Merrimack River.

On 11 July, Anna's first child was born and was named James Abbott. He was baptized at St Anne's Episcopal Church.

Lowell has been proud of its most famous native son, whose family home is now a Whistler museum, but, as noted earlier, the feelings were never reciprocal. Once he even referred to the city as the 'taint' of his life.[6]

He was ashamed of Lowell because it was a community without culture or inherited traditions. Its site, an isthmus formed by two rivers, had been settled in 1653, but its development was long delayed. As late as November 1821 only a dozen houses were there.

In that month of November 1821 plans were formulated for what would become Lowell. Several Boston merchants, looking for a place to build cotton mills, inspected the adjacent Pawtucket Falls. (Water was the only source of power for manufacturing machinery.) They agreed upon this site, and the first mill began operating in 1823. During the next few years, plants multiplied, the population increased, and the locale was incorporated and named for the cotton manufacturer Francis Cabot Lowell.

The only problem, slow transit, was solved by the invention of the railroad, and on 24 June 1835 the line to Boston had its inaugural run.

Lowell had 22 mills and a train station but not much else. As Gertrude Stein would say in her often quoted remark on Oakland, 'There was no there there.' *Ergo* James Whistler's repudiation of his birthplace.

James's father disliked being in Lowell, not because of the city but because his

6

job was monotonous and unfulfilling. And so early in 1837 he accepted a position with the New York, Providence and Boston Railroad. He and his family, including Anna's second son, William, born on 22 July 1836, moved to his base of operations, Stonington, Connecticut.

<p style="text-align:center">❖ ❖ ❖ ❖</p>

A quiet town with tree-lined streets, Stonington protrudes on a narrow point into Long Island Sound. Whereas in Lowell almost nothing was more than ten years old, Stonington was permeated with what in America seemed ancient. The attractive gable-roofed Whistler home, with a fine view of the sea, predated the origin of the nation. (A century later the poet Stephen Vincent Benet would live there.)

James Whistler would always speak well of Stonington. He liked a town that had had a history and had made history. (Twice, in two wars, it had been the scene of a naval victory over the British.) He enjoyed living within sight of water, and he struck up friendships with neighborhood boys. Above all, there he drew his first pictures.

Decades later a Stonington woman recalled the 'beautiful' three-year-old boy 'lying prone with an inch of lead pencil in his hand and two inches of paper before him on which he was "drawing".'[7] The few surviving sketches are what might have been done by any moderately talented child. No one thought that they were special.

At this time the most gifted family member was his half-sister Deborah, a fine pianist and harpist. Born on 24 October 1825, she was beautiful, intelligent, delightful, adored by her brothers and her father. She gave Jimmy piano lessons and played duets with her father, a flutist.

The least musically inclined Whistler was Anna, singularly devoid of any talent, artistic or intellectual. Her overriding passion was a personal, evangelical religiosity. Her sons recited a memorized Biblical verse every morning at breakfast, and Sundays were totally dedicated to God.

Anna became more strongly attached to Stonington than to any other place, partly because of her younger sister Catharine ('Kate'). Kate had a romance with the town physician, Dr George Palmer, and they were married on 23 March 1849.

Six weeks later the Whistlers left Stonington. The size of the family was the same as on arriving, but its composition had changed. George's older son, Joseph, had died of typhoid, and on 16 July 1838, Anna had given birth to her third son, Kirk.

They departed in a state of exhilaration. Finally, in his twelfth year of railroading, Whistler was a chief engineer.

<p style="text-align:center">❖ ❖ ❖ ❖</p>

George Whistler's professional accomplishments have been greatly exaggerated. He was competent, not exceptional. His first chief engineering job came when he was 40. William McNeill, two years younger, was then a chief for the seventh time.

McNeill, who had resigned from the army in 1837 as a major, was now with the Boston and Albany Railroad. Since Whistler's offer came from this line, he probably had been recommended by his brother-in-law. He was to complete a segment of the road from Albany, New York, to Worcester, Massachusetts, with his headquarters in Springfield, Massachusetts.

Springfield was an industrial city of 11,000, home of the United States Arsenal and numerous manufacturing plants. One might think that Jimmy would be appalled by such surroundings, but he never spoke disparagingly of Springfield. It was not another Lowell.

This city has existed uninterruptedly since 1635 and is, like Stonington, dominated by water, the Connecticut River. Overlooking the river, table lands rise by terraces, on the second of which, Chestnut Street, the Whistlers lived. For the first time Jimmy came under the spell of moving water.

Springfield's influence extended beyond the river. Despite its industrialism, it was known as a 'city of homes,' stately houses in a small, exclusive district on the heights with tree-named streets. The Whistler home was typical: twenty rooms, each with a fireplace and marble mantle; walnut doors, panellings, and staircase; and external verandahs and balconies. (In 1925 the building was replaced by an eleven-story hotel.)

The neighbors were proud, self-satisfied scions of old families steeped in snobbery, and here James Whistler learned of a new way of life.

His father was also gaining new experiences. As chief engineer he made decisions, in one of which he chose as supplier of locomotives his colleague on the British trip, Ross Winans, who had recently opened his own Baltimore machine shop.

The first locomotive arrived in the spring of 1841, delivered by Winans's 21-year-old son Thomas, a man who eventually would be of some importance to James Whistler.

Thomas Winans was able to affect Jimmy's career because of two earlier visitors from far-off St Petersburg, Colonels Kraft and Melinkov, of the Imperial corps of transport engineers. Even though Russia had only 18 miles of rail, joining St Petersburg to a suburb, Tsar Nicholas I envisioned a 420-mile line from the capital to Moscow. Kraft and Melinkov were sent to the United States, and another man to western Europe, to inspect roads and confer with builders. In June 1840, Kraft and Melinkov reached Springfield and saw the Boston and Albany's newest chief engineer.

Whistler regarded this as just a routine visit. His current project would be

finished in mid-1842, and in February he wrote to Swift, 'I trust this coming summer will see us together much.'

The two men did not get together. Five thousand miles away, other plans were being devised for Lieutenant George Washington Whistler.

* * * *

After his emissaries had returned, Tsar Nicholas established a commission to preside over the construction of a railroad. Its principal members were Colonel Melinkov, who would oversee the northern section, and Colonel Kraft, who would control the southern section. It would be built and financed by Russians, but because of their inexperience the commission agreed in January 1842 to hire a foreign consultant. Kraft and Melinkov recommended Whistler, whereupon the Tsar instructed his Minister in Washington to forward an offer of a job at a salary of 60,000 roubles ($12,000).

It is not clear why he was selected. He certainly wasn't chosen because of professional eminence. When the colonels talked with him, he had been a chief engineer for exactly one month. Perhaps the commissioners wanted someone who was not prominent, who would not question their authority or ask for more money, or perhaps Melinkov and Kraft remembered Whistler because he was almost the last person they had seen.

After talking with associates, he accepted provisionally. If he should have doubts after arriving in St Petersburg, he wished to be free to withdraw. This was agreeable to the Russians.

His family, at least temporarily, would remain in America. In Springfield it had gained and lost one. On 27 August 1841, Anna's fourth son, Charles Donald, was born. On 10 July 1842, her third son died. She wrote in her diary, 'Kirk left us on a beautiful Sabbath morning, his hands clasped in prayer. His last words were, "Mother, I want to go to Heaven." '[8]

A couple of weeks later, escorted by the Tsar's personal representative, Whistler departed. If his acceptance became firm, perhaps the others would follow. But perhaps not. Several friends advised him to live alone in St Petersburg because it was an extremely expensive city for foreigners. Even on $12,000 a year, maintaining a family might use up his savings.

For all of the Whistlers, the future was very much up in the air.

2

St Petersburg

[1843–48]

After selling the household furniture, Anna moved with the children back to Stonington, where they would live with the Palmers.

Whistler's acceptance of the Tsar's offer soon became final, but back home the future was still uncertain. Anna was planning a family voyage, but after visiting her, William Swift gained the impression that they would go only as far as England, to see her half-sisters.

They were to leave in May but postponed the trip because Jimmy was hit with rheumatic fever which was nearly fatal. After his recovery, Anna wrote in her diary, 'May God have prolonged his life as a blessing to us!'[1]

Late in July he was fit to travel, and a party of six went by train to Boston: Anna; Deborah; Jimmy; Willie; the family servant Mary Brennan, who had joined them in Springfield; and Whistler's son George.

Twenty-year-old George William Whistler was an affable, loving son and brother, idolized by his sister and half-brothers. Anna was saddened by his disinterest in religion, and his father was troubled by his drifting from one job to another. Currently he was an apprentice engineer in the Lowell machine shop which the senior Whistler had supervised.

A close associate would refer to George as 'one of the comparatively few men who are not content to take life according to the prescribed pattern, but mould it according to their individual will and capacity for enjoyment.'[2] This description is interesting in light of George William's position as James's first 'role model.'

George was on leave from his job in order to escort his family on a long trip, all the way to St Petersburg.

 * * * *

In 1838 trans-Atlantic steam travel became a reality, and by 1840 steamships made scheduled crossings. The trailblazer was Samuel Cunard, who founded the

British and North American Steam Packet Company, the Cunard Line, which began with the 200-foot sister ships *Britannia* and *Acadia*, capable of carrying 115 passengers across the ocean in 12 days. The ports of departure were Liverpool and Boston. (Cunard's selection of Boston as his American terminal shocked many New Yorkers.)

On 16 August 1843 the Whistlers arrived at the elegant Boston wharf, ascended the gangplank, and stepped onto the *Acadia*. They were not travelling cheaply. There were no second-class or steerage passengers; everyone went first class. A one-way ticket cost $200 (half-fare for children under 12). By way of contrast, the fare for European immigrants on sailing ships was $13.50.

The Whistler travel bill was $1100, slightly less than what the head of the family had earned during his last year in the army. According to a Cunard brochure, the rates included 'Steward's Fee, Provisions, and all Requisites, but not Wines or Liquors.' The ship's facilities did not measure up to the fare. Cunard had not yet entered the era of luxury travel. There was just one passenger deck and one small, gloomy saloon, and the staterooms were so tiny that Charles Dickens, a voyager in 1842, called them 'a cheerful jest.'[3]

The Whistlers didn't complain. They merely enjoyed a calm crossing. For the boys the most memorable experience came on the second day, when the ship overturned a bark. They excitedly watched the boat's crew taken aboard and rushed to tell their mother about it. 'I doubt not,' she said, 'that they felt like heroes themselves.'[4]

Ten days later, on 29 August, the *Acadia* docked in Liverpool. The Whistlers then travelled by train for 28 miles to the cotton-spinning city of Preston, home town of Anna's half-sisters, Alicia, a widow, and Eliza, married to a man named Winstanley. After a two-week visit, they went on to London and spent a night in a hotel, in Norfolk Street, off the Strand, only yards from the river that would give Jimmy his greatest artistic inspiration.

From London they took a steamer to Hamburg; from Hamburg they rode all night in an open carriage to Lübeck; from Lübeck they journeyed by stage coach to Travemünde, the usual port of embarkation for St Petersburg. George saw the others aboard the German ship *Alexandre* and then began his trek back to America. His departure affected most of the others. Deborah was extremely sad. Willie, in his mother's words, was 'almost heartbroken and for two hours was inconsolable.'[5] The littlest one said, 'Charlie wants brother George back again.' Only Jimmy was unperturbed, demonstrating not that he wasn't fond of George but that even as a child he easily adapted to changes in his life.

On the first night out from Travemünde, Charlie became ill. He could neither eat nor sleep and could barely say his prayers.

'Charlie is too sick to kneel down,' he told his mother. 'Say them in bed.'[6]

He did just that, clasping his hands together.

'If only a doctor was on board,' said Deborah.

Anna was content to 'trust in Him.'

On the next morning the young patient could not hold medicine. 'No medi for Charlie, if you please,' he said.

There was no improvement during the day, and that night, squeezing his mother's hand, he spoke his last words: 'Charlie's *own* Mama.'

Like Kirk, he died on a Sunday. 'God took them to a better world on the Sabbath,' Anna told Jimmy and Willie, 'to impress upon you the importance of always keeping it holy.'

With Mary's help, she prepared the body for her husband's eyes. But at the port of entry, the island of Kronstadt, customs officers informed her that corpses could not be taken into St Petersburg. And so Charlie was placed in a casket on a ship bound for Boston, to be buried in Stonington alongside Kirk. 'Death cannot divide our youngest darlings,' Anna wrote in her diary. 'They shall mingle! They are one in Christ!'[7]

As was true of most ships arriving at Kronstadt, the *Alexandre* was too large for the remaining fifteen miles. The passengers boarded another vessel which sailed on Friday, 28 September. After it had entered the River Neva and approached the city of 440,000 persons, Jimmy and Willie excitedly questioned a Russian count about the gilded spires and domes in the spectacular skyline, while Anna was wondering how to deliver the sad news to her husband, waiting on the fashionable English Quay, where the boat docked.

After travelling on three trains, three ships, two boats, one carriage, and one coach, they had come to the end of their journey.

<p style="text-align:center">*　　*　　*　　*</p>

'Where's the little one?' Whistler asked.

'Please, I beg of you,' Anna said, 'don't ask any questions until we're home.'[8]

'Home' was on the city's most exclusive street, the Galernia, just beyond the English Quay. Large and luxurious, it had recently been the residence of Charles Stewart Todd, the American ambassador. It was richly furnished, had a modern kitchen, and was fully staffed, including a butler, cook laundress, stovekeeper, footman, and two housemaids. Anna liked the home but not the rent of $2000 a year – they would leave when the lease expired in June 1844.

During that year on the Galernia, the boys studied with their tutor, a German. Deborah practiced on her piano, provided by Ambassador Todd, and on her harp, shipped from Stonington. She also attended classes at the German Institute, and, with her brothers, donned fur clothing to explore the city. Anna mainly wrote letters to America and read the Bible.

As for Whistler, his enterprise, the Russian National Railroad, popularly called 'the Nicolai,' got off to a fine start, and, partly because of slave labor, it would be completed more speedily than any other similar enterprise. Whistler had been hired to give advice, and, as in Springfield, one suggestion involved the

supplier of machinery. He recommended the Philadelphia firm of Harrison & Eastwick, which then received from the Tsar a five-million-dollar contract for engines and passenger and freight cars. Representatives of British train builders had tried to influence the commissioners, and a resident American reported that the Tsar's decision produced 'a prolonged groan in the British quarter. That the infernal Yankees should be insinuating themselves into Imperial favor was almost beyond endurance.'[9]

Ross Winans had not been overlooked. Whistler asked the Philadelphians to let him join them, and they offered him a partnership relating to work in Russia. Because he was not physically able to travel, Winans proposed partnerships for his sons Thomas and William, 22 and 21 years old. This was done. The four partners would share profits, which, with earnings from several successive contracts, enabled the younger Winanses to become millionaires before they were 25.

Harrison & Eastwick built a factory on the outskirts of St Petersburg. The top positions were held by Philadelphians, except for the brothers Winans.

Whistler worked closely with his countrymen, who often visited him at home, but never on Sunday. They learned about this quickly. Soon after Anna's arrival, an engineer called when Whistler was absent and asked if he might stop by on Sunday.

'My husband's friends are welcome on any day but the Sabbath,' Anna said. 'On that day we are not at home.'[10]

The visitor said, 'The major is not as particular as you are on that point.'

Whistler was not in fact strict on religious matters.

Also, he was not a major.

Curiously, this resigned first lieutenant was habitually referred to in Russia as 'Major Whistler'. On his birthday an English woman raised a glass and said, 'I drink to the major's health.' When Anna and Deborah opened a letter intended for him, a visitor asked, 'What will the major say when he finds his letter unsealed?' And so it went. He was always 'the major.'

More recently, his two biographers and everyone who has mentioned him while writing about his most famous son have called him 'Major Whistler.'

In point of fact, he never served for even one day as a temporary captain, let alone as a major. This is established not only by the War Department letter accepting his resignation, which is now in the Manuscript Division of the New York Public Library, but also by the semi-official *Biographical Register of the Officers and Graduates of the U.S. Military Academy*, edited by Colonel George W. Cullum (New York: Van Nostrand, 1868), which on page 189 of Volume I verifies Whistler's resignation as a first lieutenant.

When, how, and why did the lieutenant become a 'major'? One can only speculate, and I offer this conjecture. Whistler was a 'major' only in Russia. To my knowledge no American in the United States ever addressed him thus. I

submit that he acquired this rank when Kraft and Melinkov arrived in Springfield. Colonels of the Tsar might have looked askance at a forty-year-old lieutenant. Perhaps as a joke, perhaps at the suggestion of the real major, William McNeill, he jumped a couple of ranks, never to return to his lieutenancy.

It is instructive to keep in mind that a continuing witness to this sham was young Jimmy, who saw his father achieve his greatest success through chicanery.

* * * *

In September 1844, the Whistlers moved into a new residence, the third floor of a block of flats on the English Quay. Although less luxurious than their first house, it had ten rooms, including a parlor with wall-to-wall carpeting and a bathroom with a hot and cold shower bath. There was also a balcony with a fine view of the Neva. The rent was $900 a year. For Anna even this was 'extravagantly high,' but she bore with it, and they lived here for the rest of their Russian stay.

Anna was rightly concerned about finances. As she had been warned, St Petersburg *was* an expensive city for foreigners. Whistler told Joseph Swift that if they remained for five years, he would be lucky to save enough to earn a yearly income of $1000.

He might not have been able to save anything if they had had an active social life. They could have gone out every night, to the theater, to concerts, to dinner parties, to balls. Yet Anna once thus explained a two weeks' hiatus in her diary: 'There is so little variety in my life, that nothing has been worthy of record.' Her life was uneventful because she never wanted to do *anything*. She shunned social and cultural events, and she was incurious about her surroundings. During her first two months in this exotic city, she left her house only three times, except for going to church.

She might be contrasted with a compatriot, one Mrs Bodisco, married to a Russian diplomat and living in the capital during the winter of 1843–44, known as the 'beautiful American.' On the infrequent occasions when Anna attended a social affair, she saw Mrs Bodisco, and immediately afterwards would record her impressions in her diary. At a dinner party of the ambassador, Mrs Bodisco 'wore a green dress with short sleeves, her round fair arms bound by three bracelets and a weighty necklace of pearls fastened with a very large, rich locket of diamonds.' At the Grand Duke Michael's ball, she wore a $1000 dress and 'spoke in raptures of the uninterrupted season of pleasure she has participated in at this dissipated court.'

Whereas Mrs Bodisco lived for pleasure, Anna detested pleasure. When a death in the royal family forced amusement places to close for six weeks, she thought it 'a pity they should ever reopen.' Even a fireworks display she called a 'dissipation.'

14

One day a lively English couple, the Ropers, had tea with Anna and Deborah. Mr Roper told several humorous stories, causing Mrs Roper and Deborah to burst out laughing. Anna admitted that she 'could not resist the peals of laughter,' but her 'heart was sad after joining in it.' She felt guilty about this moment of secular enjoyment.

She capsulized her credo by quoting from the First Epistle of John: 'Love not the world nor the things in the world. If any man love the world, the love of the Father is not in him.'

She was 'impatient' to enter the 'real world,' where she would 'at once join [her] Saviour.' Perpetually she professed her total dedication to Christ, and yet she was curiously oblivious of a fundamental point in the teaching of Jesus. She had very little compassion for poor people. Indigent persons gazing longingly at a shop window were 'idlers.' Workers who repaired her flat were 'filthy' and had a 'dreadful odor.' She 'shuddered' when she brushed against a man whose 'breath of leeks and vodka almost made me sick.' She lamented that during festivals 'the Emperor's poorest subjects forget their shackles and revel with perfect freedom.'

Unlike her stepmother, Deborah had a healthy zest for the here and now. She enjoyed visiting friends, going on sleigh rides, studying languages, playing parlor games, caring for her pet bird, attending theatrical performances, conversing on almost any topic.

Everyone loved this girl, nicknamed 'Dasha,' who was unspoiled, unaffected and devoid of snobbery. People repeatedly visited the Whistlers to talk with her or to hear her play. At least 32 times in her diary, Anna mentioned Deborah's musical performances. A guest missed an appointment because he 'could not resist the temptation of lingering to hear Debo's harp.' Another acquaintance 'would ride for miles to listen to Debo's harp or piano.' A Scottish friend did 'a Highland dance to the quickest time Debo's fingers could move over the keys.'

Anna condescendingly tolerated her husband's flute playing; she was 'amused' by his careful treatment of this 'toy.' Deborah's passion for music, however, was something else. It was 'excessive' to spend 'whole mornings' practicing on the piano and to be constantly attending concerts. The only music Anna enjoyed was that 'which lifts the heart in heavenly choirs,' and, she added, 'if I were Empress, I should prohibit any other music.'

Deborah went out so often that Anna was 'relieved' when the first season ended and she would 'no longer be tempted into crowded rooms to keep late hours.' Because of her night life, she frequently skipped the family's morning devotions, and she might even 'be neglecting bedtime prayers'!

A significant commentary on the two women came from William Swift in a letter to his brother. After visiting them prior to the departure for Russia, he wrote,

Anna has quite a fancy for making a figure. I am sorry that I do not like her, but I cannot help it. I believe her to be artful and selfish. On Debo's account I am rejoiced that she will be near her father. There is quite a difference in Debo when Whistler is at home and when he is absent. All will be all right if she goes to her father.[11]

Unfortunately, in St Petersburg Deborah necessarily spent much more time with her stepmother than with her father, and this seems to have affected her physical well-being. Actually Deborah was exceedingly healthy. When her father wrote to Joseph Swift in the spring of 1844, he noted that illness had frequently struck Anna and the boys but Deborah 'never.'[12] Then early in 1845 Anna began to refer in her diary to her stepdaughter's real or imagined maladies. She had an 'intense headache'; she looked 'ghostlike' at breakfast; she had 'a general eruption of her skin'; and, finally, in mid-April, she was 'so feeble this spring.'

Soon after these last words were written, Deborah asked if she could go to England for a health cure. When her father and stepmother assented, she revived remarkably. 'I have never seen Debo so energetic,' Anna wrote. 'Her first and last question night and morning is about steamers for England.'

Passage was booked for her and a chaperone to leave on 26 June, but on the eve of her departure she suddenly became as eager to stay as she had been to go. Without advance notice, unpredictable George William appeared. (He was now working for Ross Winans as an engineer.)

Deborah turned in her ticket, and she and her brother shared a delightful summer. Before it was over, on 29 August, their last stepbrother, John, was born.

Soon after John's birth, Deborah left for England, accompanied by George, returning to Baltimore.

In her diary Anna wrote, 'May my daughter only seek friends among those who are friends of Jesus!'

<div align="center">* * * *</div>

When Deborah left, her eldest stepbrother was an art student.

Since his arrival in St Petersburg, Jimmy's biggest interest had been drawing, so much so that Anna often found it difficult to get him to put away his materials and go to bed. Then in the summer of 1844 his work was professionally evaluated. The Scottish painter Sir William Allen, in Russia to fulfill a commission for the Tsar, visited the Whistlers. After the boys had retired, he looked at some of Jimmy's drawings, which, he said, displayed 'uncommon genius.'[13]

Jimmy's parents now arranged for him to take weekly lessons from an advanced art student, Alexander Karetzky.

Karetzky was enrolled in the Imperial Academy of Fine Arts. Founded by

Peter the Great and modelled after its French counterpart, it was on Vasili Island, in the Neva about 200 yards from the Whistler residence, in plain view from the boys' bedroom. Four hundred feet long and seventy feet high, it was, physically, Europe's largest, most spectacular art school. Its teachers and facilities were good, and it provided free instruction for 400 students.

After a few months of lessons, Karetzky, a member of the highest of the Academy's four classes, urged Jimmy to take the entrance examination, which he did early in 1845, performing well enough to qualify for the second class.

On 14 April, wearing the prescribed uniform, he crossed the bridge to Vasili Island to begin formal art instruction.

His class met three times a week. The languages of instruction were Russian and French, in both of which he was becoming fluent. It was called 'Drawing from Nature,' but not nature as we understand it. Copying from the Greeks was considered to be imitating nature, and the pupils copied from casts of ancient statues.

This instruction was prototypical of European art academies, where, under the spell of Jacques-Louis David, uncritical admiration of ancient art approached religious worship. Pupils could not even try to be inventive, original, innovative. Free drawing was disallowed. They did only what they were told to do.

Although the work must have seemed unimaginative, Jimmy wasn't restless or rebellious. He completed assignments punctually, and except for illness he was never absent. At the final examination, on 2 March 1846, he was twenty-eighth in a class of more than 100 and received the top grade, a 'first.'

Nearly thirty-three years later James Whistler swore in a courtroom that he had been born 'in St Petersburg, Russia.' Since he said this in a trial that dealt solely with artistic matters, he was not totally out of line. Whistler the artist *was* born in St Petersburg. There he had his first drawing lessons and received his first studio instruction. And there he saw his first large collection of paintings.

Whistler's writings and recorded conversations do not refer to the Hermitage, but surely he visited it, probably often. His family once went with Ambassador Todd on a tour of the Tsarskoe Selo palace, and, Anna said, Jimmy 'wished he could stay to examine the pictures and know who painted them.' The Hermitage has many times more paintings than Tsarskoe Selo, and it was nearby. Karetzky, moreover, copied some of its pictures. It is inconceivable that Jimmy could have stayed away.

Concerning the Hermitage, I shall make one observation. The paintings were then all on the second floor, and the entrance foyer was dominated by nocturnal water scenes of the seventeenth-century Dutch master Aert van der Neer, with the moon shining down on rivers, lakes, and harbors.[14] Was this the original inspiration for James Whistler's most significant works of art? If so, it is another reason for calling St Petersburg his artistic birthplace.

Beyond the Hermitage, a celebrated picture was probably influential if only because of its size and location, Karl Bryulov's 20 by 15 foot *Last Days of Pompeii*, in the vestibule of the Academy, depicting several groups of residents just before the lava arrived. The volcanic glow and a flash of lightning combine to create effects which were then highly innovative. Jimmy saw it every time he entered and left the building.

Just after his final examination, the Academy was the scene of the nation's triennial exhibition of contemporary art. It continued for six weeks, and Jimmy was there every day.

'It is the greatest treat we could offer him,' Anna said.[15]

At the same time they informed him that he would not return for a second year at the Academy.

The Whistlers thought that Jimmy was spending too much time on a hobby. Also the West Point father felt that his sons needed to be more disciplined. And so at summer's end in 1846 they became pupils in Monsieur Jourdan's French boarding school.

On 14 September, after getting close-cropped regulation haircuts, the boys put on uniforms of velvet stockings, gray trousers, black jacket, and a round black cloth hat. They were leaving home for the first time.

Willie was in tears and clung to his mother. Jimmy was dry-eyed, ready to go.

During their first week in school, a family friend visited them. Willie, he said, looked 'very doleful,' suffering from homesickness, but for Jimmy it was ' "first-rate" to be among fifty other boys.'

The boys entered Jourdan's just after John's first birthday. 'My heart is overflowing with thankfulness to the Giver,' Anna wrote, 'for providing a healthy baby to cheer me for the loss of Charlie.'

This sentence is painfully ironic. On 15 September Whistler left for Hamburg to meet Deborah, who was returning home. For 11 days Anna neglected her diary. Then came this:

> What a shock it will be to Whistler and Debo when they hear all I have gone thro. They will see how near we came to losing our precious little Jonie. The crisis is past and we may hope God will spare us the affliction of having to bury this little one. Never have I witnessed sufferings so extreme.

His illness, common to foreigners, was dysentery, resulting from the drinking water.

Johnnie got the best possible treatment. The family doctor, an Englishman, called four times a day, joined once a day by a German pediatrician. Anna prayed for the pain to be alleviated, but not for the life to be spared 'if our Infinitely wise and compassionate saviour designs to take him to Heaven.'

On 14 October the baby was 'returned to God, who had lent him to cheer us and to warn us! Be ye also ready!'

A day later Deborah arrived. Life with mother was not going to be easy. 'Our darling daughter,' Anna wrote in December, 'seems at times solitary and melancholy.' These adjectives fit strangely on Deborah. But after 14 cheerful months in Britain, her pensiveness is understandable, especially with her father gone during the day and her brothers at school.

The boys had a Christmas vacation of three weeks. Willie had been miserable away from home and didn't want to go back to school, and Jimmy sided with him because of a recent incident. On weekends, from mid-afternoon Saturday until bedtime Sunday, Jourdan's pupils could go home. It was then that Jimmy met with Karetzky for his only current art instruction. But on Saturday, 28 November, he was not allowed to leave because after reciting in front of the class that morning he had stopped to chat with a classmate instead of marching back to his seat. This punishment turned him against Monsieur Jourdan.

Deborah supported the boys. Eager for something to do, she volunteered to be their tutor. And Anna pleaded with her husband to let them stay because, she said, 'I tremble for their morals at that school.' Whistler yielded.

Working with her brothers was good for Deborah. She had lost her appetite, had been sleeping badly, had become, in Anna's words, 'feeble, pale, and very fragile.' Now she was enjoying herself. She taught the boys separately. Willie received his lessons in the parlor, but Jimmy got his in bed. He had become an invalid.

A few days after it had been decided not to send him back to school, Jimmy couldn't get out of bed. He had a recurrence of rheumatic fever.

Anna and Deborah each in her own way endeavored to keep his spirits up. Anna sang hymns, 'the only welcome sounds to soothe anguish.' Deborah borrowed a book of engravings by Hogarth.

The large volume was put on top of the bed, and Jimmy sat in a chair and turned the pages. Infatuated, he pored over it by the hour. He could hardly wait to show it to Karetzky. He was even thankful for his ailment. 'If I hadn't been ill,' he said, 'perhaps no one would have thought of showing it to me.'[16]

Jimmy's response is not surprising. Hogarth is entertaining and immediately accessible, and he is an excellent story-teller. And something else surely impressed a boy who had been immersed for a year in the concept of 'ideal beauty.' Hogarth wasn't interested in remote creatures of no particular time and place. He depicted his own society in its fullness and variety – rich and poor, powerful and weak, artisans, tradesmen, soldiers, politicians, beggars, thieves, merchants, squires, the idle rich, strolling players, musicians – without moral judgments. They are vividly realistic because Hogarth had learned his craft not in an academy but on the streets of London. 'There is but one school,' he said, 'and it is kept by nature.' It is no wonder that he had such an impact on a boy

19

who had undergone conventionalized academic training while absorbing St Petersburg's street scenes.

Far from being a passing fancy, Whistler's love of Hogarth, as noted by his official biographers, the Pennells – whose name will appear frequently in the present book – became 'an article of faith with him.'

Another painter surely known to Jimmy was a former junior officer in the Russian army who had resigned in 1844 to become a full-time artist, Pavel Fedotov. Before his career was cut short in 1852, he enjoyed a brief period of immense popularity that began with two paintings exhibited at the Academy in the spring of 1847. He became famous in 1848 with *The Major's Courtship*, which shows an impoverished nobleman, a rich merchant, and the merchant's daughter, trying to escape from the scene. Because of pictures like this, reminiscent of *Marriage à la Mode*, Fedotov was sometimes called 'the Russian Hogarth.'

Fedotov said that one-tenth of his work was done in a studio. He spent the rest of his time walking the streets with an observant eye. With subjects from contemporary St Petersburg, his immediate effect on Jimmy may have been even greater than that of Hogarth.

By the end of March 1847 Jimmy was on his feet again, but he, and everybody else, confronted something more frightening than rheumatic fever.

In April there was an influenza epidemic, with many deaths. This was only the beginning. The flu was a harbinger. For the first time since 1831, Russia had been invaded by that most dreadful of scourges, cholera.

It hadn't reached St Petersburg, but everyone was talking about it, and some foreigners left when the Neva opened for navigation. Whistler decided to send his family to England, and if he did not regain his health, Jimmy would perhaps remain there.

In May, Deborah left ahead of the others, intending to spend the summer in Switzerland. Then on Saturday, 8 June, Anna, the boys, and Mary Brennan departed on the steamer *Nicolai*.

On the second day aboard, Jimmy was surprised to see men playing cards on the Sabbath, and, moreover, he told his mother, 'they lose their tempers!'

'I think the impression will be deep on him,' Anna said, writing to her husband.[17]

Probably Jimmy was influenced by the incident, but perhaps not as she had hoped. It may have been a revelation to see people cavorting normally on Sunday.

In her letter from the *Nicolai*, Anna contrasted the personalities of her sons:

I watched Willie striding about the deck holding the Captain's hand and talking German so eagerly. How pleased you would be with his manliness. He is a lovely

combination of gentleness and determination to do what is right. I feel as if he were prompted by his dear father, whom he is so much alike.

Dear Jemie has divided his thoughts between squeamishness and drawing. When I examine my own life, I am brought to see how much patience I ought to have towards Jemie. You, who are so forebearing to Annie's [that is, her own] failings, should not be despairing about conquering those of this noble minded boy, for all his faults he inherits from his mother. If Jemie and I could take time to think before we act, or speak, how much mortification we should save both you and ourselves. I hope that you may find him improved in every respect when we are restored to our home.[18]

On their arrival at Travemünde, Jimmy's 'impatience as usual could not be restrained.' He wanted to go ashore immediately.

They travelled by the customary stage coach to Hamburg and by steamer to the port of Hull, arriving one week after leaving St Petersburg.

After Sunday in York, attending services at the Minster, they rode to Scarborough in a second-class rail carriage, which Anna said, 'wounded Jimmy's pride.'

With its fine beach, cliffs, and gardens, Scarborough was then known as the 'queen of watering places.' The Whistlers occupied a seaside cottage for what Jimmy told his father was 'a delightful week' of 'riding and bathing.'

In this letter he wrote, interestingly in light of later attitudes, 'I like England and the English people a great deal better than I thought I would.'[19]

He liked everything well enough to ask if he could stay there beyond the summer:

'What do you think of placing us at Rossel [sic] school? It is so beautifully situated, on the open sea. Everyone says it is the best school in England, and if it was not for the disappointment of not seeing you for such a long time, I should like to go there.'

The well-known Rossall public school does indeed command a spectacular view of the Irish Sea, but since it had opened only three years earlier, it could hardly have been the 'best in England.' Jimmy mentioned it because of its closeness to Preston, where he spent the rest of that summer and heard people talk about the new school. Actually he wasn't especially eager to go to Rossall; he just wanted to stay on in England.

His wish was apparently to be granted. As a precautionary measure, Anna decided not to take him back to Russia. She enrolled him, not in Rossall, but in a more prosaic boarding school in Liverpool. Because the boys didn't want to separate, Willie was also registered. The school term would start early in September, when Anna and Deborah had planned to return to St Petersburg.

In mid-August, Deborah appeared. She brought tidings that would transform the life of everyone in her family.

✣ ✣ ✣ ✣

During her first day in Preston, Deborah was extremely nervous. Anna thought that Switzerland had not improved her health.

On the next day they sat together, and Deborah said, 'Mother, I want permission from you and Father to be married.'[20]

In Switzerland she had fallen in love with a 29-year-old English surgeon, Francis Seymour Haden (always called 'Seymour'). His family was financially comfortable and socially prominent. His grandfather and father, both deceased, had been surgeons, and an uncle had been priest-in-ordinary to two monarchs and was presently Preceptor of Westminster Abbey. Many Hadens had been, and were, good amateur musicians, and Seymour was a talented artist.

His family members – mother, brother, and two sisters – were, one of the sisters said, 'delighted that dear little Debo is to be among us.' And Anna was happy. Despite the brevity of their acquaintance, she readily sanctioned the match. Now they need only a seal of approval from the 'major.'

In three or four weeks they would hear from him. Meanwhile the boys settled down in school, and the young couple behaved properly. Neither visited the other, but, with Anna's approval, they exchanged daily letters.

Eliza told Anna, 'You might as well chop Debo's head off as propose that she go back to Russia.'[21]

Whistler was startled by the news. He was willing to endorse the marriage but hoped for a delay.

> If our dearest child could come home for this winter, [he told Anna,] my happiness would be complete. If you think I should not ask this, say nothing of it, for I would not pain her for the world, yet if her health would not be injured, it would be a great comfort to me. I have never till now felt what it was to contemplate her leaving. She doesn't know how much I shall miss her. Surely she can be spared me these few months.[22]

In any event, he would leave at once for England. He would take a semi-business trip and would confer with railroad men in London.

Anna said nothing to Deborah about her father's plea. The wedding date was set for 16 October, eight days before her twenty-second birthday.

Whistler arrived on 11 October. When he learned about the wedding, he asked Anna to remove the boys from school because he could not 'bear to part with all of my children at once.' After 'seeking counsel from God,' she agreed.

The marriage took place in Preston's Old Parish Church. At the reception, which Anna enjoyed except for the champagne, Deborah looked 'the happiest of the happy,' and then departed 'without a tear, her eyes shining with happiness.'[23]

22

The Whistlers left immediately afterwards to catch the season's last ship to St Petersburg.

They were in London for a day. Whistler transacted business in the City, and the others visited the Haden home in Sloane Street.

Contrary to what has been said by some writers, Sloane Street was not then conspicuous for elegance. In his authoritative *Handbook of London*, completed in 1849, Peter Cunningham characterized it as 'a very long row of third-rate houses lying between Knightsbridge and the King's-road.'[24]

In one sense the houses were 'third-rate' because for rating purposes they were in the third category. (In Britain, assessments on property are called 'rates.') But in the middle of the nineteenth century 'third-rate' was rapidly gaining its depreciative meaning. Historians regularly used the term in this context. Connop Thirlwall in his history of Greece referred to 'an actor of third-rate parts'; George Grote in *his* history of Greece mentioned 'a town of third-rate magnitude'; and Thomas Macaulay in his history of England spoke of a 'third-rate pamphleteer.'

Sloane Street, it would seem, was in both connotations 'third-rate.' Only its western side had private residences. Across the road there were dozens of tradesmen: grocers, tailors, hatters, paperhangers, butchers, fruiterers, plumbers, shoemakers, cheesemongers, pawnbrokers, etc. This was not exactly a replica of Curzon Street or Belgrave Square.

Number 62, where Seymour Haden's father had established a medical practice in 1812, and where Seymour had been born, was at the corner of Hans Street, midway between Knightsbridge and Sloane Square, an unostentatious, cream-colored, four-story brick house. The housekeeper took Anna and the boys on a tour of the parlor, dining room, bedroom, Seymour's study, and Deborah's boudoir, decorated with Seymour's drawings of scenes in Italy and Switzerland. (One of the last unsullied homes on Sloane Street, it and several other houses were torn down in the early 1970s to make room for the Danish Embassy.)

From Sloane Street the Whistlers went to Westminster Abbey, where Jimmy sketched the monuments. They also had time for St Paul's and the Colosseum, a Regent's Park exhibition hall currently showing prize-winning cartoons from the 1843 Westminster Hall competition.

Before dawn on the next morning they passed through a district that would be important in Jimmy's early adult life, the area of the docks. For Anna it was 'frightening' to be in the midst of this 'squalid wretchedness, pollution, and crime,' and, upon leaving their carriage, to face 'the Thames boatmen! Swearing at each other, seizing our luggage and hurrying us so savagely into our boats I trembled and scarcely expected they would put us aboard without pilfering some of it.' Whistler did not question their demands for gratuities, and nothing was taken.

They returned by the usual route: London to Hamburg to Travemünde to St Petersburg.

Whistler spent the last leg of the voyage in his cabin, thoroughly depressed. On the morning of 1 November he was glad to disembark and get back to work.

3

A London Interlude

[1848–49]

Jimmy's fifth Russian autumn and winter were uneventful, but the spring of 1848 was a season of frenzy. After a period of remission, the cholera revived and it hit St Petersburg, where by mid-June it had struck down 15,000 residents, more than half of whom died. The shops were deserted, and many foreigners fled, including the Whistlers' family doctor, who advised them to get out.

George Whistler would not abandon the railroad, but again he shipped his family to England.

<p style="text-align:center">* * * *</p>

Upon arriving at 62 Sloane Street, Anna and the boys were warmly greeted by Seymour. When Deborah, who had been upstairs, came down, Anna found her 'looking better than when she was a bride' and 'even happier now.' The couple were 'truly one, their tastes the same, with perfect harmony and cheerfulness.' The only missing element was 'family worship.' Anna could only hope that someday they would 'raise an altar.'[1]

On her first Sunday most of the Hadens gathered at the house, and Deborah proposed a medley of religious songs. For thirty or forty minutes they sang sacred melodies.

After a week in London, Anna and the boys began an extended holiday on the Isle of Wight. An early incident showed that even as a child James Whistler attracted attention.

They were in a shop when a titled woman said to him, 'I have seen you before. I think it was last summer. Were you at Cheltenham?'

'No, ma'am, I've never been there.'

'Then surely it was at Scarborough?'

'Yes, ma'am, we were there for a week last year.'

'I knew it.'

The Lady told Anna, 'I could never forget that boy's face.'[2]

Jimmy had a new box of paints, a gift from Seymour, which he used for his first landscapes. His favorite spot, Anna noted, was 'a wide chasm in a cliff where he would sketch the waterfall by the hour if I would let him expose himself to the dampness.'

He enjoyed the opportunity of working on his own, uninstructed. Excitedly he wrote about it to his father, who was 'delighted' and asked for a sketch. After receiving several, he pronounced them 'good' but reminded Jimmy that 'I have not seen these places. Therefore a few more touches would make them a much better illustration of what you have seen.'³ Already James Whistler's landscape art was highly personalized.

Three weeks later, after getting another batch, Whistler dispatched an admonition that he had voiced previously and would often be expressed by others:

> Jamie, my dear, carelessness was wont to be your evil genius – *finish* your work, my boy. I will not repeat any of the many talks we have had on this head. I am *sure* that you remember them, and I think you will make every effort to master this evil one. Depend upon it, my dear James, I shall feel most happy when I see indications of *regularity* and *perseverance*. These are the faults that need your greatest attention, my dear Jamie. Without them it is impossible to accomplish much that is really useful – and without *regularity* and *perseverance* labor is lost. As the first lesson, finish whatever you begin.⁴

Whistler encouraged Jimmy to draw, but only as an avocation or as an adjunct to his profession, which 'must be, or should be, Engineering or Architecture.'

Then he offered advice which is noteworthy when one bears in mind that his son would become almost as well known for writing as for painting:

> As a professional man it is of the utmost importance to be able to write well and with facility your own language. To write English clearly and forcefully is so desirable, James, that you cannot do wrong in considering it of the *first* importance – and doing anything that shall in any way aid you in it. Read, Jamie, read much and read carefully. Write as much as possible and write carefully.

In this letter of September 1848, Whistler addressed Jimmy with greater warmth and affection than at any other time.

> You know, Jamie dear that I *should be your best* friend. I trust you feel that I *am* so. I entreat you, my dear child, always treat me as your *most intimate friend.* Indeed Jamie, you will always be most happy when you feel that I am your best friend. Mother and I feel certain that you will never hesitate to tell us all your griefs, nor will you ever deprive us of our right to supply all your wants. We shall

be jealous of our share of your enjoyments, and be assured, my dear James, no one could be more anxious or willing to bear with you all your sorrows and troubles. Feel free to tell us everything, as *I am sure you will be.*

Write me with *perfect freedom*, my boy. This I entreat of you. Say everything to me.

There were probably two reasons for this unprecedented tenderness.

In the first place, Anna had decided that because of his health Jimmy should not return to Russia, and so, without Willie, he was enrolled in an English school. When informed of this, Whistler said that he was 'quite prepared' for it and was 'quite happy' that his son would 'advance his education *in English*' and would 'acquire good habits of regularity of application.'

A second likely explanation of this sudden affectionateness is that in this month of September 1848 Whistler became seriously ill. Surrounded by people dying from cholera, he perhaps felt that he might never again see his son.

When Jimmy received his father's expansive communication, he was living in an undistinguished boarding school, Eldon Villa, whose headmaster, Mr Phillott, was a friend of Seymour Haden. It was near Bristol, at the fashionable, picturesque watering place Portishead, the scene of several paintings by Turner.

Jimmy liked the town and the school, but, as in St Petersburg, he dropped out after one term. During the Christmas vacation he persuaded Deborah and Seymour to let him live with them on Sloane Street, and they arranged for tutorial lessons from a clergyman.

Anna was not thrilled to learn that her son would be living in the world's largest city (with a population of two million). In a letter signed, 'Your *anxious* and *loving* mother,' she pleaded with him 'not to be a butterfly sporting about from one temptation to idleness to another.'[5]

This may have been the first linkage of James Whistler to the insect with which his name would forever be associated.

* * * *

In 1847, George Whistler had commissioned a painting of his son by the noted portraitist William Boxall, a man who had exhibited for 25 years at the Royal Academy and would become Director of the National Gallery and a knight. Boxall began the portrait in December 1848 and finished it a month later. Jimmy pronounced it 'very like me and a very fine picture. Mr Boxall is a beautiful colorist. The background is very fine, and such a warm tone, very like one of Gainsborough's. It is a beautiful creamy surface, and looks so rich!'[6]

Captivated by the lad, Boxall took him to Hampton Court to see the cartoons of Raphael and gave him his most important childhood gift, a copy of the two-volume collection of biographies of Renaissance and pre-Renaissance artists,

Anna Brownell Jameson's highly acclaimed *Memoirs of the Early Italian Painters and the Progress of Painting in Italy.*

Jimmy eagerly devoured the book, his first artistic watershed.

Jameson went far beyond Jimmy's neo-classical teachers. He learned from her that the best painters 'held the mirror up to nature'; that almost anything may be used for a subject because 'beauty lies wherever one looks'; that artists must be self-reliant and self-determined; that when Ghiberti was urged to finish his bronze doors at once, he 'would not be hurried into carelessness, nor would be contract to complete it like a blacksmith's job in a given time'; that Cimabue would destroy his work if dissatisfied 'no matter what pains it might have cost him'; that Michelangelo 'considered himself to be striving after ideal excellence which had been revealed to him but to which others were blind or indifferent'; that the best painters were unconcerned about popularity; that Giotto, Italy's first master artist, was 'but small in person,' was 'as independent in other matters as in his art,' had 'little reverence for received opinions,' and was 'celebrated for witty and satirical repartees.'

The sentence that perhaps most strongly stirred the fourteen-year-old reader hailed Masaccio as 'one of those rare men whose vocation is determined beyond recall almost from infancy.'

One week after getting the book, Jimmy told his parents that he wanted to become a full-time painter.

'I hope, Dear Father,' he wrote, 'you will not object to my choice [of a career], for I wish to be one so *very* much, and I don't see why I should not, many others have done so. I hope you will say "Yes" and that Dear Mother will not object.'[7]

In this same letter, he thanked his parents for a parcel they had sent, containing his skates and several books.

'I am particularly glad,' he said, 'to have received Joshua Reynolds's discourses.'

Despite his typically eighteenth-century cautiousness, leading him, for example, to emphasize obedience to the rules of art, Reynolds would have a lasting influence on James Whistler.

Whistler's open-minded respect for and interest in other people's productions might have been prompted by Reynolds's pronouncement that an artist 'who is acquainted with the works which have pleased different ages and different countries has more materials to work with than he who is conversant only with the works of his own age or country.'

And surely he who became celebrated for his colors would remember this sentence: 'Unless he is skillful in the art of using color the Painter has no more right to that name than a Poet to his who cannot versify.'

Jimmy's parents may have regretted sending the *Discourses.* Anna's response to his latest letter was what might have been expected from a respectable woman whose son had expressed a wish to be a professional artist. She understood his

'quite natural' feelings. His father had had the same thoughts, and just as his talents had been 'more usefully applied,' she hoped that Jimmy would properly use *his* gifts, as her husband had suggested, in architecture or engineering. His art work could enrich his 'hours of leisure.'[8]

Anna advised him to be 'governed by the daily direction of dear Sis and Seymour.' Haden must have seemed like an ideal role model. While studying medicine in Paris, he had found time for drawing lessons, and afterwards he spent a summer in Italy doing pencil drawings, water-color sketches, and a few experimental etchings. In recent years he had actively continued to pursue his hobby.

Since there was a strong bond of affection between them, Haden did provide 'daily direction' for Jimmy, which only strengthened his resolve to become a painter. They talked about painting – sometimes with such guests as the soon-to-be President of the Royal Academy, Charles Eastlake; they visited galleries and museums; and, of particular importance, in February and March they attended a series of four lectures primarily for students of the Royal Academy, by Charles Robert Leslie.

Leslie was a subject painter who had been a Royal Academician since 1826, and was now, in 1848, Professor of Painting at the Academy. Jimmy was impressed by Leslie's credentials, and also by the knowledge that he was by birth an American who had grown up in Philadelphia and had taught drawing at West Point. Since Leslie's remarks were reprinted in the leading weekly journal of the arts, the *Athenaeum*, and Seymour Haden surely subscribed to the *Athenaeum*, Jimmy not only heard the lectures but also undoubtedly studied their text.

Leslie constantly emphasized art's relationship to nature and the necessity of remembering that 'nothing really excellent in Art is not strictly the result of the artist's obedience to the laws of Nature.' Nature, he noted, includes human nature, and so an artist should carefully observe human beings. And he need not go beyond his immediate surroundings nor seek out a noble subject. Simple subjects, indeed, Leslie said, provide a fine test of one's talent.

No one could do more with simple subjects than the painter whom Leslie called the best British example of neglected genius, a man who 'could scarcely sell his matchless pictures at the lowest price,' William Hogarth.

Hogarth received more attention from Leslie than anyone else, and for this reason alone Jimmy would have absorbed the lectures. Hogarth's genius, the speaker said, was 'peculiarly original,' and 'from the outset he disdained to travel in the high roads of art, or to avail himself of directing posts set up by his predecessors.' Everything, 'his subjects, his arrangements, his characters, his style, his manner,' was 'all his own, derived immediately from Nature.' Hogarth's superb employment of color, moreover, 'instead of interfering with his storg or the expression, greatly aids them.'

Jimmy could now examine Hogarth's coloring, about which he knew nothing in St Petersburg, in the Soane Museum and the National Gallery. Initiated in Russia, Whistler's enthusiasm for Hogarth matured in London under the guidance of Charles Robert Leslie. His long-lasting respect for Leslie is demonstrated by the inclusion in the University of Glasgow's handful of surviving books from his personal library of one printed volume in English, the slightly revised version of the 1848 lectures, *A Handbook for Young Painters.*

 ❊ ❊ ❊ ❊

Jimmy was having the time of his life in London, not just because of artistic functions. He was enjoying a rich social life, which included children's parties and private theatricals. When reports of these events, in his own letters and in those of Deborah, reached St Petersburg, Anna exploded.

'Yours has been too long a vacation, Jemie,' she told him. 'As an idler you have been at the disposal of those seekers of amusement whom I am grieved to fancy you among.'

She wanted him to tell her 'frankly what satisfaction you derive from mere amusement and false glitter,' and she asked, 'do you *really* pray and study your Bible every day?'

'Oh, Jemie, dear,' she pleaded, 'try to learn leisure by a better system. I fear you are pursuing it too eagerly.'[9]

Most particularly disturbing to Anna was that at some of the parties her son actually drank wine. This violated a promise he had made before her return to Russia.

In the mid-nineteenth century a frequently used word, referring to the total abstinence of alcoholic drinks, was *temperance.* There was a 'movement', as well as meetings, hotels, and societies to which the word was attached. And Jimmy's promise was a 'temperance pledge.'

'Oh, Jemie dear,' Anna wrote, 'I cannot describe what a pang shot thro Mother's heart when she heard from Sis that *false* shame would make you break your Temperance pledge! Can you break a vow to God and not sin? Be above minding the world's laugh!'[9]

She reminded him that she had 'not blushed to refuse to drink his Emperor's health at an Ambassador's table.'

Jimmy was also rebuked by his father:

Your sister says you sometimes feel an embarrassment from your temperance pledge. Of course, my dear James, I know what you mean. It is always embarrassing to be the subject of remarks – especially for a boy like you – but it would distress me beyond anything you can imagine if I thought it could so *seriously* affect you as to make you ever for a moment regret your pledge or hesitate to keep it.[11]

This letter was written on 9 March 1849. Exactly one month later George Washington Whistler, at the age of forty-seven, was dead. a victim of cholera. His last words, Willie told his brother, were 'Goodbye, be a good boy.'[12]

* * * *

It has been said, erroneously, that the Tsar offered Anna free schooling for her sons at the Imperial Academy for pages. In point of fact the Tsar offered only his condolences. In any event, staying in Russia would have been out of the question. Anna was eager to get back to America, and as soon as the Neva opened for navigation, she, Willie, and Mary were bound for England.

While awaiting his family's arrival, Jimmy was bedazzled by contemporary paintings. In St Petersburg he had had one chance to see a large show. In London during this late spring he could visit six major exhibitions, each with over 400 works by living artists, and more than a dozen smaller ones. A critic from the *Athenaeum* began a review by saying, 'Art Exhibitions are the abounding incidents of the time; we leave one gallery only to answer the summons of another.' Jimmy had to be impressed by these opportunities for artists. (The pre-eminent event was the opening of the eighty-first annual exhibition of the Royal Academy, where one of the works on display was Boxall's portrait of Jimmy.)

Anna spent a couple of weeks at 62 Sloane Street, and then she and the boys went to Preston, where they would stay until the day of their embarkation.

Concerning their trip to America, Anna brought up an interesting possibility in a 20 June letter to Mrs Harrison – wife of the locomotive builder – in St Petersburg, when she said that she hadn't yet decided on 'whether to take passage in a sailing packet or a steamer' and would 'be grateful for Mr Harrison's advice as to the propriety of either.' Five days later she wrote again to Mrs Harrison and said that travelling on a sailing ship 'would be best for the boys on many accounts – fewer luxuries, less distractions from their books,' but she acknowledged that '300 steerage passengers would be disagreeable.'[12]

Anna also wrote to her stepson George about this self-declared dilemma.

George said that under no circumstances should they travel on a sailing ship, and Harrison at once told her to draw on his London bank account.

She accepted Harrison's offer, she told him, only because George 'disapproved of my plan of taking passage in a sailing ship because of the exposure to epidemics from steerage passengers.'

She booked passage on the one-year-old, 200-passenger Cunard steamer *America*, which left Liverpool on 28 July. The line now offered weekly sailings to greater New York, and on 9 August the *America* docked in Jersey City.

4

A Schoolboy in Connecticut

[1849–51]

George William Whistler was now working for the Erie Railroad. He lived in New York City, and his family temporarily moved in with him.

Some writers have said that Anna inherited an annual pension of $1500. In point of fact her husband had not qualified for a military pension, and nothing came from the Tsar's government. Indeed, she complained in a letter to Harrison, she wasn't even given a fare reduction when she travelled by rail.

Unlike the train builders, Whistler did not save much money. His widow's income would be limited to dividends earned by a modest portfolio of stocks, supplemented by 'loans' from relatives and friends, including some grateful men in Philadelphia and Baltimore.

Somewhat surprisingly for a well-organized man, George Washington Whistler had not made out a will. Anna had to apply for letters of administration, which a financial advisor told her could be done most easily in Connecticut, where she had already planned to reside.

She did not, as might have been expected, intend to go to Stonington, where her sister lived and her husband had been buried alongside his two infant sons. Since June, probably at the suggestion of George, she had been talking about locating in New Haven, a pleasant university town easily accessible to New York City, and for several weeks after arriving in America she had New Haven in mind. Then on 23 August she wrote to the boys, visiting their aunt and uncle, the Palmers, in Stonington:

'*Where* exactly we will settle is not determined, for I am told now that New Haven is not the place for us. I have written Mr Maxwell [a friend whom they had known in Russia] to obtain for me all the information he can about the school at Fairfield, because I like its situation, and it will be as convenient for George to visit us as New Haven.'[1]

Actually they moved to a place that was most inconvenient to New York City, in the north-eastern corner of Connecticut, Pomfret.

An attractive town which nestled in hills and valleys, Pomfret had a population of 1400 and was known for dairy farms and guest houses catering to summer visitors from Boston and Providence. It had four churches, a 100-year-old library, and two schools.

The center of town, where the two main streets intersect, is called 'the four corners.' Anna rented part of a house on one of the streets, 120 yards west of the corners. In those days there was plenty of space; the house was only the third building from the intersection. It was part of a small farm which the Whistlers would share with the woman who owned the property.

Young Jimmy, late of the English Quay and Sloane Street, was now a New England farmboy.

<p style="text-align:center">* * * *</p>

In 1849, Connecticut's educational system, consisting of free common schools in every city and town, was rated by many authorities as the best in the nation. And yet, good as they were, the common schools didn't satisfy everyone. Private institutions, with tuition charges, existed throughout the state. Pupils were enrolled in them for a variety of reasons – supposed superior instruction, a religious affiliation, snobbery.

In the matter of education Pomfret was a typical Connecticut town. It had a fine common school, and in recent years it had had four private schools. One was attached to the Baptist Church; one was operated by Quakers; one was a ladies' seminary. These three were short-lived and had closed by 1845, when the fourth school opened, Christ Church Hall.

Pomfret's latest private school was an eighth of a mile south of the 'four corners,' alongside the town's Episcopal house of worship, Christ Church, a small plain clapboarded structure on a stone foundation. The rector was the Reverend Roswell Park, 42 years old. His annual salary was $200.

Park founded the tiny one-room schoolhouse and was the only teacher (occasionally assisted by his wife). In some writings on Whistler, he has been portrayed as a wimp and a buffoon. This is unfair and untrue. He was in fact a remarkable man.

Roswell Park graduated from West Point in 1831. For each of his four years at the Academy, he was at the top of his class, and he never received a demerit. (The magnitude of this achievement will become clear in the next chapter.) West Point's best cadets sometimes served as assistant teachers during their final year. Park, unprecedentedly, taught in each of his last two years. (His subjects were French and mathematics.) After graduating, he was in the élite corps of engineers until he resigned in 1836. He became an instructor of chemistry and physics at the University of Pennsylvania and taught there until 1841, when, lately ordained, he accepted the position in Pomfret.

Park was already the author of a volume of poems, a history of West Point,

and *Pantology*, an exposition of his philosophy of education. He believed in high academic standards, strictly enforced discipline, and a curriculum that included doctrinal religious studies.

Anna enrolled her sons in Park's school. It was he who had inspired her move to Pomfret.

Kate Palmer's daughter Emma stayed with the Whistlers during the first year in Pomfret and attended Christ Church Hall. She remembered Jimmy as 'a sweet, lovely boy' with a 'pensive, delicate face, shaded by soft brown curls' and a 'somewhat foreign appearance and manner which made him very charming.'[2] He was 'a great favorite' with his classmates.

His popularity was due in part to his drawing talent. He entertained the others with caricatures of pupils, of townspeople, even of the Reverend Park.

At least once Jimmy was paddled because of a parody of the teacher. And at least once he was sent home because of 'irreverence' during morning prayers.

Despite – or, perhaps, because of – his mother, he was indifferent to religion. At the end of the school year, confirmation instruction was offered, which Willie accepted but Jimmy declined.

As always Jimmy's dominant interest was drawing. He was stimulated by his reading and by observed incidents. His work was frequently humorous, as in the picture of a road mishap, showing a woman sprawled on the ground, surrounded by scattered boxes, bundles, and a bird cage, and labeled 'H-awful H-accident.' More serious was *A Fire at Pomfret*. On 21 February 1850, the schoolhouse roof caught fire, and neighbors and pupils helped Park put it out. For several days classes were cancelled, and during the recess Jimmy recreated the scene of buckets being passed up a ladder to the roof.

These school pictures aren't remarkable, but they show what a commentator on Whistler's early work called 'imaginative independence.'[3]

As part of their study of geography, the pupils drew maps. A classmate recalled Jimmy's as 'the pride and envy of the rest of us – so perfect, so delicate, so exquisitely dainty in workmanship.'[4] These words came from Louise Moulton, author of forty published volumes – poetry, essays, short stories, travel books, biographies, and novels. At Christ Church Hall she was Ellen Louise Chandler.

In Pomfret, Ellen was creatively well ahead of Jimmy. Sometimes her work seemed too good. Once after reading aloud one of her poems, she was asked by Park to stay after school.

'Where did you find that poem?' he asked when they were alone.

'I don't know. It came from my mind. It just wrote itself.'

When he realized that she was telling the truth, Park said, 'That is a very good poem, Ellen. I congratulate you.'

Perhaps it was this poem that appeared in a magazine in 1851 as her first publication at the age of fifteen.

Ellen lived on the western edge of town, beyond the Whistlers. She and Jimmy often walked home together. One afternoon after their crayon maps had been handed back, she lamented that hers couldn't compare with his.

'Do you really like my map?' Jimmy asked.

'Oh, yeth,' she lisped. 'I like it very much.'

'Well, then, here it is. You may have it.'

It had been intended for his mother.

He then said, 'This is nothing. Tomorrow you will see what I really can do! I'll bring you something worth talking about.'

On the next day, Jimmy appeared at school with a fancily wrapped package.

'Here, Ellen,' he said, 'this is for you.'[5]

A water color entitled *The Light at the Door*, it showed a monk standing under a Gothic arch. Ellen Louise Chandler Moulton never parted with it. It was first exhibited in Boston in 1904, the year after Whistler's death.

In a letter to Jimmy when he was visiting the Palmers, before the move to Pomfret, Anna said, 'I beg you to be getting out of the habit of *lounging*.'[6] Emma recalled that in Stonington:

he used to sleep so late that we would be all through breakfast before he could be induced to get up, so one day my mother had the table cleared, and when he appeared, she said she was sorry but she couldn't keep the table and servants waiting for him. So there was nothing for him. 'All right, Aunt Kate,' he said, 'it served me right. I am not hungry.'[7]

A little later Mrs Palmer found him in the kitchen eating a hearty breakfast which he had persuaded the cook to prepare.

There was no lounging or late rising for Jimmy in Pomfret. His home, Emma related, was 'without a single modern convenience,' and 'thinking I suppose to toughen the boys,'[8] Anna kept a pig, which Jimmy and Willie took turns feeding, regardless of the weather. They also brought in firewood, and, in the winter, shoveled snow. It was quite severe at first to lads accustomed to living luxuriously, and sometimes, Emma said, 'their feet were frostbitten,' but they eventually adjusted to their new life. They never murmured or openly yearned for what they once had had, and their mother never had to reprimand them for shirking household duties.

Sometimes, however, Jimmy disobeyed her by not coming home immediately after school. Once he was more than an hour late because he had been playing marbles. 'I was mortified,' Anna wrote in her diary.[9] Because of the marbles, not the disobedience.

Anna's views on leisure-time activities had not changed. In the spring of 1850, when a dancing class was organized in Pomfret, she called it 'disgraceful'.

A few days later, on 3 April, Jimmy left for Brooklyn to spend the spring

recess with Uncle William McNeill. 'My heart sank at losing sight of my dearest James,' Anna wrote. On the next day she thought nothing but her 'absent boy,' her 'precious Jemie.' She felt utterly helpless.[10] Her diary contains similarly plaintive entries until 20 April, when Jimmy returned.

Anna was devastated by a seventeen-day absence. Yet if her dreams were to be realized, a four-year separation would begin in the middle of 1851, when, she hoped, Jimmy would become a cadet in the United States Military Academy.

* * * *

The idea of a military career for James Whistler was not new. When he was ten, he informed some Russian army officers that he too would serve his country in a uniform. Two years later, Anna told Joseph Swift that 'Jemie hopes to become a graduate at West Point.'[11]

It was natural for him to think like this. He was carrying on a family tradition. Even after he had begun to talk about becoming a painter, he didn't drop the notion of going to West Point. Part of its allure lay in its exclusivity. An extremely difficult club to join, it had more than a little snob appeal for Jimmy.

In 1851, the qualifications for becoming a cadet seemed simple enough. An applicant merely had had to be 'over 16 and under 21 years of age, at least five feet in height and free from any deformity, disease, or infirmity which would render him unfit for military service.'

In reality it was far from easy to get into West Point. To be admitted, one had to obtain an 'appointment.' Each congressional district was entitled to one cadet at the Academy, appointed by the Secretary of War on the recommendation of its congressman. When someone was admitted, his district could not get another appointee until he had left. In addition to congressional district appointees, at any given time ten cadets had been appointed 'at large' by the President. Here the competition was fierce, perhaps ten thousand applicants for three vacancies.

Anna aimed at an 'at large' appointment, and she was optimistic. Jimmy's grandfather had been an army officer. His father and two uncles had graduated from West Point. More recently, a cousin, Joseph Whistler, class of 1847, had gained a battlefield promotion in the Mexican War for 'gallant and meritorious conduct.'

Most important, Jimmy's application would be endorsed by two of the Academy's most eminent graduates, Roswell Park and Joseph Swift.

Anna had settled in Pomfret because she hoped that Park would prepare Jimmy for, and help him get into, West Point. As early as September 1850 she talked with him about this. Convinced that Jimmy could cope with the curriculum, he would do what he could to get him an 'at large' appointment.

As for Swift, no one could have been more influential. He had been the Academy's very first graduate and for five years its superintendent. He had been

Chief Engineer of the United States Army and, since retiring in 1818, a distinguished civil engineer. He had known three Presidents – Adams, Jefferson, and Madison.

General Swift had helped Anna's brother to get into West Point. He was eager to do the same for Anna's son.

On 19 February 1851, George William Whistler wrote to Secretary of State Daniel Webster, formally requesting an 'at large' presidential appointment for his half-brother.

A month later a response came from President Millard Fillmore. The message for Jimmy was one of congratulations.

Enclosed with the letter of appointment was a circular from the Secretary of War Charles Conrad noting that fewer than half of the Academy's entrants completed the four-year program. The appointee was advised that if he lacked an aptitude for mathematics, he might consider declining the offer, thereby escaping 'the mortification of failure.'

Jimmy didn't give a thought to failing. After receiving the President's letter, he left for New York. On 21 March, General Swift wrote in his diary, 'Took James Whistler to West Point and introduced him to my friends there, all of whom, for the sake of his father, took an interest in his success.'[12]

One friend was the Academy's second highest official, the commandant of cadets, Captain Bradford Alden. He had been in the class of 1831, along with Roswell Park. Another friend was the top man, the superintendent, Captain Henry Brewerton. He had graduated in 1819. A member of the class of 1819, it may be recalled, was George Washington Whistler.

* * * *

Early in June 1851, the academic year at Christ Church Hall ended. A couple of days later, a month before his seventeenth birthday, James Whistler packed one small suitcase and kissed his mother goodbye.

5

West Point

[1851–54]

West Point is a flat plain 150 feet above the Hudson River, surrounded on three sides by water and on the west by steep hills. In 1851 it was secluded from the outside world, untouched by main roads or rail lines.

There was one way to go there, on a paddle-wheeled river steamboat. Whistler boarded one in New York City and three hours later got off. A non-commissioned officer met him and several others and led them up to the plateau, where they registered, deposited their money, and marched off to the barracks to be greeted by a cadet officer.

'Stand attention!' he bellowed. 'Hats off! Hands close upon your pants! Stand erect! Hold up your head! Draw in your chin! Throw out your chest!'

They then followed the officer into the building and received uniforms, temporary room assignments, and regulation haircuts.

Until they passed an examination at the end of the month, the newcomers were 'candidates' for cadetship and wore black probationer uniforms. They were civilians but had to swallow a large dose of military discipline. They rose at dawn to the sound of drums. They were drummed to the mess hall and to the drill field, where they drilled, drilled, drilled, to the point of exhaustion. After a few days, one 'candidate' wrote to his sister, 'I expected weary work and hardship, but never anything like the dog's life and toil to which we were subjected.'[1] Several of them fainted. But Jimmy took it all in stride.

Besides drilling, they prepared for the entrance examination. They needed only to be 'well versed in reading, writing, and arithmetic,' but even this was too much for some appointees, and so they were all tutored by senior cadets. For Whistler the tutoring sessions were periods of relaxation.

After breakfast on Monday, 30 June, the probationers marched off to the Academic Hall. A physical examination opened the proceedings. Because of his weak eyesight, which classmates usually mentioned in their recollections, Anna

was worried. 'Are you a cadet?' she asked eagerly early in July. She was 'alarmed' to hear that 'your nearsightedness will oblige you to leave.'[2]

He probably should have been disqualified, but the nephew of General Swift was found physically fit for service.

After the medical staff had finished, the young men faced the Academic Board, comprising the superintendent, the commandant of cadets, and department heads, forming a crescent-shaped row of seats. They stepped forward one at a time, mostly terrified because, a former cadet recalled, 'they were a rigid, cold, merciless-looking set of men.'[3] But Whistler wasn't daunted. He had met most of them, and they knew his uncle. Besides, how could they intimidate someone who had been tutored in St Petersburg and London and had studied under Roswell Park?

Eighty men were examined. Seventy-one passed and received gray uniforms and conditional appointments to become permanent for those who completed the first term.

After lunch on Examination Day, the 1851–52 cadet battalion was organized. All members of the four classes lined up according to height. The tallest man, six feet four inches, was followed by the next tallest, on down to the shortest, an even five feet. The first half made up the flank companies, 'A' and 'D'. The others went into the center companies, 'B' and 'C'. At five feet four inches, Whistler was much closer to the lower than to the higher end of the line, and he was assigned to Company C. For the first time he became sensitive to something about which he would always be touchy, his shortness.

After the battalion had been organized, cadets in the second class (the third year) went away for their only academic furlough. The others began to take part in a summer encampment on the plain, and now the newest members of the corps, the 'plebes,' were transformed from civilians into soldiers. As part of the process, they suffered all manner of discomfort. They lived in uncomfortable tents, slept on hard floors, and constantly drilled. Their professional lives, they quickly realized, had nothing to do with democracy. As the Academy's most famous superintendent, Sylvanus Thayer said, their duty was 'to listen and to obey.'

For the plebes, the encampment was arduous, but it also animated their egos. They were constantly told that they were the cream of the crop, superior to outsiders, and they believed it. Along with this attitude of pre-eminence over others went a posture of internal equality, since they were all treated alike and lived under the same conditions. In practice, however, some were more equal than others. The corps had its élitists, mostly Southerners, particularly Episcopalian Southerners, who were generally exceedingly conservative and did not look kindly upon anyone who was suspected of being an abolitionist.

Probably because of this élitism, Whistler now began to consider himself a Southerner. This claim was not totally groundless. His mother, born in North

Carolina, had never relinquished her heritage. She was an unapologetic defender of slavery, which she insisted was good for the victims.'The slave owners,' she told an English friend, 'are benefactors to the race of Ham. Blacks in the South are cared for by their Christian owners and are taught from the Bible. I take the view that God has permitted this.'[4] Whistler may have been influenced by his mother's racism but probably no more than by her religiosity. He never called himself a Southerner until he got to West Point. Although he would never set foot south of Washington, he was henceforth a 'Southern gentleman' who would refer contemptuously to 'niggers' whom he 'hated as much as any other Southerner,' and would speak wistfully of 'a little healthy American lynching.' This had its genesis at the United States Military Academy.

* * * *

One area of West Point life has been devoid of favoritism. Discipline has always been rigid and impartial.

According to a USMA regulation, 'Any cadet who disobeys a command or behaves in a refractory or disrespectful manner shall be dismissed or otherwise less severely punished.' Dismissal for a single offense is rare. Cadets are almost always 'less severely punished' with demerits, ranging from ten for 'mutinous conduct,' down to one for such minor offenses as being late to dinner or wearing improperly shined shoes. When a cadet gets more than 100 demerits in six months, or 200 in an academic year, he is subject to dismissal.

This procedure of evaluating a cadet's performance is called Conduct. At the end of year grades in Conduct count as much as grades in most courses.

A few cadets, such as Roswell Park and Robert E. Lee, graduated without a demerit. Most of the others didn't escape the first encampment unscathed. It takes time to adjust to the system.

Whistler already knew the rules, and for sixteen days his record was unblemished. Then on 17 July he got three demerits for being absent from a formation. On the next day he was cited three times for lateness. During the following week he was marked down for laughing during drill, for 'gazing about' in the ranks, and for being 'inattentive.' (My authority for the demerits is the unpublished *Register of Delinquencies*, in the West Point archives.)

By the end of August, his demerit total stood at thirty-eight, but classmates who would recall this summer did not stress his misconduct. His future roommate, Henry Lazelle, remembered meeting him on a rainy day when 'his bright, sunny face peered through the opening of my tent, and he asked if he might come in.' After entering, he 'related stories he had read and described the characters so graphically that one would know them if met on the street.'[5] He soon became known to everyone because of his drawings. He sketched whenever

and wherever he could, even on camp stools and tent flaps, which, a classmate remarked, were 'decorated by some beautiful heads.'[6]

The encampment ended on the last day of August. The cadets then moved into a new 210-room, three-story barracks, two to a room, 14 by 22 feet.

The latest decree in the Cadet Living Code stipulated that they had to 'bathe once a week.' Anyone who wanted more frequent baths needed a written permit from the superintendent. Whistler wasn't troubled by this rule, but he quickly ran afoul of another one. His first delinquency of the term came on moving-in day: 'Hair not cut. 1 demerit.' The mandatory monthly haircuts were a lasting problem. 'He disliked parting with his pretty locks,' Lazelle said, 'so he would try by cajolery and flattery to have old Joe, the negro hair cutter, let up a little. Joe would say, "Mr Whistler, do you want me to cut your hair or not?" This would end the argument. Whistler would come back, look in the glass, and swear at Joe.'[7]

Haircuts were only a nuisance. What really caused trouble was the drilling. During the first term Whistler was cited 77 times for improper drill field conduct. On 22 occasions he arrived late, and 23 times he was inattentive. Six times he laughed, and five times he talked when he should not have done so. In light of his later sartorial fastidiousness, it is interesting that he was punished for wearing a jacket without buttons, for wearing a cap out of uniform, for wearing his waist belt, 'in a slovenly manner,' for wearing shoes out of uniform, for appearing without a shirt collar, for having scuffed shoes, and for being improperly shaved.

The person most disturbed by this conduct record was, of course, Anna, who in mid-September learned from a War Department official of her son's demerits.

'I must warn you,' she wrote to him, 'to be attentive to the rules' so as to avert 'the disgrace you are threatening us with.'

Her letter was an emotional plea: 'Oh bring not upon yourself the blight of remorse for breaking a widowed mother's heart . . . Think of how many you will mortify . . . Can you stoop so low as to waste your hours in amusing the idlers? Or have you imbibed contempt of orders from the foolhardy?'[8]

She said that 'if demerits cut short your course, alas for honors anywhere!'

Actually Whistler was in control of the situation. Since the system was new to the plebes, a third of their first term demerits were written off. They could collect 149 and be in good standing. Whistler's total for the term was 137. He got 19 in July, 19 in August, 38 in September, and 38 in October. With two months remaining, he had run the score up to 114. Then in November he got just 15 and in December only eight. He knew how to exercise self-restraint.

＊　　　＊　　　＊　　　＊

A plebe's academic studies included three subjects – English, mathematics, and French. (French was the language of some untranslated scientific textbooks.)

41

Classes met Monday through Friday, four hours daily for English, three for mathematics, and two for French. (On Saturday mornings there was drilling and instruction in the use of small arms.)

Perhaps in no other college or university were students so methodically evaluated as at West Point. They met in sections of 12, organized at first alphabetically and rearranged periodically according to merit. Every day in every section of every course, each cadet would go to the blackboard and be rigidly examined and given a grade ranging from three to zero. At the end of every week class standings were posted openly.

For some cadets the routine was backbreaking, but for others it was not particularly difficult. When George McClellan was at the Academy, he wrote home, 'I study a little, but not much.'[9] In the class of 1846, future General McClellan ranked number two. Whistler also had time on his hands. Lazelle remembered him as 'one of the most indolent of mortals.' In the evening they sat on opposite sides of the study table, books open. After about an hour Lazelle almost invariably saw his roommate 'with his head supported by one hand, fast asleep.'[10] When not dozing, he would 'while away the time drawing sketches.'

But on weekends he wasn't idle. He spent Saturday afternoons and Sundays reading library books.

West Point's library had been established by Superintendent Joseph Swift, and in 1851 it occupied a large room in the Observatory Building, with about 16,000 bound volumes. The librarian was Second Lieutenant Henry Coppée, class of 1845. With permission from an officer, a cadet could withdraw one book on a Saturday afternoon and keep it until Monday.

The library didn't play a role in the lives of most plebes. Whistler, however, charged out volumes on nine Saturdays during his first term.

Most of the books dealt with military, scientific, and historical topics, but Whistler wasn't interest in *them*. His borrowings included two of Scott's novels, Samuel Butler's *Hudibras*, Goldsmith's *Vicar of Wakefield*, volume 37 of *Knickerbocker Magazine*, and volume 2 of *Chamber's Miscellany*. (My source is the *Entry of Books Issued to Cadets on Saturday Afternoons, 1851–53*, an unpublished document in the Academy library.)

Later, people asserted that Whistler had no taste for reading. A friend in the fifties and early sixties said, 'He did not read very much.'[11] Someone close to him in the eighties said, 'I cannot imagine him reading.'[12]

But why did he make a special effort on nine occasions to borrow books that were unrelated to his academic work? Because he remembered his father's advice on reading, and also Charles Leslie's observation that literature may be helpful to a painter. Thomas Stothard, for example, after reading the prologue to *The Canterbury Tales* created a painting in which 'the personages of Chaucer pass before our eyes as if they were shown to us by a painter contemporary with the poet.'

And so Whistler read with the eyes of a painter seeking subjects. When his work was literary, he read avidly. When he lost interest in this genre, the reading declined (but did not stop entirely).

One interesting borrowing is volume 2 of the *International Magazine*, running from December 1850 to March 1851. The piece that probably struck his attention is an anonymous essay, 'Art-Unions: Their True Character.'

Art-unions were lotteries with original works by living artists as prizes. These lotteries, the author said, stimulated mass production and mediocrity. He offered advice that Whistler would never forget:

> Artists must control their affairs and must not trust their interests to those who are not of their profession. Let artists depend upon private sales to those who appreciate their works and build up a solid body of friends and patrons. Permanent success and a distinguished name can be attained only by honesty and excellence in one's works.

* * * *

On 2 January 1852, Whistler confronted his first big academic hurdle, mid-year examinations, conducted orally by the Academic Board. Eleven plebes were, in West Point parlance, 'found,' that is found to be deficient. They departed.

Whistler and 59 others received permanent appointments and pledged, if academically successful, to serve for three and one-half years as cadets and four years as officers. They swore to 'bear true allegiance to the National Government' and 'to defend the sovereignty of the United States paramount to any allegiance, sovereignty, or fealty to any State or county.'

That night Whistler and Lazelle celebrated by playing cards after taps. They were surprised by an officer, who charged them with playing cards at 11 p.m.

Afterwards, Lazelle suggested to his roommate that since they weren't actually playing when the officer entered, they might ask for the charge to be reduced to the lesser offense of 'cards in possession.'

'No,' Whistler said, '*We had been playing.*'[13]

They each got eight demerits.

During the second term, Whistler continued his outside reading: Thomas Hood's poems, Swift's *Tale of a Tub*, three volumes of Scott, a miscellany called *Wide, Wide World*, and, again, volume 37 of *Knickerbocker Magazine*.

Knickerbocker was a high-quality monthly literary journal. Volume 37 covers the first four months of 1851. The selection that interested Whistler was surely a poem of 19 four-line stanzas that appeared in January, 'An Artist's Studio.'

The artist's riverside studio, a 'lofty room,' was:

> The inner shrine of one whose brow the stamp of genius bore.
> And who the laurels of his fame with child-like meekness wore.

The poet: 'touched his easel and his brush' and 'saw his colors laid':

> Those simple implements of art, they made me half-afraid;
> For with such trifling means alone, to bid their visions glow,
> Appelles, Zeuxis, Raphael, wrought wonders, long ago!

Eight stanzas describe a large picture of pilgrims in the harbor of Delft-Haven on the *Southwell*, bound for Southampton. This was to be the first ship with colonists for the New World, but because of unseaworthiness it was replaced by the *Mayflower*. The picture is a mural in Washington's Capitol rotunda, the *Embarkation of the Pilgrims*, by Robert W. Weir.

It is understandable that Whistler twice carried the volume with this poem to his room. Weir was West Point's Professor of Drawing. The plebes who passed the yearly examinations in June would be his students in September.

After the examinations, eight plebes were dropped. Promotions to the third class were awarded the others, including Whistler, who ranked forty-second in his class. (As to Conduct, among 224 cadets, in all four classes, who completed the year, he finished in a tie for 212th place.)

The fall term of 1852 began with a new superintendent, a colonel in the corps of engineers, Robert E. Lee.

Soon after taking over, Colonel Lee heard from Anna Whistler, living in Scarsdale, a New York City suburb, and about to leave for England to spend a year with her sisters. (William was attending a preparatory school in Baltimore and staying with the Ross Winans family.)

Anna wrote on 24 September. She knew that leaves of absence were usually granted only to cadets with two years behind them, but she wondered if perhaps Colonel Lee might 'relieve an invalid and widowed mother' by enabling her 'to exchange adieus' with her son. For James the visit might 'be an incitement to study throughout the term.' She asked for a leave that included a Sabbath, 'the memory of which may comfort a lonely voyager.'[14]

This letter might suggest that Anna had been totally isolated from her son. Actually she had visited him at West Point at least seven times. And although she now requested a leave to 'comfort a lonely voyager,' in February she had written to him, 'I hope you will manage to bone a furlough to visit me in Scarsdale.'[15] In this context 'bone' was a slang term for 'manipulate' or 'wangle.'

Jimmy didn't get a furlough to go to Scarsdale, and probably he didn't try for one. Judging from their correspondence, one might conclude that he was not overly eager to visit his mother. She wrote weekly letters to him, still edged in black, with her signature phrased in such words as 'Your afflicted but grateful Mother' or 'Your devotedly attached and widowed parent.' Rarely were her letters answered. 'Are you studying so closely that you cannot write a *half-line*?' she once asked. On another occasion she wrote, 'Excuse me for trespassing on

your precious time, Cadet Whistler.'[16] She even sent him a supply of stamps after one of his infrequent letters arrived stampless, obliging her to pay double postage.

Colonel Lee could have, and probably should have, denied Anna's request, particularly because her son's academic standing was low and his demerit total was high. (He had collected 85 during the summer and nine more since the start of classes.) Nevertheless he issued a leave for three and one-half days, including a Sunday. He told Anna that he hoped 'for the sake of the pleasure he will receive and give, he will make the necessary effort to recover lost ground.'

Whistler was now enrolled in four courses: mathematics, three hours daily; English, two hours; French, two hours; and drawing, one and one-half hours. Standings would be based on six and one-half points: mathematics, three points; French, one; English, one; Conduct, one; drawing, one-half a point.

Even though it didn't count for much in the ranking, drawing wasn't unimportant. With photography in its infancy and aerial reconnaissance only a dream, battlefield maps and fortification sketches were done by hand. The art of drawing was an indispensable military tool.

West Point's drawing studio provided a seat and a desk for everyone, and it was well lighted. Professor Weir had worked in several genres, including portraits and landscapes. He was artistically conservative and painstakingly methodical. Before starting on *The Embarkation of the Pilgrims*, he spent several months on library research to be sure that his details were historically correct. He was not someone who was likely to condone carelessness.

Weir's course was called 'Elements of the Human Figure, Landscape with pencil and India ink, and elements of Topography with pen, pencil, India ink, and colors.' Obviously not designed for a James Whistler, it would nevertheless provide him with valuable groundwork.

Whistler's talents were quickly recognized by his professor, who was more indulgent than might have been expected in a military school. Habitually he walked about with a brush and India ink making corrections. Once he approached Whistler, who pleaded, 'Oh, don't, sir, don't! You'll spoil it!'[17]

Weir smiled and walked away.

On another day, one of Weir's assistants, a Lieutenant Smith, looked at a water color Whistler was drawing. It showed a monk casting a shadow.

'Your work is faulty in principle,' Smith said smugly. 'By no principle of light or shade could that shadow be there. There is nothing to cast it. You should have known better.'[18]

Whistler dipped his brush into a color. With a sweep of his arm he placed a cowl over the monk's head. He had drawn the shadow first.

Outside the drawing hall, Whistler enjoyed putting on a show for admiring classmates. One of them, William Averell, said that when he did an easel picture, 'he would wriggle and twist about like an animated interrogation point.'[19] And

Thomas Wilson recalled how he seemed 'to work at random, perhaps starting a figure drawing with "the face, then a foot, then the body, skipping from one part to another."' When finished, 'it all fit together like a mosaic.'[20]

He relished humorous and satirical sketches. Classmate George Ruggles spoke of his 'keen sense of the ridiculous,' which might be aroused in class, on the drill field, in church, indeed 'almost anywhere.' In seconds he would dash off 'cartoons full of character, displaying an appreciation of the ludicrous.'[21]

Sometimes his work reflected Hogarth's influence, as in a series of four pen-and-ink sketches *On Post in Camp*. The 'First half-hour' shows a cadet standing by a tree, musket on his shoulder. In the 'Second half-hour,' he is leaning against the tree, musket lowered. In the 'Third half-hour' he sits with his back to the tree. The 'Last half-hour' shows him under the tree asleep.

For largely the same reasons that he loved Hogarth, Whistler was now fascinated by Dickens. His second-year library borrowings included *The Pickwick Papers*, *Oliver Twist*, *Nicholas Nickleby*, *The Old Curiosity Shop*, *Barnaby Rudge*, *Martin Chuzzlewit*, and *David Copperfield*. Among the Dickens novels published thus far, only *Dombey and Son* is missing. As with Hogarth, Dickens's influence would be lasting. Joseph Carr, who knew him much later, said, 'When Whistler wanted a quotation to heighten the sarcasm of a biting sentence, it was often happily chosen from Dickens.'[22] And sometimes it came from a novel published after his departure from West Point.

Whistler's second-year library visits occurred mostly during the first term. There may have been doubt about whether he would have a second term. On 30 September he had 94 demerits. For him to acquire just five more in three months would have been a miracle. Actually his conduct was not bad. He got 22 demerits, giving him a six-month total of 116. But he was not dismissed.

Even without influential connections, he might have stayed. Most of the demerits came during the encampment. After classes had started, especially after seeing his mother, he tried to behave properly. In three months he was cited only once for being late; his misdeeds were mainly spontaneous. And so he was allowed to take, and to pass, the mid-year examinations.

During the second term, his demerit total was a modest 51, but he wasn't on hand for the whole period. On 26 May, Lee wrote to his mother, recently returned from England and staying with her brother in Brooklyn, 'I regret to inform you that your son is quite sick. He was taken with an attack of rheumatism and is in Hospital. His attack does not yield to remedies, and the Surgeon fears his lungs are seriously involved.'[23] He was sent to New York, where his ailment was diagnosed as endocarditis. He went on convalescent leave, with his year-end examinations postponed. Except for drawing. Professor Weir excused him from the test and ranked him number one.

Weir's action is significant. Shortly before retiring, he named as his all-time second best student William Roe, class of 1867, whose career was ended early

by an accident. In his own drawing class, Roe did not finish at the top because, Weir said, he 'could never be persuaded to take pains with the mechanical features of the course.'[24] Inferentially, this is a commentary on Whistler, particularly meaningful in light of the frequent assertions that he was careless.

On 28 August 1853 a healthy James Whistler returned and got a demerit for 'reporting with long hair.' He passed his examinations, and in a class reduced to 48, he was number 32. He was thus above one-third of those who had lasted for two years.

The second class (third year) program included three courses: chemistry, one point; drawing, one point; and 'Natural and Experimental Philosophy,' three points.

The third year was the most difficult one because of 'Natural Philosophy,' the Aristotelian term for physics. It was taught by William Bartlett, West Point class of 1826, who, like Roswell Park, led his class every year and never got a demerit. He had written, or would write, books on acoustics, optics, astronomy, mechanics, and molecular physics. His class covered mechanics, statics, dynamics, hydrostatics, hydrodynamics, magnetism, electric magnetism, and astronomy.

Professor Bartlett's class met for three hours in the morning. In the afternoon, his students unwound in the drawing hall. This is Weir's summary of his second course: 'Landscape taken up under the following heads: 1) measurement; 2) form; simple and compound; 3) aerial perspective; 4) light; 5) different scales; 6) drawing in tinted paper; 7) use of brush (sepia); 8) coloring; 9) finished drawing from standard works.'

To complete the assignments in this valuable course, providing him with his first instruction in landscape art, Whistler used a set of particularly good drawing instruments, which had been brought from England by Anna, a present from Seymour.

The first month of Whistler's fifth term, September 1853, marked his low point in Conduct. By the twenty-third he collected 73 demerits for 32 offenses. Including seven from the last four days of August, he acquired 80 in 27 days following his leave of absence.

Since he could hardly again expect leniency from the superintendent, he would have to go for 99 days with fewer than 20 demerits. So what happened? From 24 September until 31 December he was cited three times for a total of seven demerits.

In the spring term he behaved pretty much as usual except for one uncommon incident. His Conduct register contains this entry: '18 February 1854. Off cadet limits, skating in river. 8 demerits.' Since he hadn't shown any recent interest in skating, one might wonder why he ran this risk on a Saturday afternoon. He was not with another cadet; only he was punished. But surely he did not skate alone.

His companion was perhaps the 'heroine' of his three-page fragmentary essay, written four months later:

> She was a beauty, by Jove! the belle of the Point! Dear me, how fond we were of each other – if anything like faith can be put in affectionate demonstrations and warm vows of strong and lasting love. I don't wish to be mawkish, but *mon cher* she had large languishing deep black eyes that would excuse even the most cold blooded misanthrope in being guilty of an enthusiastic burst of admiration – and such *really* red lips that you must pardon a reminiscence, even though you find it stupid to read – which you haven't the slightest right to do.
>
> Ou en suis-je? where have I strayed to? voyons-oh! I was at charming little 'Em's' delicious lips – not a bad resting place – parole d'honneur! and when I last heard her 'Goodbye' I was 'right sorry' to leave them.[25]

 ❖ ❖ ❖ ❖

With his customary sense of timing, Whistler paced himself well during this term. By the end of May he had 189 demerits, but during 19 days of June he got only five. He just had to be self-disciplined for 11 days.

Consider what happened.

On Tuesday, 20 June, he was late to breakfast. Two demerits. For no apparent reason he dashed out of the mess hall. Two demerits.

On Wednesday, 21 June, he was late to reveille roll call. Two demerits. He had reached the magic number, 200.

On Thursday, 22 June, he was late to breakfast, carried his musket improperly, and left guard duty without permission. Eight demerits.

On Friday, 23 June, he missed dinner roll call and was absent without leave in the afternoon. Six demerits.

On Saturday, 24 June, he was outside without permission at 2.18 a.m. Five demerits.

There can be only one explanation for this bizarre behavior. He wanted to be dismissed.

 ❖ ❖ ❖ ❖

Ever since he had read the books of Anna Jameson and Joshua Reynolds, and had heard Charles Leslie's lectures, Whistler knew what he wanted to do. Now after two years of encouragement from Robert Weir, he knew that he could do it. He must have decided not to be an army officer.

After the first term of the first year, a cadet could not resign. The only way to leave before graduation was to be 'found' in academic work or in Conduct.

Whistler could easily have surpassed 200 demerits. But a bad Conduct discharge carried a stigma, a measure of disgrace. He needed a failing academic grade.

Because of its importance in the standings, the obvious course to fail was Natural Philosophy. But it had an irresistible challenge, that of being the most demanding class in the school. Also for many years Professor Bartlett had been a friend of his parents.

He was left with one course of action. He had to fail chemistry. But in chemistry his daily grades had been above average. For one period of three weeks he got the highest possible mark for every daily recitation and was promoted to a higher section. How could be possibly fail? Only by making the final examination a complete fiasco.

Asked to define silicon in his examination, he began by saying, 'Silicon is a gas.' Whereupon his questioner supposedly said, 'That will do.' Years later Whistler remarked, 'If silicon has been a gas, I might have become a general.'

That his downfall was due to silicon has been reported repeatedly. In all likelihood, he was flippant during the whole test, with silicon part of a purposeful plan of action. But it did not immediately achieve its purpose.

Chemistry was taught by Professor Jacob Whitman Bailey, West Point class of 1832. He was a good friend of Roswell Park and an acquaintance of Anna Whistler. On Saturdays and Sundays, James had often visited the Bailey home and drawn sketches of the professor's daughter Kitty. Bailey thought well of him, and he didn't like to fail students who had performed well during the year.

For two weeks after examination day, Whistler's conduct was exemplary. He was presumably waiting for a notice of dismissal. But if my conjecture is correct, it never came. The Academic Board, probably influenced by Bailey, was apparently going to give him a second chance.

If the 'good news' arrived on the 19th, this would explain his erratic behavior of the next few days. His impulsive departure from the mess hall and his appearance out of doors at two in the morning are otherwise incomprehensible.

* * * *

In his essay of 1854, Whistler wrote,

> After a brief but brilliant career as a military man, it was discovered that the sphere whose limits are determined in the Academic Regulations was entirely too confined for one of my elastic capacities, and so my 'gray changed for blue,' or rather a buff colored shanghai brought by a newly arrived 'Plebe' of fashionable pretensions, in return for which I made him happy with my 'shell jacket.'

Whistler was glad to be a civilian again, but he didn't enjoy facing his mother.

Because of her, on 1 July he wrote to Secretary of War Jefferson Davis, pleading for a re-examination in chemistry and a reduction of his demerits, which he had received not for 'grave offenses,' but 'for things neither vicious nor immoral.' The letter ended with this peroration: 'Let me beg you, Sir, to

remember that after three years at the Military Academy, all my hopes and aspirations are connected with that Institution and the Army, and by not passing my prospects are ruined for life.'[26]

Davis sent the letter to Superintendent Lee, who advised against a re-examination because Whistler's performance in the initial examination had been 'a complete failure.' This should explode the notion that the dismissal resulted from an answer to one question.

As for the demerits, Lee could not understand Whistler's 'belief in the practicability of their reduction except for the indulgence that has hitherto been extended to him.'[27] He regretted 'that one so capable of doing well should so have neglected himself and must now suffer the penalty.'

<p style="text-align:center">*　　*　　*　　*</p>

Whistler left West Point, but West Point never left Whistler. One of the first copies of his first book, appearing more than 25 years after his departure, went to the Academy, inscribed, 'From an old cadet whose pride it is to remember his West Point days.' And shortly before his death, he said, 'I would not exchange my three years at West Point for all the honors that I have received.'

6

Washington

[1854–55]

Upon leaving West Point, Whistler went to his mother's home in Scarsdale. A neighbor remembered him 'sitting quietly in a dark corner.'[1]

'It was hardly,' he said, 'a moment for the return of the prodigal or for slaying fatted calves.'[2]

After his application for reinstatement had been denied, he roamed about New England, with no shortage of pocket money. He returned late in August with what would be a permanent hallmark, a small moustache, probably adopted and preserved because of vanity and a belief that it gave him – five feet four inches tall – an appearance of defiance.

He stayed briefly with his mother and then left to take a job in Washington.

While he had been drifting, letters for him arrived in Scarsdale. Two came from a young woman in West Point. Anna opened both and 'forgot' to tell him about them. After he had left for the second time, she sent the writer a response.

She had opened the *billet doux*, she said, because, receiving them at twilight, she had misread the envelopes and thought they were addressed to her. She did not say why she had read the letters, nor why she had kept her son in ignorance of them.

Because 'the temptation is so irresistible at West Point,' she 'excused' James's 'flirtation.' He had a 'natural fondness for ladies' and had been indulging in the 'gratification of his vanity.' Lately he had been '*devoting* his attentions to a Stonington belle every day, for it is his way!'[3]

She advised the young woman to 'forget about James,' who, she said, was now working for the government in Washington.

Whistler actually was in Baltimore, a house guest of Mr and Mrs Thomas Winans.

Winans had returned to America in 1851 with a Russian wife and more than two million dollars. (His brother would stay in Russia until 1862.) On a six-acre plot of land he built a mansion, with a grand entrance on Fremont Avenue,

which he named Alexandroffsky. It was filled with lavish furnishings, mainly from Russia, and surrounded by spacious gardens whose winding paths interspersed sycamore, maple, oak, and poplar trees, fish ponds, rustic seats, a sun dial, and nude statues from Italy. Because some neighbors were offended by the statues, a high brick wall was built around the estate, a secluded rural retreat within the boundaries of an industrial city.

Winans was ostentatious, but he was also generous and grateful. He had consistently helped Anna and now insisted that Jimmy stay at Alexandroffsky in luxurious accommodations.

Winans offered Jimmy an apprenticeship, with a good salary, in his mechanical drawing department and gave him a tour of the facilities. An employee recalled how the young man 'loitered about in his peculiar *bizarre* way' and picked up a couple of pencils and drew sketches on their stretched paper and on the backs of their boards. He 'ruined our papers and pencils, but we loved him all the same!'[4]

Whistler never seriously considered working for Winans. But he stayed on. He enjoyed Alexandroffsky, and he liked Baltimore well enough so that, along with St Petersburg, it became one of his two favorite 'birthplaces.' With a population of 190,000, it was America's third city – after New York and Philadelphia – and Whistler was a denizen of cities. The narrow streets and crooked alleys with rows of small houses with white steps and red brick fronts reminded him of some parts of London.

Baltimore is a border city, but to Whistler it seemed like the Deep South. It had America's largest urban black population, 30,000, and although only ten per cent were slaves, the others were not really 'free.' They couldn't vote or serve on juries; they couldn't attend public schools; they couldn't enter hospitals as patients; they couldn't ride on street cars, except on the rear platform; they couldn't walk the streets after eleven at night.

Baltimore's blacks were hod carriers, white washers, draymen, laborers, and, particularly among the women, domestic servants. Some worked at Alexandroffsky, which for Whistler was comparable to a plantation. He loved it! He was now living like a Southern gentleman. (His art work was limited to a few literary drawings, mainly scenes from Dickens and Scott.)

On 30 October the good life came to an end. His mother arrived in Baltimore.

Anna declined Winans's offer of rooms in Alexandroffsky and moved into a modest apartment house. She reproached her son for 'succumbing to a life of pleasure and indolence' and ordered him to join her.[5]

He departed from Alexandroffsky, but he didn't go to his mother. On 6 November, Winans noted in his journal, 'Gave Jas. Whistler $10.00. He left to take service in Washington.'[6]

<p style="text-align:center">* * * *</p>

In Washington, a sleepy city of 50,000 residents, mostly transients, Whistler rented a small furnished room in a two-story brick building on the northwest corner of 12th and E Streets for ten dollars a month.

After depositing a month's rent, he walked nine blocks along Pennsylvania Avenue to Capitol Hill. South of the Hill, on the west side of New Jersey Avenue, he entered a large rustic-looking building which appeared to be a private residence. This was the headquarters of the Coast Survey.

The Coast Survey, which in 1879 would become the United States Coast and Geodetic Survey, was founded in 1807 as the government's first technical bureau. In the 1850s its responsibility was making maps of the nation's coast line. The maps, which spelled out the shore line, ocean bottom, islands, tidal rivers, harbors, bays, capes, lagoons, headlands, lighthouses, and beacons, were used by mariners and had to be painstakingly accurate.

The bureau was divided into a drawing division and an engraving division. The drawing division took data from cartographers and typographers and drew maps which the engravers used to create the actual charts used by sea captains.

Whistler never formally applied for a position. Again he benefited from personal influence. The director of the bureau was Captain Henry Benham, West Point class of 1837, with a record paralleling Roswell Park's: number one every year and no demerits. He had known Whistler's father, and he also knew General Swift, whom he assured of an opening for Jimmy.

A colleague recalled Whistler's arrival. He was 'slender, with dark, curly hair and a small moustache, wore a Scotch cap set forward over his eyes and a dark blue and green plaid shawl thrown loosely over his shoulders, and he was friendly to everyone.'[7]

He became a draftsman in the drawing division at the usual beginner's salary, $800 a year.

The head of the division was Captain Augustus Gibson, who had graduated 23rd in West Point's class of 1839, with a grand total of 670 demerits. Whistler could relate to *him*.

Gibson was easygoing, and Whistler did pretty much as he pleased – when he was there. He was sometimes absent without cause, and even though the office was open only from nine to three, he was often late. His tardiness led Benham to ask another draftsman, Adolphus Lindenkohl, to visit him on his way to work and to stress the importance of punctuality.

> I called at half past eight, [Lindenkohl said.] He was somewhat astonished at this early intrusion but received me with the greatest bonhomie, invited me to make myself at home, and promised to make all possible haste. Yet he proceeded with the greatest deliberateness to dress and prepare his breakfast, a strong cup of coffee brewed in a steamtight French machine, which was then a novelty. He insisted on treating me to a cup. We reached the office at half past ten.[8]

Whistler was habitually late because he was innately unpunctual, and because he didn't enjoy his job. 'The accuracy was not to his liking,' a co-worker said, 'and the laborious application was inconsistent with his nature.[9]

Since he was obviously bored, Benham in December transferred him to the engraving division. On his first day there, a senior engraver demonstrated the process of etching.

'For the first time,' an associate, John Ross Key, recalled, 'he was intensely interested in his work, realizing that a medium was within his grasp. He listened attentively, asked a few questions, and squinted inquisitively at the samples of work placed before him.'[10]

He was given a copper plate and a needle. With enthusiasm, he produced his first etching. Around the edges he inserted a few humorous portraits.

His first assignment involved a portion of the California coast near Santa Barbara. He completed two plates and then lost interest. He was as indifferent to this work as he had been in the drawing division because, Lindenkohl said, 'he had an aversion to employment which did not allow freely introduced artistic touches.'[11]

He had promised his mother to stay for a year. It would be difficult to abide by this pledge.

<p style="text-align:center">* * * *</p>

While Jimmy was in Washington, Willie, until the end of the year, worked for Winans. In June 1854 he had completed his first year at Columbia College, New York, and then dropped out for a term. In January 1855 he switched to Trinity College, Hartford, Connecticut. He enrolled as a pre-medical student and joined Delta Psi, Trinity's only fraternity. Fraternity life was not cheap, but Willie could afford it.

Soon after his brother had gone to Hartford, Jimmy told his mother that he would leave the Survey to become an artist.

Anna's reply to his letter, dated 1 February, began, 'My own dear Butterfly,' again foreshadowing his pet name. His 'foolish course' was undermining her health. Her heart was 'the repositer of hopes disappointed, promises unfulfilled.' She reminded him of his pledge to stay for a year. 'If you go to Europe,' she said, 'it will ruin our little stock and it will be impossible for Willie to return to College.'[12]

Anna's income could hardly be affected by a trip that would be financed by others. And Willie was already in college, living in a fraternity house.

In her next letter, dated 15 February, she said that because of stock devaluation she was bankrupt. This wasn't true, but it didn't matter. Three days earlier, Whistler's employment at the Coast Survey had ended.

<p style="text-align:center">* * * *</p>

No one at the Survey was surprised by Whistler's departure. They all knew of his commitment to art. One official recalled, 'Any odd moment he could snatch from his work he was busy throwing off impromptu compositions on the margins of his plates; odd characters such as monks, knights, beggars were his favorites. He was equally skillful with pen and ink, pencil, brush and sepia.'[13] He worked on the second floor, and the staircase leading downstairs was covered with sketches.

Even apart from his art, Whistler was memorable.

'I retain a more vivid recollection of him than of any other draftsman,' a fellow worker said. 'He would have attracted attention anywhere.'[14]

His clothes and hair style were enough to catch one's eye. He often wore a conspicuous soft crush hat with a wide brim. He liked fancy waistcoats, which could easily be seen because he usually left his outer coat open. As for his head, Lindenkohl thought that 'each separate hair had been curled.'[15]

This preoccupation with his physical appearance was an early example of how he would appear in Europe, but another aspect of his later personality was wholly absent in Washington. He didn't demonstrate even a trace of combativeness or asperity. Everyone remembered him as well mannered and friendly. Key, closer to him than anyone else, never saw him 'ill-natured or in a bad mood' and 'never knew anyone to say an unkind word about him.'[15]

After work, he and Key often visited a billiards parlor at the corner of 13th and Pennsylvania. Whistler played badly but was a good sport. After losing he would toss a quarter onto the table and say, 'There goes my breakfast for tomorrow.'[17]

'He was good humored but not gleeful,' said Key, who never heard him laugh.

His co-workers liked him, and he was also popular away from the office.

'It was amazing,' he once said. 'I was asked and went everywhere – to balls, to legations, to all that was going on.'[18]

In Washington society, as elsewhere, Whistler had the right connections. The city directory for 1855 reveals that the Envoy Extraordinary and Minister Plenipotentiary of the Russian Empire was Alexander de Bodisco. This was none other than the husband of the 'beautiful American' who had repelled Anna in St Petersburg. The presence of the Bodiscos in Washington helps to explain why an apprentice draftsman attended some of the capital's most glittering social affairs.

Because he enjoyed the social life, and wished to avoid his mother, Whistler stayed in Washington for a couple of months after leaving the Survey. He did his first serious painting, the portrait of a young woman named Annie Denny, married to an army officer. As his first real work of art, it was often mentioned in correspondence with his mother, but the picture disappeared long ago.

When Thomas Winans heard about this portrait, he wrote, 'Bring your easel

and brushes and I will find you a face to paint that will ease your pocket and give you practice – and perhaps fame.'[19]

Winans was not sure that Jimmy would ever be able to support himself, and, he told Anna, 'he will always have to be taken care of.'[20] Winans seemed willing to perform that service himself.

A few days after hearing from Winans, Whistler was again living in Alexandroffsky.

He enjoyed his second stopover in Baltimore – especially since his mother had acquiesced in his decision to be an artist – but he did not intend to stay.

In the nineteenth century serious young American painters and sculptors studied in Europe if they could afford it. They went because of the teachers, the museums, and, above all, the heritage. At first they generally chose London. Then from about 1830 until some years after the Civil War, most students preferred Italy, and American art colonies flourished in Rome and in Florence. Whistler, however, was attracted to a city that had not yet become 'in' for Americans, Paris.

One obvious reason for his choice was his fluency in the French language. More important was his desire to live the life of a Bohemian.

The word 'Bohemian' had long been used in France as the equivalent of 'gypsy' or 'vagabond.' In 1840 it gained a new context in Balzac's *Prince of Bohemia*, which characterized Bohemians as 'young, unknown men of genius in their art' who would someday 'achieve real distinction.'

Ten years later this definition was expanded by Henri Murger in *Scènes de la vie de Bohème*, a series of loosely connected sketches involving a poet (Rudolph), a painter (Marcel), a musician (Schaunard), and a philosopher (Colline), who lived, worked, and played in Paris's Latin Quarter. Murger eulogized these four young men, who weren't troubled by poverty, illness, or hardships; who repudiated outside authorities, rules, conventions, and customs; who were presented as the freest of human beings.

Scènes de la vie de Bohème was much talked-about in Washington society in the mid-fifties, and Whistler certainly knew about and was excited by this book. Probably he read it in its original language. In any event, its influence upon him was overwhelming.

The free and easy, unconventional Bohemian way of life, Murger said, could exist only in the Latin Quarter, and Whistler naïvely accepted this at face value. Held down for all of his life by one authority or another, he would find freedom in Paris.

* * * *

At the end of July, Whistler was ready to leave Baltimore. Winans 'loaned' him $450. George agreed to send $350 a year. On the 30th he departed for New York City.

After seven weeks with his uncle in America's metropolis, he was primed to go. He decided that he would like the adventure of crossing the ocean in a sailing vessel. (Unlike westbound sailing ships, loaded with immigrants, those going east carried only a few passengers.) Late in September he boarded the *Amazon*, and as it set out from the harbor he stood at the rail and looked upon the United States of America for the last time.

7

'La Bohême'

[1855–59]

Whistler reached London on 10 October and spent three happy weeks with his sister and her husband, whom he characterized as 'handsome and clever.'[1]

Then on the morning of Friday, 2 November, he took a cab to Waterloo Station and entered a first-class train compartment. He would travel in style to the Latin Quarter.

<center>*　　*　　*　　*</center>

'*Hotel Corneille, s'il vous plait,*' he instructed a cab driver at the Gare du Boulogne (now the Gare du Nord).

In the middle years of the nineteenth century, almost every foreign student in the Quarter who was not impoverished stayed at one time or another at the Corneille, a shabby six-story building on the Rue Corneille, just off Place de l'Odeon. When Whistler's cab arrived, early in the evening, he was stimulated by the sounds of singing and shouting in several languages. He got out, paid the driver, entered the lobby, and handed over forty francs ($10) for a month's rent. He then walked up to his fourth-floor room, furnished with a bed, a chest of drawers, a writing table, three chairs, and a small carpet. The walls contained several cheap prints, depicting an opera singer, a ballerina, and Telemachus on one of his adventures. After dropping his luggage, he went out to enjoy a night in Paris.

The streets of the Quarter were teeming with students, mostly from the provinces, but also from Britain and other European countries, studying law, medicine, literature, philosophy, music – and art. In this year the fine arts arrivals included Frederick Leighton, Camille Pissarro, and Edgar Degas, their appearance coinciding with the world's second International Exhibition. (The first had been held in 1851 in London.)

One enormous building on the Champs-Elysées housed the Universal Exposition of Science, Art, and Industry. The 'Art' consisted of the largest

<center>58</center>

collection of paintings and sculpture ever gathered together in one building, 5000 works of 2000 living artists.

On his first morning in Paris, Whistler walked over to the right bank to see the show, which would close twelve days later. He paid an entrance fee of one franc and proceeded to the focal point of the exhibition, two adjoining galleries with retrospective presentations, 40 paintings by Jean Auguste Ingres and 35 by Eugène Delacroix.

* * * *

Ingres and Delacroix!

The 75-year-old Ingres and the 57-year-old Delacroix were the high priests, the elder statesmen of French painting, and were now joint recipients of the Grand Medal of Honor.

This was almost the only thing they had in common.

'*Monsieur*,' Ingres said stiffly after they had received their medals, '*le dessin est la probité de l'art*.'

This encapsulated his philosophy. 'If I had to put a sign over my door,' he once said, 'I should inscribe it "School of Drawing."' For him form was everything, color was almost nothing.

Ingres hammered this nail uninterruptedly, as when he told the youthful Degas, 'Draw lines, young man, and ever more lines. This is the only way to become a good artist.'[2]

In emphasizing form to the exclusion of almost everything else, in insisting upon classical restrictions of subject matter, in deprecating the appeal to emotions and feelings, Ingres was *par excellence* the nineteenth-century painter of classicism, the rightful heir to the mantle of David.

If Ingres was the master of drawing and classicism, Delacroix was the champion of colors and romanticism.

Sometimes called the 'Victor Hugo of painting,' Delacroix said that 'Colorists are the men who unite all phases of art.' He covered a greater range of subjects than Ingres, and, like all romanticists, he wasn't shy about his feelings and emotions.

Delacroix felt that he was working within a traditional framework, reviving the principles of Titian, Veronese, and Rubens. He was not a true revolutionary, only a rebel against classicism and Ingres.

Ingres and Delacroix deserved their medals, but few of their followers had earned any honors. Their work was mostly unimaginative and predictably mediocre. Many of them imitated commercially successful pictures, imitations of imitations.

Clearly this state of affairs could not endure indefinitely. French art was ripe for a genuinely revolutionary change.

* * * *

'The true painter will soon draw his subjects from everyday life,'[3] Charles Baudelaire had predicted in 1845. Ten years later a prominent critic urged artists to depict what they 'personally have seen.' This appeared in an article entitled 'On Realism.'[4]

'Realism' became the latest Latin Quarter battle cry, and in 1856 Edmund Duranty founded a journal entitled *Réalisme*. His maiden editorial exhorted painters to 'create what you see!'

Several good painters had been doing just this. Three names come to mind, Corot, Millet, and Daumier. Each of them painted what he saw. Corot saw landscapes. Millet saw peasants. Daumier saw city streets. They broke with tradition but didn't stir waves in the waters of officialdom. Daumier wasn't taken seriously because he was primarily an illustrator. Corot even received praise because of the imaginative and poetic qualities of his work. Millet was reprimanded for his commonplace subjects, but, quiet and unobtrusive, he didn't fight back and wasn't subjected to a concentrated attack.

Daumier, Corot, and Millet were unaggressive realists. Very different was another painter whose link to realism was like that of Ingres and Delacroix to classicism and romanticism. His name was Gustave Courbet.

In 1850 at Paris's most prestigious art show, the Salon, 31-year-old Courbet had two large pictures of personally observed scenes. *The Stone Breakers* shows a pair of workers splitting stones. *Burial at Orleans* depicts a country funeral. The response to these paintings was amazing. In the words of a Courbet biographer, they engendered 'astonishment, consternation, alarm, and rage.'[5] A representative reviewer said, 'Never has the cult of ugliness been practiced more frankly.'

The pictures aren't really ugly, but they are gigantic. Huge, fully detailed paintings of simple contemporary incidents were too much for a critical audience unprepared for such ventures.

'Show me an angel, and I'll paint it,' Courbet said, as he carried on with his portrayals of what he had seen and continued to be controversial. He reveled in notoriety and enjoyed being offensive. His posture was captured in a drawing which showed him watching a man standing placidly before one of his pictures. 'That bourgeois is not having a nervous attack,' says the cartoon Courbet. 'My show is a failure!'

His 'show,' held in 1855 was something as yet almost unheard-of, a one-man exhibition. After three of a dozen paintings he had sent to the International Exposition were rejected, he angrily withdrew them all, erected a pavilion on the Rue Montaigne, near the Exposition, and with four drawings and 40 paintings opened his show with a placard proclaiming 'Le Réalisme.' The catalogue

announced his aim: 'To be able to represent the customs, the ideas, the appearance of these times, according to my way of looking at things.'

The exhibition was condemned by critics but relished by young painters and students, including several who would be known as Impressionists. They delighted in this defiance of the establishment.

Whistler arrived too late for the show, but not too late for the discussions it engendered.

* * * *

Parisian art students fell under the sway of Courbet almost everywhere but in the studios of their teachers. Painting instructors in 1855 seemed oblivious of Courbet and not much affected by Delacroix. French art education was rigidly governed by the principles of Ingres, especially at 14 Rue Bonaparte, the address of the École des Beaux Arts. Under government supervision, the École aimed to take young men and women as far as they could go with instruction, but it was for advanced students and offered no elementary tutelage.

The training grounds for the École were those establishments which formed the foundation of French art education, the ateliers. Each atelier was directed by an experienced teacher, and while they had their differences, they all prepared pupils for the École, and, teaching in the shadow of Ingres, they all emphasized drawing.

Whistler did not at once enter an atelier. Six days after his arrival, he began to attend morning and evening classes at the École Imperiale et Speciale de Dessin, which provided what might be called pre-atelier instruction. He was there for eight months, and then in June 1856 he matriculated at one of the best-known ateliers, at 36 Rue de l'Ouest, administered by Charles Gleyre.

Gleyre was a 49-year-old Swiss painter who had worked in various genres. He was noted for his carefulness and his independence. A contemporary called him a man who 'takes as much care with his painting as an honorable man does with his conduct,' and 'mouths no shibboleth, confines himself to no formula, refuses to join any school.'*[6] Personally, he was a brooding, introspective loner.

He began teaching in 1843 by taking over the atelier of another painter, on the ground floor of a building at the end of a large courtyard. Years later, one of his students recalled 'a large, dirty studio with many large, dirty windows facing north, with a stove, a model-throne, low chairs with backs, easels, drawing boards, and walls adorned with caricatures in charcoal and white chalk and the scrapings of many palettes.'[7]

This unsightly room may have been Paris's best teaching studio. When Monet arrived, he was counseled by an experienced painter, 'You must go to Gleyre. He is the master of us all. He'll teach you to do a picture.'

Almost uniquely he taught without pay because he remembered the hardships

of his own student days. (The usual fee was 30 francs a month.) The only charges were for the studio rent and the model's compensation.

Usually about thirty students were enrolled with Gleyre. They worked six days a week, mostly in the morning, when the light was at its best. As in the other ateliers, elementary students copied plaster casts of ancient statues, and the others, including Whistler, drew from a live model.

Twice a week Gleyre dropped by and inspected each person's work. He offered advice softly and courteously. Most teachers corrected their students' work, but Gleyre encouraged them to become personally involved in their own progress by making the corrections themselves.

As a teacher Gleyre was open-minded. Unlike some of the others, he did not insist upon adherence to a particular style. He encouraged his pupils to develop their own artistic personalities, and, above all, not to imitate anyone. He would say, 'Don't draw on anyone's resources but your own,' and he even permitted some selection of subjects for compositional assignments.

None of Gleyre's pupils became disciples, and some would be noted for their individuality, notably the four future Impressionists – Monet, Renoir, Sisley, and Bazille. When they expressed interest in landscapes, he advised them to paint *en plein air*. Each of them showed his appreciation by exhibiting pictures as a 'pupil of Gleyre.'

Actually Gleyre's only pupil who never publicly represented himself as such was Whistler, but he was indisputably helped on the Rue de l'Ouest. He was encouraged by Gleyre; he developed a method of forming a palette which he would never abandon; and he received practical instruction in a technique he had learned about from Joshua Reynolds and Charles Leslie and would be important to his later work, drawing from memory.

Although he gleaned more from Gleyre than he would admit, Whistler was not faithful in attendance nor prompt in completing assignments. Eventually he stopped going to the studio. Partly because of this, he gained a reputation for being an idler.

'In those days,' a Parisian contemporary, Joseph Rowley, said, 'Whistler did not work *hard*.'[8] A fellow pupil of Gleyre, Thomas Armstrong, said that Whistler came to the studio 'so erratically that his very appearance caused surprise.'[9] Another art student, George Boughton, reached Paris soon after Whistler had left and 'began to hear of the previous set who "had lived the life" in Paris, and among such the name of "Jimmy" was enthusiastically prominent – more for wild pranks than serious studies.'[10]

Rowley, Armstrong, and the men who talked to Boughton were all English, and it was they who created the image of Whistler as a Parisian reveler.

One of them, George Du Maurier, also a pupil of Gleyre, popularized this notion in his novel *Trilby*, set in the Latin Quarter in the fifties. One character

in the first version of the book was a verbal portrait of Whistler. He was called Joc Sibley.

<p style="text-align:center">* * * *</p>

Joe Sibley was 'the king of Bohemia.'

Whistler would have accepted this as a compliment. No one could have been more Bohemian than he, who adjusted perfectly to life in the Quarter.

Part of this easy adaptability came from his linguistic fluency, but it was also another illustration of his adaptation to his environment. After three weeks in Sloane Street and a ride in a first-class rail carriage, he wholeheartedly joined his French comrades in student restaurants whose 'lowness of prices' a contemporary guidebook called 'almost alarming.' A hot dish, a decanter of *vin ordinaire*, and a dessert cost eighteen sous.

Eating in cheap student restaurants was part of the Bohemian lifestyle. As was living with a young woman, uniquely Parisian although she probably came from the provinces, known as a grisette.

Historically *grisette* referred to a burgher's wife or daughter who typically wore clothing that was soberly gray (*gris*). By 1855 the word was no longer used in this context, but it seemed to defy easy definition, even in the dictionary of the French Academy, which characterized *grisette* as '*un vêtement d'étoffe grise de peu de valeur et aussi d'une jeune femme de médiocre condition qui portrait ce vêtement*' (a dress of cheap gray material and also a young working-class woman who wears such a dress). This isn't particularly helpful, nor was it entirely accurate. A grisette was indeed a woman of the working class – perhaps an embroiderer, a milliner, a seamstress, or a florist – but she rarely dressed in gray. In 1857, a seasoned observer wrote,

> You know the grisette at once by her pretty dress of bright colored cotton, by her tasteful and coquettish cap, with its gay knots of pink ribbon and by her neat, well-fitting boots; or if you fail in her costume, you know her by her bright eye, her rosy cheek, her ready smile, and her elastic step.[11]

In the summertime, this writer added, grisettes really blossomed, when 'by the dozens they may be seen strolling along the gardens of the Luxembourg, charmingly dressed in the most simple, yet coquettish costume, each leaning on the arm of a student.'

Grisettes and students were traditional partners, and on this matter Whistler did not flout tradition. Perhaps because of his mother's influence, he did not have a particularly strong sex drive, but he wanted to play by the rules, and so for a while he shared a room with a grisette named Eloise but known as Fumette, who enjoyed poetry and was hot-tempered. Once after neglecting her, he came

home and found some of his drawings torn to bits. He wept and then, uncharacteristically, went out and got drunk.

Whistler lived with Fumette for a few months. When they broke up, he made no effort to replace her with another grisette, but instead turned to a group of women who were second in the hearts of Parisian students, can-can dancers. His new inamorata was called 'Finette' and performed at the Closerie des Lilas, popularly known as the Jardin Bullier, on the Boulevard Saint-Michel. His sojourn with her lasted no longer than with Fumette.

Fumette and Finette were the only women romantically linked with Whistler who can be identified. It was not clear how he met them. He may have picked them up in a café. Probably Fumette and perhaps Finette fell in love with him, but he was not really serious about them. He was just playing the game of Bohemianism.

<p style="text-align:center">* * * *</p>

To return to Joe Sibley, he was 'always in debt.' This was often true of Whistler, but so what? Students have perennially been in debt, especially in the French capital in the 1850s, when prices everywhere but in Latin Quarter restaurants were frightfully high. In 1856 a Paris correspondent for *The Times* reported that 'the commonest necessities, bread, milk, and wine, are exorbitantly dear, and house rent is something fabulous.' In the summer of 1855, newly arrived Frederick Leighton told his mother that 'after great trouble and manifold inquiries' he had found a studio, 'the *only* one that suited me, and I must pay unfurnished 150 francs a month.'[12]

For most of his student days, Whistler had no studio of his own, and he never had one like Leighton's. Nor did he ever live in anything like what *The Times* cited to illustrate high rents, a medium-sized third-floor flat on the Rue de Rivoli for 10,000 francs per year. He always resided in the Latin Quarter, never long at one address. His lodgings included a pension in the Rue Dauphine; a little hotel in the Rue St Sulpice; a furnished room just off St Germain des Près; and a room in the Rue Campagne-Première. He was in one of these places when William Swift, on a visit to Paris, turned up. 'He declares that he lives the life of an "Artiste,"' Swift wrote to Anna. 'He lives in just the kind of place we read of in Paris, but rarely see even there, and never in America. Frankly I don't think much of the lodgings.'[13]

Whistler wasn't bothered by primitive living quarters, nor by frequent spells of poverty. He once showed his carefree attitude by pawning a jacket on a hot afternoon to obtain money for an iced drink. When reprimanded for recklessness, he replied. 'But it is warm.'

We could afford to be cheerful about his indigence. He received monthly checks from George and occasional gifts from Winans and Harrison. And sometimes he dashed across the Channel to see his sister and brother-in-law and

probably to obtain a 'loan.' His poverty was only a concomitant of being a Bohemian.

Like Joe Sibley, he was 'eccentric in his attire, and people stared at him – which he adored!' Contrary to popular opinion, French artists and art students did not generally dress ostentatiously. In this respect Whistler differed from them. An acquaintance recalled that when introduced to him he was 'clothed entirely in white duck, and on his head a straw hat very low in the crown and stiff in the brim, bound with a black ribbon with long ends hanging down behind.'[14] The initial publication of *Trilby* contained Du Maurier's own drawings, and Sibley (that is, Whistler) appears in two of them, dressed like a dandy. He is shown with a large group in a studio, with easily the longest hair of any man in the room. He is also seen strolling down an avenue, twirling a walking stick and holding a cigarette. (At this time he was a heavy smoker.)

Joe Sibley, and James Whistler, loved to be the center of attention.

Another description of Joe Sibley reads 'genial, caressing, sympathetic, charming, the most irresistible friend in the world.' This judgment accords with virtually every evaluation of Whistler's personality at this time. An English companion said, 'If he had money in his pockets, he would spend it royally on his friends.'[15] A Frenchman remarked, 'He was truly amiable. His vanity was good natured, and he would laugh about it himself.'[16]

No one had yet seen a James Whistler who was in any way sarcastic, vitriolic, or pugnacious.

<p align="center">✳ ✳ ✳ ✳</p>

While enjoying his company, Whistler's English friends and acquaintances never really understood him. His relationship with them, and the allied matter of the English lifestyle in Paris, is a topic which, because of his subsequent deportment, should not be overlooked.

If only because of their common language, Whistler knew numerous Englishmen, four of them quite well: Du Maurier, Armstrong, Thomas Lamont, and Edward Poynter. He briefly shared living quarters with Lamont and Poynter, and he frequently saw the quartet in their studio at 33 Rue Notre Dame des Champs.

When these four young Englishmen – known to friends back home as 'the Paris gang' – had finished a day's work, they would often be entertained by their American comrade.

Whistler amused us, [Armstrong recalled] with his nigger songs of slavery and plantations. He would take a stick or umbrella, hold it in his left hand like a banjo, twiddle on it with the finger and thumb of his right hand, and patter grotesque rhymes founded on supposed adventures of Scriptural characters. One of them had this refrain:

'Takey off your coat, boys,
'Rolley up your sleeve,
'For Jordan am a hard road to travel, I do believe.'[17]

Whistler sang for 'the Paris gang,' and he saw them constantly, but he was never truly close to them. As Armstrong acknowledged, 'he was never wholly one of us.'[18]

The English youths could no more take Whistler to their bosom than they could the Parisians, from whom they remained aloof – even though Du Maurier was fluent in French and Poynter spoke the language well. Armstrong recollected 'most joyful evenings,' when 'we descended into the middle of Paris and treated ourselves to British food and drink.' They went to a place near the top of the Rue de la Madeleine, where the menu featured roast beef, mutton, boiled potatoes, 'household bread,' horseradish, English mustard, apple pie, Cheshire cheese, and British gin and beer. This seeking out of an English restaurant illustrates not only English aloofness but also English insularity and the all-too-often English disinclination to adapt to other people's ways of doing things. In an English restaurant one could be sure that a butter knife would be provided and, above all, that no one's hands would have touched the food.

'We were none of us real Bohemians,' Armstrong admitted, 'for we had those behind us in England who would have come to our help if we had been in dire necessity.'[19] Whistler was also bolstered by well-heeled people, but this did not dissuade him from plunging into the life of the natives. His English friends could not understand his behavior: frequenting dance halls, living with a grisette, cultivating 'no-shirt' acquaintances, so called because they were allegedly too poor to own a shirt. How could he be serious about art?

Artistically as well as socially, 'the Paris gang' was conventional and circumspect. Du Maurier's principal biographer, an English woman, observed, 'They believed that all that was necessary to become a good artist was the requisite number of attendances at the atelier, complemented by work of their own along the same lines. They were in Paris to learn the craft of painting, rather than to question its principles.'[20] To them, Whistler's atelier absences and his failure to do the assignments demonstrated a lack of dedication.

One might strikingly contrast Whistler with his English counterparts by following Du Maurier's precedent and setting him against Edward Poynter. In *Trilby*, Poynter was Lorrimer, the 'industrious apprentice,' introduced immediately after Joe Sibley, the 'idle apprentice.' A man 'of precocious culture, who read improving books, and did not share in the amusements of the Quartier Latin,' Lorrimer 'spent his evenings at home with Handel, Michael Angelo, and Dante. Also he went into good society sometimes, with a dress-coat on, and a white tie, and his hair parted in the middle!' As for Poynter himself, a contemporary remembered that in his student days he was 'diligent in

attendance, faultless in discipline, eager and painstaking in following the instructions given.'[21] For Poynter there was no short cut to success. To be an artist, one had to work, work, work.

At a Royal Academy banquet soon after Whistler's death, Poynter, who was now 'Sir Edward' and President of the Academy, said,

> I knew him well when he was a student in Paris – that is, if he could be called a student who during the two or three years I was associated with him devoted hardly as many weeks to study. His genius, however, found its way in spite of an excess of natural indolence of disposition and love of pleasure.

Although he was once James Whistler's flatmate, one might wonder if Sir Edward ever did 'know him well.'

8

Becoming an Artist

[1855–59]

If diligence is measured by obedience to prescribed procedures, Whistler's friends properly charged him with indolence. He did not habitually report to Gleyre's, he did not faithfully follow directives, and eventually he stopped attending altogether. But he wasn't unique. In the fifties, art students frequently stopped going to their ateliers. Even at a comparatively lenient one like Gleyre's, the instruction could cause an independent person to rebel. After all, these studios prepared pupils for the École; this alone might stifle individuality.

Interestingly, Sir Joshua Reynolds, of all people, remarked upon this topic, and Whistler may have remembered the passage:

> We all must have experienced how lazily, and consequently how ineffectually, instruction is received when forced upon the mind by others. Few have been taught to any purpose who have not been their own teachers. We prefer those instructions which we have given ourselves, from our affection to the instructor; and they are more effectual, from being received into the mind at the very time when it is most open and eager to receive them.[1]

Actually it was recognized in Paris that art students sometimes needed to work alone. Until the early sixties, there was a large studio on the Ile de la Cité called Atelier Suisse, founded by a former model named Suisse, where for a small fee anyone could paint or draw from a living model without instruction. Among those who worked there were Ingres, Delacroix, Courbet, Manet, Monet, Pissarro, and Cézanne. But not Whistler. He needed more space than could be found in a studio.

Following in the footsteps of Hogarth and Fedotov, he regarded his real studio as the world in which he lived – restaurants, ballrooms, streets. For him play and work were inextricably joined. He was always on the job, 24 hours a day.

He was doing what his teacher once had done. As a student in Rome, his biographer said, Gleyre 'spent most of his time looking around and dreaming.'*2

While guarding his independence and individuality, Whistler respected and appreciated the work of others, past and present. In 1857 he went to Manchester for the Exhibition of Art Treasures, 900 paintings by old masters and about the same number by modern artists. The *pièces de résistance* were several works by Velasquez, with whom among all painters of the past Whistler would be most closely linked.

He had of course seen Velasquez's *Infanta Margarita* at the Louvre. He was familiar with much that was at the Louvre, which he visited over and over again, and provided him with standards of judgment. 'What is not worthy of the Louvre,' he said more than once, 'is not art.'3

Like most of the students, Whistler engaged in the traditional practice of copying pictures, but without much enthusiasm. Although he often copied informally, only once, on 28 February 1857, did he officially request permission to reproduce a painting, Pierre Mignard's Raphaelesque *La Vierge à la Grappe*, which shows the Virgin with a cluster of grapes from which the child in her lap is eating.

On this matter he surely thought back to Reynolds. Sir Joshua acknowledged that 'copying occasionally may be useful,' but he also regarded 'general copying as a delusive kind of industry' which 'requires no effort of the mind' and is 'tedious,' 'mechanical practice,' and 'drudgery.'

Apart from Reynolds, it would have been out of character for Whistler to duplicate somebody else's work in a servile fashion. When he copied unofficially, it was often a lark. On one occasion, a French acquaintance recalled, he 'helped himself to a box of colors, and, when discovered by its owner, was all innocence and surprise and apology: he supposed the boxes were for the benefit of the students.'4

There were other amusing episodes in the Louvre, but they were less important than a commonplace occurrence in the autumn of 1858, his introduction to Henri Fantin-Latour.

 * * * *

Born in Grenoble in 1836, Fantin-Latour had lived since 1841 in Paris. In 1858 he was an advanced student at the École and an inveterate copyist. The Louvre's register of copyists lists more than two dozen pictures for which he got formal permission to copy, and informally he sketched many others.

Fantin was shy and reserved. His mother was the adopted daughter of a Russian countess, he seemed almost to be an incarnation of the celebrated Russian melancholia. He did not make friends easily and did not reach out to people. He concentrated on his work. But he couldn't help noticing on several occasions a short, rather frenetic American who always wore a large, wide-

brimmed hat. One day the American stopped to admire his work and to start a conversation. This was the beginning of a long friendship.

In the evening, Whistler and Fantin-Latour continued their conversation at the Café Moliére.

As everyone knows, nothing is more typical of Paris than its cafés. Those especially favored by artists in the 1850s were the Taranne, the Fleurus, the Brasserie des Martyrs, the Brasserie Andler, and the Moliére. Whistler enjoyed going to cafés and joining in discussions. Perhaps surprisingly, he did not do a great deal of talking; at this stage of his career he was a willing, eager listener. He learned from the young engraver Felix Bracquemond about his current enthusiasm, Japanese art. He heard the Belgian painter of Parisian women, Alfred Stevens, state his philosophy of art: 'In painting, the subject is of minor importance. A picture should need no explanation.'[5]

And he was a witness to performances by Gustave Courbet.

For ten years Courbet had lived and painted in the Quarter, at 32 Rue Hautefeuille. His favorite haunt, two doors away, was the Andler, where he was cock of the roost. He would enter, his friend François Fournel said, with 'a resounding laugh' and fill the room with his quips and sallies.'* Anyone who disagreed with him on anything would be demolished with ridicule. He particularly couldn't abide the vocabulary of aesthetics. 'If a stray aesthetician,' Fournel said, 'pronounced the word *beauty* within his hearing, he would be met with one of those extraordinary fits of laughter causing, for at least three minutes, the windows of the brasserie to shake.'* His favorite subject of conversation was always himself. 'No one,' Fournel said, 'could offer him a tenth of the compliments which he addressed daily, morning and evening, to himself.'*[6]

To illustrate Courbet's vanity and conceit, Fournel described an incident he had observed in a café not long after a minor painter named Lambron had created a momentary stir in Parisian art circles with his picture *The Undertaker's Music.*

When Courbet entered, he was followed by a callow almost beardless youth.

'Monsieur Courbet,' the young man said, 'may I offer you a beer?'

'A beer? Willingly, my boy.'

They sat at a table nearby. Courbet took out his pipe and settled down comfortably. He rested his body on one chair, which groaned painfully. [He was stout.] His soft hat rested on another, and his legs on a third.

After the beers had been brought, they began to converse.

'Have you seen Lambron's picture, Monsieur Courbet?'

'Who, Rambron?'

'Lambron, Monsieur Courbet.'

'Oh, Mambron. Don't know him. Oh, wait a minute. You mean that pretentious ass?'

'Yes,' the young man answered. 'How do you find that pretentious ass, Monsieur Courbet?'

'My boy, he stinks. He doesn't exist. One doesn't even speak about *that*. That's nothing but a blockhead, nothing but filth, just shit.'

[Courbet's contempt comes out with particular power in the French when he refers to Lambron as a 'ça,' a neuter object, a mere thing.]

'But Monsieur Courbet, some people believe that he is your pupil.'

'The idiots! What can you expect of France with such ignorant louts?'

'It is certain, Monsieur Courbet,' the neophyte said obsequiously, 'that he doesn't have your skill, your dash, your . . .'

'It's not only that, my boy. Look here, do you really want to know what the difference is between this "Gambron" and myself?'

He swaggered self-importantly in his chair, which gave out repeated squeals.

'The difference is simply that that animal has nothing in his belly, while I have something in mine. That's all there is to it.'

'Yes, and everyone knows that he hasn't a single idea on art, while you . . .'

'It has nothing to do with ideas. That's just hogwash. Your "Lampron" has nothing in his belly while I have something in mine. That's all there is to it. Look here, let's suppose an imaginary situation. If I were thrown into prison and were told "You won't get out until you have recreated Michelangelo's *Captive*," I would answer, "Give me a mallet, a chisel, and a piece of marble, and I'll eat my hat if it doesn't come out better than Michelangelo's." Do you know why?'

'Why, Monsieur Courbet?'

'Because I have something in my stomach! That's all there is to it.'

The youth listened, overwhelmed with admiration.*7

James Whistler also, more than once, was an admiring onlooker who would not forget what he had observed.

<p align="center">✻ ✻ ✻ ✻</p>

Whistler's relationship with most of the people he met at this time was superficial. But with Fantin-Latour he formed a genuine friendship. Fantin had one other close companion, an impoverished art student from Burgundy, Alphonse Legros. On that first evening at the Moliére, Fantin introduced Legros to Whistler, and the three of them began to call themselves a 'Society of Three,' denoting mutual interest and support.

Fantin and Legros were disciples of an independent-minded teacher, Lecoq de Boisbaudran, who more than anyone else emphasized the development of one's visual memory. Boisbaudran incorporated his ideas in a small book, *The Training of Memory in Art*, wherein he said that cultivating one's memory is not a clever trick, nor is it necessarily unthinking and rote-like. And there need not

<p align="center">71</p>

be a conflict between memory and imagination. Actually artists with a well-developed memory will 'become more exact and intelligent when working from a model,' and memory training can be 'a great stimulus to artistic creation by ministering to and reinforcing the imagination.'[8]

Boisbaudran's students practiced in the Louvre. After memorizing everything in a picture, they would try to reproduce it at home. In this way Legros did a fine copy of Holbein's *Erasmus*. Fantin preferred to copy in the museum, but he was also an advocate of memory training.

With his two friends, Whistler put his memory to use, and years later he would demonstrate the value of this discipline.

* * * *

Fantin and Legros were industrious and intolerant of indolence. Their acceptance of Whistler should destroy the notion that he was a loafer. The most compelling argument, however, against the 'idle apprentice' idea lies in the work that he did.

He turned out a large number of drawings, mostly realistic Latin Quarter sketches. In 1856 he sent an assortment to William in a parcel which was addressed to him but opened by Anna. Shocked by what she saw, and fearing for the morals of her medical student son, she burned all of it at once. She then sent a strongly-worded letter to James, scolding him for depicting scenes of 'depravity.'

The drawings probably resembled a pen-and-ink sketch done at the same time, now owned by Chicago's Art Institute. Called *A Scene from Bohemian Life*, it shows a group of young men and women in various positions of relaxation, smoking cigarettes and drinking wine.

Whistler's drawings were good, but less important than his work in another medium.

* * * *

Whistler reached Paris in the midst of a revival of etching, a medium which, dormant since the death of Rembrandt, had captured the imagination of Delacroix, Daubigny, Corot, Millet, and the man mainly responsible for its rejuvenation, Charles Meryon.

In 1846, after a ten-year naval career, Meryon began seriously to study art. Color-blind, he concentrated on etching, and between 1850 and 1854 he produced his masterpiece, *Les Eaux-fortes sur Paris*, a series of views of almost everything in Paris that was old and picturesque – streets, bridges, quays, and, above all, buildings. Although extolled by critics, the etchings weren't commercially successful. Until he died in 1868, Meryon lived in penniless obscurity, and he spent the last ten years of his life in a mental institution.

Meryon's legacy lay in his influence. Discriminating artists who saw his work

realized what could be done in this neglected art. Among them was James Whistler, who returned with alacrity to the procedure he had practiced at the Coast Survey. In Washington he had been bored, but now he was enthusiastic because nobody was going to tell him what to do.

In 1857 he induced his British friends to join him in a project called PLAWD, an acronym for Poynter, Lamont, Armstrong, Whistler, and Du Maurier. Each would do two etchings upon subjects freely chosen, and the ten prints would be sent as a group to England for possible publication. Whistler finished his immediately. Eventually Poynter and Du Maurier completed theirs, but Armstrong and Lamont submitted nothing. These four etchings by Poynter and Du Maurier comprise the totality of work in this medium by the English quartet during their stay in Paris.

As for the 'idle apprentice,' during 1857–58 he hammered out dozens of etchings. Unlike Meryon, he was attracted mainly to human beings, ranging from Fumette and Finette to Bibi Lalouette, the young son of the owner of a popular student restaurant. For a time he even rented a small studio in the Rue Campagne-Première, where he had a hand press and pulled his own prints.

The first admirers of his etchings were patrons at the Moliére, who saw his depictions of Latin Quarter types, and also several prints resulting from a recent adventure in the countryside.

Late in the summer of 1858, Whistler accepted an invitation from a fellow pupil of Gleyre's to visit him at his home in the Alsation community of Saverne. He persuaded a young French artist, Ernest Delannoy, to accompany him on an etching journey with Saverne as one stop. They travelled by train to Nancy, Luneville, Saverne, and Strasbourg, and by Rhine steamer to Cologne, all the time doing etchings. In Cologne they ran out of money.

'What shall we do?' Delannoy asked after the first night in Cologne.

'Order breakfast,' Whistler replied.[9]

The only American consular official was away on holiday, and no one was available for assistance. They wrote to people who might help them, but after ten days there had been no response. They decided to return to Paris on foot. Because of their unpaid bill, Whistler put his plates in a knapsack and carried it to Herr Schmitz, proprietor of the inn where they were staying.

'We are penniless,' Whistler said. 'I leave my copper plates as security.'

'What shall I do with them?'

'Take good care of them. I will send you money from Paris, and then you will send me my knapsack.'

Schmitz agreed and served his guests one last breakfast. A chambermaid slipped a coin into Whistler's hand as they departed with light luggage, just paper and pencils.

On each of their several nights on the road, they paid with drawings for food and lodging. Whistler did portraits, and, he told his sister, 'I did my best. Each

portrait was such as Seymour would have been pleased to see. We have clear consciences and can hold up our heads.[10]

They walked as far as Liège, where they were able to borrow enough money to finish the trip by train.

The significance of the journey lay not in the homeward-bound drawings, but in the work left behind, in which, Whistler told Deborah, he had made 'more progress' than he could have 'otherwise in three times as many months.'

After hearing the Café Molière comments on his work, Whistler walked over to the Rue de la Huchette and approached the man who had been Meryon's printer, August Delâtre. He liked what he saw, and the result was *Twelve Etchings from Nature*, a baker's dozen including the frontispiece, generally called *The French Set*.

It is not truly a set since nothing ties the plates altogether except their common stimulus, 'nature.' They aren't even all French: two of them, 'Annie' and 'Little Arthur' are portraits of the Haden children, done in London. Of the others, five are Parisian, and five plus the frontispiece came from the journey. The subjects include children (the London etchings and the frontispiece, which shows Delannoy with some Alsation youngsters); a sensitive full-length portrait of Fumette; an impecunious old woman selling flowers; a young woman sitting under a parasol; a farmyard, a dilapidated farmhouse; a narrow, lamp-lit street in Saverne, Whistler's first nocturnal scene; and, perhaps the *chef d'oeuvre* of the collection, a kitchen scene whose blending of light and shade is suggestive of Rembrandt.

No one could have been more excited about *The French Set*, and more helpful to Whistler, than a recently elected Fellow of the Royal College of Surgeons, Seymour Haden. He went to Paris to see it and then handled its publication in London. Whistler showed his gratitude by dedicating it '*à mon vieil ami* Seymour Haden.' To meet the publishing costs, he had to sell fifty copies at two guineas each. Haden guaranteed the sale of 25. For the others, Whistler looked westward.

He had not written home regularly or even frequently. On 7 May 1858, Anna reminded him that while Deborah corresponded every fortnight, more than three months had passed since she had last heard from him. Fortunately she had a devoted younger son. In May 1857, William left Trinity College and began an informal medical apprenticeship in Philadelphia. After a year of this he matriculated at the University of Pennsylvania medical school.

William was a diligent student, and he was also attentive to his mother. Her feeling of dependence is often revealed in her correspondence. In October 1858, for example, she wrote to a friend, 'If Willie were at my side, as he usually is on Sunday, he would be my eyes in devotional reading. But his medical lectures and study keep him so confined he needs country air to relax his mind and invigorate his frame. He was sorry at leaving me alone, to be gone two nights.[11]

When she finally heard from James, she was asked about perhaps obtaining American subscribers to his folio of etchings. She wrote to Thomas Winans, who promptly sent a draft for £63, as payment for thirty sets.

* * * *

An artist did not, and does not, gain much money or celebrity from drawings or etchings. Wealth and fame come from paintings. And so late in 1858, while continuing to etch, Whistler began to paint in earnest.

Sometimes he worked in both media on the same subject. Thus an elderly, nearly blind flower seller outside the Bal Bullier, who was known as La Mère Gérard, sat for an etching in *The French Set* and also for one of his first oil paintings, the portrait of a white-capped, white-haired woman with an apparently sour disposition.

Soon after painting *La Mère Gérard*, Whistler persuaded a poor, superannuated peddlar of crockery to sit for forty sous. The result was a fine study of a serene old man smoking a pipe, now owned by the Louvre. This early interest in old people perhaps came from studying Rembrandt in the Louvre.

Another current work seems surely to have been influenced by Rembrandt, a three-quarters head and shoulders view of a handsome, confident young man in a broad-brimmed hat, Whistler's first self portrait.

The early portraits were uncompromisingly realistic. Armstrong, who watched him doing one of them, said, 'I have never seen anyone take more time in making up tints on his palette before applying them to the canvas. Then he worked very slowly and deliberately. If he didn't like what he had done, he would take off the wet paint with a palette knife and wipe the canvas clean.'[12]

This is hardly the *modus operandi* of an idle apprentice.

* * * *

'The true artist,' Alfred Stevens said, 'strikes the keynote in the dawn of his work.'[13] Whistler's portraits provide a sign of the future, but the first real keynote was a painting begun late in 1858 on a visit to London.

Whistler had already etched portraits of all of the Hadens, and now in the music room of 62 Sloane Street he launched into a family painting, *At the Piano*. The subject is simple: a woman dressed in black sits at a piano while a young girl in white, arms folded, leans on it, listening meditatively. Deborah and Annie sat for the two figures.

In several ways *At the Piano* looks ahead. Annie is the earliest of Whistler's beautifully painted children. The skillful use of horizontal lines was the first appearance of what would become a Whistlerian trademark. The combination of colors suggests a 'harmony,' although he had not yet used this term, and the prominence of black, white, and brown foreshadows the famous portraits. Also, he tells us nothing about the personae; he was preoccupied with surfaces rather

than inner meanings. Most important, all the elements are integrated; everything joins with everything else. Nothing seems to be missing, and nothing is superfluous or irrelevant. To do this would be Whistler's principal lifelong artistic goal.

He finished *At the Piano* in Paris early in the spring of 1859 and submitted it to the impending Salon.

Exhibitions of the Salon had been held uninterruptedly since its establishment in 1673. Most artists in France, native and foreign, regularly submitted pictures to the Salon because it was *the* place in which to be recognized. With only a few private sales-rooms to provide exposure, all but the very famous painters depended heavily on the Salon. Regrettably, it had veered from its original purpose, and by the end of the first third of the nineteenth century it had become a gigantic spectacle, 'a bazaar,' Ingres said, 'in which the tremendous number of objects is overwhelming and business rules instead of art.'[14] Ingres abstained from it for twenty years, but to lesser lights this was an unaffordable luxury.

When William Swift was in Paris in mid-1858, Whistler said that he planned to try his luck at the next Salon. Swift thought 'he had much to study and practice before he could expect to be rewarded at an exhibition.'[15]

The Salon's board of admissions agreed. *At the Piano* was rejected, along with other works that have stood the test of time, such as Manet's first submission, *The Absinthe Drinker.*

The exhibition was not critically well received. Most of the pictures, Charles Baudelaire said, were 'so many successfully-completed platitudes, so much carefully-labored drivel and cleverly-constructed stupidity and falseness.'[16] The recently founded *Gazette des Beaux-Arts* told the 'victims of the jury' that 'there is nothing dishonorable in seeing one's name added to the glorious list of those who have won fame and recognition despite rejection by the Salon.'*

François Bonvin, a genre painter who owned a small gallery in the Rue Saint-Jacques, did something out of the ordinary by sponsoring and publicizing a show for some of the 'victims,' including Whistler. One visitor to the gallery was Gustave Courbet, who, despite his arrogance and self-centeredness, encouraged young artists if he thought they had talent. At Bonvin's he extravagantly praised *At the Piano.*

Bonvin's exhibition was a milestone. It ended Whistler's apprenticeship and began his professional career. His period of study completed, he would cross the Channel and live in London. As for the three and a half years in Paris, the Pennells observed that 'his pictures and prints were amazing in quality and quantity for a student who, Sir Edward Poynter would have us believe, worked for only two or three weeks.'[17]

Finally, Armstrong noted that in Paris 'he was always known to us as James Abbott Whistler.'[18] Still absent from his name was 'MacNeill.'

9

Settling Down in London

[1859–61]

In 1858 Whistler told William Swift that he expected to stay in Paris indefinitely because it had everything he desired. He soon changed his mind. There were good reasons for moving to London.

During the Parisian residency, he had frequently crossed over the Channel and visited 62 Sloane Street, where he maintained excellent relations with all of the Hadens. Because Seymour, the medical man, was afraid that Jimmy wasn't taking proper care of himself while living alone, he was persuaded to spend the winter of 1858–59 on Sloane Street, where he painted *At the Piano*.

Upon returning to Paris, he wrote to Deborah, 'My stay with you and Seymour has done me an immense good in my art.'[1] This would have been true if only for *At the Piano*, but there was more. He and Seymour had spent many hours together with their etching needles, encouraging and stimulating each other as they turned out their plates.

Seymour and Deborah loved having Jimmy with them, and even before he returned to Paris they were urging him to live in London.

Apart from Seymour Haden, there were sound artistic reasons for Whistler's decision.

Paris was more competitive, not just because of its many young artists, but because of fewer opportunities to go before the public. London's Royal Academy was as prestigious as the Salon, and, as noted earlier, five or six other organizations held at least one yearly exhibition of contemporary art. Also there were numerous shows in private galleries. In London it would have been difficult for a talented painter to go unrecognized.

In London, moreover, painters were probably freer to do what they pleased than anywhere else. In 1855, William Rossetti, no establishmentarian, said that 'the English school' was 'the most hopeful in Europe and the most open to new impressions – the least fettered by dogma or preconception in applying their impressions.'[2] The group to which Rossetti belonged, the Pre-Raphaelite

Brotherhood, might be cited in support of his statement. Outrageously denounced in 1850, they had become when Whistler reached London eminently respectable. And none of them had yet conspicuously compromised their principles.

Unfortunately, few painters took advantage of the opportunity to be creative. In his preface to the second edition of the *Lyrical Ballads*, Wordsworth said that he had 'abstained from the use of many expressions, in themselves proper and beautiful, but which have been foolishly repeated by bad poets till such feelings of disgust are connected with them as it is scarcely possible to overpower.' Wordsworth's words of 1800 apply to English painting of half-a-century later. What had been fresh and original became enfeebled and deadened through repetition. The author of a typical mid-century R. A. critique said,

> The spectator will discover little else than a reflection of last year. He will find the same sheep and cows under the same trees, reproduced without the slightest variation. Evening shadows fall on the same upland, with a cottage on the left and a clump of autumn foliage on the right. Inexhaustible Vicars of Wakefield gather about as thickly as ever. There is no end of fishermen coming home or going out. And there are the same bits of the Rhine, Dutch beaches, and Mont St. Michels. And the same overwhelming gallery of portraits, with strong likenesses in the faces and costume.[3]

One reason for the lack of originality, paradoxically, lay in the manifold opportunities for artists. With so many walls to cover, people incapable of a fresh thought could have pictures shown because space had to be filled. Even good painters were tempted to be imitative and repetitive. Why labor to create a thing of beauty when a pot-boiler could be sold as quickly, for as high a price?

All of this mediocrity emphasized the need to encourage anyone with a spark of originality. Just when Whistler arrived in London to stay, an essayist said, 'Some artists will rise above the level of their less-gifted contemporaries. All lovers of art must search for, and encourage, any signs of remarkable talent.'[4]

The year of 1859 was a propitious one for the start of an English art career.

* * * *

After a brief spell with the Hadens, Whistler settled in Newman Street, a short extension of Cleveland Street. Among those living and working on this lively, colorful road were a surgeon, a dentist, a professor of dancing, three professors of music, a pianoforte tuner, two pianoforte makers, two pianists, one professor of singing, one writer, one whipmaker, two bookbinders, one harp maker, one picture dealer, one plumber, two sculptors, seven tailors, and seventeen artists. Studios were available in Newman Street for a modest rent, and Whistler took one near the northern end, at number 72, a long narrow room in the middle of

which he attached a string joining the two walls. Over the string he threw a piece of silk drapery, separating the 'bedroom' from the 'parlor.'

In the spring of 1860 he was joined by Du Maurier. As always, Whistler had readily adapted to his surroundings, but Du Maurier wrote to his mother, 'This room is so beastly uncomfortable. As soon as I sell one drawing I shall cut the place.'

Du Maurier nevertheless enjoyed living with Whistler. 'We pull together capitally,' he told his mother, 'no rivality [sic] whatever. Jimmy's *bon mots* are the finest I ever heard. And nothing I ever read of in Dickens or anywhere can equal his amazing power of anecdote. He *is* a wonder, and a darling – we are immense chums.'[5]

The roommates spent a weekend at the suburban home of friends of Du Maurier's parents. 'Jemmy talked nearly the whole time,' he recounted to his mother. 'He is in my opinion the grandest genius I ever met, a "wit" greater than Hook or Sydney Smith, by those who have known those swells.'[6] (Theodore Hook and Smith were early nineteenth-century writers known for their wit.)

Du Maurier soon lost some of his enthusiasm for his roommate's skill as a raconteur. 'I have often heard,' Armstrong recollected, 'of how Whistler kept him awake far into the morning hours telling of the wonderful adventures he had during the day. After a while life with Whistler became impossible. He was so inconsiderate.'[7]

Those less closely associated with him didn't mention inconsiderateness. Nor did anyone find him to be quarrelsome or aggressive. Everybody spoke well of him.

The versatile painter George Boughton, Whistler's contemporary, recalled the early sixties as 'the real "Jimmy period." He was at his very best, lavishing on his friends his most sunny and affectionate nature.'[8] Another artist, Arthur Severn, remembered him as a dining-room entertainer:

Towards the end of the evening, there were yells and shouts for Whistler, the eccentric Whistler! He stood on a stool and assumed the most irresistibly comic look, put a glass in his eye, and surveyed the throng, who only screamed and yelled the more. When silence reigned, he began to sing in the most curious way, suiting the action to the words with his small, sensitive hands. His songs were in *argot* French, imitations of what he had heard in low cabarets on the Seine.[9]

His performances occurred most memorably in the Brixton home of the wealthy merchant Alexander Ionides, father of Luke Ionides, whom Whistler had known in Paris. Du Maurier called the Ionides family 'very useful acquaintances,' which Whistler had already discovered. In Paris he had painted a portrait of Luke, commissioned by his father. Now in London, Du Maurier reported, he became

'the pet of their set,'[10] because his stories had everyone howling with laughter. In Brixton he was rarely serious.

Once, apparently only once, at the Ionides home, Whistler was drunk, and he put on the hat of a young woman from a wealthy family, Rosa Major. When he returned the hat to her, she detected what appeared to be saliva.

'You may keep the hat,' she said. 'Someone spat in it.'

'By Jove, Miss Major,' Whistler answered, 'if that's how things are to be obtained from your family, I only regret I didn't spit into your hand!'[11]

<div align="center">* * * *</div>

The Ionides circle had not led Whistler to forget Legros and Fantin-Latour. Late in 1859 he paid a flying visit to Paris and invited them to London, where he said much money could be earned. Legros left at once, began working in Whistler's studio, and obtained some good commissions.

Whistler then wrote to the melancholy Fantin,

> My dear child, for you are a child! To think that you are unhappy over a pile of cretins! My friend, let yourself go. Sneeze on the whole world, and shake it off! You can be rich and surrounded by all the luxury I know you dream of. Come, Fantin, come! come! come! The brother-in-law [Haden] will send you money. You have reproduced other people's masterpieces for small sums long enough. Simply come straight to my place. You will find everything to continue the profit and wealth that have already begun for you. [A reference to several commissions that Whistler had obtained for him.] Everything waits for you, easel, color box, everything! I am not exaggerating when I say that Alphonse [Legros] does not put his brush onto a canvas without making a thousand francs! Never under 800! The same for me!! In three or four weeks he has made eight thousand francs!!! Dear Fantin, it can be the same for you! Write to say that you are coming! I will meet you at the station.* [12]

Whistler's generosity with friends was limitless. But helping others gratified his own ego. When impoverished companions visited households like those of the Haden and Ionides families, and received liberal commissions, they were demonstratively grateful to the man who had provided them with the all-important introductions. A more untainted munificence was Seymour Haden's. He sent passage money to Fantin, and perhaps Legros, and provided them, and Ernest Delannoy, with temporary living accommodations. He bought their pictures – originals and copies – and introduced them to other patrons. His actions were those of a man genuinely interested in helping the young and gifted. (Legros became a permanent resident of London, but Fantin, after one enjoyable and profitable summer, in 1860, returned to Paris.)

During the latter half of 1860, after Fantin had ended his London visit,

Whistler was often absent from Newman Street, sometimes leaving Du Maurier alone for prolonged periods. Where had he gone? Where else but along the river. He was staying in the least refined section of the metropolis, the dock area of Wapping and Rotherhithe.

The docks provided a striking contrast to the genteel area where Whistler played, sang, and joked. Even Du Maurier, his most cosmopolitan, least conventional associate, was startled by his action. In October 1860 he told his mother that Whistler was 'working hard and secret down in Rotherhithe, among a beastly set of cads and every possible annoyance and misery,' but 'no difficulty discourages him.'[13]

Rotherhithe, on the Surrey side of the river, and Wapping, on the opposite bank, were then associated only with shipping. They serviced the port of London, which extended four miles below London Bridge and accommodated more than two thousand ships. The two communities were joined by the Thames Tunnel, built in 1843 for pedestrians and carriages and now used by the Metropolitan line of the London Underground.

After staying briefly in Wapping, Whistler went across to Rotherhithe and moved into the three-story Angel Inn, where his room with a balcony overlooked the river. His fellow residents were mariners and bargemen. (He continued to pay his share of the rent in Newman Street, which he visited regularly.)

No place was more historically bound to the Thames than Rotherhithe, which for centuries had been preoccupied with shipping. In 1860 it was an insular borough of 25,000, rarely penetrated by outsiders. Rotherhithe and Wapping were virtually unknown to 'respectable' Londoners, who, someone said, were 'better acquainted with the canals of Venice than the banks of the Thames.'

Strangers in the dock area, even someone as perceptive as Nathaniel Hawthorne, generally saw only superficialities. Hawthorne came by on a river boat in 1863 and described the shore as 'lined with the shabbiest, blackest and ugliest buildings that can be imagined,' and Wapping as 'mean, shabby, and unpicturesque.'[14]

'Who says all of this is ugly?' Whistler might have replied. Perhaps he remembered Anna Jameson's observation that 'beauty lies wherever one looks.' Establishing a pattern for his future career, he found inspiration in his immediate surroundings. He wandered pleasurably along wharves and poked into muddy alleys where no proper Londoner would be found dead or alive. He examined warehouses, taverns, barges, and deep-sea vessels. An Englishman writing in the sixties said, 'Thousands on very low rungs of the social scale would think hell had begun on earth if they were compelled to live a month in the dock area,'[15] but Whistler loved it. He was totally immersed in this vividly exciting manifestation of modern life.

* * * *

As in Paris, Whistler in London began his serious artistic work with a needle. He produced *A Series of Sixteen Etchings on the Thames and other Subjects*, popularly called *The Thames Set*.

These etchings, presenting a picture of life 'below bridge,' form a genuine set (although not issued as a group until 1871). Showing the influence of Courbet, they are filled with realistic details of people, places, and things: warehouses, jetties, sheds, piers, balconies, quays, landing steps, gazebos, masts, and rigging; bargemen, ship chandlers, warehousemen, boat builders, Thames police, ancient mariners, young sailors, corn-porters, and wherry-men.

'Sergeant Thomas has bought Jimmy's etchings,' Du Maurier wrote later in this summer of 1860, 'and is exhibiting them – he does all the printing and advertising and gives Jimmy half.'[16] A barrister who owned a print shop in Old Bond Street, Thomas had reprinted *The French Set* and was now selling the Thames etchings for one and two guineas each. They weren't best sellers – no etchings are – but they gave Whistler added recognition.

Before he had met Whistler, the young critic William Rossetti, brother of painter–poet Dante Gabriel Rossetti, saw these etchings and praised their 'marked propensity for shore-life, river-life, boat-life, barge-life.' It was ironic, he said, that the artist who perceived 'the opporunities which the Thames offers to art should come from a birthplace across the Atlantic.' Rossetti prophesied that 'the fogs, beauties, and oddities of our river bid fair to become Mr Whistler's *specialité*.'[17]

The Thames had already become Whistler's particular field of interest. Before finishing his etchings, he had started an important river painting, which he called *Wapping* and wrote about to Fantin: 'I would like to have you here to see a picture that I am counting on very much. It's from a balcony on the second floor [first floor, British usage], looking out on the Thames. There are three people, an old man, a sailor, and a girl,'*[18] whose mutual relationships, he said, would be ambiguous.

Whistler was attempting to recreate the bustle and excitement of the real scene. The figures would be seen against a background of boats and wharves, mast and rigging, which he told Fantin, had been 'boldly painted.'

Apparently recognizing the possibility of failure, he ended his letter by saying, 'Ssshh! Don't tell Courbet about it.'

This was the most formidable task he had yet undertaken. 'I wish you were here,' he told Fantin, 'so that we could discuss it.'* Others were there – his English friends and Legros, who sat for the sailor. But he didn't talk about the picture with them. His only confidant was Fantin.

Portraying the woman, a prostitute, was particularly demanding.

The girl [he said,] has a superlatively whorish air which is awfully difficult to paint. I have already painted her three times. Believe me, I have managed to put an *expression* there, a real expression. Ah! if I could only describe the head, and the hair, the most beautiful you have seen! It is red, *copper-colored* – everything one dreams of in a Venetian girl! with a golden skin and a fine expression, an air of saying to the sailor 'That's OK, old chap, I've had others!' She winks and makes fun of him. All of this is *against* the light and consequently in a half-tone, which is horridly difficult.*

Whistler's model for the prostitute was also his mistress, living with him in the Angel Inn, an Irish woman, Joanna 'Jo' Hiffernan, whom he had lately met in Newman Street, where her family resided at number 69. All we know about them is that Jo had at least one younger sister and a father who drifted from job to job.

It is surely not coincidental that Whistler's early liaisons – 'Fumette,' 'Finette,' and Jo – were with women from the underclass. (He made no effort to begin a serious relationship with anyone whom he met in Brixton.) They were undemanding and uncomplicated, and they did not require much of a commitment.

In some ways, Whistler's alliance with Jo resembled that of Dante Gabriel Rossetti and his long-standing mistress, Lizzie Siddal, although Jo, unlike Lizzie, was neither neurotic nor hot-tempered. Rossetti moreover eventually married his mistress. Whistler never even thought of marrying Jo, mainly because, like Rossetti, forced into matrimony after an intimacy of more than ten years, he was temperamentally unsuited for marriage. He was selfish and preoccupied with his own welfare, and, while always treating Jo with deference and courtesy, he would not take on marital responsibilities.

As for Jo, sympathetic, good-humored, and imperturbable, she enjoyed her free and easy life with Whistler and apparently never pressed the issue of legalizing their relationship. (In this volume, Jo is depicted in *Wapping*, *The White Girl*, and *The Little White Girl*.)

The sittings continued for *Wapping* through the winter of 1859–60, and for a while Whistler hoped to have it ready for a big summer show. Before the winter had ended, however, he realized that this would be impossible and made other plans for the coming season.

* * * *

He was always welcome in Sloane Street, so long as Jo wasn't with him, and early in 1860 at the scene of the *Piano* picture he completed his second major painting, *The Music Room*. (A multi-faceted artist, he could simultaneously work on river etchings, a Thames oil painting, and a Knightsbridge interior scene.)

The Music Room is an artistic cousin of *At the Piano* but goes further in the direction of 'modern art.' *At the Piano* has some narrative content, but *The Music Room* has none at all. A woman in a riding costume stands on the right. Behind her a girl sits reading a book. A mirror on the left reflects a young woman's face. (The face was Deborah's; the girl was Annie; and the standing woman was a family friend.) Originally the picture was titled *Morning Call*; altering this removed any suggestion of narrative content. A fine scheme of colors and spatial patterns, it was also Whistler's most highly detailed painting. His practice of reproducing everything he saw on the river carried over to Sloane Street.

As a middle-aged woman, Annie recalled sitting for *The Music Room* and remarked on what would be her uncle's lifelong rapport with children:

> It was a distinctly amusing time for me. He was always so delightful and enjoyed the 'no lessons' as much as I did. One day I got tired and suddenly dissolved into tears, whereupon he was full of the most tender remorse and rushed out and bought me a lovely writing set, which I am using at this very moment! We were always good friends, and I have nothing but the most delightful remembrance of him.[19]

Before he had finished his second Sloane Street painting, the first one was accepted for hanging at the Royal Academy.

<p style="text-align:center">✳ ✳ ✳ ✳</p>

Founded by Royal Charter in 1768, the Academy included forty full members – painters, sculptors, and engravers – Royal Academicians entitled to have 'R. A.' after their names, and twenty associates, 'A. R. A.'s,' from whom vacancies among the R. A.'s were filled. To become an R. A. was to gain Britain's supreme artistic honor. When Whistler arrived in London, the Royal Academy was at the height of its power and prestige. There were other art societies but no real rival. London had many exhibitions but only one Exhibition, until 1869 in the National Gallery building in Trafalgar Square, beginning on the first Monday in May and ending on the last Saturday in July.

The ostensible purposes of the Exhibition were to provide exposure for the best contemporary art, and, with an entrance fee of a shilling, to gain revenue for the Academy. Its real importance went well beyond these goals. The flavor of mid-Victorian Exhibitions may be savored from a piece by the popular and prolific novelist–essayist Margaret Oliphant:

> No public event creates so much interest as the opening of the Royal Academy Exhibition. From all corners of the country people rich enough to pay a yearly visit to London reckon this one of the inducements, and even the hastiest excursionist

thinks it necessary to glance at the 'pictures.' No book receives the attention and public notice which the Exhibition does. At every dinner table during the season it is in everybody's mouth. From ten till six the rooms are thronged with an eager crowd placidly enduring dust, heat, and fatigue because the Exhibition is an act of faith. To miss it would be worse than many a little moral peccadillo. A certain latitude may be allowed about going to church, but not about going to the Academy.[20]

As for the show itself, the R. A.'s were more tolerant than their French counterparts. The selecting and hanging were done by a Council of eight members, four of whom retired each year not to return until every other member had served. A constantly changing body was more likely to accept innovative works than a permanent one, as at the Salon. Although inevitably there were complaints about rejected and badly hung pictures, the Royal Academy was probably more impartial than any other similar organization.

In 1860 the Academy decided to accept fewer entries than usual – about 1100 instead of the customary 1500; thus, as the *Morning Post* observed, pictures would not be 'piled on top of another from floor to ceiling, with many beyond the vision of any animal with a shorter neck than a giraffe's.' Fewer admissions meant more rejections, but this did not affect Seymour Haden or James Whistler.

In order to separate his hobby from his profession, Haden used the pseudonym 'H. Dean' and submitted two etchings, both of which were accepted. Whistler offered *At the Piano*, along with five etchings, and all were taken.

Whistler's well-hung painting was praised by numerous artists. Holman Hunt, rarely enthusiastic about anyone else's work, called it 'a striking example of frank manipulation and wholesome but not exhaustive colour.'[21] When Hunt's fellow Pre-Raphaelite John Everett Millais was introduced to Whistler at a party, he exclaimed, 'I am very happy to know you! I never flatter, but I will say that your picture is the finest piece of colour that has been put on the walls of the Academy in years.'[22] And George Frederick Watts said simply that 'as far as it goes, it is the most perfect thing I have ever seen.'[23]

Another painter who was struck by *At the Piano*, even before the show had opened, was John 'Spanish' Phillip, R. A. Phillip, who had acquired his nickname after visiting Spain and painting pictures in the spirit of Velasquez, was the royal family's favorite artist. He had sold four paintings to the Queen, and at the current Exhibition his principal entry was *The Marriage of the Princess Royal*.

Phillip visited Whistler at his home in Newman Street.

'I really like your painting,' he said.

'Thank you very much,' Whistler replied, overwhelmed.

'I would like to buy it. What is your price?'

'I don't know about things like that, Mr Phillip. I will leave it to you.'[24]

John Phillip took out his billfold and handed over 30 pounds. He could afford it. Recently he had sold a dozen Spanish paintings for £20,000.

* * * *

Daily papers and weekly journals covered the Exhibition thoroughly, but space was never available for more than a small fraction of the works on display. An unknown artist's first entry was rarely noticed. And yet *At the Piano* was mentioned, and mentioned favorably, by almost everyone. Three years later the *Morning Herald* looked back and recalled Whistler's debut as 'a sensation.'

The *Athenaeum*, one of the two most influential reviewing publications, lauded the picture's form, its design, its 'splendid power of composition,' and, most particularly, the artist's 'genuine feeling for colour.' The painting demonstrated 'a just appreciation for nature that is very rare.'

The critic for the other potent molder of opinion, *The Times*, was 'reminded of Velasquez.' Like the Spanish master, the young American had achieved a 'powerful effect' with the 'simplest materials' and 'produced what we are inclined to think the most vigorous piece of colouring in the exhibition.' The writer said that 'if this work be a fair result of Mr Whistler's own labour from nature, and not a transcript or reminiscence of some Spanish picture, this gentleman has a future before him.'

'We were amazed,' Thomas Armstrong said, 'at Whistler's sudden and unexpected success.'[25] The British students in Paris, George Boughton reported, 'were much surprised to hear that the Girl at the Piano had been purchased by John Phillip, R. A., and was making a talk in the big city.'[26]

* * * *

Before the Exhibition had closed, Whistler received news that his brother, having graduated from medical school, was a resident physician in Philadelphia and engaged to a woman from Virginia. He also learned that delegates to the Republican Party's national convention in Chicago had chosen Abraham Lincoln as their presidential candidate. If Lincoln were elected, the Southern states almost certainly would secede from the Union, and secession meant civil war. How might this affect a young American with three years of military training, who had sworn allegiance to the United States of America but sympathized with those who might start a rebellion against the United States?

* * * *

Whistler dismissed from his thoughts all faraway matters and concentrated on his art. With checks from George and 'loans' from Winans and Harrison, he could work as he pleased.

'I envy you,' Du Maurier said to him. 'You can do anything you like to do. My subjects are cut out for me.'[27]

He could afford to continue with his unremunerative etching. In 1860 he completed *The Thames Set* and met an 18-year-old 'printer's devil' who would become a frequent printer of his plates, Frederick Goulding, from a third generation printing family. When Whistler appeared at the shop in Gate Street, Lincoln's Inn Fields, Goulding was assigned to him. Whistler placed his etchings on a table top, and Goulding prepared to 'prove' them, that is to take and examine the first impressions, called 'proofs.' To his surprise, the little man in the slouched hat 'insisted on "proving" his own plates.' Goulding mixed the ink, handed over paper, turned the press and 'watched keenly the handiwork of this artist who insisted on occupying himself with the printer's business.'[28]

In addition to *The Thames Set*, Whistler had brought several other etchings, including *The Miser, Soupe à Trois*, and, most notably, *Annie Haden*.

Annie Haden presents Whistler's eleven-year-old niece, hair falling about her shoulders, in a round hat, long cape, and full skirt, standing in slippers on a patterned carpet in front of a curtain. Her delightfully saucy expression ever so slightly reflects her impatience and anticipates the great oil painting of the seventies *Cicely Alexander*. James Laver, who was not given to extravagance, called it 'one of the great portrait etchings of the world.'[29] Whistler himself late in life told Edward Kennedy, compiler of the definitive portfolio of his etchings, that 'if he had to make a decision as to which of his plates was the best, he would rest his reputation upon "Annie Haden."'[30]

Annie Haden was signed 'Whistler 1860.' Another current work may be more precisely dated, the painting *Thames in Ice*, originally called *The Twenty-fifth of December 1860, on the Thames*. This bleak picture of men working on an anchored ship in the ice-bound river was done in three days, one of which was Christmas. Painted from Whistler's balcony at the Angel Inn, it contrasts strikingly with his other river work and with *Annie Haden*. The Thames etchings and *Wapping* are lively and buoyant, *Annie Haden* is cheerful and happy, but *The Thames in Ice* sets forth a scene of unrelieved gloom. The Pennells said that 'for an idle apprentice it was a curious way of spending Christmas Day.'[31] It might also seem like a curious subject for the most festive day of the year. Actually Whistler was not inclined to celebrate a holiday. He had lately received disastrous news from America. Abraham Lincoln had been elected as the sixteenth President of the United States, and the slave states were preparing to secede from the Union.

Indeed, although Whistler didn't know about it, South Carolina, as a protest against Lincoln's election, had already adopted an Ordinance of Secession. What could follow secession but war, Americans fighting against Americans on American soil? It is no wonder that a young man who almost became an American army officer preferred the Angel Inn to Sloane Street. His feelings

explain the rapidity with which he dashed off the painting and then got rid of it. He sold it to Haden for the absurd price of ten pounds. He was in no mood to haggle.

<center>* * * *</center>

Because of his preoccupation with overseas events, Whistler produced almost nothing during the early months of 1861, and for the R. A. Exhibition he followed up his success of 1860 by submitting his Parisian portrait *La Mère Gérard*.

One-tenth the size of *At the Piano*, *La Mère Gérard* got less than one-tenth the attention of the earlier picture. Two reviews briefly mentioned it. The *Athenaeum* found 'admirable qualities of real art,' but the *Telegraph* deemed it 'fitter to be hung over a studio stove than at the Royal Academy.'

If Whistler saw the *Telegraph*, he couldn't have been greatly affected. Too much had been happening overseas for him to be concerned about a reviewer. By the end of January seven states had seceded, and early in February, calling themselves the Confederate States of America, delegates formed a provisional government and elected a president, Jefferson Davis. A month later came the inauguration of Lincoln, who still hoped for peace. For about six weeks, although four more states seceded, the situation was relatively calm, and then in mid-April the rebels bombed Fort Sumter, in Charleston harbor. The point of no return had been reached. Shelling Fort Sumter meant war.

The early war news had to be painful. Maryland, a non-seceding slave state, was the site of the first hostilities. Massachusetts soldiers passing through Baltimore angered some residents, resulting in bloodshed and the stationing there of occupation troops. Whistler must have speculated on what was happening in his favorite American city. Then came more personal news. His brother, encouraged by his Virginia wife, had become a medical officer in the army of the Confederacy.

Early in June, Whistler collapsed, and for more than a month he was bedridden in Sloane Street, attended to by a full-time nurse under the supervision of Haden's associate, James Traer. This illness has never been satisfactorily diagnosed. Du Maurier, who was convinced that he would die, thought it had resulted from the dampness of the Thames, but it may have been more psychological than organic, arising from feelings of guilt that a West Pointer should be living comfortably in London while his brother was a uniformed officer on active duty.

In any event, after he had spent many weeks in bed, he needed a holiday, and early in autumn he and Jo left for the coast of Brittany.

10

'The White Girl'

[1861–62]

As the prelude to a winter in Paris, Whistler and Jo stopped briefly in Brittany, just long enough for him to complete two pictures. One, an etching called *The Forge*, shows the inside of a blacksmith's shop and would be included in *The Thames Set*, even though it has nothing to do with the river. More important was an oil painting, *The Coast of Brittany*.

Realistically depicting a rocky beach, blue sky, white clouds, and, among the rocks, a sleeping peasant woman, *The Coast of Brittany* is Whistler's most literal transcription of a scene in nature. But it is more than that.

Partly because of his nearsightedness, Whistler had no interest in landscape as such. 'You do not suppose,' he wrote to a friend from a rural locale, 'that I *look* at the *landscape* of the place. No, never for more than an hour a day! Very often not at all.'[1]

His main interest in landscapes, as in all of his pictures, was to arrange the details properly. Because he felt that he had admirably succeeded in *The Coast of Brittany*, it would always be one of his favorites. Du Maurier told his brother, 'There is not one part of the picture with which he is not thoroughly satisfied.'[2] Thirty-seven years later his feelings hadn't changed. He called it 'a beautiful thing.'[3]

After *Brittany* was finished, he and Jo left for Paris.

<p style="text-align:center">✳ ✳ ✳ ✳</p>

Even if he had shunned newspapers, Whistler could not have escaped the American conflict; his mother's letters were loaded with war news. In one of them she described the horrors of the first battle of Bull Run, a Confederate victory, demonstrating that the war would not be short. In another, she said that William's wife had 'made him a thorough secessionist,' but, surprisingly, she herself was neutral: 'Truly *I* know no North, *I* know no South.'[4]

While William was a warrior in America, his brother, never previously in a

fight, became a belligerent in Paris. He was walking in a narrow street, and a worker on a ladder dropped plaster on him. He didn't wait for an explanation. He punched out the plasterer, for which he was fined by a magistrate.

Shortly afterwards he quarreled with Ernest Delannoy, his companion on the Alsatian trip, with whom until that moment he had not exchanged a cross word.

<p style="text-align:center">* * * *</p>

Whistler avoided the left bank because, Du Maurier said, he was 'no longer Bohemian.'[5] He and Jo settled on the Boulevard des Batignolles, in Montmartre.

After his initial pugilistic endeavor, he was ready to concentrate on his work. With Jo as his model, he began.

The idea for it almost certainly came to him soon after settling in London.

In the Victorian period, novels by well-known writers usually were first published serially in magazines. The initial installment of one of the best-known works, Wilkie Collins's *The Woman in White*, appeared on 26 November 1859 in *All the Year Round*, a journal edited by Dickens. From the beginning this suspense story was enormously popular. Every Saturday morning, publication day, crowds formed outside the magazine's Wellington Street office to snatch up the latest copies as soon as they were available. During the week a widely played parlor game was one in which the object was to guess the contents of the next installment.

Late in 1860, the serial ran its course, and *The Woman in White* became a two-volume hardback and an instantaneous best seller. A perfume, cloaks and bonnets, and a quadrille were soon named after it.

Whistler was living in London while this was going on, and surely he saw copies of the familiar *All the Year Round*, edited by the author whom he preferred above all others. If, as is probable, he read the opening segment, this is what he encountered on the first page:

I was strolling along the lonely high-road [from Hampstead to London at one a. m.], when in one moment every drop of blood in my body was brought to a stop by a touch of a hand laid on my shoulder from behind.

I turned, with my fingers tightening on the handle of my stick.

There in the middle of the road stood a solitary woman, dressed from head to foot in white garments, her hand pointing to the dark cloud over London.

'Is that the road to London?' she asked.

I looked attentively at her. All I could discern by the moonlight was a colourless, youthful face, meagre and sharp to look at, about the cheeks and chin; large, grave wistfully-attentive eyes; nervous, uncertain lips; and light hair of a pale, a brownish-yellow hue. There was nothing wild or immodest in her manner: it was quiet and self-controlled, a little melancholy, not exactly that of a lady, and at the same time not that of a woman in the humblest rank of life. What sort of

woman she was, and how she came to be there an hour after midnight, I altogether failed to guess.

The picture that Whistler began in Paris was to be a life-size, full-length portrait of a young woman dressed entirely in white, gazing cryptically at the viewer, and it would be called *The White Girl*. She was, it is fair to say, inspired by, rather than an incarnation of, Wilkie Collins's heroine. Instead of the Hampstead high road, she stands indoors on a white skin in front of a white curtain. In Whistler's hands the painting had become his own work of art, a study in 'white on white,' which in 1862 was quite extraordinary.

Through the winter he spent every day from eight in the morning until late afternoon on this large work, until, early in April, he and Jo returned to London, where he expected his creation to hang at the Royal Academy.

<center>* * * *</center>

Whistler arrived a few days before the deadline for submissions to the R. A., with *The White Girl* still unfinished. Even so, he found time to write to Edwin Edwards, a Middlesex solicitor and art patron, on behalf of Fantin-Latour. Already upon Whistler's recommendation, Edwards had bought several examples of Fantin's specialty, flower pictures, and now he was asked to submit one of them to the Exhibition so as to enhance Fantin's reputation. He wrote from 62 Sloane Street, where he was staying, without Jo, still on excellent terms with Haden. This was the year of London's second International Exhibition, and Haden, a juror for the British section of fine arts, had virtually hand-picked four plates from *The Thames Set*.

After three days in Sloane Street, Whistler rejoined his mistress. But not in Rotherhithe. After a winter in Paris, she could hardly live along the docks. In February she and Whistler had briefly visited London, and according to Du Maurier she was 'got up like a duchess – the mere *making up* of her bonnet by Madame somebody or other cost 50 fr.'[6] Du Maurier called her an 'insufferable' woman playing the role of a '*grande dame*.' A *grande dame* obviously couldn't be seen in the Angel Inn, and so she and Whistler settled in Chelsea, in a brick cottage in the Queen's Road (now the Royal Hospital Road).

<center>* * * *</center>

The R. A. show of 1862 was not outstanding. As the *Illustrated London News* observed, it contained 'very small leaven of invention, few original thoughts, and little elevation of aim.' The reviewer added that 'this year the greatest artistic achievements are elsewhere.'

Art was indeed thriving beyond Trafalgar Square. A Haymarket gallery charged one shilling, which 86,000 people would pay, to see one picture, William Frith's panoramic view of the new terminus at Paddington, *The*

Railway Station. On Berners Street, another one-picture exhibition spotlighted Millais's *Carpenter Shop*, which 12 years earlier the *Athenaeum* had denounced as a 'pictorial blasphemy.' Nearby, Matthew Morgan's Berners Street Gallery was holding its first show. The principal work was listed in the catalogue and in the gallery as *The Woman in White*.

Yes, Whistler's *White Girl* had been rejected by the R. A. His other entries – *The Thames in Ice*, *The Coast of Brittany*, and the etching *Rotherhithe* – were accepted and politely received. But all of them together meant less to him than the big one. He had been apprehensive about it, afraid; Jo told an American friend in Paris, George Lucas, that 'the old duffers may refuse it' because 'some stupid painters don't understand it.'[7] Perhaps more to the point was its size. Seven feet by three and a half, it needed two and one-half times the wall space of *The Coast of Brittany* and nearly six times that of *The Thames in Ice*. That was a big area for a single figure arrangement of white on white. And so its rejection is not surprising.

As he had done three years earlier in Paris, Whistler went to a small independent gallery. In June he told Lucas that 'the white child looks grandly in her frame and creates an excitement in the Artistic World which the Academy did not foresee. In the catalogue it is marked "Rejected at the Academy." What do you say to that! Isn't that the way to fight 'em!'[8]

Actually far from causing a stir, the picture was noticed by just one principal journal, the *Athenaeum*.

A minor member of the Pre-Raphaelite Brotherhood, F. G. Stephens was in his second year as the *Athenaeum's* principal art critic, and he had not yet met Whistler. In his 'Fine Arts Gossip' column for 28 June 1862, he mentioned the Berners Street Gallery.

> The most prominent work on display is a striking but incomplete picture, *The Woman in White*. Able as this bizarre production shows Mr Whistler to be, we are certain that in a few years he will recognise the reasonableness of its rejection by the Academy. It is one of the most incomplete paintings we ever met with. It is simply a woman in a quaint morning dress of white, with her hair about her shoulders, in a background of nothing in particular. The face is well done, but it is not that of Mr Wilkie Collins's 'Woman in White.'

Whistler responded in a way that would become characteristic. At once he wrote a letter to the *Athenaeum* and generated his first mini-controversy. Somewhat disingenuously, he said that the title had been attached by the proprietors of the gallery without consulting him. He also seems to have trifled with the truth when he asserted, 'I had no intention of illustrating Mr Wilkie Collins's novel, which I have never read. My painting simply represents a girl in white standing in front of a white curtain.'

Whistler's letter was published on 5 July. Two weeks later the *Athenaeum* issued a reply from the manager of the Berners Street Gallery: 'Mr Whistler was well aware of his picture being advertised as "The Woman in White" and was pleased with the name because it seemed apt for the figure of a female attired in white, with a white background.'

<p style="text-align:center">*　　*　　*　　*</p>

In Paris during the summer of 1862, the Martinet Gallery, on the Boulevard des Italiens, owned by the painter–etcher Louis Martinet, was holding the first public showing of *The Thames Set*. No less a person than Charles Baudelaire saw and liked the prints. He called them 'subtle and lively as improvisation and inspiration, representing the banks of the Thames; wonderful tangles of rigging, yardarm, and rope; farragoes and intricate poetry of a vast capital.'[9]

Perhaps because he was constantly affected by events overseas – on 1 June, Robert E. Lee became commanding general of the Confederate forces – Whistler reacted unreasonably. He told Fantin, 'They write better articles in London! Baudelaire says many poetic things about the Thames but nothing about me or my etchings.'[10]

He received no sympathy from Fantin, who said simply that any artist should be grateful for appreciation from an important writer.

<p style="text-align:center">*　　*　　*　　*</p>

If this summer was artistically vexing, it was also a happy period, when Whistler became friendly with the Dante Gabriel Rossetti circle. After his wife's death in February 1862, Rossetti left their Blackfriars flat, and in October he moved into Tudor House, 16 Cheyne Walk, Chelsea. Already he and Whistler were acquainted with one another. On 28 July 1862, Rossetti's friend George Boyce mentioned in his diary a housewarming party at 77 Newman Street for Rossetti's disciple Algernon Swinburne: 'Spent the evening at Swinburne's. Present: D. G. Rossetti, Whistler . . . Whistler gave humorous vent to a lot of comic stories.'[11] Ten days later Boyce wrote, 'Went to Whistler, 7a Queen's Road Chelsea. Found there Gabriel Rossetti, Swinburne . . . Whistler's "Joe" was present, a handsome girl with red hair and altogether fine colour.'

For nearly ten years Whistler and Rossetti saw each other constantly, sometimes on a daily basis, and although neither man was easy to get along with they never had an altercation. Actually at this time none of Whistler's friends found him to be quarrelsome or belligerent. Years later William Rossetti remembered him as 'a most amusing talker and pleasant companion, full of good-humoured genial *camaraderie*,' who 'never exhibited any short temper or readiness at taking offence.'[12]

Various cross-currents of influence passed between Whistler and the Rossetti coterie. Among his new friends, the one most strongly affected by his ideas was

<p style="text-align:center">93</p>

the impressionable young poet Swinburne. At this time Whistler was almost a soapbox orator on the subject of 'pure art,' and Swinburne was a good listener, as he demonstrated in the 6 September 1862 issue of the *Spectator* with an unsigned review-essay, 'Charles Baudelaire: *les Fleurs du Mal*.' In the opening paragraph Swinburne said,

> The poet's business is to write good verses, not to redeem the age and remould society. The courage and sense of a man who professes and acts as if the art of poetry has absolutely nothing to do with didactic matters are proof enough of the wise and serious manner in which he is likely to handle the materials of his art.

Replace 'poet' and 'poetry' with 'painter' and 'painting,' and these lines might have come from James Whistler.

In 1862 Whistler briefly worked in a medium that could hardly have been farther removed from the doctrine of art for art's sake. In a letter to Edwin Edwards, he said, 'I've been guilty of something in Once a Week !!!!'[13] He was referring to a popular magazine which had lately used several of his drawings to illustrate a story. This was the golden age of illustrations, when virtually every artist was doing them, usually for nine pounds a picture.

The 1862 volume of *Once a Week* – one volume of one periodical – contains 27 illustrations by Charles Keene, 23 by George Du Maurier, 23 by John Everett Millais, seven by Edward Poynter – and four by James Whistler, female, single-figures. He did two others for another magazine, *Good Words*, but like Rossetti, who rarely illustrated, he had too much creative originality for this kind of work, and too much self-respect to toil solely for pecuniary rewards, and his six drawings of 1862 constituted all of his work in this genre.

The £54 Whistler received for illustrations augmented his relatively healthy finances, and in October 1862 he and Jo left for Spain, supposedly to view the work of Velasquez in Madrid.

> I will be the first one to look at him for you, [he told Fantin.] I will tell you all about it. If there are photographs to be had, I will bring some back. As for sketches, I hardly dare attempt it, but if I have the nerve, I may try. You know, that glorious painting cannot be copied. Oh, mon cher, how he must have worked. *[14]

He and Jo went by train to Southampton, crossed the Channel to Cherbourg, and then travelled to Biarritz, within ten miles of the Spanish border – where they stopped.

After passing over the border for part of one day, Whistler told Fantin, 'Yesterday we were in Spain, yes, mon cher, in Spain! In a ravishing little gem

of a town. But it is *impossible* to stay there without speaking Spanish or Basque! *No one* understands *a single word* of French!* [15]

Ostensibly because no one spoke French or English, he returned to Biarritz and never again set foot on Spanish soil.

After the brief incursion into Spain, he remained in Biarritz for a holiday that was not very enjoyable. He almost drowned, and artistically he was exasperated. 'I have had awful luck,' he told Fantin. 'Rain, rain, and more rain, or the stupid sun without any reflection and a sea so flat you want to spit in it. I am almost demoralized.'* On another day he complained, 'I am languishing horribly. The weather is diabolical. Each time it rains I must wait three days for the soil to dry before working. What luck! Ah, the countryside! The big canvas goes so slowly I am despairing.'* [16]

His confidence in memory painting was reinforced:

My picture drags. I do not work fast enough! Moreover painting from nature can only be large sketches. It does not work. A wave or cloud is there for one minute and then is gone. You must catch it in flight as you kill a bird in the air – and then the public asks for something finished.*

It is foolish, he said, to go away to paint: 'Precious time is wasted. There is the arrival in an unknown country, models to train, natives who pose only with much coaxing, and weeks pass before the painting is in the works. In the future, I shall swim in closer waters.*

This suggests that all along his goal had been the sea of Biarritz.

Whistler did not complete his large painting, about which we know little, but he finished a small oil, *The Blue Wave: Biarritz*, a return to realism. A sequel to *The Coast of Brittany*, it shows two large waves beneath a grayish sky breaking on a rocky shore. Everything bespeaks Courbet's influence. Whistler, indeed, sometimes called it 'my Courbet.'

After a few weeks in Biarritz, with one small picture, he was happy to leave. Before departing, he gave Fantin a creative reason for not going on to Madrid:

I am postponing my trip until next year, and then you will come with me. It will be our greatest happiness! It will be a sacred pilgrimage, and nothing must stop us. Think of the fun we'll have examining those masterpieces together. That is a thousand times better than going alone! Let's swear on it.* [17]

Neither separately nor together did they ever go to Spain, and it is doubtful if Whistler ever again mentioned the projected trip.

His real reason for avoiding the Prado Museum in Madrid may have been a fear of being too greatly influenced by Velasquez. He had seen paintings by the Spanish master in the Louvre, in the National Gallery, and at the Manchester

Exhibition, and perhaps that was enough. Going to the Prado might have jeopardized his own individuality.

As a footnote to the Biarritz trip, one letter to Fantin ends, 'Your devoted friend Jim McN. Whistler.'*18 Since Fantin must have known what 'McN.' stood for, the name may have been annexed during the preceding winter in Paris. The tentative adoption of 'McNeill' at this time was probably prompted by feelings of guilt for being a passive bystander to events in America. The McNeills had been warriors, and if he couldn't be a fighter, he could at least have a fighting name.

Returning to London, he was in a transitional state between James Abbott Whistler and James McNeill Whistler.

<p style="text-align:center">* * * *</p>

Whistler and Jo stayed temporarily near Westminster Bridge. The stone structure immortalized by Wordsworth was being replaced by a nearly finished iron span. For Whistler the scene was meaningful, and he arranged to use the river-front studio of the momentarily absent landscapist Walter Severn.

His new picture was called *The Last of Old Westminster*, a misnomer because the subject is the removal of the scaffolding from the new bridge. A realistic painting, it shows workers beneath a background of warehouses, domes, chimneys, and the trees of Lambeth Park (all of which would be obliterated by the construction of St Thomas's Hospital).

Walter Severn's younger brother Arthur occasionally watched Whistler.

'It was most interesting,' Arthur said, 'to see him at work. He would look steadily at a bridge pile for some time, then mix up the colours, and then holding his brush quite at the end, with no mahlstick, make a downward stroke, and the pile was done.'19 (A *mahlstick*, usually spelled *maulstick*, is a stick used by painters as a hand rest while working.)

Arthur Severn added that 'Whistler was always most courteous and pleasant.'

He was courteous and pleasant because he was glad to be back in London.

And he was there to stay. Now for the first time in his adult life he would have a fixed place of residence. It was in Chelsea fronting the river above Battersea Bridge. His acceptance of a three-year lease, with an annual rent of £50, signified that at least for the time being his inner turmoil over events in America had subsided. He had decided to be an artist on the Thames.

11

Chelsea

[1862–64]

'The choicest bit of London,' American novelist William Dean Howells said of Chelsea in the early sixties.[1] At the same time the *Illustrated London News* called it the metropolitan area's 'most picturesque spot.' They, and other enthusiasts, did not refer to the whole borough of 63,000 people, not the King's Road, and certainly not the slums, of which Chelsea had some of the worst, with sordid lodging houses and pavements teeming with prostitutes. Chelsea's devotees raved about the river-front, the red-brick houses with white window frames and deep verandahs, behind small gardens and wrought-iron fences, only a few yards from the water.

The houses haven't changed much with the passage of time, but otherwise the scene is far different today from what it was in 1863. It was altered by the building of the embankment and the arrival of the automobile. When he made his move, Whistler knew that the setting would not for long remain untouched. Already Parliament had appropriated money for the embankment. But the English do not habitually move with haste, and for another decade his riverside would retain its pristine quality.

Whistler's new address was 7 Lindsey Row, which in 1878 was changed to 110 Cheyne Walk, a narrow, three-story house, thirty yards above Battersea Bridge, with a splendid upstream view of the river. Nearby, just beyond the bridge, was Tudor House, the home which Gabriel Rossetti shared with his brother and Swinburne. They liked Whistler, and they repeatedly praised his work, as, for example, on 1 February 1863, when Rossetti wrote to one of his patrons, Newcastle lead merchant James Leathart, about *The Coast of Brittany*: 'Whistler is willing to sell it for 80 guineas, a decidedly moderate price. I have such a hearty admiration for his style and use of nature that I suggest this purchase to you.'[2]

Leathart did not buy it, but Whistler was gratified by the encouragement he was receiving. Swinburne revered him as the world's greatest living artist.

97

Rossetti's friend the Pre-Raphaelite painter Ford Madox Brown echoed William Rossetti's commentary by calling *The Thames Set* the work of 'a great genius.' And F. G. Stephens, whom Whistler met at this time, promised to be helpful in the *Athenaeum*.

All in all, things looked good in Chelsea.

Whistler's new friends did not separate him from the past. He still occasionally saw Poynter and Du Maurier, and for a time his tenant at 7 Lindsey Row was Alphonse Legros. Late in March he and Legros went to Holland. Their travelling companion, and, probably, their benefactor, was Seymour Haden.

Before leaving, Whistler wrote to Fantin from '62 Sloane Street': 'My dear friend, I am coming! I am coming on Sunday. I am staying in Paris for one day. I'm bringing *The White Girl*! I shall unroll it and frame it in your studio, so we can see it together before sending it to the Salon. It will be such a great pleasure to consult you about it.'* 3

In Paris, he instructed Fantin to ask Martinet to exhibit it in the event of a Salon rejection.

From Paris he went to Holland, where he rhapsodised over Rembrandt's *Night Watch*, saw several of his own prints on exhibit in The Hague, did a fine maritime etching in Amsterdam, and had a delightful holiday, thanks to his brother-in-law.

Whistler returned in time for the R. A. Exhibition. Five of his etchings and *The Last of Westminster* had been accepted but were badly positioned. *Westminster* was down at the floor, but the critics found it and were generally patronizing. The *Spectator* called it 'a very good sketch,' *London Society* said it was a 'clever sketch,' and the *Morning Herald* saw 'a very slight sketch [which] represents the subject well.' The *Illustrated London News* said openly what the others had implied: 'Since the painter would have us believe he can do so well with so little pains, we think he would show more respect to himself, his art, and the public by trying to do better.'

The etchings were just below the ceiling in the worst of the galleries, the infamous Octagon Room, seemingly invisible to everyone but Stephens. 'If anything can match the injustice and absurdity of the placement of these marvellous plates,' he wrote, 'it would be for the Academy to ignore etching altogether.'

Stephens's quibbles didn't disturb anyone, and, artistically speaking, the summer of 1863 was quiet in London, quite unlike the state of affairs in Paris.

On 12 April, Parisians learned that three-fifths of 5000 paintings submitted to the Salon had been turned away, an action that some called 'a massacre.' Louis Martinet was deluged with requests from excluded artists, but his gallery was obviously too small for any really significant counter-action. Then, acting without precedent, Emperor Napoleon III announced the formation of a rival exhibition alongside the Salon which would be open to all of the rejected artists.

'This exhibition is enchanting for us!' Whistler wrote to Fantin, also a rejectee. 'Certainly I will have my picture there.'* 4 Most of the others were of the same mind, and 1200 artists, including Jongkind, Bracquemond, Legros, Pissarro, Manet, and Cézanne, were represented at what came to be known as the Salon des Refusés.

Financially, the show was a success, with as many visitors as the regular Salon. But most reviewers didn't take it seriously. Some just stayed away. Theophile Gautier wrote twelve notices on the Salon for the *Moniteur* but could not spare one word for the rejects. Those who did mention the exhibition were generally negative. Even Martinet, who might have been expected to be friendly, labelled it an 'exposition of comics.'

Surrounded by mediocrity, the few good works stood out. Among them, hanging prominently and impossible to overlook, was *The White Girl.*

Immediately after the opening, Whistler wrote to Fantin and asked if Gautier had liked it, if the *Gazette des Beaux-Arts* had referred to it, 'if Figaro had been good,' and if the café crowds were talking about it.

Fantin told Whistler that he 'had won a great success,'* 5 with 'the biggest sensation' of the show. This was not an overstatement. *The White Girl* was even more widely discussed than Manet's notorious *Luncheon in the Grass.*

> The whites are excellent, [Fantin said,] and at a distance (that's the real test) they are superb. Baudelaire finds it charming, exquisite, absolutely delicate. Legros, Manet, Bracquemond, De Balleroy all think it is admirable. You are now famous.* 6

Whistler was not really famous, but he had become well-known in Parisian art circles. Art criticism had a higher standing in Paris than in London, and unlike their British counterparts, French reviewers usually signed their pieces. And most of them loved *The White Girl.* The well-known revolutionary critic Étienne Thoré, who used the pseudonym Wilhelm Burger, said 'The image is rare and is conceived and painted like a vision.'* 7 Ernest Chesneau found 'superior picturesque qualities, an imagination filled with dreams and poetry.'8 Fernand Desnoyer called it 'vibrant and remarkable, one of the most original paintings in the show.'* 9 Paul Mantz said, 'Mr Whistler's work radiates a strange charm, and for us it is the choice specimen in the heretics' salon.'* And Louis Étienne, who denounced *Luncheon in the Grass,* challenged 'anyone even slightly imbued with artistic feeling not to stop and admire this austere young woman.'* 11

Whistler's triumph was noted on the other side of the Channel. He wrote to Fantin, 'Christ, if you could only see the effect of this novelty on the people here in London. They are all quite disgusted because *The White Girl* was so well accepted after being so poorly treated here.'* 12

This is a tacit admission that he had stretched a point when he told George Lucas that in London his painting 'creates an excitement.'

<center>* * * *</center>

Before that summer ended, Whistler was awarded a gold medal by the Academy of Fine Arts in The Hague for his etchings. He immediately told Stephens about it, and the *Athenaeum* alone reported the news. 'After the manner in which the etchings were hung here,' Stephens wrote, 'it is some consolation to know that their merit has been recognised in the country with the right to judge of such work [because of Rembrandt].'

<center>* * * *</center>

The Rossetti circle was pleased with Whistler's success. Two others who savored his good fortune were the brothers Henry and Walter Greaves.

Henry and Walter were sons of Charles Greaves, a prosperous boat builder, and the family lived a couple of doors away from the Whistler house in a milieu which, with water stairs, wharves, warehouses, and barges, was somewhat reminiscent of Rotherhithe. Although not a formally educated man, Charles Greaves encouraged a daughter to become a musician and his two sons to take up painting. The more talented of the two, Walter, created one minor masterpiece, the celebrated *Hammersmith Bridge on Boat Race Day*, owned by the Tate Gallery.

One day not long after he had moved onto Lindsey Row, Whistler stopped to watch the brothers sketching. After a few minutes, he invited them to 'come over and see my work.' They went, and at once, Walter said, they 'lost their heads over Whistler.'[13]

The Greaveses seized the chance to associate with an established artist, and he welcomed the annexation of his first satellites. They developed a camaraderie, but it was always understood who was the leader and who were the followers. The relationship was once described as 'the intimacy one sees between a master and his dog.'

They mixed his colors and stretched his canvases. They painted the inside of his house and, night and day, rowed him wherever and whenever he wanted to go. They did this for years without receiving so much as a shilling from him, but, Walter said, 'We didn't mind.'

Whistler's domination over the brothers was total. They even tried to look like him. They wore hats, ties, and gloves like his, and they grew little moustaches.

Walter recollected that Whistler was 'a rare fellow for music.' Sometimes he 'would have a passing hurdy-gurdy in the little garden in front of the house play for a quarter of an hour or so because he liked the sound,' and in the Greaves family home the brothers would often 'play the piano for hours while Whistler

<center>100</center>

danced.'[14] Occasionally he had dinner with them, and afterwards he would sing comic plantation songs.

When he was alone with Henry and Walter, Whistler frequently voiced his views on art and artists. Walter remembered in particular his unsparing comments on J. M. W. Turner, a former resident of Chelsea, for whom the senior Greaves had rowed on sketching excursions. Whistler had once idolized Turner but then came almost to hate his work, because, in his opinion, it didn't fulfill either the purely natural or the decorative requirements of landscape art. The Greaveses never heard him say anything good about Turner. Nor were they the only ones to whom he spoke out. Early in 1863, Du Maurier wrote to his brother about:

> a long discussion in which Jimmy pitched into Turner for being so particular about being mounted. [Murray] Marks [an Oxford Street art dealer] with great indignation said, 'Particular! Why he'd leave his pictures out to be pissed against!' Jimmy retorted, 'Well, that accounts for some of the damned peculiarities we have to swallow!'[15]

* * * *

In February 1864, George Boyce wrote in his journal, 'Whistler has begun two pictures of the Thames, very good indeed.'[16]

One of them was *Chelsea in Ice*, about which a house guest of his told a friend, 'During a very sharp frost of a few days, ice was passing as we looked out upon the Thames. He could not resist painting at the open window while I sat shivering.'[17]

The writer of these lines was Anna Whistler.

> All of a sudden in the middle of the affair, [Whistler had written to Fantin a few days earlier,] my mother arrived! General upheaval!! I had to empty my house and purify it from collar to attic, look for a *buen retiro* for Jo, an apartment for Alphonse [Legros], and to Portsmouth to meet my mother. If you could only see the state of affairs! Affairs! Up to my neck in affairs! *[18]

The most urgent of these affairs involved Jo, and not because she had to move into new lodgings. This was the worst of times for Anna Whistler to turn up. Joanna Hiffernan, it seems, was in an advanced state of pregnancy.

Jo's pregnancy has been a matter of speculation. Walter Greaves and one of his sisters said that she gave birth to a son during Whistler's residence 'at No. 7,' where he lived until early 1866.[19] Surely she became pregnant before Anna's arrival, and several signs point to 1863. What did Whistler mean by saying that his mother had come 'in the middle of the affair'? In the middle of *what* affair? Then there is an etching of late 1863, *Weary*, a full-length portrait of an

obviously fatigued Jo in an easy chair. Why was the woman who had stood tirelessly day after day for *The White Girl* now in a state of exhaustion? In February 1864 Du Maurier told his brother, 'Jim stands in mortal fear of Joe, and he is utterly miserable. I saw him lately and he wasn't very nice to me. I fancy that Joe is an awful tie.'[20] Was Whistler 'miserable' and Jo an 'awful tie' merely because she had to make way for Anna? If Jo was pregnant, everything – Whistler's panic, the oblique passage in the letter to Fantin, the etching *Weary*, and the treatment of Du Maurier – falls into a consistent pattern.

As for the child, a Greaves daughter said that 'a carriage came one day, and French nurse, baby and all, got in and went to Paris.'[21] She did not say where Jo had been living in London, nor where she would stay in Paris.

So little indeed was said, by Miss Greaves or anyone else, that I was the first writer, in *The Young Whistler*, to establish that in fact a child was probably born at this time. What happened to him or her? Who knows? Nowhere in Whistler's extant correspondence or his other writings, nowhere in the recollections of friends or acquaintances, is he or she mentioned. Whistler seems to have been totally disinterested in his offspring, and it is my guess, based solely on intuition, that the infant was given up for adoption in France.

<p style="text-align:center">* * * *</p>

Jo's putative pregnancy and his mother's arrival distracted Whistler only temporarily. Nothing could for long keep him from his work.

'He is so pressed for time,' Anna wrote, 'because of a picture now on his easel that he can neither read nor write for his mother.'[22]

This picture was the second of the two paintings of the Thames mentioned by Boyce. It had been commissioned by Alexander Ionides and was called *Old Battersea Bridge* (the first of two pictures with that title).

The Battersea Bridge of Whistler's tenancy at 7 Lindsey Row was a narrow wooden structure, almost a hundred years old. It had always been hazardous. People had fallen off because of inadequate railings, and boats and barges had struck its closely-set piers. Because of its dangers, there had been repeated calls for its replacement. But even if it had been safe, people would have demanded its demolition. Mid-Victorians called it 'an ugly edifice,'[23] 'one of the most horrible constructions imaginable,'[24] and 'a sad contrast to the elegant structures that now span the river.'[25]

James Whistler again saw beauty in what others found ugly. A follow-up to *The Last of Old Westminster*, this realistic representation of Battersea Bridge shows a group of watermen, a barrel-laden barge, the bridge itself with waggons, vans, and pedestrians, and, in the background, homes and factories of Battersea.

Some years later when it was to be replaced, a writer for an art magazine thanked Whistler for preserving on canvas the old span. 'Cumbrous as it is,' she wrote, 'it is far more in harmony with its surroundings than any stone bridge,

however massive and handsome, can ever be.'[26] This was exactly why Whistler was attracted to the old wooden structure.

* * * *

In 1864, while working on the two pictures inspired by the view from Lindsey Row, Whistler was also, at long last, completing his first painting of the river, a relic of his dockside days, *Wapping*.

Before Anna had reached London, Gabriel Rossetti and several others wrote to James Leathart about *Wapping*. Rossetti called it 'the noblest picture he has done, *the* one for your collection.'[27] Ford Madox Brown said that 'it would enhance the value'[28] of one of Britain's best private collections of art. A part-time member of the Tudor House set, the Scottish poet William Bell Scott mentioned the 'extraordinary power' of *Wapping*, which, he told Leathart, 'would be so distinct among yours that all would be benefited.'[29]

Leathart agreed to the asking price, 300 guineas, but he was too late. On 25 April 1864 Scott informed him that 'it had been sold to an American for £350.' The purchaser was Thomas Winans.

Originally Whistler had the young woman of *Wapping* wearing a blouse that was unbuttoned, and Armstrong, visiting him in Rotherhithe said, 'The Academy will never accept it because of the open shirt.'

'I will open it more and more each year,' Whistler retorted, 'until I am elected an R. A. and can hang it myself *hors concours*.'[30]

But when it went to the Academy in 1864, the shirt was buttoned. It was accepted, well hung, and as Whistler's first public appearance since the Salon des Refusés, an object of more than passing interest.

The first person mentioned in the first notice of *The Times* was Whistler. 'The painting of the Thames and its rivercraft,' the reviewer said, 'could hardly be surpassed for force and truth. If Velasquez had painted our river, he would have painted it in this style.' That was the good news. This was the bad news: 'It is a pity that this masterly background should be marred by a trio of mean old figures. Mr Whistler should learn that eccentricity is not originality. It is a thousand pities to give us figures as repulsive as these.'

The Times set the pattern for the response to *Wapping*. The *Telegraph* called the colors 'almost perfect,' the atmosphere 'simply marvellous,' but the human beings 'carelessly painted and unpleasant.' For the *Art Journal* 'the river and the craft' displayed 'singular power,' but the men and women were 'repulsive' and 'completely sunk in vulgarity.' The *Builder* wondered why 'an exquisite view of the Thames' had been spoiled by 'meaningless, ugly figures.'

Only Whistler's Pre-Raphaelite companions saw nothing repellent. Writing for *Fraser's Magazine*, William Rossetti said that 'a pictorial genius' had exhibited a 'triumphantly well painted' picture. Stephens found the painting to be 'incomparable.'

103

Wapping summoned up an earlier phase in Whistler's career. It was accompanied to Trafalgar Square by a strikingly dissimilar picture which marked the start of a new way of looking at things.

12

'Japanese' Paintings

[1863–65]

When Commodore Perry and the Emperor of Japan signed a treaty on 31 March 1854 in Yokohama, their action would have an impact upon art studios in Paris and London. No longer isolated from the West, Japan began freely to export products abroad, including works of art. The nation, to be sure, had not been totally cut off from the rest of the world. For 300 years the Dutch had maintained a trading post on a Japanese island, enabling a trickle of art objects to filter back to Europe. Twice in the early fifties Japanese art was publicly displayed in London: a small section of the 1851 International Exhibition, and, three years later, the first completely Japanese show in the West, consisting of furniture, in the gallery of the Old Water Colour Society. Then the Commodore and the Emperor conferred, and Japanese merchants outdid one another in shipping off their merchandise.

So much was sent that London's International Exhibition of 1862 presented the largest collection of Japanese works of art ever seen in the West. When the show closed, most of the items went on sale in Regent Street at the newly opened Farmer & Roger's Oriental Warehouse. Among the purchasers were the Rossetti brothers, George Frederick Watts, Edward Burne-Jones, Frederick Leighton, John Everett Millais, Lawrence Alma-Tadema, Norman Shaw, William Morris, John Ruskin, and James Whistler.

In Paris at about the same time, a couple named De Soye, who had recently visited Japan and returned with miscellaneous works, opened what was called 'an exotic junkshop' under the arcades of the Rue de Rivoli, La Porte Chinoise. The De Soyes's customers included Baudelaire, Manet, Degas, Monet, Emile Zola, Philipe Burty, James Tissot, the Goncourt brothers, and, most assuredly, Fantin-Latour and Whistler. Even at high prices, everything was quickly sold.

What caused this excitement in Regent Street and the Rue de Rivoli? Why were so many artists captivated by Japanese objects? With regard to the paintings, the answers lie in the works themselves.

Japanese art is conspicuous for suggestiveness. The painters go to the heart of the subject, show what is essential, and leave the rest to the viewer's imagination. If only for this, the pictures would have struck responsive chords in London and Paris. But there was more.

The subjects of Japanese paintings are limited but constantly repeated in new and contrasting ways. This particularly impressed Whistler. 'On a canvas,' he told Fantin, 'the same color should reappear continually like threads of an embroidery, the whole forming a harmonious pattern. Behold how well the Japanese understand this. They seek not contrast, but repetition.'[*1]

Another seductive aspect of Japanese art is its non-literary, non-historical character, which, with daringly combined colors, presents abstract perceptions and appeals not to the intellect but to the eye – literally, impressionism.

Whistler saw it all: the suggestiveness, the paucity of details, the elimination of irrelevance, the freshness of repetition, the abstractions, and the combinations of colors. This purely pictorial view of things consummately suited his temperament, and his vision would forever be affected by what he saw in Regent Street and the Rue de Rivoli.

Late in 1863 Whistler began his first 'Japanese' picture, which, he told Fantin, 'represents a porcelain salesman painting a pot.' It wasn't going to be easy. 'I have to rub out so much,' he said. 'Sometimes I think I've learned something, but then sometimes I am greatly discouraged.'[*2]

Anna mentioned the painting in a letter to America: 'A girl is seated, as if intent upon painting a beautiful jar resting upon her lap – a quiet and easy attitude. She sits beside a shelf covered with matting, upon which several pieces of china and a fan are arranged, as if for purchasers; a Schinde rug carpets the floor.'[3]

The central figure had become a woman, who was not posed for by Jo, one reason for the continuing difficulties. Whistler was a hard taskmaster in his studio, but Jo understood him and his ways perfectly, and they worked well together. Other models, however, often found it difficult to sit for him, which sometimes created problems, as with this first Japanese painting.

The picture was called *The Lange Leizen of the Six Marks*. The Dutch words *Lange Leizen* denote a type of pottery found in Delft, and 'of the six marks' refers to the potter's signature and date. The porcelain, the carpet, the fan, even the woman's gown, came from Whistler's steadily growing collection of orientalia. The accessories create an eastern milieu, but the picture itself is hardly 'Japanese.' The figure looks like a Victorian Englishwoman at a masquerade party.

The picture was hung at the Academy and received mixed reviews.

The Pre-Raphaelite critics echoed one another. William Rossetti called it 'the most delightful piece of colour on the walls,' and Stephens said it was 'among the finest pieces of colour in the Exhibition.' Others who responded favorably

included reviewers for the *Morning Advertiser*, which called it 'wonderfully truthful'; the *Evening News*, which found 'decided originality and feeling for character'; and the *Telegraph*, which said that 'in rich glow and tender brilliancy it has no rival.'

As for negative notices, the *Builder* faulted Whistler for being 'careless in drawing and execution'; *The Times* referred to his 'slovenliness of execution' and wondered why he felt it necessary 'to win our attention by doing everything unlike other people'; and the *Art Journal* wished that he would 'bring his talent under the control of common sense.'

Soon after the show had opened, *The Lange Leizen* was sold for its asking price, 100 guineas, to the nation's best-known art dealer, Ernest Gambart. This would be his only sale to Gambart, which 'is not surprising' to the dealer's biographer 'because he was a print publisher, and Whistler was the least engraveable of artists (that is, for large popular prints like those from pictures by Landseer, Frith, and Bonheur).'[4]

From *The Lange Leizen* Whistler went at once to his second 'Japanese' painting, *La Princesse du Pays de la Porcelaine*, which shows a kimono-clad woman standing before a screen. The model was Christine Spartali, daughter of the Greek consul-general in London, whom Whistler had met at the Ionides home. For several months she stood for him twice a week, sometimes for more than four hours at a stretch, until finally she collapsed from exhaustion. Fortunately for Whistler, the picture was nearly complete.

Once again the stage props are Japanese and the woman is unmistakably occidental, but the picture does seem atmospherically more 'Japanese' than its predecessor.

Rossetti found a purchaser for it and took him over to Lindsey Row.

'I like your picture very much,' the prospective buyer said. 'I just want you to make one small alteration.'

'Yes? What would you like me to do ?'

'Your signature seems rather large. Could you please make it a little smaller?'

'That sounds reasonable,' Rossetti said.

'Reasonable!' Whistler bellowed. 'That's outrageous. I would not sell a picture of mine to anyone who asks me to do something like that. Good day, gentlemen.'[5]

Later the picture 'as is' was bought by another of Rossetti's patrons, the Liverpool shipping magnate Frederick Leyland.

* * * *

Before completing *La Princesse*, Whistler late in 1864 began his third Japanese painting, *The Golden Screen*, with another woman in a richly embroidered robe, seated on the floor looking at colour prints by Hokusai. The model for this

picture was Jo Hiffernan. Anna had gone to Torquay for her health, and Jo was back in Lindsey Row.

Now that she had returned, Whistler made good use of Jo. Before the end of 1864 she sat for the superlative *Little White Girl*, which shows a deeply thoughtful red-haired woman in a white dress leaning against a fireplace, with her face reflected in a mirror.

Swinburne saw the picture in progress and was inspired to write a poem, 'Before the Mirror.' He mentioned the poem and the picture to an acquaintance, art critic John Ruskin. He invited Ruskin to accompany him to Whistler's studio, but the critic had a prior commitment. This inability to accept an invitation may have affected Victorian art history.

<p style="text-align:center">* * * *</p>

Late in the summer of 1864, thanks to the Rossetti group, Whistler could tell Fantin that 'this year I have had my greatest success yet. Purchasers offer me three times what I asked for last year.' * 6

Rossetti liked Whistler, but his friendship was not boundless. Toward the end of the year the house next to his became vacant, and he wrote to Leathart, who was looking for a London residence, 'I think it would suit you very well. Whistler is after some other place, and *entre nous* I had rather have you for a neighbour than that dearest but most excitable of good fellows.'7 Leathart did not move into the house, nor did Whistler, depriving us of the spectacle of Dante Gabriel Rossetti and James Abbott Whistler living side by side.

Because of Whistler's chumminess with the Tudor House clan, Du Maurier wrote to his brother, 'Jimmy and the Rossetti lot are thick as thieves. They show a noble contempt for everyone but themselves. I think they are best left to themselves, like all Societies for the mutual admiration of which one is not a member.'8

Du Maurier's generalization did not apply to Fantin-Latour. 'I am so discouraged,' Whistler wrote to him early in 1864. 'My work is always so painful and uncertain. When will I work more quickly? I put out so little because I wipe off so much. I would like to talk to you about it. I never feel a complete confidence in anyone but you.' * 9

Soon the two friends would speak face to face. As a tribute to Delacroix, dead for a year, Fantin planned a picture of artists gathered before his portrait. The mourners would include Baudelaire, Manet, Jules Campfleury, and, Fantin, hoped, Legros and Whistler.

'Naturally,' Whistler told him, 'Legros and I will come to Paris. Save two good places for us.' *

They sat for the picture, which was completed speedily, sent to the Salon, and received with enthusiasm.

No one could have been happier than Whistler.

> I wanted to be with you for your success, [he wrote,] and to see you finally take your rightful place. I thought of everything we would say to each other. I thought of those wonderful long talks at night when we understood each other so well. You must also have wanted to talk with me, for I am happy to think that we need each other for a true exchange of sympathies which we cannot get from others.* 10

Because of Whistler, Fantin continued to do pictures on commission for London Greeks, mainly flower paintings at prices ranging from 100 to 1000 francs.

This friendship with Fantin was solid, but in 1864 two other long-standing relationships virtually ended.

 * * * *

Until early in 1864, Alphonse Legros lived at 7 Lindsey Row. After he moved out, he and Whistler seldom saw each other. In October, Du Maurier told his brother that the two men had 'quarrelled over money matters.'11 Earlier in the year Du Maurier had said that they would 'part company' because of 'the extreme hatred which Legros has inspired in the fiery Joe.' It is true that Jo never liked Legros, and that there had been a dispute about money. But there was a more basic reason for the breach. For some time Legros had depended on Whistler for many things, from picture commissions to assistance with the English language. Gradually, however, he adapted to life in London and became self-sufficient. As he grew more independent, he was increasingly reluctant to submit to domination, and, except for Fantin, Whistler could not easily maintain a close friendship with an equal.

Near the end of the year, Legros married. Apparently because he had not been consulted on this matter, Whistler exploded. He spoke so caustically that Legros told Du Maurier, 'I can never see him again because of what he said.'12

Whistler and Legros had met for the last time as friends.

 * * * *

Also in 1864, Whistler terminated his friendship with Seymour Haden.

Early in the year he began to make fun of his brother-in-law. He told Fantin that whenever an opportunity arose for mocking Haden, he 'did not let it slip away without using it completely,' * 13 and when Haden was briefly in Paris, Whistler wrote to his friend, 'He must really be sounding off and making a fool of himself.'

That the changed feelings were one-sided is shown by Haden's dedication of an etching in mid-1864 'to Whistler.' And Du Maurier told his brother, 'I wonder that Jim cannot agree with Haden. I always get on capitally with him. I say with a deferential air, "Mr Haden, doesn't it occur to you that snow in reality is of a fine jet black colour?" He answers heartily in the affirmative.'14

Haden was indeed a most accommodating person. What, then, brought on

Whistler's altered attitude toward him? This is speculative, but I think it was engendered by Haden's etchings.

At first, when etching was just a hobby for Haden, he was warmly accepted by Whistler as an 'amateur.' Then gradually, while not neglecting professional duties, Haden was increasingly recognized for his art work, culminating in 1864, when he exhibited for the fifth time at the Academy and also appeared at the Salon, and when Philippe Burty, the first critic to acclaim Meryon's work, wrote an essay that filled 28 pages of the September and October numbers of the *Gazette des Beaux-Arts*, entitled 'The Work of Francis Seymour Haden.' It included a eulogistic critique and a wholly complimentary descriptive catalogue of 54 etchings. The longest notice that Whistler had received in Paris for his etchings consisted of two sentences. Can it be accidental that Whistler turned against Haden in 1864?

Before the end of the year, Whistler ceased entirely to see his brother-in-law. He had only one regret about this breach, he told Fantin: 'My sister and I now see each other only rarely, at the homes of mutual friends.' * 15

13

Valparaiso

[1865–66]

In the spring of 1865, Whistler had four pictures at the Academy. *Old Battersea Bridge* harkened back to an earlier period, while *The Scarf*, *The Golden Screen*, and *The Little White Girl* represented his current phase.

The bridge painting was well received. The *Telegraph* called it a 'vividly true piece of English mist and greyness'; the *Saturday Review* said it was 'what every landscape should be, an inlet into nature through a frame'; the *Illustrated London News* praised Whistler's 'unrivalled power of matching subtle hues and gradations.'

The Scarf and *The Golden Screen*, 'Japanese' pictures, were largely unmentioned because of the concentration on *Old Battersea Bridge* and, particularly, *The Little White Girl*.

Over the years, *The Little White Girl* has been one of Whistler's most highly praised pictures, and it all began at its first public showing. *The Times's* reviewer loved its 'delicate harmonies of colour and subtle suggestions of form' and said that 'before this picture even those who resent most strongly Mr Whistler's freaks must admit that he has power of the rarest kind.' The *Telegraph* extolled the 'soft purity and full undertone of exquisite tint.' The *Morning Advertiser* lauded Whistler's 'mastery over colour and his facility in drawing.' Even Charles Blanc, of the *Gazette des Beaux-Arts*, who detested the 'Japanese' pictures, said, 'Mr Whistler has marvellously attained his objective in this work. All of its features are a total success.'

And so it went. Almost everybody liked *The Little White Girl*. The enthusiastic response, however, was less memorable than a personal event of this late spring, the reunion, after ten years, with his brother.

William was on a mission for the Confederacy, which had been an adventure.

He received his assignment in Richmond, Virginia. Because of the Union blockade of rebel ports, he had to penetrate enemy lines and sail for England

from a northern city. He ordered a civilian suit for $1400; the bundle of notes to pay for it was so heavy he 'had to get a darky to tote it to the tailor.'[1]

When the suit was ready, he left for Chesapeake Bay in an ambulance waggon. The fare was $510, but because of the condition of the roads he walked most of the way.

Before leaving Virginia, he stopped at a private home to 'shave and clean up,' and then crossed the bay to Maryland in a canoe. In Union territory, he took a train to Philadelphia, and another to New York City. Military sentries were in the stations, but no one challenged him. Under an assumed name, he booked passage to Liverpool, where he delivered dispatches to a Confederate agent.

He was in London on a brief furlough, and when, one week after his arrival, he learned of Lee's surrender he decided to stay in Britain since he had no family to return to in America. (His childless wife had died in 1863.)

* * * *

James Whistler did not find William's presence comforting. For some time he had erased the war from his mind, but now with someone in his home who had been an officer throughout the hostilities, his guilty feelings returned. Had the war continued, he might have gone back to America with his brother, but the surrender at Appomattox ended his chance for battlefield glory. (Thirteen West Point classmates became temporary generals, and his cousin Joseph also wore a brigadier general's star.)

His lately controlled restlessness revived. During the summer he visited Cologne, and early in autumn he and Jo joined Courbet in Trouville.

Perhaps to avoid his brother, he spent nearly two months in Trouville. 'This is a charming place,' he wrote to Luke Ionides. 'I am staying to finish two or three seapieces.'[2] He painted altogether six pictures, minor works but, drifting away from realism, portents for the future.

Outwardly this working holiday was a pleasant interval for Whistler. He and Courbet swam, exchanged stories, and enjoyed a free-and-easy relationship with Jo. (At times the three of them probably simultaneously shared the same bed.) Inwardly, however, it was a time of turmoil, and not because of Jo's intimacy with Courbet. He was a dissatisfied, confused painter, in the midst of a quandary. Although working alongside Courbet, who called him 'my pupil', he no longer regarded himself as a realist. But he had not yet stepped onto a new artistic path. For a while *The White Girl* seemed to point to a new direction, but it stood by itself and didn't lead to anything. The Japanese had helped in shaping his technique but not in providing a road on which to travel.

Lately, however, he had detected a ray of hope for the future.

'At this time,' Fantin told Joseph Pennell, 'he was closely allied with A. Moore.'[3] This was Albert Moore. Perhaps he would provide light at the end of the tunnel.

＊　　　＊　　　＊　　　＊

Twenty-four years old in 1865, Moore had exhibited landscapes at the R. A. in 1857, 1858, and 1859, and highly detailed Biblical paintings in 1861 and 1862. Then during a winter in Rome he rediscovered classical Greek art. Immediately he eliminated narrative elements from his work and concentrated on decorative arrangements of figures in classical drapery. Like almost everyone else, he was affected by the Japanese, and he combined the two influences.

The 'new Moore' made his public debut at the R. A. in 1865 with *The Marble Seat*, which shows three Grecian-dressed women sitting on a bench, surrounded by trees, flowers, and a nude young man pouring wine into a cup. This painting exemplified Moore's artistic code: a painter's sole responsibility is to create beauty through lines and colors. The subject doesn't really matter.

Whistler was transfixed by *The Marble Seat*. This is what he had hoped to do with *The White Girl*. He visited Moore at his home in Russell Place and found him to be even more shy than Fantin, aloof to everything but art. Again captivating by charm, Whistler struck up a friendship with him and suggested to Fantin that he replace Legros in the Society of Three.

Albert Moore and his work were a revelation to Whistler. They were also the source of concern. Was his own technique good enough for him consistently to paint non-subject pictures? He pondered this matter in Trouville, and upon returning to London he was immersed in thought.

＊　　　＊　　　＊　　　＊

On 31 January 1866, Whistler signed a 'last will and testament,' leaving his 'Real and Personal Estate . . . unto Joanna Hiffernan of No. 7 Lindsey Row.' On the same day he had Jo 'fully empowered . . . in all transactions to act as fully and effectually on my behalf as I could myself.'[4] In another document he gave her a power of attorney.

He was doing all of this, he said in a preamble to the last paper, because he was 'about to proceed to America.' He encouraged friends to think that he had gone to the United States, and he even gave them a precise destination, which *Punch* illustrator Charles Keene noted in a letter to Edwin Edwards: 'That was a rum stunt of Jimmy bolting to California, was it not?'[5]

The mystery of why he had gone to California would not soon be solved, for no one heard from him during 1866. And no one could have received a letter from him postmarked California because he was never there. The America that Whistler went to was South America, specifically Valparaiso, Chile.

＊　　　＊　　　＊　　　＊

Many people had found Whistler's trip to Chile unexplainable. It has even been suggested that he never really made the journey. Elizabeth Pennell, who knew

him better than anyone else in his last years, called it 'the most inexplicable incident of his life.' She could not 'find even the suggestion of a necessity for him to leave London.'⁶ Actually he had two compelling reasons for getting away. He continued to be embarrassed by his absence from his nation's war, and he needed to be alone with his thoughts to try to resolve his artistic conflict.

Almost certainly he did not choose arbitrarily to go to Chile. In October 1865, following a Spanish blockade of its coasts, Chile had declared war on Spain. 'The spirit of 1810,' the *Illustrated London News* reported from Valparaiso, 'is again awake, and Chileans are prepared to fight the war of independence again.' In 1866 Chile was just the place for Whistler.

He spent most of the year in Valparaiso but never said much about it, and nothing at all for thirty years. (In the 1890s he told a friend that on the outgoing voyage he had been the only passenger on 'a slow sailing ship.')

He arrived in time for one flare of hostilities. For three hours on 31 March a Spanish ship fired on the city but caused little damage. A shell fell within ten yards of an elderly woman, and one death resulted from the attack, that of a donkey.

This battle, which frightened an old lady and killed a donkey, set the tone for this comic opera sojourn. He probably saw more military action than this, but he didn't think it was important enough to write home about or to talk about after he had returned home.

The Chilean interlude brought forth the 'fighting Whistler.' Until then, he had been in one physical altercation, the 1862 incident in Paris. Now, in slightly less than six months after leaving Valparaiso, he would have five fist fights.

The first three bouts occurred on the return journey.

Among the handful of his fellow passengers was a black Haitian. They all ate at one table, and it was not easy for a self-styled Southerner to eat three times a day with a black man. Nevertheless he managed to exercise self-control and to avoid unpleasantness – until the day before the ship docked at Southampton.

'Finally,' Whistler said, 'the degree to which he offended my prejudice as a Southerner who for the first time found a negro at the same table led to our coming into collision.'⁷

For no reason but skin color, he gave the Haitian a punch in the face, hard enough for him to have to rest his arm in a sling for a few days.

For the remaining hours of the voyage, he was confined to his cabin, where he was visited by the ship's mail agent, who had spoken harshly to him after the encounter and now delivered a lecture on race relations.

After listening patiently for a while, Whistler said, 'This is all very well, but it's not to any purpose. I thought you came to apologize for your ungentlemanly language.'

The mail agent shouted, 'I intended to insult you, and I'll do it again! Nothing but cowardice has kept you from resenting it.'

'I won't hit an old man.'

'That's a lie! You're a coward!'[8]

Now he had gone too far. With his free hand, Whistler hit the face of his adversary, who then rushed upon him and struck him on the eye. A member of the crew broke up the skirmish.

In Victoria Station there were more fisticuffs, but the incident remained clouded in obscurity. 'He never spoke to us about it,' the Pennells said, 'but everybody else says that when he got out of the train someone besides his friends was waiting for him, and somebody got a thrashing.'[9]

<p style="text-align:center">* * * *</p>

In November 1866 a new man arrived in London, and also a new artist. He didn't bring back much, only a few small seascapes, far from his best work. They were, however, important in what they foreshadowed. As *The French Set* was seminal to the early years, the Valparaiso paintings signal the start of another era.

The Chilean pictures have no 'local color,' and few readily identifiable details. What they do show is 'an increasing preoccupation with fleeting effects of light and atmosphere, thereby achieving significance as the direct ancestors of the Nocturnes of the '70's.'[10]

The Valparaisan interlude ended the life of the young Whistler.

THE MIDDLE YEARS

14

Back in London

[1866–67]

'Went to Whistler's house,' Boyce wrote in his diary a few days after he had returned and settled temporarily at 14 Waltham Grove, just above the Fulham Broadway. 'He made us some wonderful brandy and whisky.'[1]

Whistler was eager to return to the exhibition scene. And he wouldn't have to wait long.

London did not have regular 'out of season' art shows before December 1853, when Ernest Gambart held an opening at his workplace, the French Gallery, in Pall Mall, a 'Winter Exhibition of Pictures by British Artists.' The venture was successful and other dealers followed suit, until by 1866–67 there were nine winter shows in London. The best of them was the original one, where Whistler took one of his new pictures. He was three weeks late, but Gambart, unfettered by inflexible rules, accepted the entry.

The picture, *Crepuscule in Flesh Colour and Green,* is a scene in Valparaiso harbor, Whistler's first nocturnal painting. Only one journal mentioned it, the *Athenaeum,* where Stephens noted that the subject was not 'topographical but the greyish green twilight on gently moving sea.' He called it 'a poem in colour and tone worthy of attentive study by all who care for originality in landscape art.'[2]

* * * *

'Went to dine with Whistler,' William Rossetti wrote in his diary on 5 February 1867, 'for his housewarming at his new house in Lindsey Row.'

His former residence, number 7, was now inhabited by an artist improbably named John Spreckley Cuthbert, but number 2 was vacant and became Whistler's new home. It was just to the west of number 7 and was similar to it – narrow, white, three-storied, with two large front windows, and, in pre-embankment 1867, it was only a few yards from the river. (The embankment

had reached a point midway between the Waterloo and Westminster Bridges. Chelsea would have its unimpaired view of the water for only a few more years.)

With his mother for the time being in Hastings for her health, Whistler was free to move into number 2 with Jo, who, picking up where she had left off in Trouville, had spent part of his absence having an affair with Courbet. Whistler knew about this and professed not to have been agitated by it.

As soon as they had settled in, he was ready to resume his career as a British artist.

Even before the housewarming, Whistler had voiced his feelings in a letter to the man who was still his confidant, Henri Fantin-Latour:

> If I have made any progress, it is in the use of colours, which I believe I have all but mastered and reduced to a system. But color can be a vice! When it is controlled by a strong hand, and led by her master, design, color is a splendid girl, the most magnificent mistress possible. But if coupled with a weak, timid design, color becomes a whore, dishonoring herself and making fun of her little man. The result is a chaos of sorrow and drunkenness, an unfinished thing!
>
> Now you know about the enormous task I have set for myself.* 3

The letter ended with a reference to 'the only one worthy of us, young Moore, whom I have mentioned so often.'

Moore's influence was evident in Whistler's current unfinished picture, showing simply two women on or near a sofa. His next letter to Fantin included a sketch of it.

> Jo is in a very *white* dress [he said,] the purest figure I have ever done. Charming head. Body, legs, etc., are perfectly visible through the dress. The other girl has blond hair and a yellowish white silk dress.
>
> I have made enormous progress. Finally I think I am reaching my goal. I completely understand what I am doing, and day by day everything seems simpler. Now it is mainly composition that keeps me busy.* 4

He then turned to an immediately practical matter. Paris would have two big art shows in the spring, the Salon and a Universal Exposition. What should he send over?

Fantin advised him to enter some of his early works because 'the pictures with which one started explain what one is doing today. He reminded Whistler that because of his recent absence 'these exhibitions are very important to you.' *

※　　　※　　　※　　　※

Whistler decided to go to Paris for the exhibitions, and everything was calm until just before he left.

120

One morning in March he visited Luke Ionides in his office. Ionides was talking to Legros, whom Whistler had not seen since returning from Chile.

The atmosphere was cool but peaceful until Legros disagreed with something that Whistler had said.

'*Ce n'est pas vrai*,' he exclaimed.[5]

Unhesitatingly, Whistler struck him with his fist, knocking him to the floor.

William Rossetti told the Pennells that the root cause of the dispute was 'women' and provided details which, the Pennells said, were 'unfit for publication.'

Not only were the Pennells tight-lipped about this in their biography, but even their personal papers, now in the Library of Congress, contain no hint as to who these women were. Because of this reticence, I suggest that they were ladies of the night who frequented the notorious Chelsea pleasure grounds for the lower half of London society, Cremorne Gardens, several of whom had been picked up by Whistler and his friends on their occasional visits to Cremorne.

15

Pugilism in Paris

[1867]

Two days after decking Legros, Whistler went to Paris.

His travelling companion was his brother, now an active London physician who was gradually becoming a specialist in laryngology, with a residence-cum-office in Old Burlington Street. A stout five feet eight inches, William was placid, unhurried, not easily ruffled. He and Jimmy had never quarreled.

After checking into their hotel on the Rue St. Honoré, the brothers walked over to the Champs-Elysées and entered the Salon. Again inhospitable to innovations, it had rejected entries from Monet, Renoir, Sisley, Bazille, and Cézanne. But not Whistler. He had sent *At the Piano* and *The Thames in Ice*, easily understood pictures. They were not well received by reviewers. Epitomizing the French reaction, *l'Illustration* called them 'strange, carelessly done rough drafts, interesting only to specialists.' * 1

As for the Universal Exposition, the art section was in a huge building on the Champs de Mars. There was enough space for four of Whistler's paintings and 24 of his etchings. One work had lately hung in Gambart's gallery; everything else was pre-Chilean. They weren't easy to find. The pictures were arranged in national groups, with all entries from each country bracketed together. The United States was assigned space, a French magazine reported, 'in a hidden, obscure passageway, along with Liou-Kiou and China, a pacific which few people will see.' * 2

In London, Whistler had heard about this, and he reacted in a way that would become characteristic. He instructed his friend George Lucas to see 'the scoundrel' who had been responsible for 'hiding' his pictures and to insist that they be removed to a more desirable wall.

'Make a scene!' Whistler said. 'Tell him what a damned fool he is. I won't have my pictures hung where they are.' 3

Lucas did not make a scene, and the pictures were not relocated.

Because of their position they were generally overlooked, except for one that

couldn't be ignored even in 'Siberia,' on its reappearance in Paris, the still unsold *White Girl*. Most critics were of two minds about it. The *Gazette des Beaux-Arts*, for example, found 'charming and rare harmonies' but called the head 'unbearably ugly,'* and *Galignari* said it was 'remarkably able and faulty, but more able than faulty.'

Now Whistler had had enough of French reviewers. He would abstain from public exhibitions in Paris until 1882.

<p style="text-align:center">* * * *</p>

He was not cheered by letters from London. Rossetti and Ionides asked him to apologize to Legros.

'What *can* you mean by saying that an apology is due to Legros!' he told Ionides. 'A man gives you the lie to your face, and you naturally strike him.'[4]

To Rossetti he said, 'Legros's case is of the plainest. I made a statement which he had the madness to say was false! For this he got himself instantly thrashed.'[5]

But the fight with Legros was only a preliminary match. His main event opponent was Francis Seymour Haden.

<p style="text-align:center">* * * *</p>

Whistler's bad feelings toward his brother-in-law erupted in April 1867. The catalyst was Haden's associate, the man who had looked after Whistler during his illness of 1861, 34-year-old James Reeves Traer.

In April 1867, Traer also happened to be in Paris, to attend a medical conference. On the 22nd he had an attack of apoplexy and dropped dead.

On the 24th, Haden arrived to take care of the burial. He had consulted with Traer's widow, who, with an inheritance limited to a small insurance policy, wanted an inexpensive funeral. Haden arranged for burial in an unmarked grave in Pére Lachaise cemetery.

Suddenly Whistler showed great concern for a casual acquaintance.

On the 25th, he wrote to the British medical journal *Lancet*. After referring to Traer's death and burial, he said, 'The least one might have expected is that the last painful duties should be paid to his remains. It is a melancholy fact that the gentleman who undertook the arrangements left the corpse to be buried without any religious rites whatever.'[6]

Later in the day, the Whistler brothers had a cross engraved 'James Traer, Member of the Royal College of Surgeons' and placed it on his grave. Now, William told Deborah, 'any Englishman who wanders *among the graves of the paupers and the fosse commune* may be able to detect the last resting place of a gentleman.'[7]

On the 26th, the brothers entered a café – whether accidentally or purposely is not clear – and encountered Haden.

James Whistler at once unleashed a torrent of abuse.

<p style="text-align:center">123</p>

James Traer was my intimate friend, the poor fellow! [he screamed.] He was a fine, honest gentleman, loved by his friends and respected by his colleagues for his brilliant talents. What have you done? You have slandered him behind his back! You have called him a disgrace to his profession. You have bullied and browbeaten him. Even after his death you treated him disgracefully. His burial was a disgrace! It was enough to make the poor boy turn in his grave!

I know you, Seymour Haden. With your fulsome perfection and your solemn priggishness, you are a Pecksniff! Your whole life is one big lie! You're a transparent humbug![8]

Haden probably had been making disparaging remarks about Traer because he was trying to terminate their professional relationship. The problem was that Traer had become an alcoholic. Six weeks earlier he had disappeared, and Haden knew nothing of his whereabouts until informed of his death.

Now red in the face, Haden sputtered, 'You don't know what you are talking about.'

'Oh, don't I?' Whistler responded. 'Well then, I'll stop talking. Perhaps you'll understand this.'

Haden had been standing in front of a plate-glass window, and Whistler smashed him in the face, sending him through the window. He lay flat on his back, surrounded by broken glass. The brothers left without pausing to ascertain if their victim needed medical attention (even though one of them was a practicing physician).

<div style="text-align:center">

* * * *

</div>

News of the one-punch knockout quickly reached London.

'I am horrified at what I hear,' Deborah wrote to James. 'What do these brutal assaults mean? Surely you cannot know what you are doing. Your conduct is a cruel shame. For Heaven's sake, my dear Jem, stop while there is time or you will die Traer's death.'[9]

This latest incident, she said, following the attack on Legros, had made him a figure of notoriety in London. 'As one who has your interest at heart,' she wrote, 'I advise you *not* to return. For your own sake keep away. I could never see you after this.'

Her brother's response suggests that he had not really been motivated by any alleged mistreatment of Traer:

For years I have tolerated passively your husband's insolence and insults. On many occasions when outraged by conduct such as no gentleman should be submitted to, I have for your sake put aside dignity and anger, held out my hand and bowed myself down that amicable relations might continue.

No one can expect me to go through life submitting to deliberate insult. You must perceive that a limit has been reached and passed.

He ended by saying, 'I have utterly *done with* your husband, and sorry as I am on your account, my dear sister, *I mean it.*'[10]

Deborah returned his letter, 'lest it should be supposed by keeping it that I for a moment sympathize with you in your conduct. To my mind *nothing* could excuse it.'

* * * *

There was one person to whom Whistler felt no need to justify his conduct. She had lately asked if he might stop in Hastings on his way home.

My own darling mother [he wrote,] of course I will come to you for a few days and then accompany you back to London. [She would travel from London to Liverpool and then sail to America for a visit.] We will have much to say and be sad about, for we are surrounded with gloom. Our poor, dear intimate friend, Traer, has gone from among us. Seymour Haden, full of insolence and brutality, made Traer lead a dog's life, making his existence one forlorn shrinking from this bully! Then when he was grossly insulting to me, until I no longer could put up with it, I struck him then and there. Dear Mother, no son of yours *could* or *would* bear long with the blackguard insolence of such a bully.[11]

Whistler's accusations concerning Haden's alleged mistreatment of Traer are, as far as I could discover, unsupported by a scintilla of reliable evidence.

Traer, incidentally, has gone unmentioned in nearly all writings on Whistler simply because there was no relationship of any kind between the two men except that of doctor and patient briefly during one summer. Nowhere in friends' reminiscences or his own letters – except in connection with the current incident – can one find his name. Even the Pennells' two-volume opus contains just two passing references to him, in both of which he is referred to simply as 'Traer,' the authors apparently unaware of his first name.

* * * *

What brought on Whistler's recent irascibility, which seems particularly sudden and violent? There are a couple of reasons for this behavior.

He was, in the first place, continuing to experience an inner ferment because of uncertainty about his work. Many artists in this predicament have turned to drugs, particularly alcohol, but Whistler consistently abstained from artificial stimulants. He gained relief from his fists.

Secondly, and this cannot be overemphasized, he languished over his lost opportunity for becoming a hero on an American battlefield. This was

something that he would never get over and was, I think, the principal motivating force behind his violence that erupted shortly after the Civil War had ended.

As for his most recent, most egregious act of fury, it may be explained by Whistler's feelings, not toward Traer, but toward Haden.

Haden had been increasingly honored as a surgeon and as an etcher. Whistler could have endured, even enjoyed, the kudos for medicine, but not for art. Haden's large folio *Etudes à l'eau-forte*, published in 1865, received lengthy, laudatory notices – one-and-a-half columns in *The Times*, which called it a 'remarkable volume,' and two columns in the *Athenaeum*, which characterized it as 'a grand work.' Then just after Whistler's return from Chile, a four-and-one-half page article, 'Etching,' by the important young critic Philip Hamerton, appeared in the *Art Journal*. Whistler was mentioned four times, Haden 14 times.

Such sweeping recognition for an 'amateur,' especially this amateur, was impossible for Whistler to accept.

Then, too, it may be significant that Haden was a strikingly handsome man, about five feet eleven inches tall.

If Whistler was compensating for feelings of inferiority by attacking Haden, physically and verbally, by trying to humiliate him, and then by blaming him for everything that had happened, he was hardly the first or the last person to do this.

Late in 1867, Gabriel Rossetti celebrated in verse his friend's newly acquired reputation:

> There is a young artist called Whistler
> Who in every respect is a bristler.
> A tube of white lead
> Or a punch in the head
> Come equally handy to Whistler.[12]

16

The First 'Symphony'

[1867–68]

Whistler ignored his sister's advice to stay in Paris. He was back in London for his eighth Exhibition, with three entries.

Two were pre-Chilean: *Battersea*, a realistic view of the river from Lindsey Row; and *Sea and Rain*, an impressionistic glimpse of a nearly deserted beach at Trouville during a heavy shower. Neither of these caused much of a stir.

Hardly anyone, however, failed to notice the third picture, the one that Whistler had written about to Fantin, with two women and a couch. In the completed painting, one woman reclines upon and the other is leaning against the divan, assuming positions that are improbable, unnatural, and uncomfortable. The left arm of one and the right arm of the other extend horizontally for no apparent reason except to create compositional balance. The only 'subject' is that of two women dressed in white along with a sofa that is also white.

Early in the year, when it was not quite finished, Whistler had sent it to Paris for Fantin to see.

'It pleased me enormously,' Fantin wrote. 'It's rather strange, but original and very well done. The general impression is like that of a cloud or a dream. [Alfred] Stevens thinks it is very good, and [James] Tissot [a fine young French painter] was like a madman in front of it, jumping for joy.'*[1]

Whistler named it *Symphony in White, No. 3*, surely influenced by Paul Mantz, who in the *Gazette des Beaux-Arts* had called *The White Girl* 'nothing more or less than a symphony in white.' Whistler liked this concept, and thereafter almost all of his paintings would have musical titles. He even renamed some earlier ones. *The Music Room*, for example, became a *Harmony in Grey and Green*.

Whistler said, 'I point out something of what I mean in my theory of painting by the names of my pictures.' Far from being superficial or frivolous, these titles are pivotal to his philosophy.

A picture [he said,] should have its own inherent merit and not depend upon
dramatic or legendary or local interest. As music is the poetry of sound, so
painting is the poetry of sight, and subject matter has nothing to do with it. Art
should be independent of claptrap – should stand alone and appeal to the artistic
sense of eye or ear without reference to such foreign emotions as devotion, pity,
love, patriotism, and the like. That is why I call my works arrangements and
harmonies.[2]

The names were not selected arbitrarily or casually. 'They are,' he said, 'the
result of much earnest study and deep thought. To me, each picture represents
a problem laboriously solved, and its title suggests as much to all who are
capable of understanding or inferring their meanings.' These titles are confusing,
repetitive, and hard to remember, but they developed logically from the art itself.

Many critics could not, or would not, take the names seriously, but because
of them he was ridiculed and caricatured, charged with being eccentric, peculiar,
charlatanish, affected, perverse, and pretentious. His reputation unquestionably
suffered because of the labels attached to his pictures.

<p style="text-align:center">* * * *</p>

At the R. A. in 1867, the title of *Symphony in White, No. 3* was not dealt with
unfairly, but the picture itself wasn't much liked. Typically, the *Morning Star*
dismissed it as 'an affectation'; the *Art Journal* called it 'an alarming
eccentricity'; and the *Daily News* complained of 'Mr Whistler harping on one
single string.'

One notice, by Philip Hamerton in the prestigious *Saturday Review*, is of
particular interest because of Whistler's riposte. Exactly Whistler's age,
Hamerton would become, after John Ruskin, the second most influential
Victorian art critic. Because his practical work in the visual arts had been limited
to art school assignments, he was a prime example of Whistler's pre-eminent
bête noir, a critic who has not practiced the art on which he passes judgment.

After writing at length on Whistler's pictures, Hamerton thus ended his
commentary:

The *Symphony in White* is not precisely a symphony in white. One lady has a
yellowish dress and brown hair and a bit of blue ribbon, the other has a red fan,
and there are flowers and green leaves. The girl on the sofa has reddish hair, and
there is the flesh colour of the complexions.[3]

Whistler, who probably remembered Hamerton's praise of Haden in the *Art
Journal*, came up with a retort that did not become public until many years later.
Although the tone is offensive, his point is well taken:

Can anything be more amazing than the stultified prattle of this poor person! Did this ass expect white hair and chalked faces, and does he think in his astounding wisdom that a Symphony in 'F' could have no other note! but shall be a continued repetition of F! F! F! F! Fool![4]

17

The Battle of the Burlington

[1867–68]

While his *Symphony* was hanging in Trafalgar Square, the second battle in Whistler's war with Haden began. The field of combat was the Burlington Fine Arts Club.

Recently established in Piccadilly, the club was formed to bring together persons interested in art and to provide them with the usual amenities of a London club. Its 200 members included a few painters – Sir William Boxall, Sir Coutts Lindsay, and Dante Gabriel Rossetti. Among the others were William Rossetti, William Bell Scott, and art patron Frederick Slade.

The membership rolls also contained the names of Seymour Haden and James Whistler.

Club correspondence was carried out by Ralph Wornum, 55, an undistinguished portraitist who had become a critic–scholar, and since 1854 had been Keeper at the National Gallery.

On 11 June 1867 Wornum began a lengthy postal dialogue by informing Whistler that because of his assault upon another member, the club's governing committee agreed 'that it is inexpedient for you to remain a member.'[1] Wornum hoped that he would 'see the fitness of withdrawing your name from the list of members, in which case the Committee will return your entrance fee and year's subscription.'

Expressing surprise 'that a personal affair unconnected with the club has been taken up *at all* without my being consulted,' Whistler refused to resign without a hearing. 'If it be judged,' he said, 'that Mr Haden's conduct is that becoming a gentleman, I shall gladly cease to be a member.'[2]

Wornum also heard from Gabriel Rossetti, who contended that because the club had acted behind his back, 'an apology is owing to Mr Whistler.'[3]

Wornum replied that a club could hardly function 'if a member cannot enter except under fear of being subjected to an assault.'

Wornum's two letters and those by Whistler and Rossetti were delivered on

the same day, 11 June. This illustrates not just the speed of the Victorian postal service but also the zeal with which Whistler acted upon receipt of the secretary's communication.

On 13 June, Wornum told Whistler that the committee would 'give full consideration to any explanation' of the affair, but he noted that 'the assault upon Mr Haden is not the only one which it is alleged you have committed.'

Also on 13 June, William Rossetti wrote in his diary, 'I will resign if Whistler is expelled.'

More letters passed back and forth until on 2 December the secretary said,

Unless the Committee are informed of your withdrawal on or before the 10th of December, the following notice will be posted in the reading room. 'The committee are of the opinion that Mr J. Whistler should not continue to be a member and hereby call a special meeting to state the reasons for this conclusion.'

Again refusing to resign, Whistler asked that 'if possible, the meeting be held in the evening after dinner, as the loss of daylight at this time of the year is a serious matter to an artist.'

Before the meeting took place, his mother returned from her visit to post-war America.

'I have been tremendously occupied in changing all my plans because of her arrival!' he told Lucas. 'You can understand what a Herculean work it was to make order out of Chaos!'[4]

For Anna the trip had not been a happy one. 'Mrs Whistler says,' William Rossetti wrote in his diary, 'that things were so dreadfully bad for Southerners that one lady of fortune was reduced to teaching in a school for nigger children.'[5]

A couple of days after her arrival, members of the club were informed that the 'expulsion meeting' would be held at half-past four on Friday, 13 December.

On the 12th, several of Whistler's friends met at his home to plan strategy. On the same day someone told him that 'Haden has been canvassing every member and making it a *personal* matter.'[6]

The result was recorded in William Rossetti's diary: 'Whistler's expulsion was voted by 9 against 8. Tebbs moved to take no action at this late end of the year. This had a good chance of passing if Whistler had intimated that he would not renew his membership. He declined, and the vote passed against him. I handed in my resignation.' As did his brother.

That only 17 persons were present suggests a disinclination of members to take a stand. But Frederick Leighton said in a letter to Whistler, 'They put off the business till they thought there were as few members as possible except for their own party in town.'[7]

One of those in attendance, William Bell Scott, while not saying how he had voted, told a friend, 'It was a painful scene, very like "trial and execution."'

Besides Haden's affair, the club heard about the other parties Whistler had attacked. I have long felt him to be a disreputable man.'[8]

The 'other parties' were the Parisian worker, the Haitian, the ship's mail agent, and Legros, who personally read a statement at the meeting. Details on the first three episodes were revealed by Haden, whose action Whistler commented on in a letter to the club president, who had been absent. On the Paris affray, Whistler said, 'the source from which Mr Haden had the story was *myself*! in an unguarded moment *at his own table*! – little dreaming that he was making notes for private revenge.' The report of his striking the black man 'also was the bitter fruit of pleasant but imprudent after-dinner talk at my brother-in-law's fatal table!' And the second shipboard incident provided "one of the passing solaces of our joint leisure over wine and walnuts." '[9]

<div align="center">

✽ ✽ ✽ ✽

</div>

Whistler's expulsion did not end the affair.

Convinced that Legros's statement had been composed by Haden, he communicated with Legros for the first time since their encounter:

> The base, cowardly letter which you read at the Burlington Club makes you despicable in the eyes of all men of courage and honor. Don't fight any longer. It's not worth the effort. Thanks to the services you rendered Haden, who has treated you like a dog, you have made yourself detestable and ridiculous for life.* [10]

Haden actually had had more to do with Legros's professional advancement than anyone else, one reason for Whistler's hostility toward both of them.

For more than six months, Whistler ignored Haden. Then, out of the blue, on 14 July 1868 he wrote to him,

> I warn you that I know of your having written for Legros the letter which he read at the meeting. This and other facts I shall make known everywhere, in London and in Paris. Abject poltroonery may be protected *in your club*, but elsewhere it is despicable, and in Paris it will be greeted with ridicule.[11]

Haden's solicitor warned Whistler that if he carried out his threat, 'we shall be compelled to take such steps as the interests of our client may require.'

Whistler said nothing publicly about Haden.

Why did he try to stir up trouble? The answer probably lies in the publication, less than two weeks earlier, of Philip Hamerton's *Etchers and Etching*, which opened with a page-long dedication to Seymour Haden, of which this is a portion:

The unprecedented reception your etchings met with must have given you the satisfaction of knowing that a great art, hitherto grievously neglected, has, by your labours, received increased consideration; and that as a consequence of your works many have become interested in etching who, before their appearance, were scarcely aware of its existence. Of all modern etchers you are most completely in unison with the natural tendencies of the art.[12]

In the book itself, Whistler's work was covered in six pages, while 22 pages were devoted to 'one of the busiest surgeons in London who has become one of its most celebrated artists.'

It was hardly coincidental that Whistler renewed the feud only days after the appearance of *Etchers and Etching*.

An exchange of letters between James and his half-brother George, on assignment in St Petersburg, finally terminated the Burlington Club episode. In August 1868 George warned that it would be dangerous to have Haden as an enemy, which elicited this response: 'What fearful bugaboo you made of Haden. Who is Haden? a miserable snob, of no influence in his profession, an amateur etcher! and a humbug who is much laughed at and despised!'[13]

While not commenting explicitly on this nonsensical assertion, George responded,

It strikes me that the decision of the club was not upon the merits of the case, but upon the propriety of retaining you as a member after your quarrelsome correspondence. I think there never was so good a case thrown away as yours by the course you took after the Committee's *first* letter. Your manner of treating these gentlemen, and through them every member of the Club, put you finally in the wrong. Nobody can indulge in your style of letter writing without coming to grief. It is a very serious thing that you are stifled with, this mania. You will have to correct it to succeed in life.[14]

18

An Artistic Crisis

[1867–70]

In September 1867, when he was completing *Etchers and Etching*, Philip Hamerton wrote to Whistler. 'Although I have seen many of your etchings,' he said, 'I have not fully and fairly studied them.' He requested the loan of a set. 'My opinion of your work,' he warranted, 'is so favourable that your reputation could only gain by affording me the opportunity of writing at length on it.'[1]

Whistler didn't even acknowledge the letter.

His discourtesy may have been due in part to Hamerton's commentary on the *Symphony in White, No. 3,* and in part to his involvement in the Burlington affair. There was, however, a more compelling reason for the slight. He was almost in a state of depression because of his art.

In the same month that he heard from Hamerton, he wrote to Fantin. 'I am overwhelmed! I have many pictures in my head, but they come out with such difficulty. I am now exacting and hard to please, very different from what I was when I threw everything pell-mell on the canvas, knowing that instinct and the fine use of color would lead me to the end.'*[2]

He lamented the incompleteness of his training: 'What a terrible lack of education I feel! With my natural talent, what a painter I would be if I hadn't been content to rely upon this talent.'*

He berated Courbet and what he represented:

The time when I arrived in France was very bad for me. Courbet and his influence were disgusting. My regret about that, and my anger, would stun you. It's not poor Courbet that infuriates me. Nor his works. I can see their good qualities. Nor am I complaining about his influence on my thoughts because there was none. I am very much my own person. I am rich in qualities that he doesn't have. It's just that damned realism that's been so very harmful to me. Because it made fun of all traditions and, with the assurance of ignorance, cried out loudly, 'Vive la Nature!' it appealed to my vanity as a painter. I had only to open my eyes and

paint what I saw. That's all. Then came the *Piano* picture, the White Girl, the Thames views, the sea, all produced by a rascal flushed with the vanity of being able to show off his splendid gifts.*

While not doubting the sincerity of these observations, one might wonder if the motivations underlying the comments on Courbet were exclusively artistic. Could it be that Courbet's affair with Jo while Whistler was in Chile may have affected him more than he would admit?

At the end of his letter, he acknowledged the flaws in his drawing and spoke of his greatest regret: 'Ah, if only I had been a student of Ingres! What a teacher he would have been for me!' * (Ingres had died earlier in the year.)

 * * * *

The significance of Whistler's letter goes beyond Courbet and Ingres. It discloses an artistic crisis. As always, he wanted to paint original pictures as well as possible. But how should he do it? Could he in fact carry through on his conceptions? These questions were on his mind while he was battling over a club membership.

He thought, or professed to think, about a change in scenery. In November 1867, he wrote to Lucas,

> I think I should like to stay in Paris. I wonder if you might know of a decent studio with a little room to sleep in? Perhaps for 800 or 1000 fr., not at all necessary to be swell, as I intend to be very quiet and scarcely 'receive' anyone. I have a great deal of work to do and must be more quiet than I can be here. Care but little to meet the old café set, as I have no time for talk.[3]

He really had no intention of leaving London. The letter to Lucas was just a sign of restlessness.

 * * * *

In the late sixties the British art world experienced a revival of interest in classical painting, involving, among others, Leighton, Alma-Tadema, and, naturally, Albert Moore. Whistler decided to become part of the movement, especially after he had received two sizable commissions. He planned a series of large, related canvases of female figures dressed as ancient Greeks, which he called *Six Projects*. Each individual picture also had a name. One was called *Venus*, and the others had musical titles, as, for example, *Symphony in Green and Violet*.

Six Projects proved to be the most difficult assignment of his life. At first he was excitedly confident about what he was doing. In mid-December 1867, he told Lucas, 'I am hard at work on a large picture which I hope to have quite ready for the Academy.'[4] Actually he would not come close to having anything to send

to the R. A. in 1868, and for the first time since coming to London, except for the year in Chile, he missed the big summer show.

He finished nothing at all during the rest of the year, and he continued to be restless.

In December 1868, Anna wrote to one of her sisters, 'Jemie has availed himself of an artist's offer of a studio more favorable for light and has gone to work there.'[5] It was in a small flat overlooking the British Museum at 62 Great Russell Street and belonged to a minor painter named Frederick Jameson. This studio may have been better than his own, where the light was sometimes vague and foggy, but his main reason for going to Great Russell Street was his feeling that a new locale might change his luck. Perhaps now he would do what for a year and a half he had failed to accomplish on Lindsey Row, bring a picture to completion.

For seven months he lived and worked in Bloomsbury, but, legally and officially, he continued to reside in Chelsea (where the domestic arrangements were administered by his mother). This is how his name appeared in the London Streets Directory for 1869: '2 Lindsey Row. Whistler, J. A. MacNiel [sic].' This was the first instance in which his mother's maiden name, misspelled, formally became part of his own name. In 1865, when he entered the directory for the first time, and again in 1866 and 1868, he had been listed as 'Whistler, James Abbott.' For ten years 'MacNiel' would remain in the directory, and then beginning in 1879 his name would be spelled correctly.

On Great Russell Street he was no more productive than on Lindsey Row. He still couldn't finish anything. For a while he had a model, Gussie Jones, but after a few weeks, because of increasing frustrations and weakened finances, he sent her a note saying, 'I am obliged to put off working from you for the present, but will write to let you know when I am able to go on again.'[6]

He never posted a follow-up message, presumably because in Bloomsbury he was not 'able to go on again.'

These vain attempts to complete a picture seem not to have adversely affected his disposition. During most of Whistler's residency in Bloomsbury, Jameson was in America, but for a few weeks the two men shared the flat, and, Jameson said, 'It would be impossible to conceive of a more unfailingly courteous, considerate, and delightful companion. I never heard him complain of anything. His courtesy to servants and his model was particularly charming, and I can't conceive of his quarreling with anyone without real provocation.[7]

As an artist, Jameson said, Whistler was:

very different from the self-satisfied man he is usually believed to have been. He knew his powers, but he was also painfully aware of his defects – in drawing, for instance. We had some striking talks on the subject. I think he was the most absolutely truthful man about himself that I ever met.

136

*　　*　　*　　*

Whistler returned to Lindsey Row in the middle of 1869, the year in which the Royal Academy occupied its new home, Burlington House, in Piccadilly. On the day of the grand opening, 3 May, he wrote to Lucas, 'I am sorry to tell you that I have been unable to complete my work for this year's exhibition – *tant pis* – for I should much have liked to have been among the set in this new place.'[8]

During this futile period, he frequently approached Lucas and other friends for small loans. On 23 March 1868, for example, he wrote to Luke Ionides, 'I want to borrow fifteen pounds! Do like a good fellow send me a cheque tomorrow.'[9] It arrived at once. On 12 October 1868 he asked Ionides for another ten pounds 'by tomorrow.' It came with a polite reminder that the earlier loan was still outstanding.

'I am very shocked,' Whistler wrote, 'to find that I still owe you that amount – that is too neglectful for any excuse. Look like a good fellow in your cheque book and tell me how it was left unnoticed that I may never be so careless again.'[10]

People like Ionides were good for small sums. For larger loans there was Thomas Winans. Usually Winans responded unhesitatingly to Whistler's pleas, but in the middle of 1869 he expressed some surprise at a particularly sizable request.

Whistler acknowledged Winans's right to be taken aback, but, he said, his financial difficulties had not resulted from 'ill success in my profession.' He could paint pictures that would be profitable, but he would never be content to produce 'what merely would sell.'

If dissatisfied with something, he would not let it leave his studio: 'I had a large painting far advanced toward completion, the owner delighted and everyone highly pleased except myself. And so I wiped it clean, scraped it off the canvas and put it aside. I shall begin it all over again from the very beginning.' [He was referring to one of the 'six projects.']

During the preceding years he had completed nothing because he had been 'absorbed in study,' and 'the education I have been giving myself will show itself in the future.'

He concluded, 'If you are not tired of helping me, as well you might be, five hundred pounds will carry me through these difficulties.'[11]

He got the five hundred.

He was still working on his worrisome draped figures. Only one of them ever approached completion, and it was erased.

Finally in 1870, after three years of frustration, he abandoned this scheme. His affair with classicism was over.

19

Exhibiting Again at the R. A.

[1870]

In March 1867, William Rossetti had written in his diary, 'Whistler's picture of four Japanese women looking out on a water-background is as good as done, and in many respects is very excellent.'

This picture had been virtually complete in 1865, when Whistler was still obsessed with Japanese art. The women are seated on a balcony, drinking tea. Along with the tea service and the women's gowns, there are such Oriental objects as a fan, a screen, and a three-stringed musical instrument. Again the props are Japanese, and the women, except for their clothing, are obviously Western. The background is what Whistler saw from his home – chimneys, factory roofs, smokestacks, and a gray sky. Even with the gray sky, it is one of Whistler's most brightly colored paintings. He called it *The Balcony*.

In the spring of 1870 *The Balcony* was still in his studio. He had to get back onto the exhibition scene, and, with nothing else readily available, he sent it to the R. A. It was accepted, his first work to hang in Burlington House.

This painting is small, but well placed and brightly colored, it was seen by virtually everyone. The verdict was evenly split.

London's premier 'quality' afternoon newspaper, the *Pall Mall Gazette*, called it 'brilliant and audacious,' an 'intricate gaiety of harmony.' The *Graphic* said it was 'a bouquet of colour, arranged by a master hand.' The *Standard* praised 'the wonderful exactness in the colours, carpets, flowers, and costumes, realised in a masterly style that calls to mind the hurried sketches of Velasquez.'

As for the detractors, *The Observer* proclaimed it 'a strange affair,' the *Art Journal* said it was 'singularly slight,' and the *Illustrated London News* wrote it off as 'a mere decoration.' The author of a pamphlet on the show, somebody named A. Gutherie, saw 'another of Mr Whistler's incomprehensible Japanese subjects,' a 'slovenly sample of affectation destitute of every quality we should expect to see in a work worthy of being hung on these walls.'

Several reviewers had become sick of his 'Japanese' pictures and cried out, so to speak, 'Enough!'

On this last point, Whistler would not have argued. He never again painted a 'Japanese' picture.

One feature of *The Balcony* escaped everyone's notice, the signature.

Whistler had constantly experimented with the way in which he signed his pictures. His early works were inscribed J. W., J. A. W., J. M. W., J. McN. W., Whistler, J. Whistler, J. A. Whistler, James Whistler, and James Abbott Whistler. In the late sixties he decided that his initials or name weren't enough. After much trial and error, he came up with a design that he inserted tentatively in the lower right-hand corner of *The Balcony*. Stiff and impersonal, it was understandably undetected. Later it would gain individuality, flexibility, conspicuousness, and would become James Whistler's distinctive trademark.

It was, of course, the butterfly.

20

Moonlight on the Thames

[1870–71]

On 17 July 1870, Whistler asked his solicitor to inquire about a house in the King's Road, which he was 'anxious to take at once.'[1]

He was as serious as he had been about the flat in Paris. He was still fidgety.

He didn't complete anything in 1870 nor in the spring of 1871. For the fourth straight season he had nothing for a winter show, and for the third year in four he sent nothing to the Academy.

In 1871, the only public notice of his work was another tribute to the Thames etchings, lately published in a portfolio. An article, 'A Whistle for Whistler,' appeared in a publication that hadn't heretofore paid much attention to him, *Punch*. Because he had 'immortalised Wapping and given it a grace beyond the reach of anything but art,' *Punch* urged 'all lovers of good art and marvellous etching' to 'invest in Whistler's portfolio.'[2]

These etchings went as far back as 1859, and none had been done later than 1863. Now in the summer of 1871, Whistler at last decided to return to his truest stimulus, the inspirer of his best etchings. He started two paintings of the Thames, and he finished them quickly, his first completed pictures in more than four years.

Whistler's art always had been, and always would be, a chronicle of his impressions of his surroundings. Earlier, downstream, the impressions had been presented objectively and realistically; now, in Chelsea, his work was personal and subjective. The two new pictures embodied views of the river from Lindsey Row at midday and at sunset. They were called *Variations in Violet and Green* and *Harmony in Blue-Green Moonlight*.

In a letter to her sister Kate, Anna described the creation of the *Harmony*.

She and Jimmy had gone by boat to Westminster, and after 'sauntering through St. James's Park' and riding in an open carriage, they returned home an hour before sunset, with the river 'in a glow of rare transparency.' Excited by

what he saw, Jimmy rushed upstairs to his studio. Anna helped 'by bringing the tubes of paint he pointed that he should use.' She then stood and watched.

'I was fascinated by what he was doing with his magic brushes,' she wrote, 'till the bright moon forced us from the window, & I exclaimed, O Jemie dear, it is light enough for you to make this a moonlight picture of the Thames.'[3]

This was precisely what he did.

* * * *

Reminiscent of Valparaiso, Whistler's river pictures of 1871 are unlike anything he had yet done in London. There are few explicit details. The *Harmony* presents only a hint of river surface and, reflected in the river, a shadowy mass of dimly lighted buildings. The daylight picture has the faint figure of a mudlark and a barely recognizable barge.

With zest he entered the fifth annual Winter Exhibition of Cabinet Pictures in Oil, commencing late in October at the Egyptian Hall, in Piccadilly at the corner of Bond Street. This was the Dudley Gallery, which, after Gambart's recent retirement, had the best of the winter shows.

Just before the opening, he heard from Edward Poynter, who was now a pillar of the art establishment.

I went to the Dudley, [he said] but too late alas! for the pictures were hung. One of yours is properly placed, but the 'moonlight' seems to have riled the hangers, for they have placed it badly. I admire both paintings very much, especially the moonlight, which renders the poetical side of the scene better than any moonlight picture I ever saw.[4]

A couple of important critics also liked them.

For the *Pall Mall Gazette's* reviewer they were 'a most astounding success,' demonstrating 'the most delicate and evanescent kind of truth' and 'miraculous sensitiveness' that 'any master might envy.'

This was good. *The Times* was even better. Its principal art critic, Tom Taylor, understood the musical titles, incorporating a theory 'that painting is so closely akin to music that the colours of the one may be used like the sounds of the other,' and 'that painting should not express dramatic emotions, epic incidents of history, or record facts of nature, but should simply stir our imaginations by subtle combinations of color.' The works themselves, Taylor said, were 'marked with an individual stamp, the rarest thing in pictures today' so that 'even those who entirely dissent from the painter's theory will feel their beauty and charm *sui generis*.'

There were, to be sure, negative notices. The weekly *Queen*, established in 1861 as a journal for women, informed its readers that the pictures showed 'an

artist amusing himself with colour.' And the *Morning Advertiser's* reviewer saw 'two of the most eccentric productions that Mr Whistler ever exhibited.'

Whistler was not at all disturbed by the unfriendly opinions. When the new year of 1872 arrived, he was more self-confident than at any time since returning from Chile. 'He is an early riser now,' Anna told a friend, 'that he may enjoy a row on the river from 7 until 8 o'clock when he joins me for breakfast.'[5]

After breakfast he went directly to his studio. There was no more talk about moving from Lindsey Row. James Whistler was back where he belonged, looking out upon the River Thames.

21

'Whistler's Mother'

[1872]

On 20 March 1872, Whistler received an offer from the South Kensington Museum to paint a decorative series of artists' portraits for its south court.

For whatever reason, he did not accept the commission. One thing is certain: his rejection did not indicate a distaste for portraits.

Only a week earlier, Anna had told a friend that 'Jemie is perfecting the portrait of Mr [Frederick] Leyland and trying to finish a beautiful life size of Mrs Leyland. They must be sent to the Royal Academy the first or second day of April.'[1] Leyland was a Liverpool shipping magnate, Rossetti's patron who had bought La Princesse, the picture with the large pre-butterfly signature.

It is not clear why Anna said that the portraits were going to the Exhibition because she knew they wouldn't be ready for it. She had in fact just told Leyland that her son was convinced:

> that he should only ruin your portrait by persevering in vain endeavors to finish it, mortifying tho it be to him that it is not to be exhibited this season. If energy and industry could have accomplished it, he might have. He has worked so hard night and day to please you who have been so indulgently patient by gaining a place in the Royal Academy. He has tried hard to make it the perfection of Art, but it has become more and more impossible to satisfy himself.[2]

According to an acquaintance of both men, 'Leyland said that when he stood for the portrait, Whistler nearly cried over the drawing of the legs and bitterly regretted that he hadn't learned something of the construction of the human form during his student days.'[3]

Although this full-length portrait, commissioned in 1870, couldn't be shown in 1872, Whistler wasn't excluded from the big summer show.

He had a portrait there, the portrait of his mother.

143

* * * *

'Those who saw him with his mother,' said Rossetti's friend the painter Val Prinsep, 'were conscious of the fact that the irrepressible Jimmy was very human.'[4] Every Sunday morning, for example, he escorted her to the picturesque, red-brick towered medieval house of worship at the corner of Cheyne Row and King Street, where Sir Thomas More had been a parishioner, Chelsea Old Church. Afterwards he returned to bring her home, except on those infrequent occasions when he sat with her during the services.

'Sometimes,' Prinsep said, 'Mrs Whistler must have been trying to her son. Yet Jimmy, though he would give a queer smile when he mentioned them, never objected to the old lady's strict Sabbatarian actions.'[5] And he never complained about her.

On her part, Anna adjusted surprisingly well to her son's lifestyle. As the Pennells said, 'Given her taste for an orderly life of meals on time, elaborate preparation for the Sabbath and its strict observance, and for a house uncluttered by comings and goings of strangers, it is remarkable that she adapted to his haphazard ways.'[6]

Anna served as her son's hostess and entertained visitors when he was too busy to see them. 'I have to be agreeable to his friends and patrons,'[7] she told a friend, and the woman who had abhorred social affairs in St Petersburg was always hospitable to callers at Lindsey Row. Even on Sundays.

It was only natural for Whistler to paint a portrait of his mother. Actually as early as January 1867 he wrote to Fantin, 'I will have the portrait of my mother photographed and I will send you a proof. I am thinking of sending it to the Salon.' *[8] Nothing is known of this picture except that it has vanished.

The portrait, the one that everyone knows, came about by chance.

In October 1871 he was doing a commissioned portrait of a fifteen-year-old girl. After a few sittings, she had an accident and became incapacitated.

'Poor Jemie did not talk about it,' Anna told Kate, 'but I saw his misery. But he is never idle. If he fails in one attempt he tries another.'[9]

When it was clear that the girl would not appear for a while, he said, 'Mother, I want you to stand for the picture. This is what I have wanted to do for a long time, paint your portrait.'

Anna had not been feeling well, but, she told her sister, 'I never distress Jemie by complaints, and I stood bravely two or three days – I stood still as a statue!'

Finally she became exhausted, and he let her sit down. That was the only reason for the seated position.

'Jemie had no nervous fears in painting his Mother's portrait,' Anna told Kate, 'for it was to please himself and not to be paid in other coin.'

Two or three times he was disheartened. 'I can't get it right,' he exclaimed. 'It is impossible to do it as it ought to be done.'

But he persevered, and in a few days it was finished. 'Oh, Mother,' he said, 'it is beautiful.'

<center>*　　*　　*　　*</center>

Created by accident, the painting was almost destroyed in an accident.

Whistler took it to Liverpool to show it to the Leylands. On the return trip, the luggage car of the train caught fire.

> Many valuable packages were entirely consumed, [Anna reported.] The flames were discovered just as they reached my portrait. The lid of the case holding it was burned, a side of the frame was scorched, but the painting was uninjured. I was thankful for the Interposition that my dear Jemie was spared the loss of his favorite work. I hope it is a favorable omen for the Royal Academy.[10]

It has often been said that this portrait was initially rejected by the Academy and was accepted only when Sir William Boxall threatened to resign if it were turned away. George Boughton was on the scene and provided an accurate account of what really happened:

> The portrait was hung where one saw it during the exhibition, but during the last look round one hanger thought that as it was life size it would look as well a bit higher, and then some smaller things could go *under* it. Sir William Boxall, who placed it, vowed that he 'wouldn't play' if it was *touched*, so it remained.[11]

The catalogue listed it as *Arrangement in Grey and Black: Portrait of the Painter's Mother*. Concerning the double title, Whistler said, 'To me it is interesting as a picture of my mother, but what can or ought the public to care about the identity of the portrait. It must stand or fall on its merits as an "arrangement."'[12]

This was innovative, and no branch of painting needed a new approach more greatly than portraiture, a genre that for years had elicited complaints from critics. In this context, the current exhibition was typical. As always, portraits outnumbered everything else, and as always most of them, in the words of the *Illustrated London News*, 'concern nobody but those whose vanity they minister.'

What about Whistler's entry? What was the response to this most famous of all post-Renaissance portraits? Was it recognized as something out of the ordinary?

Interestingly, at least seven major reviewers took no note of it. The *Illustrated London News*, for example, mentioned eleven portraits 'which struck us as of a high character,' but they did not include the *Mother*. And it was ignored by the afternoon *Echo*, which cited by name 23 other portraits.

<center>145</center>

Of twelve publications with space for Whistler, only one was totally negative, the *Telegraph*, which dismissed his picture as an 'unseemly eccentricity.'

The other reviews were mostly mixtures of praise and blame. *The Times* 'liked the quiet harmony among the discords,' but complained that 'the head lacks solidity.' The *Graphic* lauded the 'ingenuity in achieving so much with such limited means,' but regretted that 'the limitations result from caprice, not from necessity.' The *Guardian* called the picture a 'successful conundrum' but censured Whistler for 'fettering himself with self-forged shackles.' The *Examiner* was astonished that he could 'accomplish so much with just two colours,' but wondered why he had 'restricted himself to these colours.'

One critic was unconditionally admiring, the highly respected Sidney Colvin. Writing for *Cornhill Magazine*, he referred to Whistler's 'amazing natural genius' and 'unequalled sense of harmonies,' and said that in this picture the 'qualities of feeling are irresistible,' that 'nothing can be truer than the patient fold of the aged hands and the pathetic calm of the aged face,' and that it was 'astonishing how all this black colour should be kept so clear and luminous.'[13]

The picture led several writers to take off on flights of fancy. The *Saturday Review* conjectured that the sitting posture had been 'suggested by two famous statues – the portrait of Agrippina in the Capitol and Canova's portrait of the mother of Napoleon I at Chatworth,' neither of which Whistler had ever seen. And for the *Academy* the 'voluntary renunciation of any attempt to rouse pleasurable sensations by line and colour' created 'a vision of the typical Huguenot interior – protestantism in a Catholic country.'

As a final observation, is it not an irony of ironies that James Whistler, of all people, succeeded in creating what has become, along with the *Mona Lisa*, one of the world's two most celebrated easel paintings?

22

Nocturnes

[1872–73]

Someone once spoke to Whistler about an 'animal painter.' He retorted, 'No real artist can be an animal painter or a portrait painter or a tree painter. A true artist can paint everything he sees.'[1] That is what he consistently did, going from one type of a picture to another. Thus in mid-1872, while the *Mother* hung in Burlington House, he turned to paintings of the night.

Originally he called these works 'Moonlights,' and then, at the suggestion of Leyland he gave them their lasting name, 'Nocturnes.'

> We often stayed up all night with him, rowing him about, [one of the Greaves brothers recollected.] When he came to a view which interested him, he would stop and sketch it with white chalk on brown paper, showing the positions of the lights and river banks and bridges. Then he'd start laughing and talking again. The next day I'd go to his studio and see it all on the canvas.[2]

'Don't ever forget,' he told the Greaveses, 'I invented moonlights. Never in the history of art had they been done.'

He conveniently forgot about van der Neer's moonlight pictures in the Hermitage.

Another companion, Thomas Way, remarked that painting nocturnes 'was as difficult as training for a foot race.' He recalled walking along the river at nighttime with Whistler until they encountered a site that whetted his imagination. They would stop, and for a few minutes Whistler would scrutinize the scene. Then he would turn his back on the river and speak in this fashion. 'The sky is lighter than the water. The houses are darkest. There are eight houses; the second is lowest and the fifth is highest. The first has two lighted windows, one above the other; the second has four.'[3]

When he made a mistake, he would 'wheel about, correct his mistakes, turn

his back, and begin again. And so it would go till he was right. Then he would say, "Good night," and on the next day he would paint his nocturne.'

* * * *

In November 1872 at the Dudley Gallery, Whistler exhibited his first two nocturnes.

These subjective impressions of the Thames perplexed, provoked, bored, and, in a couple of instances, captivated the critics.

The reviewer for the staunchly conservative *Art Journal* said that these pictures, with 'unpardonably affected' names [*Nocturne in Grey and Gold* and *Nocturne in Blue and Silver*] were 'such as never have been seen in any exhibition.' Perhaps Whistler was 'trying to see to what extent the public will tolerate eccentricity in art.'

Another fine arts periodical, the *Builder*, called them 'conjuring tricks' with 'moonshine, moonshine!' The *Illustrated London News* said that 'music so monotonous could not possibly be listened to.' And the *Saturday Review* was reminded of Paganini rather than Beethoven because 'like Paganini, Mr Whistler plays on just one string.'

Stephens, however, saw 'marvellously subtle symphonies of colour.' And Tom Taylor, while acknowledging that the pictures would 'mystify' most viewers because they 'require a disciplined perception to follow,' said that for 'the few' they would be 'delicacies' with 'rare, unquestionable qualities of truth and beauty.'

* * * *

After the show in London had ended, the nocturnes were shipped over to a small private gallery in Paris.

Whistler told Lucas about them in a letter that called attention to another innovation. 'My frames,' he said, were 'as carefully designed as my pictures,' because they 'carry on the harmony.' Since this was 'entirely original,' something that 'had never been done before,' he wanted it 'clearly stated in Paris' that he had invented 'this kind of decoration' so that 'a lot of clever little Frenchmen' wouldn't be 'trespassing on my ground.'[4]

He also asked Lucas to 'fight any battles for me with the painter fellows you may find opposed to my pictures – of whom there will doubtless be many.'

Lucas didn't have to say or do anything. No one in Paris opposed his pictures. No one indeed seems to have seen them.

23

Two Great Portraits

[1872–73]

In the early seventies, along with the nocturnes, Whistler did full-length portraits. Two were of mature women, Mrs Louis Huth and Mrs Frederick Leyland.

The portrait of Mrs Huth, married to a wealthy City businessman, was done mainly in the summer of 1872, when she stood for three hours a day. It was completed early in 1873 and sold to Huth for 600 guineas.

Mrs Leyland's portrait had been intended for the 1872 R. A. Exhibition but wasn't finished until 1874, perhaps because Whistler's interest was less in the picture than in Mrs Leyland herself, of which more will be said later. It was painted in Liverpool, and for a while he was almost a commuter on the express train out of Euston.

These are good pictures, as is the contemporaneous portrait of his brother William, but they are overshadowed by two works which, with the *Mother*, stand out as Whistler's 'Big Three' paintings in this genre.

* * * *

William Claverley Alexander was a London banker who saw the *Mother* at the R. A. and then sought out the artist and commissioned portraits of four of his six daughters.

In the summer of 1872, Whistler began with ten-year-old May, whose portrait would be painted in Aubrey House, the Alexander home in Kensington. She was to wear a riding habit, and the costume was a matter of importance to Whistler. He wrote to Mrs Alexander,

> There is a shop in South Audley Street, No. 63, who have charming felt hats, and feathers, that you cannot get elsewhere. Perhaps if you were to call you might see something lovely for May – large I should have it, with a soft brim, looped up with a large feather. [He drew a sketch of what he had in mind.] I think it would

be charming to paint May with the hat on, the feather swooping grandly away! The habit will be black, I suppose, and the hat black felt or grey with white feathers and a black arrangement.

I offer to inflict myself upon Aubrey House for a week or so, and get at the picture every morning.[1]

He didn't get very far with it. After a couple of sessions May became ill, further sittings were deferred, and he never returned to the painting.

Just as the indisposition of one girl led to the creation of the *Mother*, this second girl's malady would clear the way to another masterwork.

In August 1872 Whistler wrote to Alexander, 'If you will not think me too capricious, I wish that you would bring the little fair daughter to my studio.'[2]

He was referring to eight-year-old Cicely, blond and with a lighter complexion than May, whose portrait would be done in Lindsey Row.

Again he was meticulous about clothing. After Mrs Alexander had sent a sample of the material she intended to use for Cicely's dress, Anna wrote to her, 'The Artist is very sorry to put you to any additional trouble, but his fancy is for a rather clearer muslin. I think Swiss book muslin will be right so that the arms may be seen through it. It should be without blue, as purely white as possible.'

Her son then took up the pen.

If possible, [he wrote,] please get fine Indian muslin. You might try a second hand shop, Ked's, in a little street off Leicester Square, on the right hand corner of the Alhambra as you face it. The dress might have frills on the skirt and about it – and a firm little ruffle for the neck, or else lace. And it might be looped from time to time with bows of yellow ribbon.[3]

Whistler sometimes said that his pictures 'grew.' Of none was this more true than the portrait of Cicely Alexander. He began early in September and worked steadily until the end of the year. Accompanied by her mother, Cicely came to his studio two, three, four times a week, for more than 70 sittings.

Because he could require dozens of sessions for a single-figure picture, Whistler has been called 'the Flaubert of painters.'[4] As the novelist searched for *le mot juste*, so the painter strove to catch the perfect expression.

His theory, regarding portraits as arrangements of colors, often caused him to forget that his sitters were human beings. Years later, Cicely recalled her ordeal:

I considered that I was a victim all through the sittings, or rather standings, for he never let me change my position, and I sometimes stood for hours at a time. I would get very tired and cross, and often finished the day in tears.

He used to stand a good way from his canvas and then dart at it, and then dart back. He often turned round to look in a looking-glass that hung over the

mantelpiece at his back to see the reflection of his painting. Although he seemed inhuman in letting me stand for hours and hours, he was most kind in other ways. If a blessed fog came up from the river, and I was allowed to get down, he never objected to my poking about among his paints. I even put charcoal eyes on some of his sketches of portraits in coloured chalks.

Mrs Whistler presided over delightful American luncheons, but she never came into the studio. A servant would tell him that lunch was ready, but we would go on as before, and it was generally tea time before we went to our lunch of hot biscuits and tinned peaches and other unwholesome things.[5]

Sometimes Cicely would lose her temper. When one of his later girl models became exhausted and exclaimed 'Damn!' Whistler laughed and said, 'Amazing! But you are not the first *jeune fille* who has said that to me. Little Miss Alexander stamped her foot on the floor and shouted, "Damn! damn! double damn! And I don't care if you tell my mother!"'

About a year after the picture had been done, Whistler asked Mrs Alexander, 'Has Cissie forgiven me yet?'[6]

She should have been forgiving. Her portrait, showing her standing in profile to the left, face turned toward the viewer and one foot extended forward, has been the most enthusiastically acclaimed of all of Whistler's pictures. It has been repeatedly compared to the work of the Velasquez because on this occasion the American did indeed rise to the level of his Spanish master.

* * * *

Before he had finished *Cicely*, Whistler was looking ahead to what would be his third great portrait.

Thomas Carlyle, a lifelong resident of Chelsea, approaching his eightieth year, hated to sit for portraits and had to be maneuvered into becoming Whistler's subject.

'Madame Venturi, a mutual friend,' Whistler related, 'brought him to meet me. The *Mother* was there, and he seemed to feel in it a certain fitness of things, as Madame Venturi meant he should. He liked its simplicity, and he agreed to be painted.'[7]

Whistler had decided on a position similar to his mother's, and one painting would be a pendant to the other. Carlyle would be dressed in black. A hat would rest on a brown coat draped over his knees, and he would hold a cane in his right hand. The painting would be called *Arrangement in Grey and Black, No. 2.*

When he first appeared in Lindsey Row, he sat down at once and said peremptorily, 'And now, mon, fire away.'

Soon after the sittings had begun, William Allingham, a minor poet and friend of Rossetti, wrote in his diary, 'Carlyle says that if he makes any sign of changing his position, Whistler screams in an anguished voice, "For God's sake,

don't move.'' Carlyle said that Whistler's anxiety seemed to be to get the *coat* painted to perfection; the face went for little.'[8]

With two strong-willed, highly opinionated men, one might have wondered if this undertaking could possibly succeed, especially since Whistler demanded numerous sittings after assuring Carlyle that no more than two or three would be needed. And yet no really serious friction developed. When the picture was nearly finished, Carlyle's niece wrote to Whistler,

> I send this note to say that even my Uncle is impressed with the portrait. He remarked when he returned from his last sitting that he really *couldn't help* observing that it was going to be like him, and that there was a certain *massive originality* about it which was rather impressive.[9]

Carlyle himself expressed a rather different opinion to an American friend. After referring to Whistler as 'the most absurd creature on the face of the earth,' he called the portrait 'a fatuity . . . unfinished after many weary sittings . . . a portrait not of my features but of my clothes, which seemed to occupy the strenuous attention and vigorous activity of my singular artist all the while.'[10]

If he really believed that it was a 'fatuity,' his opinion was almost uniquely his own. *Thomas Carlyle* is one of the most celebrated portraits of the nineteenth century, qualitatively only a hair's-breadth behind *Cicely Alexander*.

<div align="center">* * * *</div>

Each of the 'Big Three' portraits had a musical title. (*Cicely's* alternate name was *Harmony in Grey and Green.*) But they are indisputably more than 'arrangements' of lines and colors. In each of these paintings, Whistler captured his sitter's personality and presented a perceptive, sympathetic, suggestive interpretation of character. This is the main reason for their enduring fame.

24

A One-Man Show and a Controversy

[1873–76]

For five years after the *Mother's* appearance at the R. A., Whistler stayed away from summer exhibitions and concentrated on winter shows.

The *Saturday Review* may have explained this preference. In November 1873 it said of London's many winter exhibitions,

> Seldom has mediocrity been so greatly multiplied. New ideas are scarce, and old conceptions grow more trite through repetition. The vast majority of the pictures look like vague generalizations of something half remembered, or hasty sketches of muddled thoughts. Winter exhibitions have become a refuge for such abortions.

And, as at the Salon des Refusés, the few good pictures couldn't but be noticed.

Whistler went with the best of the bad lot, the Dudley Gallery and the Society of French Painters, which used the Bond Street branch of Paris's Durand Ruel Gallery.

In 1873, both shows opened early in November, each with one of his paintings but without the artist himself. He spent late October and much of November in bed, suffering from a recurrence of rheumatic fever.

Because of his illness, Whistler didn't hear about a lecture in Oxford. Referring to a painting that had been hung a year earlier in the Dudley Gallery, the speaker said, 'I never saw anything so impudent in any exhibition as that daub professing to be a "harmony in pink and white," or some such nonsense, absolute rubbish which took about a quarter of an hour to scrawl. The price asked was 250 guineas.'

This was the first public notice of James Whistler by Oxford's Slade Professor of Art, John Ruskin.

No such colorful language was prompted by his current Dudley Gallery entry, an unimportant view of Battersea Reach done in 1871.

For the French Artists, his offering, painted at Trouville in 1865, was less provocative for its subject than for its title, *A Yacht Race, a Symphony in B Sharp*.

'Mr Whistler,' said *The Observer*, 'has advanced beyond his usual pleasantry about music and painting by perpetrating a pun into the bargain.' The *Hour* called it a 'feeble pun.'

Upon recovering from his illness, Whistler wrote to the *Athenaeum*, agreeing that the title was 'senseless,' but denying that he had had anything to do with it.

C. E. Deschamps, manager of the Society of French Artists, then wrote to him, 'At the back of the picture is a small label with the following inscription: "The Yacht Race: A Symphony in B Sharp. (signed) J. Whistler." I naturally copied this inscription, wishing to give your own title, knowing how particular you are about such things.'[1]

Inevitably, this incident is reminiscent of the Berners Street Gallery, *The White Girl* and Whistler's 1862 letter to the *Athenaeum*.

* * * *

Whistler had appeared only minimally in the winter of 1873–74; he was saving his best work for the spring. *A la* Gustave Courbet, he was holding a one-man show.

Several critics endorsed the idea. The *Globe's* fine arts commentator said that a painter who was 'very clearly different from others,' needed to have his work 'estimated by itself' in order to be 'carefully considered and fairly viewed.' Sidney Colvin, in the *Academy*, judged that an artist was justified in doing this if his paintings 'required delicate organs to appreciate,' and had received 'scant welcome at the hands of art's official censors.' This was 'Mr Whistler's case.'[2]

The site was the small Flemish Gallery, in Pall Mall. There were 13 oil paintings, including the 'Big Three' portraits and several nocturnes. Twelve had musical titles. There were also three sketches, 36 drawings, and 50 etchings.

The exhibition was 'worth going to,' the *Illustrated London News* said, 'just for the room itself.' The Manchester *Examiner* spelled out the details: 'On the floor is a matting in two shades of yellow; couches and chairs dispersed about the room are light maroon; the walls are maroon and white; on steps and ledges are blue pots of flowers and plants; and the light is subdued and mellowed.'

The pictures were generally well received, particularly the 'darling' of the show, young Cicely. Everyone raved about her portrait, and almost everyone mentioned Velasquez, with whom the *Pall Mall Gazette* said, Whistler could justly 'claim kinship.'

* * * *

The linkage of Whistler and Velasquez calls to mind a well-known anecdote. A

woman told him, 'There are only two great painters, you and Velasquez.' To which he replied, 'Why drag in Velasquez?'

The story has been often cited to illustrate Whistler's conceit and his indifference to all art but his own.

William Chase, an American who knew him late in life, asked him what he had meant by his response.

'I simply wanted to take her down a bit,' Whistler said. 'You don't think I would couple myself with Velasquez, do you?'

As Chase observed, 'It was his way of checking flattery so fulsome as to be nauseating.'[3]

But he never publicly expounded on his words. He took a somewhat vicious pleasure in being misunderstood.

Whistler's real feelings about Velasquez came forth in a June 1874 letter to the *Hour*, whose favorable critique of the one-man show had ended with a 'melancholy reflection that the best works are not of recent production.' In his letter Whistler noted that the most highly praised pictures had been 'just completed,' including 'the "full-length portrait of a young girl" which your reviewer overwhelms me by comparing me to Velasquez.' The letter ended, 'marvelling greatly that your critic speaks of me in the same breath with Velasquez, I remain your obedient servant . . .'

* * * *

Whistler could not complain about the response to his show by the critics who were there. But he could and did grumble about those who were *not* there. Invitations had been sent to all of the usual reviewers, but the exhibition was not mentioned by *The Times*, the *Athenaeum*, the *Art Journal*, the *Telegraph*, the *Standard*, *The Observer*, or the *Saturday Review*.

Also, Anna told a friend, the show did not bring in 'money in proportion to the expenses attendant upon it.'[4] Whistler in fact lost money, and many years would pass before he would do this again.

* * * *

His first public appearance after the one-man show was in an exhibition in Brighton in the summer of 1875 in which the only other well-known entrant was Leighton. He had two nocturnes there, including *Blue and Silver: Old Battersea Bridge*, his impressionistic painting of the bridge, shaped like the letter *T*.

The Brighton *Gazette's* reviewer was remarkably perceptive:

Everyone will be struck by two studies of evening scenery, all blue, and not a few may be inclined to ridicule them. Some will be amused to find one of them valued at three hundred and the other at four hundred pounds! Viewed by close inspection, they appear like bad attempts at scene painting, heavy loads of colour

dashed with a few intermediate forms and nothing more. But if we retreat to a distance and let the subject grow upon the eye, the charm of the work comes out and the significance of every stroke tells. There is nothing superfluous, nothing wanting; nature is painted in so few strokes that they can be almost counted, and with the use of a single colour. The works illustrate how much may be done with a few strokes, and how simple are the requirements of nature if only she be rightly interpreted.[5]

<p style="text-align:center">❖ ❖ ❖ ❖</p>

A few months later, two nocturnes were exhibited at the Dudley Gallery. The *Blue and Gold, No. 3* is a summer evening impression of the Thames from the Houses of Parliament. The *Black and Gold, the Falling Rocket* shows fireworks at Cremorne Gardens, with nothing recognizable, only multi-colored daubs and spatters resembling confetti falling from the sky.

Hardly any reviewers liked them. To the *Illustrated London News* they were 'willful eccentricities.' The newly established *World* called them 'smears and smudges.' The *Architect's* commentator saw 'deliberate caprices.' The *Saturday Review* found their 'musical equivalent' in 'the drawl of Nile boatmen.' The *Daily News* asked, 'Was the artist sane when he sent them in, or is he merely poking fun at us?'

In *The Times* and the *Athenaeum*, however, Taylor and Stephens were still supportive. Taylor found 'real beauty and suggestiveness' in the paintings, while for Stephens they were 'examples of high and precious art.'

There was at least one other partially favorable response. After the show had closed, Whistler told a friend that 'my much blackguarded "masterpiece" the "Nocturne in blue and Gold" has sold itself to a total stranger for the price named [200 guineas]. So you see this vicious flippancy is not doing its poisonous work.'[6]

Its companion picture, *The Falling Rocket*, would remain unsold until 1892. No one in the 1870s would buy *that* painting!

25

The Peacock Room

[1876–77]

Just before the 1875–76 Dudley Gallery show opened, Anna Whistler withdrew permanently to Hastings.

Her son's social life blossomed. Entries from the diary of his friend the museum administrator Alan Cole epitomize his life following Anna's departure:

Nov. 16, 1873. Dined at Jimmy's; Tissot, A. Moore, and Captain Crabb. Capital dinner. General conversation and ideas on art unfettered by principles.

Dec. 7, 1875. Dined at Jimmy's; Cyril Flower, Tissot, Storey. Talked Balzac – *Pére Goriot, Cousin Bette, Jeune Homme de Province a Paris, Illusions, Perdues*. [Since it is inconceivable that Whistler would have remained aloof from this discourse, we have additional grounds for challenging the notion of a non-reading Whistler.]

Jan. 6, 1876. With my mother and father to dine at Whistler's. Mrs Montiori, Mrs Stanfield, and Gee there.

March 25, 1876. Round to Whistler's to dine. Mrs Leyland and Mrs Galsworthy there.[1]

And so it went. Dinners at home. Dinners at other people's homes. Dinners in restaurants.

Unless an 'eminently respectable' guest, most particularly an art patron, was being entertained, Jo was present as his hostess at Lindsey Row. When he dined out as an invited guest, except at the homes of Bohemian friends, he was usually alone. At restaurants he generally shared a table with from one to three male companions.

His favorite restaurant was the Café Royal, in Regent Street. A frequent dining cohort recalled that at the Café Royal he

always ordered the most elaborate meals. He was a great epicure and gave as much attention to his food as to his paintings. He loved complicated dishes, and he always summoned the chef to receive special instructions. It was a pleasure to see him taste dishes that were just to his liking. He smacked his lips, his eyes glittered, and he forgot to talk of enemies and controversies.[2]

Whether at a restaurant or at a private residence, he could not but be noticed. He usually wore a white hat that was inordinately high or had an inordinately wide brim. If dressed in evening clothes, he might have neglected to put on a tie or worn a tie that was large and obtrusive. If he carried a cane, it was unusually long. And always there was the all-too conspicuous monocle.

When visiting private homes, he arrived with a flourish.

I would watch at the window, [one of his hostesses recounted,] until I saw the cab draw up, then wait for him to knock in his own special way, which seemed to speak of importance. [The knocker, used by social visitors, made a resounding sound throughout the house.] He always started softly, so that the first knock could scarcely be heard, then increased it until the final knocks were very loud, one after another in rapid succession.[3]

Even that wasn't enough. In addition to a knocker, outer doors were equipped with a brass bell, which in those pre-electric days was pulled out. Heard only downstairs in the servants' quarters, it was used by tradesmen. And Whistler. After knocking, Elizabeth Pennell said, he 'would give a violent pull at the bell, which he always did wherever he went.'[4]

* * * *

Whistler's most celebrated gastronomic events commenced soon after his mother went to Hastings, his 'Sunday breakfasts,' which we would call brunches.

Contrary to what some writers have said, the Sabbath was not a 'dead day' for him, not even when his mother was present. On Sundays he regularly entertained visitors and painted pictures. Anna remarked on this in her letter to Leyland informing him that his portrait wouldn't be ready for the R. A., even though he had been working at it on the Sabbath:

My son has not the faith in God which is my support. I could not but fear for Jemie's temerity in setting aside the divine wisdom of resting on the Lord's day. I failed in my argument to convince him that he should profit by the day of rest.'[5]

Even so, only after his mother's departure did Whistler inaugurate Sunday breakfasts at Lindsey Row.

Each guest would receive an invitation, inscribed with a butterfly, stating that

'Mr Whistler requests the pleasure of -----'s company at breakfast on Sunday at 11.45 o'clock.'

The number of invitees ranged from ten to 20, and it was usually a motley company.

You would meet all sorts of people there, [one participant recalled,] leading men in the world of art and literature, tenth-rate daubers who adulated him, eccentric people who took his fancy, theatrical people – a menagerie that could rarely have been found anywhere else. These breakfasts were as original as himself or his work, and equally memorable.[6]

No one enjoyed these affairs more than Whistler himself. 'It was a matter of course,' a frequent guest said, 'that he should lead the conversation. He was never so brilliant as at his table, but it was always stories and small talk, nothing ponderous.'[7]

As for the food, 'it was there,' another of his 'regulars' said, 'that I first tasted the delicious buckwheat cakes, corn muffins, and various cereals that make breakfast such a tempting meal in the most hospitable country in the world.'[8] (During the week, Whistler's usual breakfast consisted of two raw eggs in a tumbler, beaten up with salt, pepper, and vinegar, along with toast and coffee.)

* * * *

At about the time that his Sunday breakfasts started, Whistler took on a noteworthy physical feature, the famous white lock of hair. For the rest of his life he would have one conspicuous white lock, dead center and front, which often hung down over his forehead. This was his most celebrated eccentricity, the delight of his caricaturists.

Concerning his hair, all of it, Whistler was obsessive.

Many a time have I been with him to his hair-dresser in Regent Street, [a soon-to-be follower related.] Very serious and important was the dressing of his hair. Customers ceased to be interested in their own hair; operators stopped their manipulations; everyone turned to observe Whistler, directing the cutting of every lock as he watched the barber in the glass.

When the clipping had been completed, he waved the operator imperiously to one side and surveyed himself in the glass, stepping now backward, now forward. Suddenly, he put his head into a basin of water, and, half drying his hair, shook it into matted wet curls. With a comb he carefully picked out the white lock, wrapped it in a towel, and walked about the room for five or ten minutes pinching it dry, with the rest of his hair hanging over his face in decorative waves.

Then a loud scream would rend the air. Whistler wanted a comb! This procured, he would comb the white lock into a feathery plume, and with a few

broad movements of his hand would form the whole into a picture. Then he would look beamingly at himself in the glass, and after saying 'Amazing!' would sail triumphantly out of the shop.[9]

During the period when Whistler was conducting his first Sunday breakfasts, two friends were the subjects of prolonged portraits, Mr and Mrs Frederick Leyland.

He was particularly fastidious about his portrayal of Frances Leyland, a beautiful woman exactly his own age, with hair like Jo's, reddish brown. In August 1875, after visiting Speke Hall, the Leyland home in suburban Liverpool, Whistler thanked her for 'a delightful little holiday.' He was, he said, 'up to my elbows in paint and venture to think but little of Speke Hall, or at once the brush would be dropped for the dreamy cigarette.' He regretted an inability to give her 'the faintest notion of my real happiness and enjoyment as your "guest." '[10]

The letter implies that they had been smoking together, daring behavior in 1875. And one might wonder why *guest* is enclosed within quotation marks.

At the end of the year, her portrait was still unfinished, and she charged him with dilatoriness.

> I feel incumbent as your painter, by devotion, if not by office, [he responded,] to right myself in the eyes of my Royal Mistress.
>
> You may have forgotten a light suggestion of general fog in the methods of one who, if indifferent absolutely to the opinions of all others, has the ambition to be seriously considered by the Artist Princess whose high opinion he has made it his duty to acquire.
>
> It saddens him to think that you should at all accept the popular belief of meretricious and willful eccentricity in the work of the painter you have been so kind to.
>
> May I offer your Royal Highness, as a tribute of devotion and gratitude, a favorite picture of my own which has successfully resisted the danger of sale on more than one occasion, which I send herewith.[11]

Even for someone who worked as deliberately as he did, Whistler devoted an excessive amount of time to this painting on his numerous visits to Liverpool. As for Mrs Leyland, she often travelled alone to London on 'shopping trips,' which always included a rendezvous with her portraitist in her hotel room. All of this combined with the phraseology of his letters leads to an inescapable conclusion: Frances Leyland was Whistler's mistress, and Frederick Leyland was a cuckold. (Some writers have reported that Whistler was briefly engaged to marry Frances's sister. Although he may have feigned interest to beguile Leyland,

he was 'engaged' to Frances's sister in exactly the same way that his father had been a 'major' in the American army.)

<p style="text-align:center">✳ ✳ ✳ ✳</p>

In the spring of 1876 Whistler finally finished Mrs Leyland's portrait, just after he had begun to work on a major project commissioned by her husband.

Frederick Leyland was a prime example of the Victorian self-made man. When he was a small boy in Liverpool, where he was born in 1831, his father abandoned the family, forcing his wife to sell pies in the street. At the age of fifteen Frederick went to work as an office boy for the Bibby Shipping Company. Thirty years later he owned the firm, which had become Frederick Leyland & Company. The family home, Speke Hall, was perhaps the most opulent mansion in greater Liverpool.

In addition to Speke Hall, he had for some years kept a London residence in Queen's Gate until late 1875, when he bought a home at 49 Prince's Gate.

Leyland's new house was typical of Kensington, but he wanted something special. He wished to have it completely redecorated, and then, it was said, he intended to live in London like a Venetian merchant. He engaged the noted architect Norman Shaw to supervise the renovation.

Shaw assigned the dining room to a prominent interior decorator, 49-year-old Thomas Jeckyll. The room was to the left of a large entrance hall and measured 35 by 23 feet, with a 14-foot ceiling. Jeckyll lined the walls with Spanish leather, attached lamps to the ceiling, and installed Oriental shelves for Leyland's collection of china.

After Jeckyll had begun, Whistler was hired to decorate the hall and staircase. He chose brown and gold colors and started on it in March 1876. Upon completing his assignment, finishing almost simultaneously with Jeckyll, he told Leyland that the dining room had been botched. Leyland agreed to let him rework the room and then left for Liverpool.

Without consulting Leyland, Whistler decided on an entirely new scheme of ornamentation, unrelated to what Jeckyll had done. It would have a unifying theme, taken from the plumage of a peacock. He called it a 'Harmony in Blue and Gold,' denoting the only colors to be used.

During the summer of 1876 Whistler expended all of his artistic efforts on the dining room.

'How I am working! – like a nigger,' he wrote to Frances Leyland. 'The other morning I was up at 6, and it was striking the quarter to nine in the evening as I walked away from ladders and paint. I am at it every day, and I am broken down with fatigue. I wonder whether you will appreciate it.'[12] (Not always did he work alone. He conscripted Walter Greaves to help with the painting, for which Greaves never received a word of public recognition.)

He had no false modesty about his efforts.

<p style="text-align:center">161</p>

One day a neighbor, Lord Redesdale, looked in, and seeing Whistler on top of a ladder, asked, 'What are you doing up there?'

'I am doing the loveliest thing you ever saw.'

'What about Leyland? Have you consulted him?'

'No. Why should I? I am doing the most beautiful thing that ever has been done, you know, the most beautiful room!'[13]

For Leyland, Whistler had time for only occasional short progress reports. 'The room,' he told his patron, 'will delight you as it does everybody who sees it' because 'it is perfect.'[14]

He wrote less hurriedly to Mrs Leyland. 'I think of you,' he told her, 'every time I pass the play bills of "Voyage to the Moon" [a play they had seen together on one of her visits to London]. Prince's Gate is so lonely and dismal without you that as I labor through the dismal silence I cannot overcome the sense of being left by you. I miss you dreadfully!'[15]

<p style="text-align:center">* * * *</p>

In its 2 September issue, the *Academy's* 'Art Notes and News,' an unsigned column by William Rossetti, was devoted almost entirely to high praise of Whistler's current project, 'a very interesting experiment in a branch of art where tradition is too apt to exercise extravagant authority.' Since his work was virtually complete, Rossetti said, Whistler would soon make a long-deferred visit to Venice.

After reading the *Academy*, Whistler wrote three letters.

The first went to his mother. 'I must tell you,' he said, 'of the completion of the famous dining room. How I have worked! In another week I can leave and say *I* am content. It is a *noble* work, so very beautiful, so entirely new and original!'[16]

Next he told Leyland that the room was 'alive with beauty – brilliant and gorgeous and at the same time delicate and refined to the last degree.' Within a few days he would be 'off to Venice,' but first he wanted Leyland to come to London 'so that we can enjoy this great work together.'[17]

The third letter went to the *Academy*. After 'reading with gratification the appreciative article,' he wanted to make clear that the original design was by 'that distinguished architect' Tom Jeckyll. 'If there be any quality in my decoration,' he said, 'it is due to the inspiration I may have received from the graceful proportions and lovely lines of Mr Jeckyll's work about me.'

It has been said that when Jeckyll saw the room, he had a fit of insanity and died in a madhouse. In point of fact, he was not displeased with Whistler's work, and he died in 1881 of natural causes.

Toward the end of his life Jeckyll was embarrassed financially. If Whistler had not come to his aid, he told his solicitor, he 'would have been kicked out of the Arundel Club.'

Far from being finished in September, Whistler continued to slave away all through September and the first three weeks of October. Early in October, Leyland was briefly in London, and Whistler told him that because the enterprise had been unexpectedly long-drawn-out, it was only fair to request a payment of 2000 guineas, doubling the sum of their agreement. Informally, Leyland concurred.

On 21 October, Whistler informed Leyland that the work was done, and he asked for the 2000 guineas.

Leyland now expressed regret for consenting to this amount and said, 'You should not have involved me in such a large expenditure on a scheme that was intended to be the work of a few days.'[18]

He was not on firm ground. In the beginning he may have thought it would be a brief exercise, but he could not have so presumed after the first few days. As the work went on, he received progress reports, and occasionally he was in London to see for himself. In his shipping business he had sometimes encountered a similar situation, and because of altered circumstances an agreement had to be revised. It would seem as if an industrial tycoon was trying to drive a hard bargain with a presumably naïve artist.

Whistler had already received £400, and now he got an additional £600 as 'payment in full.' Earlier letters from Speke Hall had ended familiarly, 'Leyland.' The note accompanying this payment was signed 'Frederick R. Leyland.'

Whistler answered,

I have *enfin* received your cheque – shorn of my shillings, I perceive! – another fifty pounds off.

Bon Dieu, what does it matter!

The work alone remains the fact – that it happened in this or that house is merely anecdotal – so that in some future dull Vasari you may also go down to posterity like the man who paid Caravaggio in pennies.[19]

(The sixteenth-century biographer of Renaissance artists Giorgio Vasari related – incorrectly – that Caravaggio had been paid in pennies for his last painting, and then walking home on a hot day, he collapsed under the weight of the money and died.)

As for the payment in pounds rather than guineas, in art transactions it was customary to quote in guineas, but the commercial world was governed by pounds. Perhaps Leyland was trying to save five per cent of the purchase price, but perhaps it was only a misunderstanding.

Additional, increasingly denunciatory, letters passed between the two men, and Whistler continued to work in the seemingly unfinishable dining room, every day in November, December, and January.

Early in January he took time off to complete a questionnaire:

Please name your favorite
 Name – Maria
 Colour – Grey
 Flower – Calciolaria
 Occupation – Whittling
 Recreation – Church and the Royal Academy
 Poet – Mrs Barbauld [Anna Barbauld, an early nineteenth century English poet and essayist]
 Prose writer – Dr. Blair [an eighteenth century Scottish preacher whose sermons were widely read]
 Religious prose writer – Solomon
 Novelist – Ouida [pen name of the prolific Victorian Marie Louise de Ramée]
 Character in history – Mazeppa [a seventeenth century Polish military hero, title character of a poem by Byron]
 Fictitious character – George Washington
 Public character – The bailiff
 French author – Madame de Staël [an early nineteenth century writer of fiction and non-fiction]
 Musical composer – Sankey [Ira Sankey, a nineteenth century American writer of hymns]
 Scriptural character – Michal
 Virtue – Modesty
 The vice you most dislike – Prevarication

It was signed with a butterfly, ' J. A. McN Whistler, 2 Lindsey Houses, Chelsea, Jan. 7, 1877.'[20]

* * * *

A month later, without asking for permission from Leyland, Whistler held a private press view in the dining room.

He handed out a pamphlet entitled *Harmony in Gold. The Peacock Room*. The reporters were suitably impressed.

The *Examiner* could not 'conceive of a scheme of beauty with a higher dignity and distinction' than 'this splendid decoration.'

London Magazine called it 'a unique spectacle of colour,' but warned prospective visitors that 'a blaze' would hit them upon entering, and that to 'prolong one's stay here would be to earn a gorgeous headache.'

The *Pall Mall Gazette's* reviewer also noted 'the brilliancy of the artist's colours' but would no more 'reproach' him for this than he would 'lecture the peacock for its plumage.'

Even after the critics had come and gone, Whistler spent a month on the job. Finally in mid-march 1877 he left the room for the last time.

'I shall run down to see the Mother,' he said, 'and then it's off to Venice.'[21]

* * * *

He did go down to Hastings but put off the trip to Venice in order to be best man at his brother's wedding.

William Whistler was evolving into an entrenched pillar of the British medical establishment. He lived and worked in Mayfair, since 1873 on fashionable Brook Street, within close range of Claridge's Hotel and the homes of two famous physicians, Sir Henry Holland and Sir William Jenner. On 17 April he entered into a notably correct marriage with Helen Ionides, Luke's sister, daughter of a very rich man. (In 1878, William Whistler would become a member of the Royal College of Physicians and would make his final move, to Wimpole Street.)

James Whistler did not leave for Venice after the wedding. He stayed on in London through April, May, and June, without any communications passing between him and Speke Hall. Then on 6 July he got a letter from Leyland, beginning 'Sir,' and denouncing him for 'taking advantage of the weakness of women' by calling at his Prince's Gate home 'and accompanying Mrs Leyland and my daughter in my carriage to look after Baron Grant's house.' Leyland concluded by saying, 'I have strictly forbidden my servants to admit you again, and I have told my wife and children that I do not wish them to have any further intercourse with you.'[22]

Eleven days later, another, quite brief, dispatch came from Leyland:

'I am told that you were seen walking about with my wife at Lord's cricket ground.

'It is clear that I cannot expect from you the ordinary conduct of a gentleman. If I find you in her society again I will publicly horsewhip you.'[23]

Whistler replied that he was 'fatigued with this whole thing,' and that it was 'positively sickening to think that I built that exquisite Peacock Room for such a man as you.'[24]

He also said that he was planning to publish their correspondence. This infuriated Leyland, who dashed off a letter as scathing as anything that Whistler had ever written. This is part of it:

Five months ago your insolence was so intolerable that my wife ordered you out of the house. I should have thought this was notification sufficient.

Your vanity has completely blinded you to civilized usages; and your swaggering self-assertion has made you an unbearable nuisance to every one who comes in contact with you. One consideration which should have led you to form a more modest estimate of yourself is your total failure to produce any serious

work for so many years. At various times during the last eight or nine years you have received from me more than one thousand guineas for pictures not one of which have been delivered; during the whole of our acquaintance you have not finished for me a single thing for which you have been paid.[25]

He ended by saying that it was a 'humiliation' to have his name 'so prominently connected with that of a man who has degenerated into an artistic Barnum.'

Whistler denied that Mrs Leyland had ordered him out of her house or had ever 'uttered a discourteous word to me.' As for incomplete works, he could only meekly ask, 'Is not the Peacock Room finished?'[26]

The ferocity of Leyland's onslaught and the mildness of Whistler's response may be explained by surmising that Leyland had discovered the truth of his wife's extramarital relationship. It was particularly distressing to him because Frances was not just having a fling with an artist. She was probably seriously in love with Whistler and soon afterwards she separated from her husband. It seems clear that she would have been willing to link up with Whistler and to have permitted her husband to divorce her. (The Matrimonial Causes Act of 1857 had provided limited grounds for divorce. A husband had one cause of action, adultery, whereas a wife was required to prove adultery plus desertion or cruelty. In this instance Frederick Leyland would have had to obtain the divorce.)

Now that she was a potentially free woman, Whistler suddenly realized that he couldn't spare time from his art. She would have taken up with him only if they were legally united, but for him marriage was out of the question. Besides, perhaps because of subconscious feelings of inferiority, her pedigree was a bit too exalted for him. (She was the daughter of a sea captain and, for a woman, she had been well educated.) And so just when it could have flourished, the James Whistler–Frances Leyland affair came to an end.

<div align="center">* * * *</div>

As for Frederick Leyland, in Whistler's very last communication to him, he acknowledged holding on to the commissioned portraits because 'my artistic scruples have prevented me from forwarding them to you.' He would, however, post them at once. Replying on 27 July 1877, Leyland ended their correspondence: 'I quite appreciate your "artistic scruples" to deliver the portraits and I must say that these scruples are uncommonly well founded. I am however willing to receive them as they are. It is high time for delivery.'[27]

Whistler then held off sending the portraits for nine years. To the poet–essayist Theodore Watts-Dunton, he explained the deferred delivery: 'It is not my wish to rob Leyland of any real right. The portraits I've withheld because of remarks impugning their artistic value.'[28]

<div align="center">* * * *</div>

On 4 January 1892, Leyland boarded an Underground train at the Mansion House Station. Before reaching Blackfriars, he collapsed. He was carried off and taken into the waiting room. He was dead at the age of 60.

He had the good sense not to tamper with the Peacock Room, which lives on in Washington's Freer Gallery, as, in the words of a present-day British art critic, 'one of the most extraordinary pieces of decoration ever to have been executed.'[29]

26

The Grosvenor Gallery

[1877]

Frederick Leyland was not the only person in 1877 to express an epistolary opinion of James Whistler. On 6 May, the popular novelist Anne B. Proctor wrote to a friend,

> We dined at the Probyns, where I talked with Whistler. He is a very remarkable looking person – dark eyes and hair, and one white lock on his forehead. He has a high opinion of himself and his works. Whenever I find a man so self-satisfied, I begin to doubt.[1]

Later in the summer, Julian Weir, the 25-year-old son of Whistler's West Point drawing master, was in London on holiday from the École des Beaux-Arts, where he was a pupil of Jean Leon Gérôme. On 21 August, along with retired General Truman Seymour and Mrs Seymour, he visited Lindsey Row.

> Whistler is a snob of the first water, [Weir wrote to his parents,] and a first class specimen of the eccentric. His home is decorated according to his own taste. The dining room is *à la Japanese* with fans on the wall and ceiling. His talk was affected and like that of a spoilt child, hair curled, white pantaloons, patent leather boots and a decided pair of blue socks, a one-eyed eye glass, and he carried a cane about the size of a darning needle. Alas! this is the immortal Whistler, who I had imagined a substantial man![2]

To his brother, Weir wrote,

> We were ushered into an eccentric waiting room where Chinese art prevailed. After keeping us waiting a half-hour, Milord enters, thin, fizzle haired, and to all appearances a coxcomb. He introduces himself with gracious smiles and makes excuses for not having looked at our cards, Major General Seymour and Mr Weir.

'Ah, yes,' turning to me, 'Major General Seymour.' No, milord. When it was straightened out, the conversation began, he striking an artistic position, displaying a pair of howling socks, patent leather boots of exceedingly old fabric and plenty of London assurance. 'Ah! ha oh! Yes, ah-no, ah-yes, ah ha yesssssss.' But behind all this he was an observing man with a sharp eye. He sent his compliments to Father and said, 'I regret he did not send you to me. Ah, pooh! I think nothing of Gérôme.'[3]

[The painter–sculptor Gérôme was regarded as one of Paris's best art teachers. He had recently taught Le Douanier Rousseau, and he would soon instruct Edouard Vuillard. He upheld the academic tradition, which might explain Whistler's feelings.]

Weir's brief mockery of Whistler's frequently rambling way of speaking received a more extended take-off from the Anglo-Irish writer George Moore. After Moore had asked him why he thought that a certain sculptor's work was 'very like the Elgin Marbles,' Whistler – according to Moore – replied,

Well, you see, you know – well, you know – you can take it up – you can put it down – and then you – look at it – you take it up – you put it down – you look at it again – and – that which is – then of course the relation of Art to Nature – which is the prerogative of the Artist – Art which is not Nature because it is Art – Art which is Nature because it is not Art – Nature which is not Art Because it is Nature – Nature which is – Art which is not – the spontaneous creation – oh, come along, my dear fellow – come along – lunch, bunch – lunch, bunch – lunch, bunch.[4]

* * * *

When Julian Weir visited him, Whistler had just experienced a summer of notoriety.

Sir Coutts Lindsay, a 53-year-old wealthy connoisseur of the arts, who was also a moderately good portrait painter, felt that the R. A. needed some real competition, and so he decided to build a gallery and hold his own summer shows. He selected a site on Bond Street, verging onto Grosvenor Street. Early in 1877 six houses were demolished, to be replaced seven weeks later by what Lindsay named the Grosvenor Gallery.

Built at a cost of £120,000 – a sizable amount in 1877 – it was spectacular and widely acclaimed, one newspaper calling it 'the most superb building in London devoted to art.'

The grand opening on Monday, 7 May, was one of the big events of the season. Everybody who was anybody was there to see an exhibition that all agreed was 'different.' Particularly was it different from London's premier art show. 'The most prominent pictures here,' *The Times* observed, 'are those least

likely to be seen at the Royal Academy.' And the *Daily News* noted that 'Babies are scarce, and scenes from the "Vicar of Wakefield" are non-existent.'

Sir Coutts's edifice clearly would not be a mainstay of the establishment, and yet his entrants included Royal Academicians Leighton, Millais, Poynter, Watts, and George Leslie. Lindsay, who had personally invited every artist in the show, had a liberal policy of admissions.

The pictures were better hung than anywhere else in London. The lighting was excellent, and there was plenty of space. Whereas 1500 works were at the R. A., the Grosvenor had only 187, adequately spaced at eye level. And, a noteworthy innovation, every artist with several entries had them grouped together.

Whistler was well-pleased with this mode of hanging. He had entered seven paintings. (Only Burne-Jones, with eight, had more.) Four had been previously exhibited: *Carlyle*, *Old Battersea Bridge*, *The Falling Rocket*, and *Westminster Bridge*, the first three of which still unsold. His other entries had been done during the preceding year, a sufficient refutation of Leyland's assertion of his not producing 'any serious art work for so many years.'

One new picture, *Arrangement in Black, No. 3*, was a full-length, full-face portrait of Sir Henry Irving as King Philip II of Spain in Tennyson's play *Queen Mary*, which Whistler had seen soon after its opening at the Lyceum in April 1876.

'Why did Whistler paint Sir Henry as Philip?' someone asked the famous actress Ellen Terry, a friend of both men.

'Who knows why Jimmy Whistler does anything?' she replied. 'He's so foolish! But in this instance I think he wanted Henry standing like someone in a Velasquez painting – after all, Velasquez painted a real King Philip, and so Whistler would paint the actor who played his grandfather.'[5]

He may also have been influenced by the portrait of David Garrick as King Richard III, by his idol, Hogarth.

Irving would agree to only two sittings, and so the work had to be done quickly. Alan Cole wrote in his diary that Whistler was 'madly enthusiastic about painting a full length in two sittings.'[6]

His other previously unexhibited paintings were called *Harmony in Amber and Black*, *The Fur Jacket*, and *Arrangement in Brown*. They were full-length portraits of one Maud Franklin, who for eight or nine years would be the most important woman in his life.

Whistler had met Miss Franklin in 1873 when as an 18-year-old professional model she sat for him. A shopkeeper's daughter with the equivalent of a high school education, she was slender, graceful, moderately attractive, and, like Jo Hiffernan and Frances Leyland, she had reddish-brown hair.

For several years after her initial session in Lindsey Row, Maud was an increasingly frequent visitor to Whistler's studio until by the time of the

170

Grosvenor exhibition she had become his principal model, sole mistress, and joint tenant. Largely because of her, he broke off with Frances and sent Jo packing.

Why was Jo replaced? For several reasons. In the first place, she was fifteen years older than Maud, and Whistler was hardly unique as a man who preferred a woman of 21 to one of 36. But there was more to it than that. Jo was even-tempered and good-natured, but she was also coarse and vulgar, and eventually Whistler became bored with and embarrassed by her. Maud was more intelligent and better educated than Jo, but not as threateningly refined and genteel as Frances. She was a happy compromise.

There was another possible, highly speculative reason for Jo's withdrawal which I should like for the time being to put on the back burner. I shall come back to this matter later.

In his diary for 12 March 1876, Alan Cole wrote, 'Dined with Jimmy. Miss Franklin there. Great conversation of Spiritualism, in which J. believes. We tried to get raps, but were unsuccessful, except in getting noises from sticky fingers on the table.'[7] This entry is interesting as a reflection of the mid-seventies interest in spiritualism, a subject that intrigued the Rossetti circle, and also for its reference to 'Miss Franklin.' Jo could not have contributed much to a conversation with a museum administrator, but Maud was surely a spirited participant. She was indeed not merely Whistler's model but would become his secretary, business manager, and general factotum.

Jo accepted her displacement with equanimity, and she will be heard from again. (Her child was presumably being raised by the adoptive parents in France.)

* * * *

Almost the only praise Whistler received from the Grosvenor's professional viewers was directed at *Carlyle*, which the *Telegraph* called 'an eloquent presentment of the illustrious historian.' His other entries were seen as 'weird productions' (*Telegraph*), 'artistic idiosyncrasies' (*Macmillan's Magazine*), 'whimsical vagaries' (the *Court Journal*), 'freaks and frolics' (the *World*), 'fit for a haunted house' (the *Echo*), and 'monstrosities without a gleam of light or a breath of fresh air (the *Morning Post*).

The youngest reviewer was a 23-year-old Oxford undergraduate who had been sent down for 'absenting himself excessively,' Oscar Wilde. In his first piece of art criticism, written for the *Dublin University Magazine*, he was not totally condemnatory. He found Whistler's pictures 'certainly worth looking at for somewhat less than a quarter of a minute.'[8]

* * * *

One commentary on Whistler at the Grosvenor in 1877 became a classic. It was written by John Ruskin.

During the 1870s, Ruskin turned out monthly booklets under the title *Fors Clavigera: Letters to the Workmen and Labourers of Great Britain*, intended to provide cultural sustenance for British workers. (Ruskin thus explained the meaning of the title: ' "*Fors Clavigera*" is fortune bearing a club, a key and a nail, symbolizing the deed of Hercules, the patience of Ulysses, and the law of Lycurgus.')

The July 1877 number was typical, 25 rambling pages on social and artistic topics. The Grosvenor got four and one-half pages, including two sentences on the only one of Whistler's entries to which a price tag had been attached, *The Falling Rocket*:

> For Mr Whistler's sake, no less than for the protection of the purchaser, Sir Coutts Lindsay ought not to have admitted works into the gallery in which the ill-educated conceit of the artist so nearly approached the aspect of wilful imposture. I have seen and heard much of Cockney impudence before now, but never expected to hear a coxcomb ask two hundred guineas for flinging a pot of paint in the public's face.[9]

27

The Decision to Sue

[1877]

John Ruskin was at the height of his fame, the world's foremost art critic. Exceptionally well qualified for his field of endeavor, he expressed his views emphatically and dogmatically because he was convinced that he was right. Like Peter in Swift's *Tale of a Tub*, he believed, 'By God, it is so because I say it is so.'

No one could denounce more fervently than he, who once called a *Blackwood's Magazine* writer a 'hopeless, helpless imbecile.' He could be just as extravagant with praise, as he had shown by his comments on that artistic iconoclast J. M. W. Turner. In 1842 the *Literary Gazette* attacked Turner with words that foreshadowed Ruskin's condemnation of Whistler: 'His paintings are produced as if by throwing handfuls of white and blue and red at the canvas, letting what chanced to stick, stick.' Ruskin responded, 'There is nothing so high in art but that a scurrile jest can reach it, and often the greater the work the easier it is to turn it into ridicule.'[1] This was the opening volley of a prolonged, impassioned championship of Turner.

The man who raved about one unorthodox painter could see nothing of value in the work of another unorthodox painter. This may have been another manifestation of his often demonstrated inconsistency. As the *Illustrated London News* remarked, 'Ruskin says one thing today and another tomorrow.'

On the other hand, a rarely mentioned reason for Ruskin's inability to appreciate Whistler's paintings relates to eyesight. Ruskin's vision was sharp enough to take in everything in nature, completely and microscopically. Hence his advocacy of the Pre-Raphaelites, whose works were famous for their detail. Turner's pictures, while less particularized than those of the Pre-Raphaelites, are more precise than any of the nocturnes. Nearsighted from birth, Whistler had become steadily more myopic with the passage of time. This partially accounts for the changed character of his work from Rotherhithe to Chelsea, and also the two celebrated sentences in *Fors Clavigera*.

* * * *

On a summer evening in 1877, Whistler was sitting with George Boughton in the smoking room of their club. Boughton was reading the *Spectator*, when he almost jumped out of his chair. He encountered, for the first time, a report on Ruskin's response to Whistler, with the words quoted. He handed it over to his friend.

Boughton said he would 'never forget the peculiar look on his face as he read it.'

Whistler returned the paper without comment, and after a couple of silent minutes he said, 'It is the most debased style of criticism I have ever had thrown at me.'

'Doesn't it sound rather like libel?' Boughton asked.

'Well, I shall try to find out.'[2]

He lit a cigarette and left the club.

* * * *

On 4 August 1877, the *Irish Times* reported, 'Notice of action for libel has been served by Mr Whistler's solicitor to Mr Ruskin's solicitor. Notice was also given that it was useless to ward off trial by apology or compromise.'

With two overbearing individuals ever convinced of their own infallability, compromise or an apology was unthinkable. As the *Irish Times* concluded, 'It is war to the knife between them.'

* * * *

Until the suit came up for trial, life went on.

Three years earlier, William Graham, an MP from Glasgow, had paid 300 guineas in advance for the unfinished *Annabel Lee*, based on a poem by Whistler's fellow West Point drop-out Edgar Allan Poe, and one of his rare adult attempts at a literary painting. On 23 August 1877, Graham wrote, 'May I remind you of "Annabel Lee," which I bought a very long time ago! Not for the purpose of pressing you to complete what I presume you no longer care for, but simply to ask for it unfinished.'[3]

Whistler answered immediately:

There has always been a miserable fatality about the little picture I meant you to have long ago. Unable to satisfy myself, I have over and over attempted to complete it and only by degrees brought about its destruction. Writing about it appeared such a mockery that I allowed silence to take such a hold that I must have woefully harmed myself in your opinion. How to thank you for your continued courtesy, delicacy and forbearance I don't know. I ought to say frankly that the work of which you have doubtless heard (Mr Leyland's dining room) which has absorbed me for the past year has been anything but remunerative. It

174

has left me so very ill off that I am not able to restore your hundred guineas. I send herewith a picture which many are pleased with and which I myself prize, 'Nocturne in Blue and Silver, No. 5.'[4]

This was the T-shaped Battersea Bridge, exhibited twice and unsold.

<p style="text-align:center">* * * *</p>

The titles of Whistler's pictures were a continuing source of fun.

'Did you know,' Anne Proctor wrote to a friend early in 1878, 'that at one of the theatres a Portrait of Whistler was brought on the stage – a caricature of the size of life. Unfortunately hardly any of the audience had ever seen him, so there was only a titter.'[5] The play was *The Grasshopper*, which had opened in December 1877 and lampooned the Grosvenor Gallery. The protagonist is a painter named Pygmalion Flippit, 'the artist of the future,' who says, 'we call ourselves harmonists and our works harmonies or symphonies.' In the last act a huge oil painting was wheeled onto the stage, a caricature of Whistler by Carlo Pellegrini, *Vanity Fair's* famed cartoonist, known professionally as 'Ape.' (Whistler had actually sat for the parody.)

While *The Grasshopper* was on the boards, a writer for *London Magazine* asked, 'If music be made tributary to painting, why not cooking and perfumery?' He mentioned 'wondrous and beautiful things' like 'A Perfume in Green and Gamoge,' 'A Sonata in Sulphur and Blue,' and 'A Symphony in Sapphire and Soot.'

It was open season for roasting Whistler.

28

Waiting for the Trial

[1878]

Sir Coutts Lindsay had not been chastened by his critics, and his second exhibition, in 1878, was a reprise of the first.

The Grosvenor Gallery, where Tom Taylor said 'an artistic and aesthetic Esotericism is reflected and honoured,' seemed ideally created for James Whistler. Again he had seven paintings there, all with musical titles: three 'nocturnes,' two 'arrangements,' one 'harmony,' and one 'variations.' The earliest, *Variations in Flesh Colour and Green*, had been at the R. A. in 1870 as *The Balcony*. The most recent were the 'arrangements,' portraits of Maud Franklin. Two nocturnes were views of the Thames; the third was a winter scene, *Chelsea Snow*. His pictures aroused much less obloquy than in 1877. Some reviewers simply dismissed them as beyond understanding. Others said, in effect, '*chacun à son goût.*'

* * * *

While his pictures were hanging at the Grosvenor, a newspaper published the longest article on Whistler that had yet appeared anywhere.

Each issue of the weekly *World* contained, under the title 'Celebrities at Home,' an interview with a well-known person in his home. The ninety-second 'celebrity,' highlighted on 22 May 1878, was James Whistler.

Described as 'a slight, active figure, clad in a blue-serge yachting suit, complete with square-toed natty shoes,' he used the occasion to defend his philosophy of art.

He pointed to one of his pictures which he called *Harmony in Grey and Gold*, a snow scene, with a black-clad figure walking through the gloom to a brilliantly-lighted tavern.

> To me that is a harmony in colour, [he said.] I care nothing for the past, present, or future of the figure, placed there because I wanted black at that spot. This is

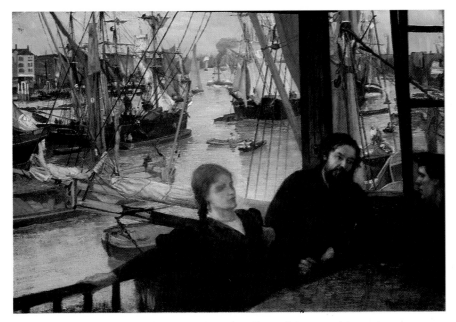

Wapping on Thames (National Gallery of Art, Washington)

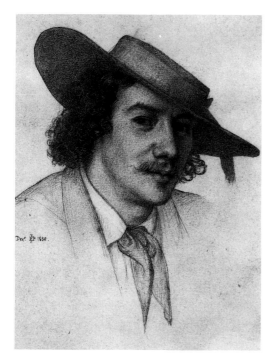

Edward Poynter:
Pencil Portrait of Whistler, 1858
(Freer Gallery)

Henri Fantin-Latour:
Portrait of Whistler, 1865
(Freer Gallery)

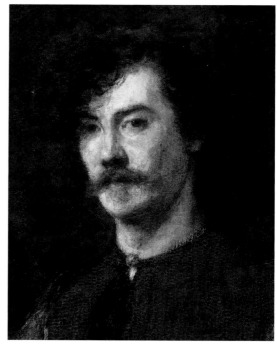

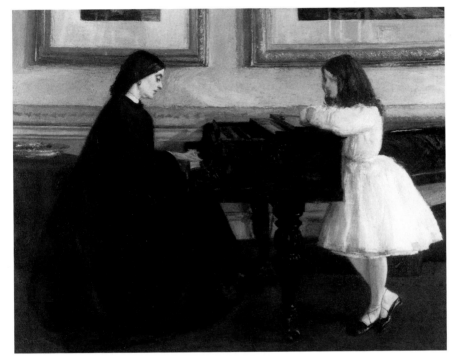

At the Piano (Taft Museum Cincinnati)

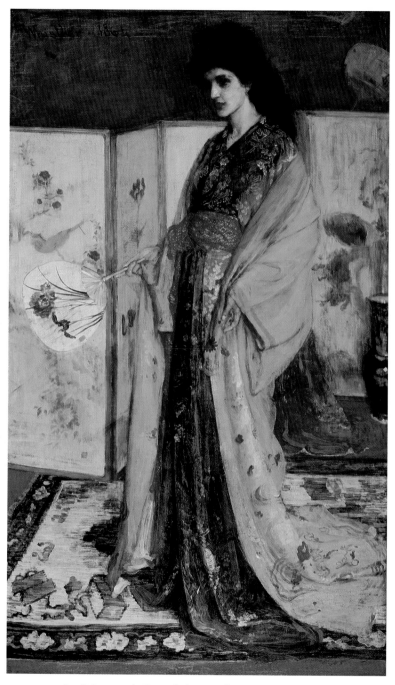

La Princesse du Pays de la Porcelaine (Freer Gallery)

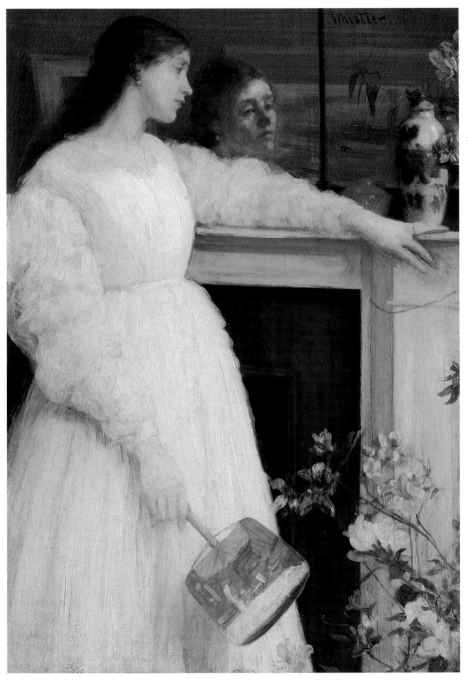

The Little White Girl (The Tate Gallery)

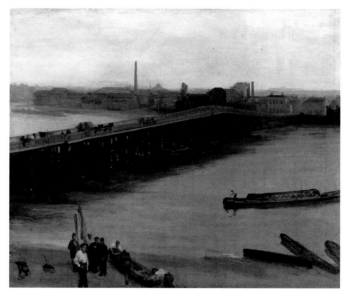

Old Battersea Bridge (Addison Gallery of American Art)

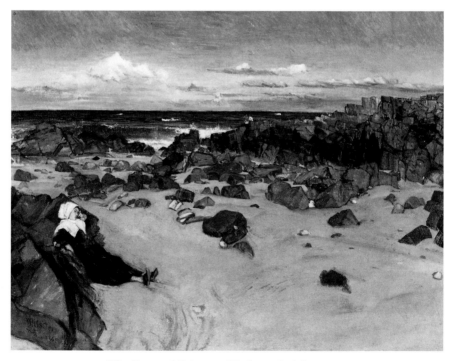

The Coast of Brittany (Wadsworth Atheneum)

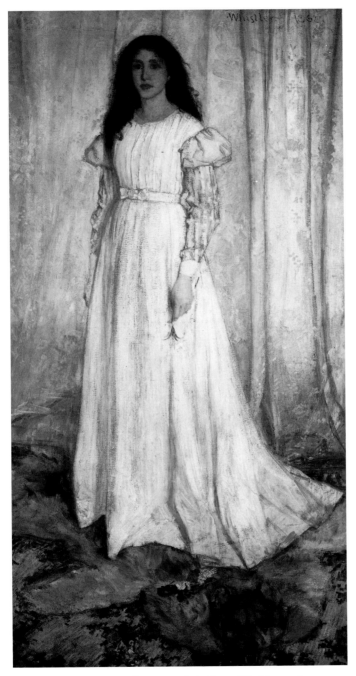

The White Girl (National Gallery, Washington)

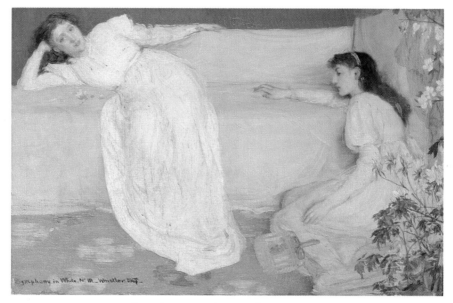

Symphony in White (Barber Institute)

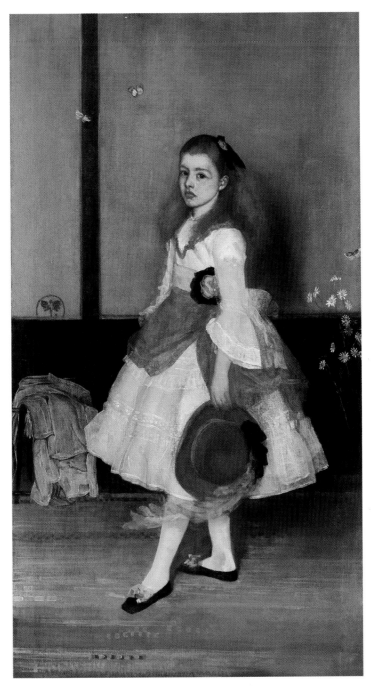

Miss Cicely Alexander (The Tate Gallery)

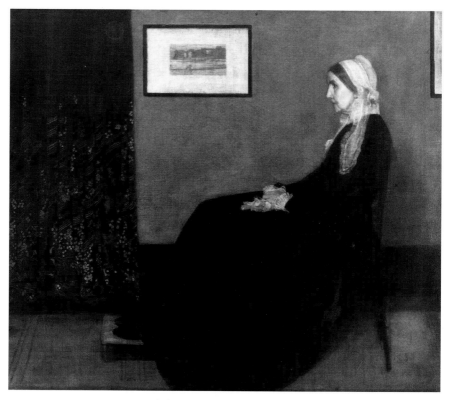

Portrait of the Painter's Mother (The Louvre)

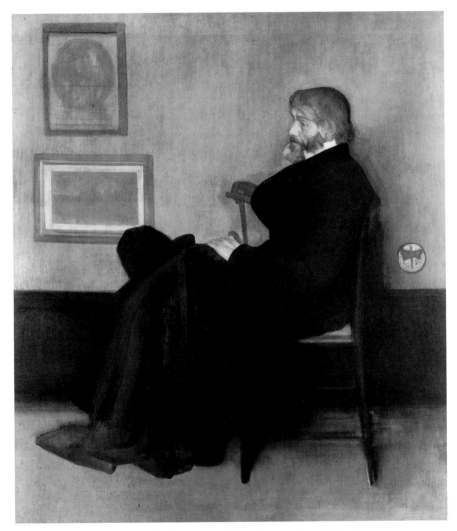

Portrait of Thomas Carlyle (Glasgow Art Gallery)

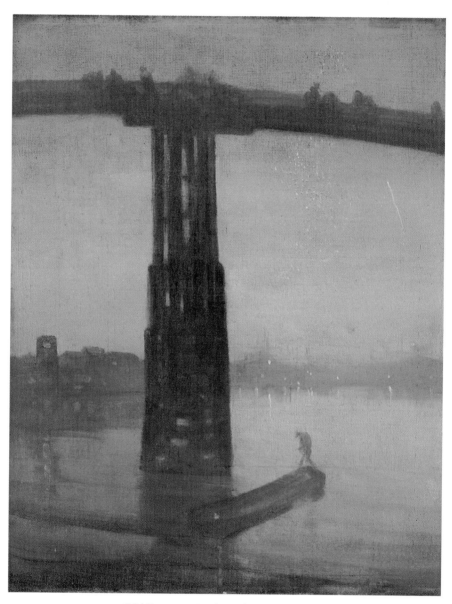

Old Battersea Bridge (The Tate Gallery)

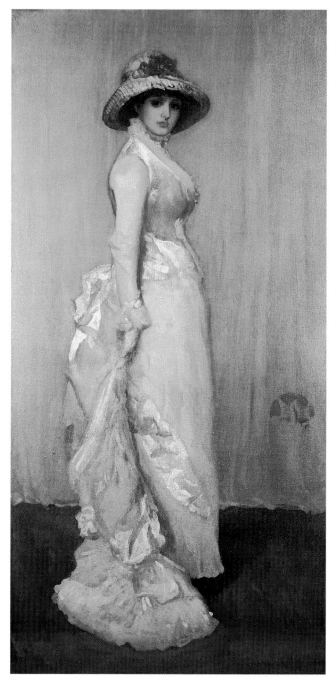

Harmony in Pink and Grey: Valerie Meux (Frick Collection)

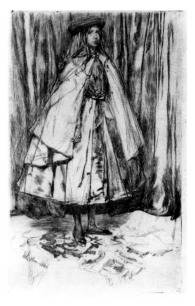

Maud Franklin as Whistler's
Young American (Freer Gallery)

Etching *Miss Annie Haden*
(Hunterian Art Gallery)

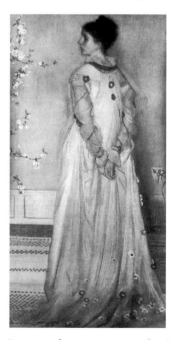

Portrait of Miss Rosa Corder
(Frick Collection)

Portrait of Mrs Frances Leyland
(Frick Collection)

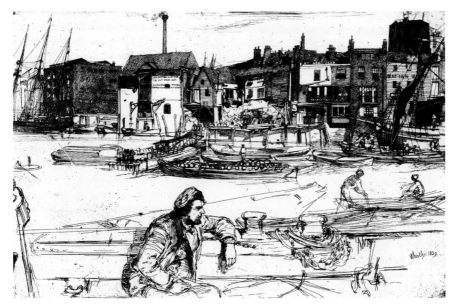

Etchings Above: *Black Lion Wharf* (New York Public Library),
Below: *San Biagio* (New York Public Library)

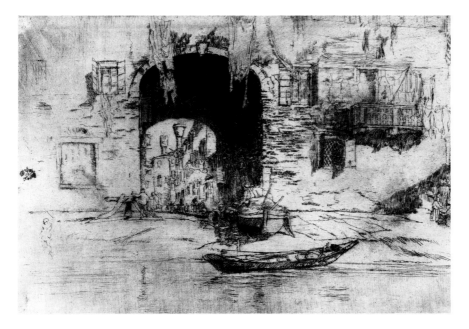

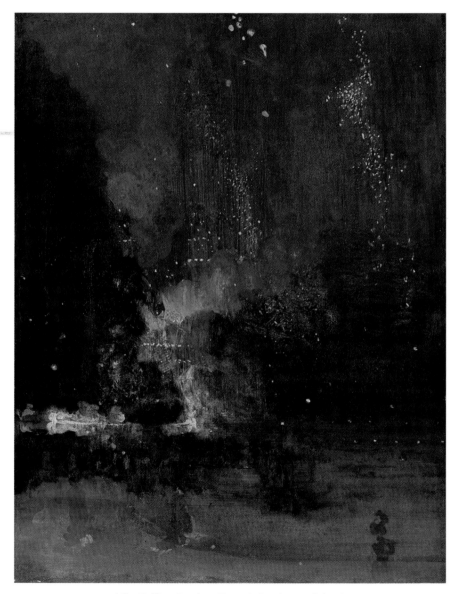

The Falling Rocket (Detroit Institute of Arts)

what many of my friends cannot grasp. They say, 'Why not call it Trotty Veck and sell it for a round harmony of golden guineas?' [Trotty Veck is the principal character of *The Chimes*, one of Dickens's Christmas stories.] I reply that not even the genius of Dickens should be invoked to lend an adventitious aid to an art of another kind. This would be a vulgar and meretricious trick. A picture should not have to depend upon dramatic or legendary or local interest.

He was asked for his opinion of copying or imitating from nature. He answered,

The imitator is a poor kind of creature. It is for the artist to do something beyond this: in portrait painting, for example, to depict more than the face of the model on that day, or in an arrangement of colours to treat the flower as his key, not his model. The dressmakers understand this. In every costume attention is paid to the keynote of colour which runs through the composition.

He turned toward a window.

'Look,' he said, 'at that young girl in gray and lemon-colour, topped by a pale yellow-rose wreath. She is a harmony in colour.'

Anticipating a question, he said, 'I know that many people think my nomenclature funny, but why shouldn't I call my works symphonies, arrangements, harmonies, and nocturnes? And, yes, I know that many people think that I am eccentric. This is their best adjective for me, "eccentric."'

He paused before saying, 'I admit that it is easier to laugh at a man than appreciate him, but why don't people give me credit for meaning something and know what I mean? Why don't they at least try to understand what I am doing?'

* * * *

During the summer of 1878, Whistler painted several portraits, the best of which is a full length of Rosa Corder, a 36-year-old artist, former mistress of Rossetti, with studios in London and Newmarket.

Dressed in black, holding a brown plumed hat, she stands in a doorway before a dark, shuttered room, facing the viewer, head held high, hair tightly rolled on top, gazing haughtily into space.

Who is this fashionably dressed woman? Why is she standing there? What are her thoughts? Where has she been, or where is she going? There are only questions, no answers.

Whistler worked hard on this picture, and so did Rosa. She stood some forty times and twice fainted. Finally she said that she had had it and wouldn't return to his studio.

Needing her one more time, he sent a note of thanks for her 'kind endurance' and requested another session of 'an hour or two.' He said, 'I am ashamed to ask

you, but one of these days you may forgive me. Perhaps tomorrow at about three?'[1]

She came the next day, promptly at three p.m.

This was the first and best of Whistler's 'black portraits,' figures in black against a dark background. Its title was *Arrangement in Black and Brown*. Like his other portraits, it is more than an arrangement of lines and colors. This was demonstrated in an incident reported by its eventual owner, Whistler's friend W. Graham Robertson.

Robertson showed the picture to a retired soldier, a man who enjoyed hunting but for whom 'art in almost any form was a sealed book.' Surprisingly, he stood for some time before the painting.

'Do you like it?' Robertson asked.

'Yes, I do. Do you know something? That woman is a horse-breaker.'

'No, she couldn't be. She's a painter with two studios.'

'Mark my word, she knows a lot about horses.'[2]

Rosa Corder in fact was a lover of animals, particularly horses. She had a studio in Newmarket because of her interest in race horses, her favorite subject. And she herself was a good rider.

<p style="text-align:center">* * * *</p>

The year of 1878 was busy for Whistler in several media.

He had lately taken up his needle again and did several etchings, including the well-known '*Adam & Eve': Old Chelsea*, showing a row of picturesque old houses between the old church in the rear and sailing barges below, a transitional plate from his Thames work to the later prints.

Etching was an art that Whistler had practiced for more than 20 years. Lithography was one that he took up for the first time in 1878.

Invented by the German commercial artist Aloys Senefelder in 1876, lithography was then the youngest of the visual arts. As a cheap form of reproduction it was popular in advertising but shunned by most reputable artists. In France, Corot, Delacroix, and Géricault had dabbled in it, but almost the only person in England who believed in lithography as a means of serious expression was a printer, Thomas Way, who persuaded Whistler, ever the experimenter, to take it up.

'Great as he was as an etcher,' Way said, 'I believe he found that he could get a more direct and personal expression from lithography than on the copper plate.'[3]

He quickly produced nine lithographs, including several studies of Maud. Two were published in the summer of 1878 in a new weekly which folded after nine issues, *Piccadilly*.

<p style="text-align:center">* * * *</p>

<p style="text-align:center">178</p>

In that same summer, Whistler might have appeared in the prestigious *Gazette des Beaux-Arts*. In May its editor, Louis Gonse, asked for permission to reproduce a woodcut for an article on his etchings. Whistler agreed only upon payment of 63 guineas.

Gonse said that the *Gazette* had never paid for woodcuts accompanying reviews of artists' work, and that 63 guineas was 'more than the price of the most expensive woodcut that has ever appeared in the *Gazette*.' *⁴

Whistler was unyielding, and neither the woodcut nor the article appeared in the *Gazette des Beaux-Arts*.

His obstinacy was due in part to a belief that making concessions is a sign of weakness and, in part, to the state of his finances.

In March, he had sent a note to his godchild, the daughter of Charles Howell, a man who tried to find buyers for his pictures. 'This is to wish you many happy returns on your first birthday,' he wrote. 'It is unaccompanied by gold forks and spoons because of an impecuniary attaching itself to your Godfather which he fervently trusts you may never experience.'⁵

The Pennells examined Howell's private diary for 1878; it revealed that Whistler was,

> living from hand to mouth, in a generally impecunious condition. Entries show Howell borrowing twenty shillings to lend immediately fifteen to Whistler, of Whistler borrowing from Howell, who had to borrow from his solicitor, who in turn had to borrow from his head clerk. Once Howell took twenty shillings out of his pocket to give to Whistler, and a half-crown came with it. Whistler said he might as well have that too. Howell wrote, 'I walked home, damn him.'⁶

*　　*　　*　　*

Whistler had never been entirely satisfied with his studio at Number 2; it was too small, and the light was sometimes unsatisfactory. But he stayed in Lindsey Row for more than ten years (and for more than three years after the arrival of the embankment). Then in 1877, the innovative architect William Godwin, best known for a seven-year liaison with Ellen Terry, came up with a suggestion.

'Why don't you build a house of your own on Tite Street?' he asked. 'Then you can have just what you want.'⁷

Named after a recently deceased Chelsea MP, Tite Street, close to Sloane Square, was new, with vacant lots that could be leased inexpensively.

Whistler seized on the proposal, and after he and Godwin had inspected the street, he settled on a double plot of land, close to the embankment and, from the rear, looking northward over the grounds of the Chelsea Hospital. On 23 October 1877, he signed a lease, £29 per annum, with a proviso that building plans had to be approved by the Metropolitan Board of Works.

Constructing the house was a joint endeavor of Whistler and Godwin, who

wanted to create something new and exciting. The keynote was simplicity. It would be a plain three-story building, with a green slate roof, white brick walls, windows where they were needed irrespective of symmetry, and no unnecessary ornamentation. There would be five bedrooms, a drawing room, dining room, kitchen, and two studios, one of which, on the top floor, would be a teaching atelier.

The Metropolitan Board of Works (the forerunner of the London County Council) rejected the original design, objecting to a totally unembellished home. After much argument, Whistler and Godwin agreed to add decorative panels around the windows and over the front door, and they received a building permit.

Late in 1877 workmen began to construct the house, which was completed early in the following autumn and was pronounced by an architectural magazine to be 'immensely better than the stucco horrors of which so many square miles have come off the same troughs and moulds.'[8] In many ways it was a precursor of the familiar Chelsea studio house.

Almost at once it became known as The White House. (It lasted until 1962, when it was demolished and replaced by another much talked-about white house.)

Whistler became a resident in October 1878, six weeks before he appeared as a litigant in the most famous courtroom battle of all time involving artists.

29

Whistler v. Ruskin. Preliminary Matters

[1878]

Early in 1878, John Ruskin was eagerly awaiting the trial. He wrote to Edward Burne-Jones, 'It's mere nuts and nectar to me, answering for myself in Court. It will enable me to assert some principles of art economy which may get sent over all the world vividly in a newspaper or two.'[1]

In February, the author of an unsigned art column in the *Referee*, a weekly sporting newspaper, reported on a recent visit with Ruskin:

> In the course of conversation with the great critic, I said, 'Were you astonished to hear that Whistler hung his pictures across a line in the garden to dry in the sun?' 'Astonished, no,' was the reply. 'I should have been astonished if Whistler had hung the pictures across the line to dry the sun, or if the sun had hung the line across the pictures to dry Whistler, or if the pictures had hung Whistler across the line to dry the sun, or the line had hanged the sun, or the pictures had hanged Whistler, or if Whistler had hanged himself.'[2]

Perhaps Ruskin had been too much in the sun. A few days later he collapsed.

<p style="text-align:center">* * * *</p>

Ruskin was seriously ill, probably resulting from overwork, and three months after his breakdown he was still an invalid. On 8 June, his solicitor sent Whistler's solicitor, Anderson Rose, a physician's certificate pronouncing Ruskin 'totally unfit to take part in the pending action.'[3]

Rose responded that his client was 'very sorry to hear of the illness' and agreed to a postponement 'until such time as your client will be able to attend.'[4]

Neither Rose nor Whistler wanted to relinquish the chance to cross-examine their opponent, but in late October Ruskin was still ill, and it became clear that the trial would have to proceed without him.

He was, however, well enough to assist in his defense. On 3 November, he

wrote to Burne-Jones, 'I gave your name to the blessed lawyers as chief of men to whom they might refer for anything concerning me.'[5]

Burne-Jones told a friend, 'My blessed oldie shall not be left alone. I am prepared to stand on my head if it can be of the least good.'[6]

He probably felt that he owed this to Ruskin. In the notorious Grosvenor Gallery critique, Ruskin had called Burne-Jones's pictures 'the only art-work at present produced in England which will be received by the future as 'classic' of its kind – the best that has been or could be. I *know* that his paintings will be immortal, the best things mid-century England could do.'

<p style="text-align:center">✻ ✻ ✻ ✻</p>

Early in November, Ruskin's solicitor asked Rose for permission to inspect, in Rose's office, the paintings that had been at the Grosvenor in 1877.

> Certainly not! [Whistler told Rose.] I most determinedly object to my pictures being shown in any accidental and promiscuous manner. Pictures may not be handed about like samples of butter to be inspected in the market place. They are to be shown as they were *originally when seen by Mr Ruskin*. If they are to be looked at, let the people see them in my studio, which is a fit place with proper light.[7]

The offer was not accepted.

<p style="text-align:center">✻ ✻ ✻ ✻</p>

On 20 November, Whistler sent this letter to Albert Moore:

> Moore, my dear brother professor, I want you now on an occasion of the kind you might want me and know that I should rush to stand by your side.
>
> On Monday next my battle with Ruskin comes off, and I shall call on you to state boldly your opinion of Whistler generally as a painter, colorist and worker. I must have with me some of my own craft to state that which I produce is *Art* – otherwise Ruskin's assertion that it is *not* remains. Moreover, he has an army of volunteers ready to swear that Whistler's work is mere impudence and sham, and prominent among these gentlemen is *Stacey Marks* ' R. A.' – ready to assert that he can paint a Whistler nocturne in five minutes in Court !! [Henry Stacy – the correct spelling – Marks, who had just been elected a Royal Academician, was a subject painter whose work was literary or historical, often humorous. One of his best known works was entitled *Toothache in the Middle Ages*.] Now, Moore, mon ami, I know you won't hesitate, and I write to prepare you for Monday.
>
> Meantime, come and breakfast with me Sunday at 11.30 – and take fresh confidence in your pal as a painter while you see again the works I have gathered together in my studio.

<p style="text-align:center">182</p>

Mind you, this is a chance for our side that may never occur again – come and suggest anything in the way of fight.

We are sure to win.[8]

Even though he was loath to appear in public, Moore agreed to be a witness.

* * * *

On 21 November, Whistler told Rose,

> I am *known* and *always have been known* to hold an independent position in Art, and to have had the Academy opposed to me. That *is* my position, and it would explain the appearance of Academicians offering to paint my pictures in five minutes!
>
> I don't stand in the position of the *popular* picture-maker with herds of admirers. My art is quite apart from the usual stuff furnished to the masses, and *therefore* I necessarily have *not a large number of witnesses*! In defending me it would be a bad policy to try to make me out a different person than the well-known Whistler.[9]

It was not easy to get artists and writers on art to oppose the nation's most powerful critic.

Charles Keene told a friend, 'I begged Whistler to do without me if he could.'[10] Others were also reluctant to testify. Even William Rossetti tried to get out of it. He wrote to Rose,

> I was rather dismayed at receiving a subpoena. Ruskin is an old and valued friend of mine, and though I don't agree with his opinion of Whistler's pictures or approve the phrases he uses, I should be very sorry to take a personal part in getting him mulcted in damages. If it were possible to let me off, I would be sincerely obliged to you for managing it. If I don't hear from you, however, I shall of course give my sincerely felt witness to the excellencies of that picture.[11]

He didn't hear from Rose and would appear as requested.

A person who was emphatic in refusing to testify was James Tissot, now living in London. Whistler wrote to him on the day before the trial began:

> My poor Tissot,
>
> You are by no means out of danger, even though out of combat! My solicitor sent you a summons, and you are required to appear, under penalty of passing your days in prison, at the will of her majesty!
>
> I did my best to extricate you from this difficult position! I explained that I was mistaken in supposing that Tissot would be proud to call himself a friend of

Whistler! and I fulfil my last duty of friendship in preventing you from going to prison!

Present yourself at 10 o'clock tomorrow morning, Westminster Hall, Exchequer Court. You will probably be the last person in the world to be called, as I have made it clear that in your pitiful position you couldn't be the least helpful, nor could you be Whistler's friend.* [12]

Tissot was not called, nor did Whistler ever speak to him again.

<p style="text-align:center">* * * *</p>

On 25 November, Ruskin wrote to an American friend, Charles Eliot Norton, 'I believe the comic Whistler trial is to be decided today.' [13]

30

Whistler v. Ruskin, Day One

[1878]

The London public is never left for many days without a *cause célèbre*, [Henry James reported for an American magazine.] The latest novelty is Mr James Whistler's suit for damages against Mr Ruskin. Mr Whistler's conspicuity, combined with the renown of the defendant and the nature of the case, has made the affair the talk of the moment. People have differed more positively upon it than they could differ on anything save the character of the statesmanship of Lord Beaconsfield.[1]

The venue was the Court of Exchequer Chamber in Westminster Hall, a small courtroom which throughout the trial would be jammed to the rafters. The judge was 60-year-old Sir John Huddleston. Before the Judicature Act of 1875, judges in the Court of Exchequer were called barons. The 1875 act eliminated the title except for sitting judges, one of whom was Baron Huddleston.

The trial would be conducted before the judge and a jury. At that time there were two kinds of juries, common and special. Common jurors were chosen at random from the general male public – women couldn't serve on any juries. Special jurors, on the other hand, were men who owned property of a specified value, or who held degrees from Oxford or Cambridge, or were regarded as 'persons of high degree,' such as bankers or merchants. Common jurors were not paid, but special jurors usually received one guinea per case. Either party could ask for a special jury and would bear the expense. In Whistler v. Ruskin, both parties petitioned for a special jury and would share its cost. (Special juries were abolished for most cases in 1949 and disappeared entirely in 1971.)

The case would be argued by four barristers, two on each side.

Ruskin's senior counsel was one of the country's most eminent trial lawyers, 50-year-old Sir John Holker, QC (QCs, Queen's Counsel, were, and are, the cream of their profession.) Since 1875 Holker had been Britain's top legal officer, the Attorney-General. (Until almost the end of the century the Attorney-

General could represent private clients.) He was a tall, portly, plain-featured, lumbering man from Lancashire, not noted for ingenuity or eloquence, considered by some to be dull. But no one was better than he in winning verdicts.

For this case, Holker's junior was the highly regarded Charles Bowen, who would soon have 'QC' after his name.

Whistler's principal advocate was 62-year-old Serjeant John Parry, one of the last serjeants-at-law. As *servientes ad legem*, they were technically, like the QCs, servants of the crown. Serjeants-at-law thinned out through attrition until the final survivor died in 1921.

Parry was assisted by William Petheram, who had been in several celebrated cases and in 1881 would become a QC.

<p style="text-align:center">✻ ✻ ✻ ✻</p>

Promptly at 10.30 on the morning of Monday, 25 November 1878, a curtain behind the judge's bench parted. Somebody called out something unintelligible, and everyone rose. In a fur-tipped cape and red gown, Baron Huddleston took his place. He made several bows, which were returned by solicitors, barristers and court personnel, and then they all sat down.

As the first order of business, each juror, holding a Bible, read aloud the oath, promising to render a verdict upon the evidence. Now the trial could begin.

After the plaintiff's junior counsel had read the pleadings, a formal statement of facts, Serjeant Parry rose to deliver the opening statement. (The ensuing speeches and testimony came from a transcript which was constructed from comprehensive reports in the *Daily News*, the *Globe*, the *Morning Advertiser*, the *Morning Post, the Standard*, the *Telegraph*, and *The Times*.)

> Gentlemen of the jury, [Parry began,] Mr Ruskin holds perhaps the highest position in Europe and America as an art critic. It is surprising that he could so traduce someone as to lead him into a court of law to seek damages. And after hearing the case, I think you will conclude that indeed great damage has been done.

Parry referred to the many exhibitions in which his client had appeared, proof positive that he was 'an untiring worker in his profession.'

It was true, Parry continued, that Whistler maintained 'an independent position in art,' and, in the witness box, 'he would expound on his theories.

'Now it may be,' the counsel said, 'that his ideas will seem eccentric. But this is no reason to treat him with contempt and ridicule. He should be given the highest respect as a man who has followed his theories with earnestness and enthusiasm and has worked untiringly in his profession.'

After reading the allegedly libelous passage, Parry said, 'There is no doubt that those words have been injurious and hurtful. This cannot be considered as

<p style="text-align:center">186</p>

privileged, *bona fide* criticism. To speak of a man as an imposter would not be tolerated elsewhere, so why should it be tolerated here?'

Parry then sat down, and the plaintiff entered the witness box.

In accordance with long-standing custom, the junior counsel questioned the first witness.

Petheram began with questions on Whistler's life before settling in London. At one point the witness said, 'I was born in St Petersburg, Russia.' No one raised an eyebrow.

When Petheram turned to the Grosvenor exhibition, he noted that four of Whistler's seven pictures were nocturnes.

'What do you mean,' he asked, 'when you call a picture a "nocturne"?'

'I mean to indicate an artistic intent, divested of any outside anecdotal interest. Since these pictures are night pieces, I chose the word "nocturne."'

'What does the word "arrangement" mean?'

'It means a planned arrangement of lines and colors.'

'What is your aim in painting a picture?'

'For me a picture is a problem to solve, and I use any incident or object in nature to bring about a symmetrical result.'

'Do you use musical titles because you want to show a connection between painting and music?'

'No. I have never intended to show any connection between the two arts.'

'Before your nocturnes went to the Grosvenor Gallery, had they been sold?'

'All but one.'

'For how much?'

'One hundred and fifty and two hundred guineas.'

'Which one was unsold?'

'The *Nocturne in Black and Gold* [*The Falling Rocket*].'

'What was its price?'

'Two hundred guineas.'

'Since the publication of Mr Ruskin's criticism, have you sold any nocturnes?'

'Not at the same price as before.'

This ended the direct examination.

* * * *

It would have been difficult to conceive of two more physically dissimilar men than the ample, superficially awkward Attorney-General and the man whom he was about to cross-examine.

'What is the subject of the *Nocturne in Black and Gold*?' the Attorney-General asked.

'It represents fireworks at Cremorne.'

'Is it a view of Cremorne?'

'If it were called a view of Cremorne, it would certainly disappoint the

viewers. [There was laughter in the courtroom.] It is not a view of Cremorne. It is simply an artistic arrangement of colors.'

'It was for sale for 200 guineas?'

'Yes.'

'You thought that this was a fair price?'

'Yes.'

'Is 200 guineas what we who are not artists would call a stiffish price?'

'Very likely.'

There was renewed laughter.

'Do you know that Mr Ruskin believes an artist should give fair value for money and not just endeavor to get the highest price?'

'Very likely that's his view.'

'Do artists endeavor to get the highest price for their work irrespective of value?'

'Yes, and I am glad to see the principle so well established.'

More laughter.

'Do you know that it is Mr Ruskin's view that an artist should not allow a picture to leave his hand if he can improve it?'

'Yes, that's very likely.'

'Is the *Nocturne in Black and Gold* a finished picture?'

'Yes.'

'Is it a picture of just two colors?'

'No. Every color in the palette is in it, as in every painting of mine.'

'Was it the only picture at the Grosvenor that was for sale?'

'Yes.'

'Did you send it there to be admired?'

'No, that would have been an absurdity on my part.'

More laughter.

'Have you heard that your pictures exhibit eccentricities?'

'Yes, very often.'

More laughter.

'You don't expect that your pictures are not to be criticized, do you?'

'No, not at all. I just don't want them to be overlooked.'

'As for the *Nocturne in Black and Gold,* how long did it take you to knock it off?'

More laughter.

'I beg your pardon?'

'I was using an expression which is rather more applicable to my profession.'

More laughter.

'Thank you for the compliment. [Laughter] I knocked it off in a couple of days.'

More laughter.

'And for the *labour of two days* you asked 200 guineas?'

'No. It was for the knowledge gained through a lifetime.'

These most famous words ever uttered by Whistler elicited loud applause from the spectators' gallery.

The judge was not amused.

'This is not an arena for applause,' he exclaimed. 'If it happens again, I shall have the courtroom cleared.'

After this warning, Sir John resumed his interrogation:

'You know that many critics entirely disagree with your views?'

'It would be beyond me to agree with critics.'

More laughter.

'You don't approve of criticism?'

'I don't in any way disapprove of technical criticism by a man whose life has been spent in the art which he criticizes. But I put as little value on the opinion of a man whose life has not been so passed as you would if he expressed an opinion on a matter of law.'

The Attorney-General asked for permission to let the jury see the *Nocturne in Black and Gold*, which had been placed in an ante-room.

Parry objected because of the poor light in Westminster Hall, which had not yet been electrified.

Baron Huddleston sustained the objection, and the cross-examination resumed:

'What is the subject of the *Nocturne in Blue and Silver*, the picture that you gave to Mr Graham?'

'It's a moonlight scene on the Thames near Battersea Bridge.'

This picture was also in the ante-room. Again the Attorney-General sought authorization for bringing a painting into court. Parry said he wouldn't object if the jury could also see a group of Whistler pictures hanging in the nearby Westminster Palace Hotel.

The Attorney-General said that the jury should be permitted to see only those pictures that had been at the Grosvenor in 1877.

Parry responded, 'Since the plaintiff has been charged with being an imposter, he has the right to show the kind of work he has done.'

The judge agreed, and it was decided that the jury would visit the hotel during the luncheon adjournment.

The T-shaped *Battersea Bridge* was brought into court and placed on an easel. The cross-examination proceeded:

'What does that picture represent?'

'Battersea Bridge in the moonlight.'

'Is this a correct representation of Battersea Bridge?'

'I didn't intend it to be a portrait of the bridge. It is a moonlight scene, a harmony of color.'

'Is that mark on the right of the picture a firework?'

'Yes.'

'What is that peculiar mark on the frame?'

'It's there to balance the picture. The frame and the picture together are a work of art.'

Baron Huddleston then asked, 'Which part of the picture is the bridge?'

Immediately, for the first time, he rebuked the spectators for laughing.

'Your lordship is too close to the picture to perceive the effect which I intended to produce,' Whistler said. 'The spectator is supposed to be looking down the river toward London.

The judge continued with his questioning:

'Is that a barge beneath the bridge?'

'Yes. I am very much flattered at your seeing that.'

'Are these figures on top intended to be people?'

'They are whatever you would like them to be.'

This exchange sheds some light on Whistler's art. The individual parts of a picture are whatever anyone wants them to be. This is a matter of no consequence, since the details are only parts of a broad, general scheme. If someone had pointed to something in his picture and said 'it's like a whale,' Whistler might have responded, 'very like a whale.'

At this time Baron Huddleston called for a luncheon recess. After they had eaten, the jurors, along with a three-man escort, took the ten-minute walk to the Westminster Palace Hotel, in Victoria Street, and examined the paintings. Everything – eating lunch, walking to the hotel, viewing the pictures, and walking back to the courtroom – was done in an hour and a half.

Now that the jury had seen a body of Whistler's work, Serjeant Parry did not protest against bringing in *The Falling Rocket*, which was small enough to be handed from one juror to another.

After the inspection had ended, the Attorney-General asked incredulously, '*This is Cremorne?*'

There was much laughter in court.

'The picture,' Whistler said calmly, 'represents a distant view of Cremorne, with a falling rocket and other fireworks.'

'Is that a finished picture?'

'Yes.'

'What is its peculiar beauty?'

'I'm afraid it would be impossible for me to explain it to *you*, although I dare say I could do so to a sympathetic listener.'

'Would you be willing to place your reputation on that picture?'

'Yes, as I would upon any of my other pictures.'

The Attorney-General sat down.

Whistler had held up quite well. He displayed his gift for repartee courteously, and he eluded all of his questioner's traps.

Re-examining, Parry asked one question:

'Did you intend *The Falling Rocket* to be a representation of a place?'

'No, it is my aesthetic impression of the scene.'

＊　　＊　　＊　　＊

'What a lark the Whistler case!' D. G. Rossetti wrote to a friend after the first day. 'Whistler shone in the box, the fool of an Attorney-General was nowhere.'

Rossetti's opinion had evolved from newspaper reports and from a conversation with the plaintiff's first witness, his brother, who stepped into the box as soon as Whistler had departed.

Asked by Serjeant Parry for his opinion of *The Falling Rocket*, William Rossetti said, 'It is an effort to represent something indefinite. As a representation of the night, it must be indefinite. It represents darkness mingled with and broken by the brightness of fireworks.'

Cross-examining, the Attorney-General asked, 'Mr Rossetti, are you a painter?'

The answer had to be, 'No, I am not.'

Whistler, it will be remembered, had said that he would put 'little value on the opinion of a man whose life has not been pased [as an artist].'

Sir John turned to *The Falling Rocket*:

'Is that painting a gem?'

Laughter in court.

'No,' Rossetti answered.

'Is it an exquisite painting?'

'No.'

'Is it eccentric?'

'It is unlike the work of most painters.'

'Has there been much labour bestowed upon it?'

'No.'

'Is 200 guineas a stiffish price for a picture like that?'

Rossetti asked the judge if he had to answer the question. He was told, 'Yes, you do.'

He then said, 'I think 200 guineas is the full value of the picture.'

More laughter.

'Would you give 200 guineas for it?'

'I am too poor to give 200 guineas for any picture.'

He might have added, 'If I could afford it, I would pay 200 guineas for it.' But that wouldn't have been truthful. Rossetti didn't like the picture. In his own review of the 1877 Grosvenor Gallery exhibition for the weekly *Academy* he had praised four of Whistler's pictures while ignoring *The Falling Rocket*.

His opinion of it might not have differed greatly from Ruskin's. In any event, he had much respect for Ruskin as a critic. In his 'Notes on Art' for the 21 July 1877 *Academy*, he wrote,

Some remarks of Mr Ruskin's on the exhibition of the Grosvenor Gallery in *Fors Clavigera* should not escape the observation of any student of contemporary art. With admirable justice and carefulness of judgment, and with even more than usual felicity and audacity of phrase, the great critic of our time has expressed himself on certain of the works in Sir Coutts Lindsay's exhibition rooms.

It was fortunate for Whistler that the Attorney-General had not seen this column. Even so, William Rossetti's evidence was less than overwhelmingly helpful. During his cross-examination, the *Whitehall Review* reported, 'Mr Whistler's face was an "arrangement" of blank dismay.'

<p style="text-align:center">* * * *</p>

Rossetti was followed into the witness box by Albert Moore, who expressed his views unequivocally.

'What is your opinion,' Parry asked, 'of the two pictures produced in court?'

'I consider them to be beautiful works of art. I wish I could do as well. For one thing, he has painted the air, which very few have attempted. I think the atmosphere in the bridge picture is very remarkable. As to the Cremorne picture, I think the atmospheric effects are marvelous. It is a wonderful work of art.'

'Is 200 guineas a reasonable price for the picture?'

'As prices go, it is not unreasonable. Considering his position, you wouldn't expect Mr Whistler to work for one hundred pounds any more than you gentlemen would. [Laughter] If I were rich, I would buy the picture myself.'

Asked about Whistler's 'eccentricity,' Moore said, 'I should call it originality.'

The third, and last, witness for the plaintiff was William Gorman Wills, an insignificant dramatist, art critic, and part-time painter. He testified that he admired the pictures brought into court; that their final realization must have been preceded by much study; and that Whistler was a genius. Under cross-examination, he admitted that his own dramatic works had been severely criticized.

One might wonder if Whistler was helped by someone so negligible. Was Wills called only because nobody of greater consequence was willing to step up?

After Wills had left the box, Serjeant Parry said, 'My Lord, this is the plaintiff's case.'

Now the Attorney-General rose to deliver the opening statement for the defendant.

The question which the jury will have to decide [he began,] is not whether these pictures are of great merit or of no merit, but whether Mr Ruskin criticized them fairly, honestly, and *bona fide*. A critic has a perfect right to indulge in ridicule and to use strong language. The only question is whether he has been fair.

I will endeavour to show that Mr Ruskin did not overstep the bounds of moderation. For years he has devoted himself to the study and criticism of art. He has written many books upon art, and since 1869 he has been Professor of Fine Arts at Oxford. He has the greatest love and reverence for the subject. He expects an artist to be devoted to his profession and possess more than a few flashes of genius. He holds that an artist should desire not simply to be well paid, but should also want to give the purchaser something that is worth his money. He believes also that no work should leave an artist's hands which can reasonably be improved.

Since Mr Ruskin entertains these views, it should not be wondered that he subjected Mr Whistler's pictures to severe criticism, even ridicule. If he honestly believed what he wrote, he would have neglected his duty if he hesitated to express his opinions.

Gentlemen, you have seen the pictures. If they had been exhibited to you before Mr Whistler's elaborate disquisitions, would you not have thought them strange and extravagant? If you had gone to the Grosvenor Gallery and had seen one of them valued at 200 guineas, would you not have said, 'That price is absurd?' Mr Whistler says they are beautiful works of art. Mr Ruskin was of a different opinion, and he did not commit a misdemeanor, or a breach of the duties and privileges of an Englishman, when he disputed Mr Whistler's view of his own productions.

When the Attorney-General paused, Baron Huddleston said, 'The present condition of the court is such that it might be called a nocturne.'

After the laughter had subsided, he declared an adjournment until the next day.

31

Whistler v. Ruskin, Day Two

[1878]

All of the daily papers had full accounts of the trial, and on Tuesday hundreds tried in vain to enter the small courtroom.

In resuming his opening statement, the Attorney-General said,

> Gentlemen, you have examined the *Nocturne in Blue and Silver*. You saw a good deal of colour, and you probably thought it would have been better if some of it hadn't wandered onto the frame. As for the structure in the middle, you probably asked, 'Is that a telescope or a fire escape? [Laughter] If it's a bridge, and those figures on top are human beings, how in the name of fortune will they ever get off?'
>
> [More laughter.]
>
> Now in the Cremorne picture, there is the blackness of night with some fireworks coming down and a blaze at the bottom, perhaps a bonfire. That is all there is.
>
> I do not deny that Mr Whistler has done some very good things, but *these* pictures are strange, fantastical conceits not worthy of being called works of art. Artists whom I almost had to drag into court will say that they are not worthy of admission into any gallery.
>
> As to the alleged libel, the defendant has the right to criticize; that is his business. But, my learned friend says, one must not prevent Mr Whistler from earning a living. Why not? In fulfilling his duty, is Mr Ruskin obliged to be tender? Then it was said, 'You have ridiculed Mr Whistler's pictures.' Well Mr Whistler should not have subjected himself to ridicule by exhibiting such productions.
>
> Mr Ruskin's language, it is said, was strong, but an action cannot be brought against a man for strong language. If a critic thinks a painting is a daub, he has a right to say so. True, Mr Ruskin called Mr Whistler a coxcomb, but as an artist, not as a man. What is a coxcomb? According to the dictionary, it carries out the

old idea of a licensed jester who has a cap on his head with cock's comb on it and goes about making jests. If that is the definition, Mr Whistler should not complain. His pictures are an amusing jest. I do not know when so much amusement has been afforded to the British public as by Mr Whistler's pictures. The old meaning of coxcomb has been well carried out by him.

Gentlemen, I ask you not to paralyze the hand of one who has given himself wholly to the art he loves. If you decide against Mr Ruskin, he will cease writing. It will be an evil day for art in this country if he is prevented from indulging in legitimate criticism, and if critics are forced to indulge in nothing but fulsome admiration.

* * * *

The first witness for the defendant was the 45-year-old leader of the second phase of the Pre-Raphaelite movement, Edward Burne-Jones.

Burne-Jones had made a most revealing pre-trial statement for Ruskin's solicitor.

In this declaration, he said that Whistler had used 'the art of brag' to delude 'the semi-artistic part of the public.' Among artists, however, 'his vanities and eccentricities' were 'a matter of joke,' and 'scarcely anybody' took him seriously because he had never 'produced anything but more or less clever sketches.'

All that Whistler had ever done, Burne-Jones continued, was 'to declare loudly that no picture is of value for the qualities that all mankind have striven for and demanded, and to announce himself not merely the only living Artist but the only Artist that has been.' In actual fact, his work had 'the merit of a clever amateur' offered at prices that were 'a jest' because 'there is not so much appearance of labour in one of his pictures as there is in a rough sketch by another artist.'[1]

In the courtroom, Burne-Jones was examined by Ruskin's junior counsel, Charles Bowen.

'How important,' Bowen asked, 'are finish and completeness to the merit of a painting?'

'I think that nothing short of perfect finish should be allowed to artists. They should not be content with anything that falls short of what is essential to the work.'

'What is your judgment of the *Nocturne in Blue and Silver*?'

'The colors are beautiful, but form is as essential as color and the picture is totally and bewilderingly formless.'

'What about its composition and detail?'

'It has none whatsoever.'

'Does it show the finish of a complete work of art?'

'Not in any sense whatever. It is a sketch.'

'What is your opinion of the *Nocturne in Black and Gold*?'

195

'I think it has less merit than the other one.'

'In your opinion, is it a work of art?'

'No, I cannot say that it is.'

'Why not?'

'I never saw a successful picture of the night. This is only one of a thousand failed efforts to paint the night.'

To demonstrate true finish, Bowen proposed to bring in a painting by Titian, but Parry objected.

Baron Huddleston asked if it was incontrovertibly a genuine Titian. When Bowen assured the judge of its authenticity, he was permitted to introduce the picture.

The painting was a portrait of Andre Gatti, a Doge of Venice, and as it was brought into court, a reporter for the *World* heard an attendant say, 'Faugh! Here is another one of those rubbishy Whistlers!'

'Is that a genuine Titian?' Bowen asked Burne-Jones.

'Yes. I have no doubt whatsoever about it.'

'What can you say about its finish?'

'It is a perfect example of the highest finish that all true artists have aimed at.'

This painting is now owned by the National Gallery and is known with certainty to have been done by a contemporary of Titian, Vincenzo Catena.

Why, of all paintings in the world, was this one brought into court to strengthen Ruskin's case? Albert Moore addressed this point in a letter to the afternoon *Echo*:

'The picture is an early work of Titian and does not represent the qualities which have gained for him his great reputation. One obvious point of difference between this and his more mature work is its far greater finish. As it was brought forward as an example of the work of the great painters, especially as to high finish, it was clearly calculated to produce an erroneous impression on the minds of the jury.'

* * * *

Burne-Jones was not, and never would be, an R. A. In his brief, Ruskin's solicitor said, 'We have applied to several Royal Academicians with a view to giving evidence, but they have all declined to do so. This refusal arises from a disinclination to appear against an artist however bad he may be.'

One R. A., however, did appear, which he said was 'very painful' to do, the enormously popular painter of large, highly detailed, fully realized crowd scenes, William Frith. If Ruskin's lawyers had set out to find an artist whose work differed as much as possible from Whistler's, they could not have done better. As the *Referee's* art columnist said, Frith was 'the apotheosis of matter-of-fact, the champion of the good old-fashioned English signboard school, just the man to give a common-sense opinion of Mr Whistler's aberrations.'

Frith was examined by Bowen. The Attorney-General may have been needed elsewhere because he left after finishing his opening statement and did not return.

'In your opinion,' Bowen asked Frith, 'do the pictures of Mr Whistler that were brought into court have any merit?'

'I should say not.'

'Is the nocturne representing fireworks at Cremorne a serious work of art?'

'Not to me.'

'What about the other picture?'

'It has beautiful colours, but no more than in a piece of wall paper.'

'Are composition and detail important in a picture?'

'Very important. Without them a picture cannot be called a work of art.'

* * * *

In the absence of his leader, Bowen delivered his client's summation.

In pre-trial notes, he had written,

> Mr Ruskin must not expect to find a jury of persons with any knowledge of Art, and it would be hopeless to try to convince a jury that his view of Mr Whistler's performance was right. They would look to the language rather than the provocation, and their sympathies would be with the man who wanted to sell his pictures rather than the professor whose criticism interfered with the sale of a marketable commodity. Mr Ruskin therefore must not be surprised if he loses the verdict.[2]

Nothing in the trial led Bowen to change his mind, and his statement was an exercise in damage control, to forestall a disastrous judgment.

> The issue [he said,] is not the merits of Mr Whistler's pictures, nor whether you think a nocturne is worth 200 guineas. The issue is whether Mr Ruskin's comments, strong though they may have been, were fair and honest criticism. A critic must not indulge in personal malice. But he is not bound to speak with bated breath. He may say what he likes if he does so honestly without leaving the subject matter before him.
>
> Mr Ruskin's criticism was of this nature. I hope that his honest opinion of Mr Whistler's pictures. I hope that no English jury will do anything to chain honest criticism, thereby irreparably damaging the future of art in this country.

* * * *

> Mr Ruskin's offense, [Serjeant Parry said in *his* summation] comes to this: 'I shall say what I please, and nobody must ever interfere.' It is to be hoped, however, that you gentlemen will tell him that he does not have this power.

197

I am astonished that someone in his position would use such language. This was not fair criticism; it was a personal attack. A pretended criticism on art which is really a criticism of the artist and holds him up to ridicule is not permissible. Can such words as 'throwing a pot of paint in the public's face' be considered fair, *bona fide* criticism?

Gentlemen, if you find in favor of Mr Ruskin, you will tell the world that Mr Whistler is a wilful imposter. And Mr Whistler was called a 'cockney.' This means that he is dirty and disagreeable. [Laughter] This is not criticism. It is defamation.

<p style="text-align:center">✳ ✳ ✳ ✳</p>

In his own summation, the judge said,

It is for your gentlemen to decide whether the defendant used his powers fairly and honestly, or whether he went beyond the work itself. If a critic honestly expresses an opinion on a work, even with strong language, he should be protected. But if he denounces the individual whose work he is criticizing, he is not entitled to protection.

If a critic feels he is dealing with a charlatan and an imposter, he may use strong expressions about his work but not about his personal character. If you think that Mr Ruskin's language was honest and *bona fide*, even though strong, you must find for him. But if you think the words were not fair and *bona fide*, the plaintiff is entitled to your verdict.

Then there is the question of damages. If you decide for the plaintiff, you must also decide whether the insult was so gross as to call for substantial damages, or whether it is a case for slight damages, indicating that the case ought not to have come into court.

<p style="text-align:center">✳ ✳ ✳ ✳</p>

After deliberating from 2.50 until 4.10, the jury returned with a verdict for the plaintiff, with damages of one farthing (one-quarter of a penny).

Because of the nominal award, Baron Huddleston assumed that the jury felt that Whistler had been ill advised to file this suit. He therefore rendered a judgment without costs. This meant that Whistler would have to pay for the expense of winning a legal victory of one farthing.

<p style="text-align:center">✳ ✳ ✳ ✳</p>

A few days later, Thomas Armstrong ran into the Attorney-General at a social affair.

'Well, Sir John,' he said 'do you have plans for ruining any more artists?'

'I was bound to do my best for my client.'

'Those paintings should never have been allowed to enter the courtroom.'

<p style="text-align:center">198</p>

'They were important to our case, and so I insisted on bringing them in.'
'You wouldn't have permitted it if you had been Whistler's counsel.'
'No, I wouldn't have. By the way, why didn't he ask me to represent him?'
'Actually I recommended you, but Rose said that your fee would be too high.'
'For Whistler I would have done it for nothing.'[3]

32

The End of an Era
[1878–79]

Three days after the trial had ended, an advertisement appeared in all of London's daily newspapers. Because of 'the life-long honest endeavour of Mr Ruskin to further the cause of art,' the Fine Art Society announced, 'we have agreed to set on foot a subscription to defray his expenses arising out of the late action. Anyone wishing to cooperate will oblige by communicating with us.'

Whistler had never heard of the Fine Art Society and had to be enlightened by his solicitor. 'The so-called Fine Art Society,' Rose told him, 'is a printseller's shop in Bond Street where Ruskin exhibits his Turners and his own works.'[1]

Although he was a man of considerable means who didn't need financial assistance, friends and admirers quickly subscribed the entire amount of Ruskin's costs, over £400.

* * * *

Because of the trial, Ruskin lost something of considerably greater value to him than money, his Slade professorship at Oxford, from which he resigned. Officially the reason for his action was 'ill health,' but in a letter to Dean Liddell he said, 'the Professorship is a farce if it has no right to condemn as well as to praise. There should have been no question possible between a University teacher and a man like Whistler, and I certainly cannot take the trouble to judge on any point of art if a scamp who belongs in a workhouse or jail can make me pay half a year's income to lawyers.'[2]

Ruskin was not forced to resign. Some Oxonians indeed tried to induce him to stay. But because of the verdict against him, nominal though it was, he felt that he could not in good conscience retain the professorship.

* * * *

No one started a subscription for Whistler, perhaps because it was thought, as

the *Standard* said, 'He has only to "knock off" three or four "symphonies" and a week's labour will set all square.'

Whistler himself was ebullient because in fact he had triumphed. 'Of course "Costs" would have been more satisfactory,' he told the art dealer Lazentry Liberty, 'but really it has been a great victory morally, and the first shot at the "Critic" has at last been fired. You know I always win in the end.'[3]

To his solicitor he wrote, 'Rose, my dear old friend, nothing could have been finer than the splendid way in which you managed and fought my battle for me! It is a complete victory!' And it was not 'merely a personal difference of opinion between Mr Ruskin and myself, but a battle fought for the painters in which for the moment Whistler is the Quixote.'[4]

He asked Rose to file an appeal because of the infinitesimal award and the subsequent judgment without costs. He was fired up for another trial.

Rose said that they had no basis for an appeal. Actually, he told Whistler in confidence, Ruskin might properly have appealed. The judge had instructed the jury that his criticism should have been fair and *bona fide* as well as honest whereas it needed only to have been 'honest.'

<p style="text-align:center">* * * *</p>

For Whistler, the verdict did not end the affair. His first 'brown paper pamphlet,' twelve pages long, was published late in December 1878. Dedicated to Albert Moore, it was called *Whistler v. Ruskin: Art and Art Criticism.*

He wrote the booklet, he told Elizabeth Pennell, to provide 'an unbiased report of the law suit to go down to posterity,' and 'to expose the empty pretensions of art criticism.' Ruskin, he said, was only 'a representative of the tribe of art critics who, in their ignorance, would make and unmake the reputation of artists with an ignorant public,' and the trial was 'the opening skirmish' of a war 'between the Brush and the Pen.'[5]

The overriding theme is that only artists are qualified to criticize the work of artists. It would be unthinkable, he said, for 'the Observatory at Greenwich to be directed by an apothecary' or 'the College of Physicians with Tennyson as President!' But 'a school of art with a *litterateur* at its head disturbs no one!' And 'Mr Ruskin preaches to young men about what he cannot perform and talks for forty years of what he has never done!'

As for the argument that Ruskin had 'devoted his life to art,' Whistler responded, 'If a life passed among pictures makes a critic, the policeman in the National Gallery might assert himself.'

Whistler acknowledged that Ruskin was 'a master of English literature,' but as a 'populariser of Pictures he remains the Peter Parley of Painting.' ('Peter Parley' was a pseudonym that had been used by several American and British authors of children's books.)

<p style="text-align:center">201</p>

❋ ❋ ❋ ❋

John Ruskin was not the only identifiable target in *Whistler v. Ruskin*. Although not named, *The Times's* Tom Taylor was the subject of one paragraph. To illustrate bad criticism, Whistler cited a brief passage in which Taylor applied the words 'slovenly in execution and poor in colour' to Velasquez. (Taylor was sent a copy of the pamphlet inscribed '*sans rancune*' [without rancor].

Taylor was no journalistic hack. He was, or had been, a brilliant student at Trinity College, Cambridge; a professor of language and literature at University College, London; a barrister; an editor of *Punch*; the author of a three-volume biography of the painter Benjamin Robert Haydon; an actor; and a highly successful playwright. Tom Taylor, someone said, was 'an institution.'

John Ruskin was also a Victorian institution. These two men were fit victims for a five-foot four-inch, near-sighted academic failure from overseas.

In a long, carefully reasoned letter to Whistler, Taylor noted that the excerpt on Velasquez had been so flagrantly quoted out of context 'as to give exactly the opposite impression to that which the article conveys.' If Whistler actually read the article, Taylor said, he 'made an unfair use of it.' Whistler in fact *had* read the article and deliberately misused one sentence, which referred to a single painting of Velasquez which Taylor called 'an exception.'[6]

This was Whistler's response to Taylor's letter:

> Dear for a ducat, dead! my dear Tom, and the rattle has reached me by post.
>
> You *did* print what I quoted, and it is unimportant what more you may have written of the Master. That you wrote anything at all is your crime.
>
> Shrive your naughty soul. Give up Velasquez and pass your last days properly in the Home Office.

Taylor replied, 'Pardon me, my dear Whistler, for having taken you *au serieux* even for a moment.'[7]

In his rejoinder, which ended the dialogue, Whistler said, 'Why, my dear old Tom, I never *was* serious with you, even when you were among us. Indeed, I killed you quite, as who should say, without seriousness, "a rat! a rat!" you know, rather cursorily.'[8]

❋ ❋ ❋ ❋

None of the reviewers liked *Whistler v. Ruskin*, and most of them ridiculed it.

The *Spectator* said that the booklet 'can only be laughed at and not answered.'[9] The *Saturday Review* called it 'almost the silliest pamphlet ever produced.'[10] The *Art Journal* held that 'as a literary production it is as poor, inconclusive, and indescribably vulgar as we conceive anything can be.'[11]

The authors of these and similar critiques were over-reacting, and their

feverish response actually aroused interest in *Whistler v. Ruskin*. When Henry James reviewed it, early in 1879, he noted that it was 'in its sixth printing.'[12] Because of its commercial success, Whistler said, 'the papers are all *furious*.'[13]

* * * *

The earnings from his booklet only slightly alleviated Whistler's perilous financial status.

In mid-January, when he had still done nothing to reduce his debt to Rose, he wrote to him, 'I hope to get a little money that I may be able to give you perhaps £40. In the meantime do try to keep [the creditors] off my back.'[14]

A typical creditor was a man named Hedderly, who wrote on 18 January,

Full nine months have elapsed since I waited upon you with an old account of £2.18.0 and especially requested its settlement. You promised that you would certainly send the money on that date – but none has come yet. I am now in considerable financial difficulties, and I should be much obliged if you would kindly forward the above sum at your earliest convenience.[15]

Sometimes he had to, or thought he had to, post his letters without stamps, relying upon the recipients to pay the postage due.

* * * *

In February 1879 the 26-year-old American painter Edwin Abbey, recently arrived in London, met Whistler at a party and wrote to his mother about the experience:

He's a queer-looking chap, short and very thin, with an immense head of black, curly hair, a black moustache, one eye-glass, and no necktie. He is perfectly good humored and has a conceit that is so colossal that it is delightful.

I told him that he had a great many admirers in America and mentioned a few of the pictures I had seen, including one of a girl sitting in the sand. 'Oh, yes,' he said, 'that *was* a good picture. You liked that? Hm, yes, that *was* an excellent picture – the girl very well drawn, as I remember!' He then showed me the farthing which he had received as damages from Mr Ruskin. He wears it on his watch chain.[16]

A few days later Abbey visited Whistler's new home.

The house is queer on the inside, [he told his mother.] The front door is in the middle of the house, and you tumble downstairs when it is opened by a solemn-looking butler. You tumble down six steps into a large low-ceiled room with pleasant windows looking out upon a neat little yard, over the back wall of which

you see trees [in the garden of the Chelsea Hospital]. There is matting on the floor, and many cosy chairs and a big table. There's an alcove with a big fire-place, and there's a piano with Whistler's portrait of Irving over it. On the wall are framed proofs of his etchings.

The butler shows us up a narrow winding stair into the studio, an immense room with white walls and one side all windows. It's like a bare country church. At one end there's a battalion of easels and canvases and an old mahogany candlestand which Whistler uses for a palette. At the other end is a printing press and table, with bottles, nitric acid, paper screen, and other paraphernalia of the etcher's art.

Bending over a pile of binder's board is Whistler, who salutes us noisily through his nose, and spits out his eyeglass, which he has swallowed preparatory to polishing it on his handkerchief. He is most kind, showing us proofs of etchings he has just finished. He also shows us a life-size painting of a little dancing girl in tights with a skipping-rope, and a large canvas of three nude girls, exquisitely drawn. I wish it could go to America. It would open the eyes of some of the Philistines there who think he can't draw.[17]

<p style="text-align:center">❊ ❊ ❊ ❊</p>

The second painting mentioned by Abbey was *The Three Girls*, which had been done a few years earlier and has disappeared. The full title of the other one is *Portrait of Miss Connie Gilchrist. The Gold Girl. A Harmony in Yellow and Gold*. In 1878, when it was painted, Connie Gilchrist was a 13-year-old dancing girl at the Gaiety, a musical theater in the Strand. The picture shows her in a yellow costume, jumping with a rope, a rare Whistlerian portrait of someone in motion.

Connie Gilchrist was one of Whistler's two major entries at the Grosvenor in 1879, along with the *Arrangement in Brown and Black, Portrait of Miss Rosa Corder*.

Because of his recent notoriety, these portraits attracted more than usual attention. Almost everyone raved about *Rosa Corder*, which was called 'full of life and animation' (the *Builder*), 'remarkably rich and harmonious' (the *Globe*), and 'worthy of Velasquez' (the *Telegraph*).

Rosa came through with flying colors, unlike the picture hanging next to it. Poor Connie Gilchrist! She was the inspiration for Whistler's most savagely vilified portrait. It was seen as 'ludicrously muddy and ugly' (*Saturday Review*), 'a sad creation upon which it is not pleasant to think' (*Vanity Fair*), 'one of the most disagreeable and vulgar things we ever met with in an exhibition' (*Builder*), and 'a pair of ghastly legs, curiously flattened and pawing the air like a spectre in the fog' (*Mayfair*).

There was one positive notice. Oscar Wilde, lately settled in London,

reviewed the show for the *Irish Daily News*. He said that *Connie Gilchrist* was 'very wonderful,' and he judged Whistler to be 'the greatest painter in London.'

✻　　✻　　✻　　✻

Whistler's most important entries at the 1879 Grosvenor show proved to be eight etchings.

Officials of the Fine Art Society, the shop that had raised a subscription for Ruskin, had lately been attracted to Ruskin's adversary. They had been talking among themselves about offering him a commission for etchings in Venice, and when they saw his plates at the Grosvenor, they acted.

Two days after the opening, Whistler wrote to Lucas, 'I rush off to Venice, where I am to be until December. I am to do a set of etchings and have engaged to finish them by the 20th of December.'[18]

The Society would pay for the trip and for modest living expenses; he in turn agreed to produce 12 etchings by the end of the year, for which he would be paid £600.

But first he had to attend to certain matters in London.

✻　　✻　　✻　　✻

Even before the opening of the Grosvenor exhibition, posters appeared in various places announcing an auction sale on Wednesday, 7 May, 'on the premises of Mr Whistler, "The White House," Tite Street.' Among the items to be sold were an 'ebonized and gilt drawing room suite,' a 'three-foot Japanese cabinet,' a 'brilliant toned pianoforte,' 'a six foot Japanese bronzed towel airer with brass mounts,' 'an excellent japanned shower bath and a set of cretonne curtains,' and 'a dwarf mahogany table, a butterfly cage on ebonized stand with stuffed bird, a pair of Chinese clogs, and 2 butterfly cages with pulley.'

On the day of the sale, Whistler's liabilities were determined to be £4643-9-3, and his assets were estimated at £1824-9-4. Two days later he filed for bankruptcy.

Because it could not be concluded in one day, the sale was carried over until 13 May, and, by request, the new posters did not include the line 'on the premises of Mr Whistler.'

The auction realized only a minor fraction of what was owing to creditors, who met in a Holborn hotel on 4 June and agreed to liquidate his affairs privately and to grant him an immediate discharge. As part of the settlement, the White House would be sold.

Bankrupt and homeless, Whistler nevertheless remained in good spirits. 'I met Jimmy in the street,' Gabriel Rossetti wrote to Watts-Dunton in August. 'He was very spry indeed and announced himself to be in full work.'[19] His work lay mostly ahead, but some of it had just been done, inspired by his principal creditor, one Frederick Leyland.

A few days after Rossetti had bumped into Whistler, Alan Cole wrote in his diary of 'his painting of a demon-Leyland playing the piano, a forcible piece of weird decoration – hideous – displaying bitter animus.'[20]

Whistler never had been, and never could be, as personally involved in any other picture. Entitled *The Gold Scab*, it shows a fiendish creature, more reptilian than human, with Leyland's face, wearing a ghastly peacock costume as he squats before a piano, sitting on a model of the White House. (Leyland was, in fact, a good pianist.) His fingers are claws, and, like a rash, coins erupt from his face and body. Upon the piano are money bags and a sheet of music labeled 'The Gold Scab, an Eruption of Frilthy Lucre,' a punning reference to Leyland's fondness for frilled dress shirts.

The Gold Scab, which fetched twelve guineas at the February 1880 bankruptcy sale, was Whistler's last completed work before he left for Venice on 16 September 1879. Two days after his departure, the White House was sold for £2700.

The new owner was 27-year-old Harry Quilter. He was employed by the *Spectator*. As its art critic.

THE FINAL YEARS

33

Venice

[1879–80]

Until the middle of the nineteenth century, artists in Venice usually focused on the famous landmarks, so much so that millions of people who had never been to Italy could recognize the Ducal Palace, St Mark's Cathedral, the church of San Giorgio, and the Rialto Bridge. Then in the mid-1850s a young Austrian with an Italian surname, Ludwig Passini, travelled to Venice, and, ignoring the tourist attractions, produced faithful studies of ordinary people, places, and events. This new way of looking at the most favored city of painters became infectious, and other artists went there to portray scenes of everyday life. Among them was James Whistler.

In Venice, Whistler was duplicating his early performances in Paris and London. He roamed about in a gondola and on foot with an observant eye. He stood apart from Passini and the others only in that instead of a brush and tubes of paint he would use a needle and a copper plate.

It soon became clear that he could not, or would not, do a dozen etchings in three months. After three months in Venice he had only just begun to fulfill his commission.

One reason for his tardiness lay in the weather. 'Of a cold you have no idea,' he wrote in December to his sister-in-law Nellie, 'cold way beyond anything I have known in London.' In another letter he called it 'the bitterest winter I have ever experienced.'[1] Coming from a four-year resident of St Petersburg, this was obviously an exaggeration, but Venetians acknowledged that this was the coldest winter that *they* could remember.

Because of the elements, it was difficult to handle a copper plate, but this wasn't the main reason for his slowness. He needed time to absorb the atmosphere, and to find the best possible subjects. He would never be rushed into doing anything, but once started, he couldn't be stopped. 'I am worked to death,' he told Nellie in March 1880, 'up in the morning by half past six tho'

it is bitterly cold. You can imagine how utterly done up I am by the end of the day – in the evening I am hopelessly stupefied with sleep and fatigue.'[2]

He completed more than forty etchings, all with simple subjects – ordinary people engaged in ordinary activities, as well as inanimate objects. In subject matter, they resembled the two *Sets*, but stylistically there was a big difference between the old and the new. Whereas the early work was detailed and realistic, the Venetian plates, with fewer particulars, more white space, and freer drawing, are impressionistic and suggestive. As he had done with his paintings, he was aiming for simplicity.

'I have achieved wonderful results,' he told Nellie. 'These etchings are far away beyond the old ones.'[3]

As always, his latest work was his best work.

<div align="center">* * * *</div>

Ever the experimenter who couldn't stay for long in one groove, he went beyond his commission and the medium of etching. He had brought from London a supply of brown paper and crayons, and now he did his first serious work in pastels.

Because of their fragility, pastels have never enjoyed much status. Prior to Whistler, the only prominent British artists who did any significant work in this medium were Gainsborough and George Morland. Earlier, Whistler had used pastels only as studies for portraits. (Cicely Alexander, it may be remembered, sometimes 'put eyes on his sketches of portraits in coloured chalks.')

As with the etchings, his subjects came from contemporary life, and the work was sparse and impressionistic – only a few lines and touches of color. 'I thought away most of it,' he said, 'and put down what was left.'[4]

He liked what was left. 'I verily believe,' he told Nellie, 'that my pastels will be irresistible to buyers. The painter-fellows here are quite startled at their brilliance.'[5]

The 'painter-fellows' were a group of art students, mostly Americans, known as 'Duveneck's boys.'

Frank Duveneck was an American art teacher in Munich who regularly took his pupils for extended working holidays in Italy. They were in Venice when Whistler arrived.

Five or six of them lived on the top floor of a four-story building jutting out at the lower end of the Riva near the Giardina Pubblico. Because the proprietor, a repairer of clocks, was named Jankowitz, the students called their place of residence Casa Jankowitz.

One of the students, an American, Otto Bacher, recalled Whistler's first appearance at Casa Jankowitz, on a rainy day, a recollection reminiscent of Henry Lazelle's introduction to Whistler at West Point:

<div align="center">210</div>

He stood, wet and smiling, and asked in a gentle voice, 'May I come in?'

And in he came. He accepted the situation charmingly, and in the spirit of fun. He received a warm welcome and dry clothes and was soon the center of a group of young fellows whom he delighted with his sparkling pleasantries. He was charmed with the vistas from our windows and asked us for permission to come and to sketch from them, which was eagerly given.[6]

A few days later, he and Maud, who shared his Venetian interval, moved into Casa Jankowitz. They took a single room with two windows facing the Ducal Palace. With apparent ease, these recent residents of a five-bedroomed home moved into a simple furnished room.

On the walls of the room, Whistler posted two pictures, a photograph of *The Golden Scab* and one of himself with, Bacher said, 'a most disagreeable sneer upon his face.' He told the students, 'That is the way Whistler wants his enemies to see him.'[7]

Referring to himself in the third person was a mannerism that he adopted in Venice.

A couple of days before his appearance at Casa Jankowitz, he was introduced by the American consul to some of Duveneck's 'boys.' With each handshake, he said, 'Whistler is charmed.'

When it was Bacher's turn, the consul said, 'Mr Whistler, this is the boy who etches.'

'Ah, indeed! Whistler is quite charmed and will be glad to see your work.'[8]

It was ostensibly to see Bacher's etchings that he went on that rainy day to the Casa.

In using the third person, which he did only with the 'boys,' Whistler was playing a role, perhaps to compensate for the humiliation of having to live, at the age of 45, in a furnished room.

＊　　＊　　＊　　＊

An English painter in Venice, Henry Woods, wrote to a friend, 'I could do with Whistler very well but for his confounded conceit and everlasting seeking for notoriety. I cannot stand it.'[9]

But the students never complained. He and they lived together compatibly. He swam and dived with them and sat with them in the piazza. He was, of course, paternalistic, particularly on professional matters. After looking at a Bacher etching, he said, 'This is a good subject. But when you find something like this you should not do it yourself. You should come and tell Whistler about it.'[10]

His role with the students was that of a benevolent despot. At times he was extremely generous with words of encouragement, as in an encounter with one of the 'boys' who did not live in Casa Jankowitz and told of his experience:

211

One day I was painting in a canal, surrounded by the usual little crowd of idlers. Suddenly I became conscious of somebody unusual behind me. I turned and instantly jumped to my feet as if the stool had suddenly become red hot. It was Whistler, posing characteristically and flourishing his moustaches.

I spoke to him, and then he sat down on the stool and spoke in the kindliest manner, suggesting where the composition might be improved, where a bit of color needed a higher tone. He did not try to be censorious, only helpful. I was much surprised, for I had heard of his being always brutally frank.[11]

Perhaps this illustrated a capacity for recognizing talent. The young man became the most renowned of Duveneck's pupils, the highly respected painter of portraits and figures, John White Alexander.

* * * *

In Venice, Whistler's financial plight was perilous. The money from the Fine Arts Society was depleted in three months, and it was not augmented. Almost literally, he lived in poverty. After he and Maud had returned to London, a letter she wrote to Bacher alluded to this: 'I've been enjoying myself, I can tell you, and have managed to spend a hundred pounds on myself. What do you think of that, after the impecuniosity of Venice?'[12]

In a letter to London, Henry Woods referred to Whistler's finances: 'He has, I hear, been borrowing money from everybody, and from some who can ill afford to spare it. When he goes out with the boys, he evidently pays for nothing. There is no mistake that he is the cheekiest scoundrel out. I am giving him a wide berth. It's really awful.'[13]

Another English acquaintance remembered his being 'in need sometimes of the wherewithal to procure his coffee. So he called on me for aid. I had scarcely soldi to pay for my own, and so I often went without.'[14]

Whistler didn't always have to borrow to pay for his supper. He and Maud received frequent dinner invitations, mainly from Americans, including the consul. Because he didn't want to do anything to hamper the flow of these invitations, he always behaved extremely well without ever showing a trace of belligerency. His conversation, Bacher said, was 'extremely charming,' and 'his manners were elegant.'[15]

Bacher reported on his physical appearance at these functions:

He was always scrupulously dressed in a sack-coat, white shirt with turned-down collar, and white duck trousers, except on rainy days, when he donned trousers to match his coat. A brown felt hat completed his costume. In wearing evening dress he always omitted his tie, and he often said, 'Only Whistler could do this and pull it off.' He always wore an eyeglass attached to a thin black cord. If he were presented to anyone it was dropped and dangled to and fro from a neat cord for

a few minutes, to be readjusted after some moments of fumbling. He generally carried a Japanese bamboo cane, using it to emphasize his remarks, and accompanying its use by his customary expression, 'Don't you know.'[16]

He had only one complaint about social life in Venice: everywhere he was served chicken. 'The food of this country is fowl!' he told Nellie. 'Chickens I have had roast and chickens I have had boiled – chickens in the pot many days old until neither the birds themselves nor their eggs are any longer tolerable.'[17]

Just once in Venice did Whistler confront a situation that threatened to become unpleasant.

The *Spectator's* art critic, and new owner of the White House, Harry Quilter, visited the city on a brief sketching holiday. He found an attractive doorway in a back canal, and for five days he was there, doing a drawing. Early on the fifth day, he heard what he described as 'a sort of war-whoop.' He looked up, and close by in a gondola was Whistler.

'Hi! hi! What! what!' Whistler said. 'You've got *my* doorway.'

'Confound your doorway,' Quilter said. 'It's my doorway. I've been here for the last week!'[18]

Because of the narrowness of this canal, there was room for only one gondola. They argued for a few minutes about who had a prior claim to the place, and then Quilter asked Whistler to come over and join him. The invitation was accepted, and the two men spent the day working together in one gondola.

Harry Quilter. And then Philip Hamerton. Both of these critics briefly entered Whistler's life in Venice.

A copy of *Scribner's Monthly* for August 1880 was sent to him. It contained an article by Hamerton, entitled 'Mr Seymour Haden's Etchings,' which included a picture of Haden, reproductions of seven etchings, and fifteen double-columned pages of unalloyed praise. According to Hamerton, Haden was 'a great etcher, worthy on some points to be compared with the very greatest,' and 'the most accomplished and most powerful landscape and marine etcher of modern times.' It was 'wonderful that an amateur should have attained to such a position.'

Whistler responded at once with a letter to the New York *Tribune* which took Hamerton to task for an alleged factual inaccuracy concerning *The Thames Set*.

As he was writing it, Whistler called out to Bacher, in the next room, 'Do you spell *Hamerton* with one *m* or two?'

'With one *m*,' Bacher replied.

'Oh, damn it! I spelled it with two. Ah, so much the better! I will send it as it is. It will irritate him all the more.'[19]

His letter on an internationally famous critic began, 'In *Scribner's Monthly* for this month there appears an article by a Mr Hammerton . . .'

* * * *

Quilter and Hamerton were reminders of London, which he sorely missed.

'Whistler must get back to London,' he often told Bacher. 'You know Whistler can't remain out of the world for such a long time.'[20]

This thought was repeatedly expressed in letters home. 'If things were as they ought to be,' he told his sister, 'I should be resting in the only city in the world fit to live in instead of struggling on in this Opera Comique country.'[21]

In December he wrote to Nellie, 'Now that it is snowing I specially wish I were back in my own lovely London fogs! They are lovely, those fogs, and I am their painter! I am bored to death after a certain time away from Piccadilly! I pine for Pall Mall and long for a hansom! I shall be so delighted to get back!'[22]

In another letter to Nellie, he said, 'I am so homesick!' Then he quickly added, 'This is between me and you.'[23]

He especially missed the gossip, and he told Nellie, 'If you can find no scandal to report, you must invent one.'

After Nellie had sent him a gossipy article, he responded, 'It was very nice of you to send me the cutting, but you can fancy the shock it gave me when I found nothing in it about my own delightful self!!!'[24]

And of course he couldn't forget the man responsible for his being in Venice.

'What in the world has that old Ass Ruskin been gabbling about lately?' he asked Nellie. 'I must call him deliberately Ass – nothing else in English so describes him as I feel him to be.'[25]

Quilter, Hamerton, and Ruskin symbolized something that he particularly missed in peaceful Venice, as he explained in one of his letters to Nellie:

> There is nothing like a good fight! It clears the air – and the only thing is not to have any half measures – for that gives a chance to the enemy who thinks you are showing signs of timidity, and so gathers courage for a general rush against you. The mistake I have sometimes made in my battles is that I have left my man alive![26]

But he wouldn't have to live peacefully in Italy foreover. In mid-autumn 1880, after he had completed more than forty etchings and about 100 pastels, he wrote to Willie and Nellie, 'I think I shall turn up in a couple of weeks! Only keep it on the strict Q. T., for I don't want anybody to know about it until I am in full blaze.'

34

Exhibiting Again in London

[1880–81]

In November 1880, Whistler and Maud arrived at Liverpool Street Station, from where they went to accommodations obtained by the Fine Art Society, a two-room suite over a stationer's shop at the corner of Air and Regent Streets.

Immediately Whistler began to prepare for two exhibitions, etchings and pastels.

He felt good about his work in Venice. Before departing, he had written to Nellie, 'I have things that are certainly very jolly and must mean gold. I doubt very much if my pictures will go abegging now.'[1]

The first show, with a private view on Wednesday, 1 December, at the Fine Art Society gallery, 148 New Bond Street, was 'Mr Whistler's Etchings of Venice.'

At his insistence, the gallery was completely decorated by Whistler himself. The ceiling was reddish brown. The walls had a Venetian red frieze on top, a band of yellow at the bottom, with a green-gold moulding and a dull yellow-green cloth dado in the middle. The pictures were placed on mounts of yellow gold or green gold.

At the private view, he was at his best, suavely receiving his guests and moving about gracefully to converse with all of them. It was great to be back!

One incident prevented him from totally enjoying the occasion.

As a member of the press, Harry Quilter was there. When Whistler saw him standing before the print of their shared doorway, he walked over and said, 'Eh! eh! What do you think of *that*!'

Then he laughed.

In Venice, Whistler had cultivated an exaggerated laugh that became a distinct mannerism. It was, a contemporary said, 'piercing, full of significance, and always artistically placed. It had a decided crescendo, with the final 'ha' accentuated and sustained with dramatic effect.'[2]

After this first public demonstration of his new laugh, 'his triumph,' Quilter

said, in recollecting the incident, 'was so unfeigned and so vehement, his desire to be unpleasant so manifest, that the devil entered into me.'

Speaking loudly enough to be heard by at least 30 persons, Quilter said, 'It's very nice, but what a pity it's all wrong.'

For once Whistler was speechless.

He could say only, 'Wrong? Wrong? What's wrong with it?'

He 'delivered himself,' Quilter said, 'into my hands.'

After spending twelve days in front of the doorway, Quilter knew it all by heart, and now in front of everybody he pointed out Whistler's inaccuracies.

Never again did the two men speak to each other.

'From that day,' Quilter said, 'his attacks upon me were so offensively personal that I found it better to cease writing about his art altogether.'[3]

As for the show itself, only 12 plates were on display. The response was overwhelmingly favorable. The critics praised Whistler for again demonstrating his talent for finding, as one of them put it, 'picturesque by-ways and odd corners of unpremeditated quaintness.' They liked the new style, which, the *Art Journal* said, showed his 'power of getting at, and presenting, the very essence of his subject,' and which reminded the *St James's Gazette's* reviewer 'more of the etchings of Goya than of any other aquafortist.'

And this was written for the *Spectator* by Harry Quilter:

> What has been done with cleverness so great as to be almost genius is to sketch the every-day aspect of canal, lagoon, and quay, and to give to those who have not seen the city some notion of how its wealth and poverty, grandeur and squalor, life and death, are so strangely mingled. This is a tangible Venice, not the Venice of a maiden's fancies or a poet's dreams.

* * * *

Early in January, soon after the exhibition had closed, Maud left for Paris, where she gave birth to a daughter.

Some readers may be surprised, perhaps disappointed, that I shall say nothing further about this girl, or, with one exception, any of Whistler's other children. There are reasons for my reticence.

On the first page of his classic commentary on literary biography, *Writing Lives*, Leon Edel, distinguished biographer of Henry James, set forth a fundamental commandment: 'A writer of lives is allowed the imagination of form but not of fact.'[4] If I were to say much about Whistler's children, or indeed about his sex life generally, I would be doing what any serious biographer is prohibited from doing. I would be inventing facts.

Material on this topic is scarce partly because while his mother was alive Whistler's friends and acquaintances were prudently silent, in their speech and in their writings. But in any event he wouldn't have talked much about his

children because he didn't really care about them. He may properly be charged with being selfish and insensitive, but recall what Francis Bacon said in his essay 'Of Marriage and Single Life': 'He that hath wife and children hath given hostages to fortune; for they are impediments to great enterprise.'

This encapsulates Whistler's feelings. After leaving West Point, his life was dominated by his work, to which everything else had to be subordinated. Including his children.

Not everyone would fault him for this.

In a 1956 interview, William Faulkner said,

The writer's only responsibility is to his art. He will be completely ruthless if he is a good one. He has a dream. It anguishes him so much that he must get rid of it. He has no peace until then. Everything goes by the board: honor, pride, decency, security, happiness, all, to get his book written. If a writer has to rob his mother he will not hesitate; the 'Ode on a Grecian Urn' is worth any number of old ladies.[5]

Whistler would have agreed completely. He felt that his only responsibility was to his art. And, I submit, the portraits and nocturnes may be worth a few neglected children.

<p style="text-align:center">* * * *</p>

While Maud was in Paris, Whistler's thoughts were centered on his next show, beginning with a private view at the Fine Art Society on 29 January, 'Venice Pastels.'

Before the opening, Maud returned and wrote to a friend, 'All of London was at the private view – princesses, painters, beauties, actors, everybody. At one moment of the day it was impossible to move, for the room was crammed.'[6] This is exaggerated, but it was a moderately exciting event, and most of the 52 works were sold, at prices ranging from £20 to £35.

Among those at the private view was the daughter-in-law of Nathaniel Hawthorne, who recorded her impressions of Whistler:

He is a slenderly built man, scarcely above the middle height, handsome in face, vivid and keen in expression. It is, in fact, a countenance to be singled out in a crowd as that of a man who must 'be' something. His hair, of an intense brown which looks black, curls all over his head in slender glossy strands and wriggles fringe-like over his forehead. Just in front of the crown of the head, there is a single snow-white feather of hair, so unexpected and conspicuous as to suggest that Mr Whistler must have forgotten to shake himself clear of the effects of a nap on a feather pillow. His eyebrows are black; his eyes are dark and brilliant, with an indescribable humorous or quizzical twinkle in them.[7]

<p style="text-align:center">217</p>

At the opening, two days later, Whistler was in a great mood because of the first critical evaluation of his work in this new medium, which had appeared that morning in the *Daily News*:

> The French have an expression by which a man is said to 'find himself' when he hits on the right mode of expressing what genius he may have. In his 'Venice Pastels' Mr Whistler has emphatically 'found himself.' . . . Every observer will have to admit that his method and *faire* are original. His strength lies in the swiftness and certainty with which he records his impressions . . . He has been swift without being slovenly. They are rapid sketches of light, of colour, and of aerial distances and architectural effects. By some magic Mr Whistler has produced the opalescent colours of sunset skies, the movements of water, the golden green lights which may be seen on the Thames as well as on the Venice canals. The distant domes and spires glow with the soft radiant blue of the sunset air of Italy. The night effects are singularly successful . . . In short we have a series of little masterpieces, which please as music pleases, or flowers, or the melody of a poem of Shelley's – pictures of which the first sight is a revelation.

At the opening, Whistler was euphoric, dancing about to greet everyone, including strangers. For about an hour he was doing this, and then a functionary of the Fine Art Society handed him a telegram.

It came from William, in Hastings. Anna was dying.

35

Oscar Wilde

[1881]

The *Daily News* review was a harbinger.

The *World* said, 'More vivid portrayals of Venice can hardly have been seen before anywhere.' The *Academy* said, 'The knowledge of what to select and reject, and then of what to express with summariness of treatment has seldom been shown so completely.' The *Court Journal* said, 'All true lovers of art must visit the Gallery, if only to dream with the artist and to be visited by the same visions of fairyland under which he must have been.' *The Times* and the *Telegraph* summed up Whistler's work in one word: it was 'perfect.'

Never had Whistler scored a triumph like this. Everybody, it seems, who entered the Fine Art Society with a press ticket loved the exhibition.

How ironic it was that the artist, especially *this* artist, could not be in London to savor his success.

<p style="text-align:center">❋ ❋ ❋ ❋</p>

'It would have been better had I been a parson as she wished.'[1]

Whistler spoke these words to his sister-in-law as they roamed the cliffs of Hastings one day during the week following his mother's death.

Nothing at all suggests that his mother ever considered the possibility of his becoming a clergyman. With Nellie he was being grandiloquently remorseful, probably to repress his feelings of guilt for not being grief-stricken. He was sad because his mother had died; he was also sad because he had to be in Hastings rather than in London enjoying the fruits of his exhibition.

The famous portrait has generated a popular impression of Whistler as a loving son. But as we have seen, never, not even in childhood, was he particularly close to her. When the two brothers left home to enter the St Petersburg boarding school, it was Willie, not Jimmy, who was sorry to go. This set the pattern for their subsequent lives.

Anna dominated the first four chapters of this book; since then she has had

only a cameo role in the narrative. This, I feel, accurately reflects her importance in James's life. Until he entered West Point, he could not escape from her domination. The departure for the academy severed the attachment. As we noted, at West Point and during the early days in Paris and London, he rarely wrote home. More recently, in Venice not a week passed without his posting at least one letter to his sister-in-law, but he wrote no more than two or three times to his mother. He had nothing to say to her.

He was always courteous, and never spoke ill of her. This was expected, even demanded, of a Southern gentleman, who never quarreled with a member of the 'weaker sex.' All of his altercations, significantly, were with men.

Did James Whistler love his mother? Yes, to the extent that he was capable of loving any human being.

Did she have any influence over his life? Yes, of course she did. She was responsible for his universal, probably everlasting, celebrity. But we should keep in mind that *the* painting came about by accident and followed portraits of James's brother, his sister and her children, his mistresses, many of his friends, as well as numerous casual acquaintances and total strangers.

When Anna Whistler was buried in Hastings at the end of the first week in February, 1881, she was in her seventy-fifth year.

<p style="text-align:center">*　*　*　*</p>

Soon after the last words had been spoken over his mother's grave, Jimmy was riding back to London. Upon reaching Charing Cross, he got news that would have alleviated whatever grief he might have felt. Already over a thousand pounds had been realized from sales of his pastel drawings.

Although the response to his show had been strongly positive, an occasional notice was less than kind, most conspicuously an article in the 12 February issue of *Punch*, 'Whistler's Wenice; or, Pastels by Pastelthwaite.'

> Mr Whistler, [*Punch* said,] is the artful Doger of Venice, [who,] unable to keep his notes to himself, exhibits them in the most generous and self-effacing way. Perhaps he wished 'to discourage brother artists from going to Venice.' Or may he have conceived a violent animosity to Mr Cook, and have hit upon this method of deterring intending tourists from visiting the 'Pride of the Sea'?

How did Whistler respond to this? He cut the piece, mounted it on a sheet of brown paper, attached a butterfly to it, framed it, and hung it in the Fine Arts gallery.

<p style="text-align:center">*　*　*　*</p>

Punch's title, 'Pastels by Pastelthwaite,' wasn't just a play upon words. Regular

<p style="text-align:center">220</p>

readers would have been reminded of a cartoon figure whom they had often seen recently, Jellaby Postlethwaite.

Created by George Du Maurier, now a staff artist for *Punch*, Postlethwaite made his debut on 14 February 1880 in a drawing called 'Nincompoopiana – The Mutual Admiration Society,' which shows a reception in the home of a wealthy art parton, Mrs Cimabue Brown, where a young man is surrounded by female admirers.

In the caption, written by Du Maurier, Mrs Brown tells one of her guests that the young man is that 'great poet' Jellaby Postlethwaite. '*Is* not he *Beautiful?*' she asks. 'Just look at the grand head and poetic face, with those flowerlike eyes, and that exquisite sad smile! Look at his slender, willowy frame, as yielding and fragile as a woman's!'

Standing behind Postlethwaite, Mrs Brown informs her companion, is 'young Maudle, the great painter. *Is* not he *Divine?*'

Periodically during the next fifteen months *Punch* presented Du Maurier's depictions of Postlethwaite, Maudle, and their friends. Here are abstracts of a couple of typical cartoons:

30 October 1880. A recently married couple gaze at a small china tea pot which the woman is holding. The 'aesthetic bridegroom' says, 'It is quite consummate, is it not?' The 'intense bride' replies, 'It is indeed! Oh, Algernon, let us live up to it!'

13 December 1880. Two men stand before a painting. One of them says, 'I believe it's a Botticelli.' The other replies, 'Oh, no! Pardon me! It is *not* a Botticelli! Before a Botticelli I am mute!'

Du Maurier was having fun with a craze known as 'Aestheticism.' Properly speaking, aestheticism was just an extension of the doctrine of art for art's sake, and Du Maurier wasn't satirizing the concept itself, which was hardly new, but rather the bizarre behavior and language of its current devotees, who walked about carrying single flowers and called everything and everybody 'too too' or 'utterly too too' or 'quite too utter.' These people were, in short, thoroughgoing phonies.

Aestheticism was lampooned in journals other than *Punch* and also, repeatedly, on the stage. The *Saturday Review* for 30 April 1881 remarked, 'Already no farce seems complete without a pale-faced, long-haired young man, with his hat on the back of his head and a flower as big as a frying-pan in his hand. The aesthetic young man is threatening to become a nuisance.'

This appeared one week after the opening night of the best-known satire of Aestheticism, Gilbert and Sullivan's *Patience, or Bunthorne's Bride*.

Patience deals with an 'aesthetic poet,' Reginald Bundthorne, who is adored by twenty 'love-sick maidens.' The opera doesn't name actual people, nor does *Punch*, and indeed Gilbert and Du Maurier pretended to be ridiculing the excesses of a movement without reference to anybody in particular. Everybody,

however, saw, or thought they saw, real people on the pages of *Punch* and on the stage of the Opera Comique Theatre, most particularly Oscar Wilde . . . and Jimmy Whistler.

<div align="center">❖ ❖ ❖ ❖</div>

When Whistler left for Venice, Wilde had lately settled in London, an obscure unpublished poet with a degree from Oxford. When Whistler returned, Wilde was still an unpublished poet, but no longer obscure. He had become famous, or notorious, as the unofficial leader of the unofficial Aesthetic Movement, the principal model for Jellaby Postlethwaite and Reginald Bunthorne. But even though Whistler himself was in Venice when the Movement came into full swing, Postlethwaite and Bunthorne had Whistlerian connections. This was apparent in the *Punch* title 'Pastels by Pastelthwaite.' And the link was obvious in *Patience*. The actor who played Bunthorne, the celebrated Gilbert and Sullivan performer George Grossmith, mimicked Wilde's mannerisms, but, small and wiry, he didn't look like Wilde, and in fact he was made up to appear like Whistler, including even a white lock of hair. And some of his lines are more relevant to Whistler than to Wilde, as in the second act, when he describes himself as:

> A Japanese young man,
> A blue and white young man . . .
> A pallid and thin young man . . .
> A greenery-yallery, Grosvenor-Gallery
> Foot-in-the-grave young man.

This composite was confusing – just who *was* Bunthorne? – but it was understandable. Whistler's philosophy of art was what the Aesthetes professed to believe, and his musical titles had subjected him to the same kind of ridicule now being lavished on Wilde and his friends.

One object of satire in *Patience*, and recurrently in *Punch*, was Whistler's favorite exhibition hall, the Grosvenor Gallery, where he appeared again in the spring of 1881.

Punch celebrated Sir Coutts Lindsay's fifth opening with a poem, 'The Grosvenor Gallery':

> The haunt of the very aesthetic,
>> Here comes the supremely intense,
> The long-haired and hyper-poetic
>> Whose sound is mistaken for sense
> And many a maiden will mutter,
>> When OSCAR looms large on her sight,

<div align="center">222</div>

'He's quite too consummately utter,
As well as too utterly quite.'

These lines are the second stanza. Stanza 5 begins,

Here's WHISTLER paints MISS ALEXANDER,
A portrait washed out as by rain;
'Twill raise RUSKIN'S dander,
To find JAMES at it again.

Whistler's dander was surely raised by Oscar's entrance three stanzas ahead of his own (with no one asking 'Oscar who?').

As for 'Miss Alexander,' since he had done virtually no painting in Venice, he had nothing new to show. And so he entered *Cicely*, on loan from Cicely's father. Again it was celebrated as comparable to the work of Velasquez.

Of the 'Big Three' portraits, only *Cicely* had been sold, to the man who had commissioned it.

Early in the fall of 1881, the *Mother* was sent to the United States, Whistler's first picture to be exhibited in his native land. It was part of a 'Special Exhibition of Paintings by American Artists at Home and in Europe,' at the Pennsylvania Academy of Fine Arts, in Philadelphia.

It hung in Philadelphia for seven weeks and was shown in two other American cities, with a price tag of $1200.

It was returned to London unsold.

* * * *

While his *Mother* was in America, Whistler was in London doing what gave him the greatest pleasure, painting portraits of young, attractive women.

He began the first of them, without a commission, soon after the Hastings burial. The subject was the most celebrated beauty of her day, Lily Langtry. She sat a few times, but because she was busy with other affairs, the picture was never completed, and its present whereabouts are unknown.

At about the time that Mrs Langtry ended her sittings, Whistler received a 1500-guinea commission for three portraits of the wife of a wealthy London brewer, Henry Meux. (In 1883, he would become a baronet, but during the Meux's association with Whistler, they were just plain Mr and Mrs.)

Twenty-five years old when she sat for Whistler, Valerie Meux, erstwhile barmaid at the Gaiety Theatre, was a beautiful woman with a spectacular figure. As always he needed numerous, sometimes protracted sittings, which often evoked a response more fitting a former barmaid than a future Lady. She was

uncomplaining, however, during the session that Mrs Julian Hawthorne observed:

> Whistler wore a fine white cambric shirt with ruffles at the wrists and down the front, tight black trousers, patent leather dancing pumps, and a silken-fringed yellow sash round his waist. The low dais in which Mrs Meux stood was perhaps a dozen feet on his right hand; the easel with the canvas on his left; and his palette was a spindle-legged little ebony table, also on his left, about fifteen feet from the easel. . . . He was extraordinarily neat; there was never a smear of paint on him anywhere. In action, he was like a wary fencer; he would approach the canvas, crouching a little, as a panther creeps toward its prey, his eyes on the lady, yet with side glances at the canvas. Arrived within arm's reach of the goal, he would deliver one touch, light but sure, snatching the brush back again, and retreating backward to the palette-table, looking at the sitter and the painter alternately; dip a brush in the colour and creep forward once more.[2]

Two portraits of Mrs Meux were done, completed by the end of 1881. In one, she faces the viewer in a sleeveless black evening dress before a plain black background. In the other, better known picture, she wears a pink dress and a large hat; her striking figure is emphasized as she stands in profile with her face turned toward the observer. Both paintings were given musical titles – *Arrangement in Black* and *Harmony in Flesh-Colour and Pink*. (In 1892, Whistler renamed the latter picture *Harmony in Pink and Grey*.) The handling of colors, however, is surely not their most striking attribute. As one appreciative spectator said, they are 'delicious likenesses of a beautiful woman, ready to step off the canvas and give you a kiss – if she fancied you. Mrs Meux could have worn anything, or nothing at all, and have got away with it.'[3]

The Meux commission enabled Whistler to rent a flat with a large studio, and, beginning in May 1881, he was back on Tite Street, at number 13, literally within an easy stone's throw of the White House.

He didn't often see his old nemesis Harry Quilter, but for a while he was chummy with another new resident of Tite Street, Oscar Wilde. They were an odd couple: the large, languorous, flabby 25-year-old Wilde and the lean, muscular, excitable 47-year-old Whistler.

Since Whistler looked upon Wilde as a disciple, it wasn't a friendship of equals. Indeed it wasn't really a friendship at all. Whistler became increasingly dubious about Wilde, considering him a charlatan whose knowledge of the arts was superficial and derivative. Wilde moveover believed in criticism as part of the creative process and viewed the critic of a work of art and its creator to be of equal importance. This alone would have threatened their relationship.

Whistler was skeptical about the literary talent of Wilde, whose record of achievement at this time, 1881, was singularly unimpressive. Late in the year his

first book, a slight volume of poems, appeared in print, only because he had financed the publication himself. It did not lead Whistler to revise his opinion, which he had already expressed rather bluntly.

Just prior to his book's publication, Wilde, sitting with Whistler in a clubroom, handed over a piece of tissue paper on which a poem had been written.

Whistler read it carefully and handed it back without comment.

'Well,' Wilde asked expectantly, 'what do you think of it?'

With great solemnity, Whistler said, 'It's worth its weight in gold.'[4]

* * * *

Despite the paucity of his productions, Wilde was famous. He was 'famous for being famous.'

In 1881, his fame was due largely to the popularity of *Patience*. In London it had prospered since its opening, and on 10 October it moved from the Opera Comique to Gilbert and Sullivan's newly built Savoy Theatre for the highly publicized premiere of the world's first public building entirely lighted by electricity. A month earlier it had had its début in New York, where tickets were as greatly in demand as in London.

Mainly because of *Patience*, Wilde was invited to the States for a tour of personal appearances.

When he arrived in America, on 2 January 1882, the *Mother* was still there. Both would return to England later in the year, Wilde considerably richer and the *Mother* still unwanted.

36

More Wrangling

[1882–84]

In June 1882, Wilde wrote to Whistler from America, 'You dear good-for-nothing old Dry Point! Why do you not write to me? Even an insult would be pleasant, and here I am lecturing on you and rousing the rage of all American artists by so doing . . . The beautiful wraith with beryl eyes, our Lady Archie, how is she?'[1]

'Our Lady Archie' had been introduced to Whistler by Mrs Meux, and he had begun her portrait when Wilde left the country. She was a beautiful, cultivated amateur actress and patron of the arts, married to the second son of the eighth Duke of Argyll, Lady Archibald Campbell.

The portrait, another 'arrangement in black,' shows her standing before a black background, buttoning her gloves and glancing disdainfully over her shoulder, a variation of *Rosa Corder*, the mysterious woman about whom we know almost nothing. The Campbell family, however, thought they knew enough to reject the picture outright, because, a friend said, 'it seemed to represent a street walker encouraging a shy fellow with a backward glance.'[2]

Although Whistler had hoped to exhibit it in the summer of 1882, it wasn't nearly ready then to be seen in public. Instead, he showed his two views of Mrs Meux, one on each side of the Channel.

The black-dressed portrait, marking his return to the Salon after a fifteen-year absence, baffled French reviewers. The *Courier des Pas de Calais* said that it was 'strange.'* *Figaro* found it to be 'very curious.' *Republique Français* called it 'dismal,' *Justice* dismissed it as 'peculiar,'* and *Clarion* deemed it 'incomprehensible.'*

Welcome back to Paris, M. Whistler!

He didn't appear personally at the Salon, but he was in good form for the Grosvenor.

Mr Whistler's wand-like walking stick [a columnist reported,] was one of the most striking items at the private view. It was much longer than himself, and even slimer, and he balanced it delicately between finger and thumb. He explained that he intended that it should become historical, and its appearance doubtless marks a new departure in the fashion of sticks.

The author of these lines was Edmund Yates, novelist, poet, essayist, and, most notably, journalist. His forte was what he termed 'personal journalism,' which we would call gossip. He was editor-in-chief of the weekly *World*, which he had founded in 1874. His multi-faceted column was entitled 'What the World Says' and appeared under the pseudonym 'Atlas.' It often included letters from readers and would be a frequent sounding board for Whistler, a devoted reader of the *World*. (When he was in Venice, it was the only paper that he regularly received from London.)

At the Grosvenor, Whistler's principal work was the other portrait of Mrs Meux, the *Harmony*. The contrast between French and British critical reactions to depictions of the same woman, painted at the same time, is remarkable.

The *Pall Mall Gazette* called the picture 'charming'; the *Globe* said that it 'delights the eye'; a high society publication aptly named *Society* judged it 'one of the most tender and charming realisations of a charming face imaginable'; the *Art Journal* said, 'Mr Whistler never painted anything more delicate.' Other reviewers were similarly enthusiastic.

A second Whistler painting was hated as much as *Mrs Meux* was loved, the picture of a girl dressed in blue, *Scherzo in Blue – 'The Blue Girl.'* It was called 'a scarecrow in a blue dress' (*Pall Mall Gazette*), 'outrageously ugly' (*Globe*), and 'positively awful' (*Vanity Fair*).

Unfortunately, or perhaps fortunately, we cannot verify or refute these judgments because long ago the portrait disappeared.

* * * *

On 17 May 1882, Edmund Yates published a letter from Whistler:

Atlas! 'Arry has taken to going to the Grosvenor
 To have seen him was my privilege and my misery; for he stood under one of my 'harmonies' – himself an amazing 'arrangement' in mustard-and-cress, with bird's eye belchear of Reckitt's blue; and then and there destroyed my year's work!
 Atlas, shall these things be?

The reference was to Harry Quilter, and his epithet came from E. J. Milliken's cartoons in *Punch* about a costermonger and his girl friend, 'Arry and 'Arriet. Because in every way, including the dropping of *h's*, they exemplified lower

227

middle-class vulgarity, a crude, uncultivated man frequently came to be called ''Arry.' And for Whistler, Harry Quilter would forever be ''Arry.'

Tom Taylor, Whistler's former favorite target, had recently died, and his logical successor was Harry Quilter. He had bought the White House. He had embarrassed Whistler at the etchings show. And, like Ruskin and Taylor, he was an object of envy. He had been an outstanding student at Trinity College, Cambridge, had studied at University College's Slade School of Art, and had written a biography of Giotto. Also he was a licensed barrister and, through inheritance, a man of wealth.

Since he would outlive Whistler, Quilter could look forward to being mocked for the rest of his life.

<p style="text-align:center">* * * *</p>

Toward the end of 1882, Whistler began preparing for another exhibition of etchings.

The show, which opened on 19 February 1883, was, officially, 'Etchings and Dry Points. Venice, Second Series.' Whistler's own title for it was 'An Arrangement in Yellow and White.' In a letter to a newly acquired friend, the young American sculptor Waldo Story, he described the gallery.

> I can't tell you how perfect it all is – there isn't a detail forgotten – there are yellow *painted* mouldings – not *gilded* – yellow velvet curtains – pale yellow matting – yellow sofas and chairs – a lovely little yellow table, of my own design – with a yellow pot and tiger lily! Large white butterflies on yellow curtains – and yellow butterflies on white curtains – and finally a servant in yellow livery (!) handing out catalogues.[3]

At the private view, guests received yellow silk butterflies to pin to their clothes and Whistler wore yellow socks.

When the reviewer for the Bristol *Mercury* entered the room, he said that he 'received an excruciating sensation of a sort of aesthetic jaundice.' and *Echo's* critic reported his 'optic nerve stung, as with mustard.'

Although the socks were a novelty, the gallery decorations may not have been as entirely original as they were purported to be. Lucien Pissarro, who saw the show, asked his father, Camille, if the idea had been borrowed. Camille, an original Impressionist, said that indeed he and his friends had been 'the first to experiment with colors in this way.'[4]

One highlight of the exhibition, however, was unprecedented. Whistler boasted about it to Story:

> The catalogue is in a brown paper cover, the same size as the Ruskin pamphlet!! And *such* a catalogue! The last inspiration! It is simply sublime – there was never

<p style="text-align:center">228</p>

such a thing thought of – I have collected all of the silly drivel of the wise fools who write, and I pepper and salt it about the catalogue, under the different etchings I exhibit! – in short, I put the nose to the grindstone and turn the wheel with a whirr! – I just let it spin! – stopping at nothing – I give 'em Hell – the whole thing is a masterpiece of mischief![5]

For years Whistler had paid for the services of a cutting agency, and he put everything he received into a file. Now he made use of the file to put together his catalogue. He listed each of the 51 works in the show, and after each entry he placed at least one quotation. Since everything was being exhibited for the first time, the excerpts referred not to these individual plates but to Whistler himself or to his work generally.

These are typical extracts:

' "He must not attempt to palm off his deficiencies upon us as manifestations of power." – *Daily Telegraph.*'

' "Whistler is eminently vulgar." – Glasgow *Herald.*'

' "An artist of incomplete performance." – F. Wedmore.'

' "It is not the Venice of a maiden's fancies." – 'Arry.'

' "He is never literary." – P. G. Hamerton.'

Five critics were cited by name, four of them more than once: Sidney Colvin (three times), Harry Quilter, always referred to as plain, unadorned ' 'Arry' (four times), Philip Hamerton (twelve times), and Frederick Wedmore (fifteen times).

Thirty-seven-year-old Sidney Colvin, like Tom Taylor and Harry Quilter was an honors graduate of Trinity College, Cambridge. After leaving Cambridge, he wrote articles on art for a variety of prestigious publications, from which he acquired a reputation that led him to be elected, in 1873, Slade Professor Fine Art at Cambridge. Three years later he became director of the Fitzwilliam Museum. He had never said or written an unfavorable word about Whistler, but he was a man of distinction with impressive credentials. That was enough to arouse animosity.

A year older than Colvin, Frederick Wedmore had a similarly formidable background. Educated in Lausanne and Paris, he had been influential in writing upon French painting and upon the art of etching. In addition to a large body of criticism, Wedmore was the author of several well-received novels. Currently he was art critic for the *Standard,* a position he would hold for another thirty years.

Wedmore had a memorable first meeting with Whistler, at a dinner party facing each other on either side of the hostess.

Directly he knew who I was, [Wedmore related,] he became curiously disagreeable. He made 'nasty' remarks about me, which of course I was to hear. Our hostess tried to stop him, but it was impossible. He was continuously

aggressive. His brassy laugh rang out louder and louder, more and more penetrating, at each example of his triumphant rudeness.[6]

What was the reason for Whistler's studied discourtesy toward a man whom he had never met and from whom he had never experienced any unkindness? No other reason than Wedmore's standing as a critic.

In the etchings catalogue Wedmore was the victim of particularly egregious unfairness. He was represented as having said about some of Whistler's pictures, 'They have a merit of their own, and I do not wish to understand it.' Actually Wedmore had written 'understate' rather than 'understand.'

In a letter, Wedmore pointed out the error to Whistler, who wrote out an apology and sent it to Yates, who included it in his column for 28 February:

> Mr Frederick Wedmore – a critic – complains that by dexterously substituting 'understand' for 'understate' I have dealt unfairly with him. Let me hasten to acknowledge the error and apologise. My carelessness is culpable, and the misprint without excuse; for I have all along known that with Mr Wedmore, as with his brethren, it is always a matter of understating and not at all one of understanding.

After he had seen it in print, Whistler wrote to Waldo Story, 'Isn't my letter to the World a *chef d'oeuvre*!'

 * * * *

Wedmore showed no thirst for revenge. In his review of Whistler's show, he was admirably even-handed. This is part of his article in the *Academy*:

> Mr Whistler's etchings are the brilliant successes of a sharply defined personality. . . . It is one of the virtues of etching to seem to be spontaneous, and Mr Whistler is never laboured. If he does not draw the figure accurately, he can draw it expressively. And if the emotional element is lacking, he is a keen observer and a vivacious chronicler of things that are commonplace only to commonplace people. His art is absolutely unconventional, and he is afraid of no new theme. . . . When Mr Whistler meets Velasquez in the Realms of the Blest, let Mr Whistler be provided with his Thames and his Venetian etchings. For Velasquez must be considered, and there must be nothing to dash his happiness in that supreme moment when equals meet.[7]

Most of Wedmore's review was devoted to the etchings rather than the decorations and the catalogue. Not all of his colleagues demonstrated his sense of proportion. This telling piece appeared in the humor magazine *Funny Folks*:

Whistlerian Enthusiast – And how did you like the Whistler Exhibition?
Fair Critic. – Oh, I was charmed. The walls, the programmes, the furniture –
everything was quite *too* lovely. All in yellow and white, you know.
Whistlerian Enthusiast – But the Etchings?
Fair Critic – The Etchings? I – I don't remember *seeing* them.

The critics who did manage to see them were divided in their opinion, ranging
from the view of the weekly *People* that again Whistler had shown a 'power to
express the feeling of a picture by a few lines,' to that of the *Echo's* critic, who
characterized most of the pictures as 'rubbish.'

Whistler thoroughly enjoyed these differing views. 'Never before,' he told
Story, 'was such a Hurrah brought about by art means in London! The people
are divided into opposite bodies, for and against – but all violent! The papers
have been full of the affair – and in short it is amazing! And the gallery is full!!'[8]

On the first Saturday, in fact, some 600 persons paid the entrance fee of one
shilling, and viewers kept coming for the duration of the show. The catalogue,
which also cost a shilling, went through several printings. As one commentator
said, 'The show became a harmony in metals.'

* * * *

Despite the notices of 1882, Whistler returned to the Salon in 1883. With *Lady
Archibald* still unfinished, and no other recent pictures at hand, his sole entry was
something that he was still trying to sell, the portrait of his mother. Most
reviewers liked it, and *Le Figaro*, after praising him for 'having his own way of
seeing nature,'* said that it was time 'to reward this artistic stubbornness with
a medal.' No sooner said than done. He received a third-class medal (equivalent
to an Olympic Games bronze medal). This began his revival of good relations
with the French, whom he would never again disparage.

In London, he appeared as usual at the Grosvenor, with a couple of seven-
year-old nocturnes. One of them, *Black and Gold: The Fire Wheel*, a non-
representational scene in which the principal element is a sparkling wheel of fire,
was, like *The Falling Rocket*, inspired by the fireworks at Cremorne. It didn't
have the shock potential of its predecessor, but it, too, had to wait many years
for a purchaser.

As in every summer since 1872, Whistler sent nothing to the Royal Academy,
but in this season of 1883 there was an R. A. début of sorts by, who else, Oscar
Wilde. On 30 June he gave a lecture to the Academy students at their clubhouse
in Golden Square.

* * * *

After a triumphant year spent delivering 90 lectures in America, Wilde arrived
in London less than two weeks before the opening of the etchings exhibition.

231

Whistler hailed his return with a quotation in the catalogue, the only one that didn't refer unfavorably to himself or his work:

' "Popularity is the only insult that has not yet been offered to Mr Whistler." – Oscar Wilde.'

During the spring of 1883, the two men saw each other frequently, and although he was irritated by the publicity surrounding the American trip, Whistler was friendly enough until the lecture in Golden Square.

Whistler had always been dubious about Wilde's fitness to deliver anything in his lectures but second-hand opinions, and the Golden Square affair shockingly confirmed his worst suspicions. Here are a few typical extracts:

An expression like English art is meaningless. One might as well talk of English mathematics. Nor is there any such thing as a school of art. There are merely artists.

There never has been an artistic age, or an artistic people since the beginning of time. There is no golden age of art.

No object is so ugly that, under certain conditions of light and shade, or proximity to other things, it will not look beautiful. The young artist who paints nothing but beautiful things misses one-half of the world. In Gower Street at night you may see a letter-box that is picturesque. On the Thames Embankment you may see a picturesque policeman.

Popularity is the crown of laurel which the world puts on bad art. Whatever is popular is wrong.

The artist is not a specialist. All such divisions as animal painters, landscape painters, racehorse painters, are shallow. If a man is an artist, he can paint everything.

A picture has no meaning but its beauty, no message but its joy. That is the first truth about art you must never lose sight of. A picture is a purely decorative thing.[9]

All of this is pure, unfiltered Whistler, which Wilde absorbed during the many hours that the two men had spent together. Not only had Wilde stolen these ideas, but nowhere in his lecture did he acknowledge any indebtedness to his source.

Not long afterwards, the prolific writer Frank Harris asked Whistler what he thought of Wilde.

'Oscar is an imitator, not an artist,' Whistler said.

'He may outgrow that.'

'The sponge is always sponging.'[10]

37

The Society of British Artists

[1884–85]

Oscar Wilde was Whistler's protégé only by virtue of plagiarism. Other young men were ready and willing to be true disciples almost to the point of being indentured servants.

The most important of his adherents were Mortimer Menpes and Walter Sickert, who became attached to him soon after his return from Venice.

Menpes was an Australian who arrived in London at the age of 19 in 1879 and enrolled in the school of art at the South Kensington Museum, where one of his teachers was Edward Poynter. In 1880 he exhibited his first picture at the Royal Academy.

Sickert, the same age as Menpes, was born in Munich, son of the Danish artist, Oswald Sickert. After studying briefly to be an actor, he entered the Slade School, University College, London, in 1881, where he was a pupil of Alphonse Legros.

In 1882, Menpes and Sickert abandoned Poynter and Legros to become Whistler's disciples.

We were true followers, [Menpes said.] We had such a reverence for the Master that, highly as we esteemed Velasquez and Rembrandt, we looked upon them as mere drivellers compared with him, and of course we placed him far above Raphael. The only master with whom we could compare our own was Hokusai, the Japanese painter.

We copied Whistler in every detail. When he painted from a table, we discarded our palettes. If he kept his plates fair, ours were so fair that they could scarcely be seen. If he adopted economy of means, using the fewest possible lines, we became so nervous that we could scarcely touch the plate lest we should over elaborate.

We even attempted to copy his mannerisms. We tried to use stinging phrases

and to say cutting things. Our mild expressions, I am afraid, did not carry them off to advantage.[1]

Menpes and Sickert ran errands and executed assignments, in the studio and outside, and they accompanied Whistler on professional journeys, the first of which took place in December 1883. The three of them travelled to St Ives, in Cornwall.

<p style="text-align:center">* * * *</p>

St Ives is an attractively situated town overlooking the sea at the western entrance of St Ives Bay. An important fishing community, its population in 1883 was about 6500. Because of the splendid sea views from gently rising hills, the locale has always been popular with artists.

Soon after arriving, Whistler wrote to his sister-in-law, 'There is nothing but Nature – and, as I've often told you, Nature is but a poor creature.'[2] A few days later, he told Ernest Brown, of the Fine Art Society, 'I shall stay here longer than I expected to – the sea is most fascinating.' There is no inconsistency here. He had never cared much for rural nature, but he had always been attracted to water.

It was hardly a holiday in St Ives. Almost 50 years old, he was as industrious as he had been on the lower Thames in his mid-twenties. Menpes told of how he and Sickert sometimes found in difficult to keep up with him:

> Whistler rose at cockcrow and seemed always full of the most untiring energy. By the time the first glimpse of dawn had appeared, he would be up and dressed and pacing very impatiently along the corridor, screaming reproaches, instructions, taunts, and commands at the somnolent followers. 'Have you got my panels prepared?' – Did you mix that gray tone and put in the tube?' – 'Menpes, have you brought those notebooks with Dutch paper in them?' – 'Pshaw! why aren't you up?' – 'Walter, you are sleeping away your very life! – 'Menpes, is this the sort of life you live in the bush?' He would continue to hurl taunts at us until we were up and dressed and in the dining room.[3]

His energy paid off. The *catalogue raisonné* of his paintings lists eighteen that were certainly or 'probably' done in St Ives. They were mostly in a medium that was new for him, water colors on panels. (Surprisingly, he had done his first serious water-color drawing, a Thames scene, as recently as the autumn of 1881.)

These St Ives pictures are small and unpretentious, typically five by nine inches, with simple subjects reminiscent of Venice: a village street, a sweet shop window, a sandy beach, a cloudy sky, fishing nets, a herring boat. They were done in the daylight – nocturnes were mostly a thing of the past – in the open air 'on location.'

<p style="text-align:center">234</p>

As usual, he was enthusiastic about whatever he was creating at the moment. 'The work I am now doing,' he told Nellie, 'may make this exile worth while. Indeed I am sometimes quite bewildered with my own sparkling invention!'[4]

In this letter, he said, 'Thank Willie for sending the ten pounds at once as I begged him to. I *really am* on the verge of destitution again. What I want now is a portrait. Do you know anyone? Also could you and Willie think of any one I might borrow from for the while?'

Because they couldn't afford anything more costly, Whistler and his followers stayed in a boarding house. But he hardly acted like someone who was impoverished. Menpes recalled their first breakfast:

> After we had begun to eat, the Master frowned. He was troubled. It had suddenly occurred to him that the landlady was neglecting us. She had not realised our position, or rather the position of the Master. She had not yet, as he picturesquely put it, 'placed us.' He rang the bell, and the landlady appeared.
>
> Whistler was very dignified and a trifle severe, 'Now,' he said, 'can you tell me something about the dinner tonight and the coffee after dinner? For, you know, it is the habit of gentlemen' – with a wave of the hand towards Walter and me, as the stout old lady was quaking and nervously shaking her head – 'it is the habit of gentlemen to take coffee after dinner. It occurs to me that it would perhaps be wise of you to turn your attention to this little matter of the coffee. It is not to be served in a large breakfast cup, mark you, but in a small dainty cup of coffee. Madam, do you think you can do this?
>
> The old lady, thoroughly demoralised by Whistler's flow of language, mumbled something and left the room as hastily as possible.
>
> 'Now,' said Whistler, 'I think she realises better our position.'[5]

That night, and every night thereafter during their stay, they were served coffee in small cups.

* * * *

Early in 1884, Whistler was back in London, and in the spring he began his last major portrait in oil. The subject was the legendary virtuoso violinist Pablo de Sarasate.

The forty-year-old Spaniard, noted for his phenomenal technique, was the featured soloist in a series of four sold-out orchestral concerts at St James's Hall in May and June 1884. After attending the first of these concerts, Whistler said to Menpes, 'It was marvellous, you know, to see him handle his violin, especially during those violent parts – his bow travelled up and down the strings so rapidly I cannot imagine how he does it.'[6]

The *Saturday Review*'s evaluation of Sarasate's performance indicates a basis of his appeal for Whistler:

He is not a great musician nor a good interpreter of great music. He is too individual in mind, he has far too much of the indefinable attribute called temperament, to do justice to any one save himself and to anything save his violin. But he has the magnetic gift, the touch of genius, the quality of 'devil,' and his interpretation of whatever is within his range, emotional and intellectual, is unequalled.[7]

Physically, Sarasate was a small, well-proportioned, nervous man with black curly hair. Perhaps because he saw a 'double' of himself, Whistler at once decided to paint the violinist's portrait.

Sarasate agreed to a limited number of sittings, and he was portrayed standing in evening dress, violin in hand, about to begin a recital. It was done in less than a month, completed by 1st of July. (This was Whistler's second full-length portrait of a man in formal attire. The subject of the first one was the French critic Theodore Duret.)

Soon after *Sarasate* was finished, a wealthy American collector of paintings, Frederick Keppel, came to London from Paris with a painting that had been sent by a mutual friend. He arrived in Tite Street at 9.30 in the morning and was kept waiting for half an hour. When Whistler appeared, he held a watch in his hand.

'I have just four minutes to spare,' he said. 'What is it that you want?'

What Keppel 'wanted' was to deliver a large parcel which he had transported from Paris at some inconvenience.

He held his tongue and said nothing that might give offense. He spoke of their mutual friend, and then, he related, 'I described the fine position in which his contributions to the Salon had been hung, and I told him some flattering things which had been said by the right sort of people.'

Whistler abruptly asked, 'Are you fond of pictures?'

'I am fond of such pictures as may be seen here.'

'Come up to my studio. I will show you something that I just finished.'

Resting on an easel was *Sarasate*.

'Isn't that beautiful?' Whistler asked.

'It certainly is.'

'No, *isn't* it beautiful?'

'It is indeed.'

Whistler slapped his knee and almost screamed, 'Damn it! Isn't it *beautiful*?'

Keppel shouted, 'Damn it! It *is* beautiful!'[8]

Satisfied, Whistler showed other things to his visitor, whom he entertained for nine hours, until, at seven o'clock, he excused himself to dress for dinner.

*　　　*　　　*　　　*

The Salon pictures which Keppel had alluded to were *Cicely Alexander*, again on loan, and *Carlyle*, still unsold, both of which were well received.

While these earlier portraits were in Paris, *Lady Archibald Campbell* had a coming-out party at the Grosvenor. Several critics felt that as a reprise of *Rosa Corder*, it was clearly inferior to its prototype, but one reviewer with an overwhelmingly favorable response was Harry Quilter. This is what 'Arry wrote for the *Spectator*:

> It is an excessively fine work, the best example of its artist which we have ever seen. Circumstances have rendered it difficult for us to write of Mr Whistler's work without considerable hesitation, but we shall at least not be suspected of any undue partiality in our admiration of this portrait. It is difficult to see how it could have been done better. The drawing is delicious throughout; the tones and colour are good; the attitude and poise of the figure are natural and graceful; and the whole picture is fresh, powerful, and striking, a masterly piece of work.

<p style="text-align:center">✳ ✳ ✳ ✳</p>

A third exhibition for Whistler in the summer of 1884 was a one-man show, 'Notes – Harmonies – Nocturnes,' which opened on 17 May at Dowdeswell's Gallery, in Bond Street, 57 pictures, mainly small ones done in Chelsea and at St Ives.

The catalogue again had brown paper covers, without quotations from or direct references to critics. This time the distinctive feature, preceding the listings, was a brief essay, '*l'Envoie.*' The title illustrated either Whistler's sense of humor or his imperfect knowledge of French. There is no French word *l'Envoie*, and although *l'Envoi* is associated with ballad poetry, it always appears at the *end* of a poem.

The piece itself contains seven oracular utterances, directed at those who think that a 'finished' painting must display obvious signs of its creator's strenuous efforts. This is part of the statement:

> A picture is finished when all trace of the means used to bring about the end has disappeared.
>
> To say of a picture, as is often said in its praise, that it shows great and earnest labour, is to say that it is incomplete and unfit for view.
>
> Industry in art is a necessity – not a virtue – and any evidence of the same in the production, is a blemish, not a quality; a proof, not of achievement, but of absolutely insufficient work, for work alone will efface the footsteps of work.
>
> The work of the master reeks not of the sweat of the brow – suggests no effort – and is finished from its beginning.

Few of the critics were impressed by this declaration. As for the pictures, the *Morning Post* found them 'so laughable' that it was 'scarcely possible to maintain one's gravity' while viewing them, and the *Saturday Review* concluded

that they 'might as easily be hung upside down.' The *Sunday Times's* reviewer saw 'only one fine thing in the gallery, Mr Whistler's footman, an elegant youth in a drab livery and patent leather pumps, whose beautiful appearance outshines that of any of the strange so-called pictures on the walls.'

There was one critic, however, who was 'fascinated' by the 'spontaneity and ease' with which Whistler had produced 'serious and beautiful work, fresh and freshly seen, and in almost every case set down engagingly.'

These lines appeared in the *Academy* and were written by Frederick Wedmore.

* * * *

Soon after his show had opened, Whistler wrote to Theodore Duret, 'Oscar is going to be married !!!'

The marriage, which deserved three exclamation points, took place on 29 May 1884 at St James's Church, Sussex Gardens.

Whistler, an invited guest, arrived after the ceremonies had concluded.

* * * *

Later in the year, the man who could and did say terrible things to and about critics, sent this letter to a casual acquaintance who had recently been briefly in London:

> My dear Locker – A most charming and kind invitation from Mrs Locker and yourself only reached me long after it was sent.
>
> Fatality! I was so sorry when I didn't get it.
>
> How very nice of you to think of me. When you are in town again, you must let me know that I may call and present my compliments and regrets to Mrs Locker.
>
> A propos – I am no longer in Tite Street – Tite Street has consequently ceased to exist.
>
> Behold the address of my new studio, 454 Fulham Road.
>
> Very sincerely, J. McN. Whistler, The remarkable Etcher with the white lock.[9]

The last line must have had special significance for the Lockers. It has the flavor of an 'inside joke.'

Whistler had moved to Fulham Road because this new residence had a particularly fine studio. He had scarcely settled in when he received a big surprise. He was invited to join the Society of British Artists.

* * * *

In 1823, the Society of British Artists was founded in Suffolk Street, alongside Trafalgar Square, a near neighbor of the Royal Academy. Its first exhibition was

held, contemporaneously with that of the R.A. in the summer of 1824. Neither in prestige nor in the quality of its shows would the S.B.A. ever be comparable to the R.A., but for forty years, or so, it maintained a healthy and vigorous second place. Then it suffered a gradual decline, until, in the late seventies, its exhibitions were at a level well below that of either the Academy or the Grosvenor. As the *Spectator* said, its position was that of 'respectable mediocrity.'

It was in this context that on 22 November 1884 a delegation from this conspicuously conservative art society personally called at 454 Fulham Road and asked its resident to become one of them.

Since it seemed clear that he would never be seriously considered for an Associate membership in the R.A., Whistler readily accepted the S.B.A.'s invitation.

The Society held exhibitions twice a year, in the summer and in the winter. Although the 1884–85 winter show began just ten days after Whistler joined, he was ready for it with two pictures, a small water color done earlier in the year and, on loan, the large eleven-year-old portrait of Mrs Huth.

Whistler's admission was symptomatic of a reawakened organization. For the first time in many years it had a show that received generally favorable reviews. It was quite plain, the *Illustrated London News* rightly concluded, that the Society had 'taken on a new lease on life.'

Whistler could look forward to an exciting future with the Society of British Artists.

38

The Ten O'Clock Lecture

[1885]

With interest and envy Whistler had observed Wilde's success as a lecturer, in the United States, in Golden Square, and, most recently, beginning on 1 October 1884, in Ealing, Liverpool, Manchester, Leeds, Edinburgh, and elsewhere in Britain. In his latest address, 'The Value of Art in Modern Life,' Wilde commended Whistler for 'rejecting all literary titles for his pictures.' None of his works, Wilde said, 'bore any name but that which signified their tone, colour, and method of treatment. This is what painting ought to be; no man should show that he is merely the illustrator of history.'

Even while praising, he was stealing!

If Wilde could read speeches loaded with Whistlerian ideas, why shouldn't the original author mount the lecture platform?

Whistler asked himself this question in the fall of 1884, and he answered it by going to work. Here are entries from Alan Cole's diary for October 1884:

'24th. Whistler to dine. We passed the evening writing out his views on Ruskin, Art, etc.'

'27th. Jimmy to dinner, continuing notes as to himself and Art.'

'28th. Writing out Whistler's notes for him.

'29th. Jimmy to dine. Writing notes as to his opinions on Art matters.'[1]

And so it sent for the rest of 1884 and the early weeks of 1885. Every day he was busy with his lecture.

To handle the practical details, he acquired a manager, Helen D'Oyley Carte, wife of the Gilbert and Sullivan impressario and an experienced theatrical administrator in her own right.

Prince's Hall, Piccadilly, was booked for ten o'clock on the evening of Friday, 20 February. The time was selected, Whistler said, so as not to interfere with anyone's leisurely dinner.

Whistler and Mrs D'Oyly Carte concocted a highly polished publicity campaign. Cards were mailed to selected individuals three weeks ahead of time,

and they were followed by advertisements in the daily papers. The cards and the advertisements announced the time and place of the event and its title, 'Ten O'Clock,' with no hint of what it was to be.

For three weeks, London society burned with curiosity, and newspaper columnists speculated on precisely what was going to happen. One of them wondered if 'Mr Whistler will stand on his head, sing songs, recite, lecture, or draw caricatures.' A writer for the society paper *Truth* asked, 'Is he going to pulverise Oscar Wilde or Ruskin?' On 14 February, as the event drew near, a London correspondent for the provincial *Western Times* wrote, 'I have not met anyone who ever pretends to know what the funny man of the art world is going to do.' Even 'Atlas' was in the dark. In the *World* for 18 February he wrote, 'The mystery as to the nature of Mr Whistler's "Ten O'Clock" remains unbroken, and the curiosity grows in intensity. I am told that only four people are in on the secret, and that they have departed into the country.'

Curiosity stimulated the sale of tickets, at the rather high price of half-a-guinea each, and on the night of 20 February, Prince's Hall, with 1200 seats, was almost filled to capacity.

Ticket holders were advised that 'carriages might be ordered at eleven.' This tells us something about the character of the audience. It was a 'carriage crowd,' including, one columnist said, 'all that was pretty, witty, artistic, dramatic and poetic.' The spectators included Sir Arthur Sullivan, the famous solicitor George Lewis, Alfred de Rothschild, Edward Poynter, George Grossmith, the noted caricaturists 'Ape' and 'Spy' (Carlo Pellegrini and Leslie Ward), a large assortment of Lords, Ladies, and 'Sirs,' and, of course, Oscar Wilde. Two-thirds of the viewers were women, who *Queen* reported, 'appeared *en grande tenue*, with diamonds flashing and satins gleaming.'

The large platform contained only a small table with a bottle of water and a glass. At ten minutes after ten o'clock Whistler appeared on the platform by himself, wearing evening clothes and carrying an opera hat. He placed his hat beside the bottle and stool silently for a few seconds, a glass in his right eye, gazing out at the audience, Wilde said, 'like a miniature Mephistopheles mocking the majority.'

At that moment, the *Telegraph's* reviewer said, 'the spirits of the assembly sank. From Mr Whistler anything might have been expected – a burlesque, a breakdown, or a comic song. But surely his eccentricity would not carry him so far as to deliver a serious dissertation on art. Alas! It was true.'

Speaking without notes, he began, 'Ladies and gentlemen, with great hesitation and much misgiving I appear before you in the guise of The Preacher.'

He was no ranting and raving preacher. He spoke in a disappointingly soft monotone, and at times he could not be heard beyond the first few rows. Cries of 'Speak up!' and 'We can't hear you!' came from various parts of the hall, but Whistler just rambled on in his curiously muted voice.

Those who could hear, or who read the text afterwards, might have been able to extract from a poorly organized lecture five main ideas: 1) Artists stand apart from the rest of society as solitary geniuses uncorrupted by the world into which they were born. 2) A work of art should have no relationship to anything beyond itself. 3) Art critics are arrogant and ignorant. 4) In matters artistic the public taste is conspicuous for vulgarity. 5) 'Amateurs' and dilettantes in art are ridiculous people.

Here are a few highlights:

Art is selfishly occupied with her own perfection only – having no desire to teach – seeking and finding the beautiful in all conditions and in all times, as did Rembrandt, Tintoret, Paul Veronese, and Velasquez. No reformers were they – no improvers of the way of others! Their productions alone were their occupation, and they required not to alter their surroundings.

A favorite faith of those who teach is that certain periods were especially artistic, and that certain nations were notably lovers of Art.

Listen! There never was an artistic period.

There never was an Art-loving nation.

The influence of the critic has brought about the most complete misunderstanding as to the aim of a picture. For him a picture is symbolic of a story, and the work is considered from a literary point of view. He deals with it as with a novel, a history, or an anecdote. He fails entirely to see its excellences or demerits and so degrades Art by supposing it a method of bringing about a literary climax.

The one chord that vibrates with all, the one unspoken Sympathy that pervades humanity, is – Vulgarity!

Vulgarity, under whose fascinating influence 'the many' have elbowed 'the few,' and the gentle circle of Art swarms with the intoxicated mob of mediocrity, whose leaders prate and call aloud, where the Gods once spoke in a whisper!

And now from their midst the Dilettante stalks abroad. The amateur is loosed. The voice of the aesthete is heard in the land, and the catastrophe is upon us.[2]

* * * *

The spectators' response was mixed.

'Half of the audience,' one reviewer reported, 'swore it was the brilliancy of genius; half of them declared it was the audacity of bosh.'

The critics were also divided, extending from the Manchester *Guardian*, which saw it as 'a rare entertainment and a most unexpected revelation of a serious and scientific work,' to the *Telegraph*, which called it 'an undigested mass of pretentious platitudes and formulated fallacies.'

Whistler wasn't much concerned about what the audience or most reviewers

said or thought, but he was affected by one notice. It appeared on 21 February in the *Pall Mall Gazette* and was written by Oscar Wilde.

<center>✻ ✻ ✻ ✻</center>

It was in his 1300-word *Pall Mall* piece that Wilde characterized Whistler as a 'miniature Mephistopheles.' This impertinence characterized the essay. It dripped with sarcasm. Whistler's disdainful remarks about 'aesthetes,' 'amateurs,' and 'dilettantes,' Wilde correctly concluded, were aimed primarily at himself. And so he retaliated.

The lecturer, Wilde reported, 'spoke for more than an hour on the absolute uselessness of all such lectures.' He 'explained to the public, with charming ease, that the only thing they should cultivate was ugliness, and that on their permanent stupidity rested all the hopes of art in the future.' The audience was also told that,

> no matter how vulgar their dresses were, or how hideous their surroundings at home, still it was possible that a great painter could, by contemplating them in the twilight, and half closing his eyes, see them under really picturesque conditions, and produce a picture which they were not to attempt to understand, much less to enjoy.

Not only was Wilde flippant, he had the effrontery to disagree with the 'master,' rightly pointing out that he was on shaky ground in denying the existence of artistic periods and nations, because 'an artist can no more be born of a nation that is devoid of any sense of beauty than a rose blossom can grow from a thistle.'

Then came this pronouncement: 'The poet is the supreme artist, for he is the master of colour and form, and the real musician besides, and is lord over all life and art; and so to the poet beyond all others are the mysteries known; to Edgar Allan Poe and Baudelaire, not to Benjamin West and Paul Delaroche.'

Whistler at once dispatched a note to Wilde:

'Oscar – I have read your exquisite article. Nothing is more delicate, in the flattery of 'the Poet' to 'the Painter' than the *naïveté* of 'the Poet' in the choice of his Painters – Benjamin West and Paul Delaroche!'[3]

In replying, Wilde explained his method of selection:

> Dear Butterfly, By the aid of a biographical dictionary I discovered that there were once two painters, called Benjamin West and Paul Delaroche, who recklessly took to lecturing on Art.
>
> As of their works nothing at all remains, I conclude that they explained themselves away.
>
> Be warned in time, James, and remain, as I do, incomprehensible; to be great is to be misunderstood.

<center>243</center>

The letter contained a postscript: 'Jimmy! You must *stamp* your letters – they are so dear at two pence.'[4]

Whistler had the last word:

'For one whose greatness depends upon remaining misunderstood, it was indeed rash to reveal the source of his inspiration – a Biographical Dictionary!'[5]

Copies of the notes, with Wilde's postscript excluded, were sent by Whistler to Yates, who dutifully had them reproduced in the *World*.

39

An Active 'British Artist'

[1885–86]

Various people have assigned various times and places to Whistler's most famous riposte, but it seems most likely to have occurred at the private view of the 1885 summer exhibition of the Society of British Artists.

Oscar Wilde, an inveterate attender of private views, was there. On the preceding evening at the Beefsteak Club Whistler had delivered a particularly witty remark. Wilde now congratulated him for it and added, 'I wish that I had said that.'[1]

Unhesitatingly, Whistler retorted, 'You will, Oscar, you will.'

*　　*　　*　　*

The show itself elicited more compliments for the S.B.A. 'This time last year,' the St James's Gazette said, in a representative comment, 'the gallery was like a dusty, dismal auction-room. Now it shines with gold and crimson and oak parquet, and a moderate percentage of the pictures are really works of art.'

Most of the writers knew who deserved credit for this rehabilitation. As The Times said, it was 'the election of a lively American painter settled in London' that had breathed 'new life in the rather ancient society.'

In addition to exerting influence, Whistler contributed the 'hit' of the show, Sarasate, which the Graphic called 'the best male portrait the artist ever produced,' and the Pall Mall Gazette judged to be 'one of the most original and powerful portraits painted in England for many years.'

*　　*　　*　　*

In the summer of 1885, Whistler and Maud moved from Fulham Road to a quiet, leafy cul-de-sac off the King's Road, known as the Vale. Their new home was an attractive little square house with verandahs and a large back garden. Because of its predominant outer color, it was sometimes called 'the Pink Palace.'

On this tranquil, rustic backwater, was Whistler, at the age of 51, ready for a life of middle-aged quiescence? Hardly! He had barely settled in when he was off on a sketching trip to Belgium and Holland. Soon after his return, he left on a journey to Dieppe. In the low countries, his travelling companion was the American William Chase, and he went to Dieppe with Walter Sickert.

While he was gone, Maud lived alone. This summer separation seems symbolic. For some time she had ceased to model for him, and they were no longer personally intimate. As with Jo, Whistler was becoming bored with Maud.

*　　*　　*　　*

After settling down in the Pink Palace, Whistler was ready for another controversy.

During his first year as a British Artist, his conduct had been exemplary, but one year of good behavior was his limit. He crossed the line at the 1885–86 winter exhibition.

The show was a good one, for which Whistler received much of the credit. After only a year's membership, the *Pall Mall Gazette* said, 'he had become the mainstay of the society.'

His principal entry was another 'arrangement in black,' a full-length portrait of the sister of American impressionist painter Mary Cassatt, dressed in a riding costume and removing a glove. Coming in the wake of *Rosa Corder* and *Lady Archibald Campbell*, it evoked a response of déjà vu. Another of his entries, however, generated some excitement, and it was only a small pastel drawing.

*　　*　　*　　*

Seymour Haden's younger sister Rosamund was married to one of Britain's best-known painters, John Calcott Horsley, who, at the time of the S.B.A.'s 1885–86 winter show, was 68 years old and had been an R.A. for 24 years and a participant at its Exhibition for 47 years. The Horsleys lived in a large home in Campden Hill, Kensington, but Whistler had never set foot in it. Probably no words had ever been exchanged between him and them at any time or place. Rosamund's unpublished diary, which her late granddaughter permitted me to see,[2] repeatedly refers to Deborah and her children, but it is without a single reference, explicit or implied, to Deborah's older brother. Even in 1860, she didn't mention *At the Piano*, the Sloane Street parlor scene which created a sensation and was bought by an R.A. The diary would suggest that for the Horsleys, James Whistler did not exist. They snubbed him, it seems fair to conjecture, because of his behavior and his lifestyle. As the black sheep of the family, he was simply ignored.

For years Whistler had been bent on getting back at John Calcott Horsley. Now, late in 1885, he had his chance.

Horsley was a strait-laced person who objected, on moral grounds, to nude models, and on 7 October, in a lecture that was covered by all of the London papers, he told a group of clerics,

> If those who talk and write so glibly as to the desirability of artists devoting themselves to the representation of the naked form only knew a tithe of the degradation enacted before the model is sufficiently hardened to her shameful calling, they would for ever hold their tongues and pens in supporting the practice. Is not clothedness a distinct type and feature of our Christian faith? All art representations of nakedness are out of harmony with it.

Whistler couldn't pass this up, especially since one of his pictures in Suffolk Street was a pastel drawing of a female nude.

On the lower extremity of the frame, he attached a label with these words: 'Horsley soit qui mal y pense.' This was a play on the motto of the Order of the Garter: Honi soit qui mal y pense. (Evil be to him who thinks evil.)

The Pall Mall Gazette reported that Whistler had said, 'This is not what people are sure to call it – "Whistler's little joke." On the contrary, it is an indignant protest against the idea that there is any immorality in the nude.'

Two days later the Pall Mall published his response:

'No! kind sir, – Trop de Zele on the part of your representative – for I surely never explain, and Art certainly requires no "indignant protest" against the unseemliness of senility.

"Horsley soit qui mal y pense" is meanwhile a sweet sentiment – why more – and why "morality"?'

Some older members were disturbed by the derision of an eminent Academician and had the sign removed but not soon enough to prevent it from being widely quoted and providing fun for London's art community.

※　　※　　※　　※

In the following summer, Whistler appeared in three exhibitions.

At the Salon, Sarasate scored another success, while back home there was a second 'Notes – Harmonies – Nocturnes' show at Dowdeswell's, 75 small pictures in a variety of media. It too was a triumph. The best of the numerous good reviews was in the Sunday Times, the first important notice of Whistler by a man who would be one of his most consistent champions, Malcolm Salaman.

Once in the gallery, Salaman knew that he was 'in an atmosphere of great and true art' and 'in the presence of a mighty master.' His 'versatile and comprehensive powers,' his 'beautiful results without our being able to trace the means by which they were brought about,' and his 'singularly keen and comprehensive artistic vision' made Whistler 'the greatest artist of the day.' Salaman prophesied that 'in the future it will be as safe and respectable to

express admiration for him as for Velasquez, or Raffaele, or Turner, or any of the "old masters." '

Existing contemporaneously with the Dowdeswell's show was the summer exhibition in Suffolk Street. Whistler's main entry was a large painting entitled *Harmony in Blue and Gold*, which was very much a focus of attention. Since it disappeared long ago, and there are apparently no reproductions of it in existence, we must rely on contemporary reports for its details. It was a life-size figure study of a young woman in a blue dress, holding a yellow parasol and leaning against the yellow railing of a pier before a background of bright blue water. Since her dress was made from transparent blue film gauze, she apparently appeared to be, for all practical purposes, in the nude. This picture, the *Builder* said, 'will send Mr. Horsley and the British matron into hysterics,' and other reviewers assumed that it had been painted to teach Horsley a lesson. Actually it had been done prior to Whistler's bankruptcy, and it was resurrected for that purpose.

<p style="text-align:center">✳ ✳ ✳ ✳</p>

On 24 June 1886, the *Court and Society Review* published three letters on Whistler.

The first was signed 'A Country Collector, a Plain Man,' who had been 'nauseated by the extravagant adulation' of this 'eccentric and very astute gentleman.' He confined his remarks to one picture, the *Harmony in Blue and Gold*, at the S.B.A., 'a colossal piece of pyramidal impudence,' a 'rubbishy sketch of a young woman who is not naked but ought to be, for she would then be more decent.' The painting had engendered a dispute within his family: 'My daughters have commanded me to admire Mr Whistler, but I will *not* admire him. My girls gaze with critical calmness on that which would have sent their grandmothers shrieking from the gallery.'

The second letter came from 'A British Artist,' someone who belonged to the S.B.A. He called the *Harmony in Blue and Gold* 'an insult to art (to say nothing of decency), and to those members of the society whose honest work surrounds it.'

The third correspondent, a self-styled 'Unknown Quantity,' was 'forced to admit that Mr Whistler is the best showman in London' and that 'the works of this impressionist look to considerable advantage when they are hung upside down.'

Why did these communications, which the *Saturday Review* characterized as 'very funny and very silly,' appear at this time, almost two months after the last of Whistler's shows had opened? The 'British Artist' provided an explanation: his own society had 'just made itself ridiculous.'

The president of the S.B.A., the Scottish genre painter John Burr, creator of inoffensive domestic scenes, had lately resigned. On 3 June, the members chose as his successor James Abbott McNeill Whistler.

40

President Whistler

[1886–88]

On 1 December 1886, Whistler officially became president of the S.B.A. A little earlier he had brought his relationship with Oscar Wilde closer to its inevitable termination.

In November, a 'National Art Exhibition' committee was formed to bring about reforms in the administration of fine arts affairs in Britain, particularly with regard to the Royal Academy. The members of the committee included Harry Quilter and Oscar Wilde. When Whistler heard about this, he whipped off a letter to the committee chairman and sent a copy to Yates, who published it on 17 November:

> Gentlemen – I am naturally interested in any effort made among painters to prove that they are alive – but when I find, thrust in the van of your leaders, the body of my dead 'Arry, I know that putrefaction alone can result. When following 'Arry, there comes on Oscar, you finish in farce, and bring upon yourselves scorn and ridicule.
>
> What has Oscar in common with Art? except that he dines at our tables, and picks from our platters the plums for the pudding he peddles in the provinces. Oscar – the amiable, irresponsible, esurient Oscar – with no more sense of a picture than of the fit of a coat, has the courage of the opinions . . . of others!

Wilde's response appeared in the *World* a week later: 'Atlas, this is very sad! With our James vulgarity begins at home and should be allowed to stay there.[1]

Whistler's rejoinder: 'A poor thing, Oscar, but for once, I suppose, your own.'

* * * *

A columnist for the socially oriented *Lady's Pictorial* asked, 'Was Mr Whistler's pen-and-ink attack on Oscar Wilde for fun, or did he mean it?' Currently, the

writer noted, Whistler was 'peacefully painting a portrait of Lady Colin Campbell.'

Lady Colin was the beautiful sister-in-law of Lady Archibald Campbell, and, beginning on Friday, 26 November 1886, the central figure in Campbell v. Campbell, the longest, most notorious divorce trial in British history.

The S.B.A. private view was also held on 26 November, and since everybody was talking about the Campbells, Whistler strained to get his portrait ready. He wasn't able to finish it – it remained forever unfinished – but even so on the day before the private view it was placed in a prominent position. (On the same day he sent a note to Lady Colin: 'You are of course Splendid! of the 'Amazing.' To be understood by you is my delight! To do beautiful things with you is my ambition.')

'The *sensation* of the exhibition,' a reviewer wrote, 'is Mr Whistler's full-length portrait of Lady Colin Campbell,' which he called *Harmony in White and Ivory*. As expected, it brought many curious people into the gallery. (Also, Whistler personally hung a landscape by the Lady herself, which one critic called 'a poor schoolgirl exercise' and the others tactfully ignored.)

The Lady Colin picture showed that, in the words of the *Builder*, the society had 'entered into the stage of Whistlerdom.' The number of entries had been reduced to about 500, half of what had been traditional. Instead of covering walls from floor to ceiling, pictures were neatly arranged in two or three rows. The overall quality was much higher than had been usually seen in Suffolk Street recently. There may not have been more good paintings, but there were certainly fewer bad ones.

And Whistler had not yet presided over his first meeting.

*　　　*　　　*　　　*

Never has there been, and probably never will be again, such a president as Whistler, [said Mortimer Menpes, brought into the society by his master.] The president at a meeting is supposed to encourage the members to talk and give their opinions; but that was not Whistler's idea. He sat in the president's chair and talked for hour upon hour. He was brilliant, flowing, caustic, but he talked not to the members but at them.[2]

He took an interest in everything pertaining to the society. Because he didn't like the old letterhead on the stationery, he designed a new one. And despite opposition from some older members, this son of Anna Whistler opened the galleries, for the first time, on Sunday afternoons and provided tea for visitors.

As for exhibitions, Menpes, placed by Whistler on the hanging committee, said, 'I was instructed to be ruthless in rejecting pictures. He impressed upon me the necessity of saying, "Out, damned spot! If you are uncertain for a moment, say 'Out.' We want clean spaces round our pictures."'[3]

Of the first show under his presidencey, the *Standard's* judgment was typical: 'The "British Artists" has almost suddenly become one of the very few exhibitions which it is essential for intelligent picture-lovers to see.'

Whistler had six pictures on display – a large portrait of Mrs Walter Sickert and five small paintings done at various times and places.

More significant than his own works were those of his steadily increasing band of disciples – Menpes and Sickert, and also Albert Ludovici, George Jacomb-Hood, Sidney Starr, Theodore Roussel, and William Stott.

The best of them was Stott, 30 years old, as defiant of art conventions as Whistler himself, but also the only one of the group – including the master – to become an Associate of the Royal Academy. (His failure to be elected an R. A. was probably due to his early death, at the age of 42.)

At his insistence, Stott's name always appeared in catalogues as 'William Stott of Oldham.' This was not, as many people thought, an affectation, as if he were emulating Leonardo da Vinci. He had studied in Paris when another English art student there signed his pictures 'Edward Stott' but was actually named William Edward Stott. To avoid confusion, 'William Stott of Oldham' was coined. Oldham is in Lancashire, and in the 1880s it had about 150,000 people and more than 300 cotton mills. It was a British equivalent of Lowell, Massachusetts. As one man was indignantly denying any connection with his place of birth, another man was gratuitously advertising *his* home town.

Stott's main entry attracted more interest than any other picture in the show. Entitled *A Nymph*, it was a large portrayal of a naked woman with luxurious gold-red hair, lying suggestively on a field of grass.

John Calcott Horsley wasn't shocked by it because he never entered the Suffolk Street galleries. On the second day, however, Whistler welcomed two other rather eminent guests, the Prince and Princess of Wales. No one could remember the last time that a member of the royal family had visited an exhibition of the S.B.A.

✻ ✻ ✻ ✻

In 1887 Britain celebrated the fiftieth anniversary of Queen Victoria's accession to the throne, and Whistler made the most of it.

On 20 June, on behalf of the society, he sent an elaborate illuminated address of congratulations to Her Majesty. On 23 July he attended the grand jubilee naval review at Spithead, when the royal yacht passed before a fleet of 135 vessels. Four days later he sent the Queen a folio of twelve etchings commemorating the event.

His efforts bore fruit. On 17 August *The Times* reported, 'At a special assembly last evening, the president of the Society of British Artists announced the command of the Queen that the Association shall henceforth be styled the "Royal Society of British Artists."'

251

Six weeks earlier, Whistler had brought the Belgian Alfred Stevens into the society, and now he sent him the good news:

> Finally – we triumph! All that I foretold during my last visit to Paris has taken place! I want you to know that the Society which had the honor of receiving you as a member has been named by her majesty the Royal Society of British Artists. So on the envelope which contains this little note I have added the initials R.B.A. to your illustrious name!
> The Academy is completely disconcerted!*4

He rather overstated the effect of this development on the world of art. Every issue of the *Art Journal* and the *Athenaeum* had a section of short notices on recent fine arts happenings considered newsworthy. Neither of these publications mentioned the name change. The relevant issue of the *Athenaeum*, however, noted that the 'Long's hotel, Bond Street, associated with Scott, Byron, and a host of *literati* is shortly to be pulled down and rebuilt.' The pertinent number of the *Art Journal* informed its readers that 'Mr Ruskin's health is so completely restored that he is better than he has been for some time.'

 * * * *

Because of his euphoria over the S.B.A. becoming the R.S.B.A., Whistler failed to heed warning signs concerning his presidential status.

Lately the society had received negative notices, and not just from conservatives. This is part of George Bernard Shaw's response to the 1887 summer show, written for the *World*:

> Many art critics who passed from the exhibition at the Dudley Gallery of the New Art Club [a new organization of painters, most of whom had been influenced by the Impressionists] to that of the British Artists must have thought that it was the first of April, and that perhaps these 'impressionist' pictures would be spirited away during the night and replaced by more sensible ones. Truly, if some of them were spirited away and not replaced at all, the public would not be the losers. Mr Whistler must recognise that there is not half-a-crown's worth of successful or even honest effort in some of the works conspicuously hung in the vinegar and brown paper bower he has made for his followers in Suffolk Street. The 'new' fashion may be capital fun for Mr Whistler and a few others who can swim any tide, but for feebler folk it means at best a short life.5

More ominous than strictures from outside was restlessness from within. Members were complaining about the expense of redecorating the gallery, about the loss of income caused by empty spaces on the walls, and about the foreign influence on a society of 'British Artists.' Most of all, the dissidents objected to

the type of picture increasingly favored by the hanging committee, which they called 'Whistlerian.'

The plight of the anti-Whistler faction was detailed in 'The Sufferings of a Suffolk Streeter,' by 'One of the old School,' published in the weekly humor paper *Fun*:

I'm an artist by profession, and my name is Truthful John,
With the school known as Impressionists I never could get on;
So, in language free from passion and from prejudice, I'll tell
How they upset our society at Suffolk Street, Pall Mall.

For nothing could be finer or more beautiful to see
Than the picture shows the first years of our Society;
Till in an evil moment we were led to think it well
To elect a fresh President, a real artistic swell.

Now it's always been the motto of our Society
That the thing the public likes is 'Mommy dear, kiss me';
Domestic scenes must always go with patrons such as ours,
Especially when eked out with some landscape-bits and flowers.

But no sooner was he seated in the Presidential chair
Than he changed our exultations into wailings of despair;
For he broke up our traditions and went in for foreign schools
Turning out the work we're noted for, and making us look fools.

In the place of neat interiors and cottage scenes so fair,
We're bedecked with muslin curtains and nocturnes here and there.
And if the British public will placidly look on
Then Art's a mystery to one whose name is truthful John.

And since he's in possession, there's nothing to be done
But to start upon some other tack and finish some other run;
But I've told in simple language how this nocturne-looking swell
Has ruffled our Society at Suffolk-street, Pall Mall.[6]

Soon after the R.S.B.A. came into existence, Whistler, seemingly oblivious of rumblings in the ranks, went to the International Exhibition in Brussels. Menpes, lately returned from eight months in Japan, was his companion by command, 'given two hours,' he said, 'to gather my luggage and present myself at the station.'[7]

Upon boarding the vessel that would take them to Belgium, Menpes related, Whistler

saw the captain looking at his compass and somehow didn't like it. He stood looking from the captain to the compass and back again for about five minutes, and people began to gather around. The captain exclaimed, 'What the deuce are you looking at?' That started Whistler. He talked for half an hour – brilliantly, caustically, stingingly. He wiped the deck with the captain, with only his gold lace and brass buttons to distinguish him from the humblest galley slave.

In the dining room, 'the stewards waited on him badly, the food was atrocious, and there were too many passengers.' In their four-berth cabin, he complained that one of the other occupants, a fat man, took up too much space.

There were additional amusing incidents in Belgium and Holland, and at the Brussels exhibition there was an explosion. Whistler confronted on one of the walls several etchings which had been done by Menpes and Sickert and had been entered in the show without his knowledge.

'I shall never forget the terror of that moment,' Menpes recalled. 'My hair all but stood on end. He put on his eyeglass and looked from me to the frames and back again, and for a time was speechless.

Then he shrieked, white with rage, "How dare you! I gave you my friendship. Aren't you ashamed of yourself?" '8

Not until two weeks later did Whistler speak agreeably to Menpes.

<p style="text-align:center">* * * *</p>

After returning to London, early in October, Whistler began preparing for his first 'royal' exhibition.

The show opened with London's very first evening private view, from nine till midnight on Friday 25 November. Among the large crowd, the *Sunday Times* reported, 'rank, fashion, beauty, and talent were well represented.'

The nocturnal private view was Whistler's idea, as was the appearance of the 'father of French impressionism,' Claude Monet, who had entered four pictures. He had exhibited once before in London, but it was in a small Bond Street dealer's showroom, with few visitors, and so this was really his British public début.

Monet's pictures weren't as well hung as Whistler would have liked, nor were his own, nor those of anyone else, because there were many more entries than in the preceding show, far too many for the president's taste. The *Pall Mall Gazette* saw this as 'proof of the collapse of Mr Whistler's attempt to hang each work with a large margin of space around it.'

The restrictive hanging policy had been a sore point with many members. Individual artists had suffered financially, as had the society itself, which received a commission on every picture sold. The rejection of 500 pictures for which space was available meant a big loss of potential income. As a practical matter of shillings and pence, Whistler had to back off.

<p style="text-align:center">254</p>

* * * *

One picture in the 1887–88 winter show was an embarrassment for the president, *The Birth of Venus*, by William Stott of Oldham.

This was another of Stott's nudes, a large round painting of the goddess rising from the waves and stepping onto a sandy beach. The reviewers liked the background but not the figure. *The Times* called her 'Venus Pandemos.' In the *Spectator* Harry Quilter characterized her as 'a red-haired, vulgar folly.' Mation Spielmann, in the lately founded *Magazine of Art*, asked, 'Why outrage so cruelly the Cyprian goddess by giving her name to a repellent, imperfectly developed type of the *atelier* model?' And the *Illustrated London News* said that she was 'the most unkempt goddess ever presented to mortal view,' with 'towlike red hair' and a 'figure possessed of neither grace nor dignity.'

The acceptance and positioning of this painting had been managed by the hanging committee, and Whistler, preoccupied with other society affairs, did not see it until it had become a public sensation.

After reading the reviews, he went at once to the gallery in which it was hanging. He stared at it, the most blatantly conspicuous painting in the room, and he was flabbergasted. For the first time since confronting Harry Quilter at the etchings show, he was rendered speechless. The model for Venus, 'the most unkempt goddess ever presented to mortal view,' was Maud Franklin!

He actually did not know that she had sat for the picture. He was cognizant of her frequent, often prolonged visits to Stott's suburban home, but he thought they were social calls because Stott's wife happened to be Maud's sister. Actually the truth was that he had been relieved to be rid of her. Now he was embarrassed and infuriated. His all-too-recognizable mistress had been publicly labeled 'a red-haired, vulgar folly'!

Despite his anger, he remained relatively calm. There wasn't much point in berating Maud since an early break in their relationship seemed inevitable. And with Stott, as with Horsley, he would wait for his revenge.

* * * *

Whistler continued for a while to be superficially amicable with William Stott, but in the spring of 1888 he cut the link to his closest follower, Mortimer Menpes.

Late in 1886, with the master's blessing, Menpes had gone to Japan to study its art and then, presumably, to deliver a report to the chief. But something happened to Menpes in Japan. He saw nature with his own eyes, developed his own artistic personality, and returned to London as his own man.

He had more than a hundred of his own paintings, drawings, and etchings, which, without consulting Whistler, he exhibited at Dowdeswell's, beginning on 16 April 1888.

This was the first show of its kind, a representation of Japanese life by a British artist. It got rave reviews, and everything was sold. *The Times* predicted, accurately, that the exhibition would 'be the talk of the town until the Academy opens.'

Menpes was famous, and Whistler was furious. He strode into Dowdeswell's and within hearing of dozens of people, he denounced his former pupil as 'a thief' and shrieked,

> Your only hope of salvation is to walk up and down Bond Street [where the show was being held] with PUPIL OF WHISTLER printed in large letters on a sandwich board at your back, so that the world may know that I, Whistler, created you. You will also write to the *Pall Mall Gazette* and say that you have stolen my ideas; you will say publicly that you are a robber.[9]

He then marched out of the gallery.

A couple of days later, Whistler sent his terminal communication to Menpes: 'Now you will blow your brains out, of course. Pigott has shown you what to do, and you know your way to Spain. Good bye!'[10] (Richard Pigott was a notorious forger who had gone to Spain to escape arrest and then shot himself.)

In a letter to Nellie, Whistler referred to Menpes as 'a treacherous rascal,'[11] and when someone brought up Menpes's name, he said 'Meneps? Who's Meneps?' (It may be remembered that mispronouncing the name of a supposed inferior had been a practice of Courbet.)

Whistler's 'good-bye' was categorical.

* * * *

'If extremes meet anywhere in Art,' the *Standard* said in the spring of 1888, 'their meeting place is certainly Suffolk Street, where the old and the new most come together.'

A few days later, the two sides in Suffolk Street had their irrevocable collision.

The old guard knew that their strength depended upon numbers, and after a special meeting on 26 March they had the numbers. Whistler and his followers were caught napping, and eleven men were elected to membership. One of them, James Shannon, was first-rate; the others were nonentities who turned out hackneyed portraits and landscapes. The election was held to strengthen the anti-Whistler forces, and when push became shove ten of the new men joined the opposition to the president. (Only Shannon supported him.)

Several special meetings were held, and, the *Athenaeum* reported, Whistler's 'position as President of the S.B.A. was repeatedly and angrily debated.' His adversaries brought their complaints to the floor and defeated him on proposals regarding finances, decorations, and the hanging of pictures.

Whistler would not surrender.

You complain of my eccentricities, [he said at one meeting.] But you invited me into your midst because of these so-called eccentricities. You elected me because I was much talked about and would bring notoriety into your gallery. Did you think that when I entered your building I should leave my individuality on the door mat? If so, you were much mistaken. I am still Whistler, the so-called eccentric, still the master.[12]

Soon he would be Whistler the former president.

Under no illusions as to his position, he did not participate as an exhibitor in, or an organizer of, the 1888 summer exhibition. Most of his followers also abstained. Their absence was noticeable. A representative response to the show was that of the *Academy*: 'The disappearance of Mr Whistler and his followers has brought the exhibition of the Royal Society of British Artists nearly to its old level. Among the subjects of pictures, children, dogs, and cats, and other specimens of the "homely" class are prevalent.'

The *Academy's* review appeared on 19 May. Two weeks later, Whistler's fate was sealed.

On 5 June 1888, *The Times* ran this three-line item at the bottom of a page: 'At the general meeting of the Royal Society of British Artists held last night, Mr Wyke Bayliss was elected president.'

Immediately above this dispatch was a note of four lines: 'Miss Julia Nelson, the recent *débutante*, appeared at the Savoy Theatre yesterday as Lady Hilda in a special performance of Mr Gilbert's poetic play *Broken Hearts*, and gained the applause of a fashionable house.'

Wyke Bayliss's election was followed by the resignation of Whistler and 22 others (not including Menpes, who had already left, or Stott, who stayed.)

* * * *

Punch's report of the election began, 'James the First, Etchist, is no longer President,' and ended, 'Who is Wyke Bayliss?'

Writing for the *Pall Mall Gazette*, Oscar Wilde drew a contrast between the old and the new: 'The former President never said much that was true, but the present President never says anything that is new, and if art be a fairy-haunted wood or an enchanted island, we must say that we prefer the old Puck to the fresh Prospero.'

Wyke Bayliss in fact epitomized mediocrity. Best known for uncomplicated pictures of Gothic church interiors, he exhibited twice, and only twice, in 1865 and 1879, at the Royal Academy. He would be president of the R.S.B.A. until his death in 1906.

* * * *

'What is the moral of it all?' Whistler was asked by a correspondent from the *Pall Mall Gazette.*

'Mr Whistler became impressive – almost imposing,' the interviewer wrote. He then answered the question:

> The Royal Society of British Artists, as shown by its very name, tended perforce to this final convulsion, resulting in the separation of the elements of which it was composed. They could not remain together, and so the 'Artists' have come out and the 'British' remain – and peace and sweet obscurity are restored to Suffolk Street! Eh? eh? Ha! Ha![13]

41

Capturing the Butterfly

[1888–90]

Whistler entered several pictures at the 1888 International Exhibition in Munich, and in August he was advised that he had been awarded a 'second-class gold medal.'

At once he wrote to the First Secretary, Central Committee, International Art Exhibition, Munich: 'I beg to acknowledge receipt of your letter officially informing me that the Committee has awarded me a second-class gold medal. Pray convey my sentiments of tempered and respectable joy to the gentlemen of the Committee and my complete appreciation of the second-class compliment.'[1]

He then departed for Paris. His travelling companion was Mrs James Abbott McNeill Whistler.

✻ ✻ ✻ ✻

'The Butterfly is captive at last. Sweet willing captivity no doubt, but still the airy freedom of bachelor days is gone. Mr Whistler was married yesterday morning.'

So the *Sunday Times* reported on 12 August 1888.

The new Mrs Whistler was Beatrix Philip Godwin, 32, daughter of a sculptor, the late John Birnie Philip, and widow of Whistler's associate in building the White House, E. W. Godwin. She had studied art in Paris and was a moderately talented painter. Whistler had met her through Godwin, and after his death in 1886 they became close companions, in London and on the Continent. (By then he had almost entirely broken away from Maud.) They were an odd couple: Trixie, or 'Chinkie,' as Whistler often called her, was a couple of inches taller than he and about forty pounds overweight. But they got on together famously. She was easy-going, always cheerful, a fine influence on him.

Occasionally and vaguely, they had talked about marriage, and their decision to take the plunge came about quite casually.

One of their friends, the MP from Northampton, Henry Labouchere, thought that they would make an excellent married pair, but he realized that left to themselves they would probably never do anything about it. And so one evening late in July 1888, as he was dining with them and several others in a restaurant in Earl's Court, he decided to give them a push:

'Jimmy,' he asked, 'will you marry Mrs Godwin?'

'Certainly.'

Mrs Godwin, will you marry Jimmy?'

'Certainly.'

'When will you marry, Jimmy?'

'Oh, some day.'

'That won't do. We must have a date.'

'All right, then. You name the date. Is that all right with you, Trixie?'

'Certainly.'[2]

Labouchere named the time and place, and he provided the officiating clergyman.

Less than a fortnight after the Earl's Court conversation, the wedding took place at the fashionable St Mary's Abbots Church, in Kensington Church Street.

On the day before the event, Labouchere encountered Trixie in the street.

'Don't forget tomorrow,' he said.

'No, I won't. I am now going to buy my trousseau.'

'Isn't it a little late for that?'

'No. I'm only going to buy a toothbrush and a sponge, as one ought to have new ones when one marries.'

At a few minutes after eleven on the morning of Saturday, 11 August 1988, the Rev. Mr Byng, Chaplain to the House of Commons, pronounced James Whistler and Beatrix Godwin husband and wife. Labouchere gave away the bride, and others in the party included Mr and Mrs William Whistler and a few friends.

Shortly before the wedding, Whistler had returned to Tite Street, to a place called Tower House, and the reception was held there. Since the furniture was not yet in place, they all sat on packing cases to eat food that had been catered by the Café Royal. (Mr and Mrs Oscar Wilde were living on Tite Street but were not invited to the church or to the reception.)

* * * *

The way in which this marriage was carried out might seem extraordinary, but the action itself is perfectly understandable from the point of view of either of them.

Whistler was 54 years old, acutely aware of his mortality, in need of companionship. And, although he wouldn't have admitted it to anyone, he

knew that his best work was behind him, that he would create no more masterworks. There was therefore no professional reason for remaining single.

He could hardly have found a more suitable mate. Trixie was a good-natured, intelligent person who had always lived in an artistic milieu, and could be counted on to be consistently even-tempered and supportive. She was not physically attractive, but this may have been a plus. Whistler had had his fill of good-looking women.

On her part, Trixie, the daughter and a widow of artists, admired, personally and professionally, James Whistler, and a woman who was neither pretty nor young nor rich was ill situated to hold out for something better.

Was there love between them? Probably. Trixie, in my opinion, was the only woman whom Whistler ever loved.

As for the abandoned woman, she moved in with the Stotts and was extremely resentful. But Maud must have seen the handwriting on the wall. The marriage may have been surprising, but not the defection. She and Whistler had been travelling on separate paths, and also she surely remembered what had happened to Joanna Hiffernan.

<p style="text-align:center">*　*　*　*</p>

In the autumn of 1888, after a leisurely French holiday, the newly-weds settled at 46 Tite Street, the Tower House, so called because it was Chelsea's tallest building, one of Godwin's last structures. It contained four flats, each with an attached studio. The Whistlers were on the (American) third floor.

A couple of weeks after moving in, James posted a letter to his most ardent journalistic advocate, the *Sunday Times's* Malcolm Salaman:

> The Royal Academy of Munich have elected Mr Whistler an Honorary Member, 'as a sign of the honour and high esteem in which they hold his superb work in the domain of Art.
>
> Upon this you might dilate as you like – pointing out the recognition from abroad as compared to the determined negation at home – not forgetting that Mr Whistler has this honour conferred upon the *very first time* his works are shown in the land.[3]

A few days later he enjoyed the almost universally negative response to the British Artists' first post-Whistlerian show.

> The galleries in Suffolk Street, [*The Times* said,] have relapsed to their ancient mood. The short reign of wayward, interesting, even brilliant, but by no means British, art is over and with the substitution of Mr Wyke Bayliss for Mr Whistler as President, the society returns to the old state of things. It is painful to have to add that, except for the more or less slight contributions good-naturedly sent by

a few Academicians, the level of the display is decidedly below what the public has a right to expect, even in Suffolk Street.

* * * *

The first few months of Whistler's married life were entirely peaceful. The spell was broken early in 1889.

Late in the evening of Thursday, 3 January, two men were sitting together, conversing in the smoking room of that favorite Victorian organization of artists, in Albermarle Street, the Hogarth Club. One of them was the fine Scottish painter John Reid, and the other was Whistler.

Suddenly someone charged into the lounge, William Stott, looking for Whistler. Maud Franklin had been vilifying the man who, she felt, had deserted her, and Stott wanted to settle the score.

He strode over to where the men were seated and began to fulminate against Whistler.

What happened next was described by Whistler in a letter to the Committee of the Hogarth Club:

Gentlemen – I beg to express my deep sense of regret at the episode of last night, in the club drawing-room, when a newly-elected member – Mr Stott of Oldham – entering the room at about midnight, came up to me, and, without preface of any kind, addressed me in the following terms: – 'You are a liar and a coward!'

We were alone in the room with Mr John Reid, who witnessed fully what took place.

I immediately rose and slapped Mr Stott's face – a spontaneous movement, and, gentlemen, you must admit, a most inevitable consequence of such gross insult.

I am grieved to add that the first slap was followed by a second one, and the incident closed by a kick administered upon a part of Mr Stott of Oldham's body that finally turned towards me, and that I leave to specify.

I thereupon resumed my interrupted conversation with Mr Reid, and was not further disturbed by Mr Stott of Oldham.

I earnestly beg, gentlemen, that some measures be taken to prevent the recurrence of such intolerable provocation and monstrous insult.[4]

Whistler then wrote to a friend in Paris,

Stott 'of Oldham' is dead! I gave him a couple of *splendid* slaps in the face and an elegant kick in the rear in the drawing-room of the Hogarth Club! all in the most perfect and distinguished manner possible! A real *acqua fortis*. Whistler with the detachable inset engraved on the backside of Stott! A 'masterpiece!' You

must tell the story on the boulevards. To top it all, I'm sending you a copy of the letter that *I myself wrote* to the Committee of the Club! * 5

Stott gave the Committee a contradictory account. Among other things, he said that since he, Stott, was much larger than his adversary, he could not have been physically mishandled. But, unknown to him, John Reid, a man of unquestioned integrity, had fully supported Whistler's version in a letter in which he said, 'I think Mr Stott of Oldham must either apologise to Mr Whistler or he must retire from the club.'

The Committee agreed and offered Stott his choice of these two courses of action. Stott resigned.

Whistler and Stott never again spoke to each other.

* * * *

In April 1889, a card went out to everybody who was anybody in London's art world, announcing 'A complimentary Dinner to Mr. J. McNeill Whistler in recognition of his influence upon Art, at Home and Abroad, and to congratulate him on the honour recently conferred upon him by the Royal Academy of Munich.' The card was headed by a list of 27 names, members of the 'Committee' for the dinner, including three A.R.A.'s and two R.A.'s (J. B. Boehm and W. Q. Richardson).

One invited guest, Pablo Sarasate, sent regrets that he could not attend because of a concert engagement, whereupon Whistler wrote to him,

'What do you mean, my dear Pablo! I just learned that you do not intend to be present at this dinner in my honour! Impossible! Cancel your concert! It's ridiculous for you not to be there at the great moment, this once in a life-time occasion.' * 6

Without Sarasate, who went ahead with his concert, the affair was held at one of Whistler's favorite restaurants, the Criterion, in Piccadilly Circus.

Whistler delivered a brief after-dinner address, ending with these words:

It has before now been borne upon me that in surroundings of antagonism, I may have wrapped myself, for protection, in a species of misunderstanding – as that other traveller drew closer about him the folds of his cloak the more bitterly the winds and the storm assailed him on his way. But, as with him, when the sun shone upon him, his cloak fell from his shoulders so I, in the warm glow of your friendship, throw from me all former disguise, and, making no further attempt to hide my true feeling, disclose to you my deep emotion at this testimony of affection and faith.[7]

It is important to recall the fable to which he alluded, Aesop's 'The Wind and the Sun':

A dispute arose between the north Wind and the Sun about the superiority of their power; and they agreed to try their strength on a traveller and see who could get his cloak off first. The Wind began and blew a cold blast, accompanied by a sharp, driving shower. But this only made him wrap his cloak around his body as close as possible.

Next came the Sun, who, breaking out from behind a cloud, drove away the cold vapors from the sky and darted his warm, sultry beams upon the head of the weather-beaten traveller. The man grew faint from the heat, and unable to endure it any longer, at first threw off his heavy cloak, and then flew for protection to the shade of a neighboring grove of trees.

Like most of Aesop's fables, this one has been variously interpreted. But Whistler seems to have used the story to indicate that he could withstand any amount of condemnation, but would melt under an outpouring of praise.

He needed enemies in order to survive.

42

'The Gentle Art of Making Enemies'

[1890–91]

Except for the encounter with Stott, 1889 was quiet, peaceful, and unproductive for Whistler.

One such year was enough, and it was clear from the start that 1890 would not be a reprise of 1889.

The January 1889 issue of the magazine *Nineteenth Century* had contained an article entitled 'The Decay of Lying: A Dialogue,' by Oscar Wilde. Whistler didn't learn about it until almost a year later. This is easy to understand. Since he is not mentioned in it, it would not have been sent by his cutting service, and *Nineteenth Century* was not something that he often read.

'The Decay of Lying' is a dialogue between Cyril and Vivian in the library of an English country home. Cyril is the 'straight man,' feeding questions to Vivian, who pontificates on matters relating to art and speaks for the author.

These are sample 'Vivianisms':

'As long as a thing is useful or necessary, it is outside the proper sphere of art. To art's subject-matter we should be more or less indifferent.'

'*Art never expresses anything but itself.* It is thus that music is the true type of all the arts.'

'Art develops purely on her own lines. She is not symbolic of any age.'

Then, as the height of audacity, Vivian says, 'The modern novelist has not even the courage of other people's ideas.'[1]

Coincidentally, when Whistler became cognizant of 'The Decay of Lying,' the society newspaper *Truth* had just published a piece on plagiarism which mentioned by name some famous plagiarists. This prompted Whistler to write a letter which appeared in *Truth* on 2 January 1890.

He began by saying, 'Nothing have I enjoyed with keener relish than your tilt at that arch-impostor, the all pervading plagiarist!' But why, he asked the editor, 'in your list of culprits did you omit that fattest of offenders, our own Oscar?'

He then exhumed the address to the R.A. students at Golden Square in June 1883, when,

> Oscar arrogated to himself the responsibility of the lecture, with which, at his earnest prayer, I had, in good fellowship, crammed him that he might not add deplorable failure to foolish appearance before his audience. He went forth as my St John, but, forgetting that humility should be his chief characteristic, and unable to withstand the unaccustomed respect with which his utterances were received, he not only trifled with my shoe but bolded with my latchet!

More recently, Whistler continued, 'Mr Wilde has deliberately and incautiously incorporated a portion of the letter in which I acknowledge that "Oscar has the courage of the opinions of others!"'

He then included the text of a letter he had sent to Wilde:

> Oscar, you have been down the area again, I see!
>
> I had forgotten you, and so allowed your hair to grow over the sore place. And now, while I looked the other way, you have stolen *your own scalp*!
>
> For the detected plagiarist there is one way to self-respect (besides hanging himself), and that is to boldly declare, '*Je prends mon bien là ou je le trouve.*'
>
> But you, Oscar, can go further, and with fresh effrontery, that will bring you the envy of all criminal *confreres*, unblushingly boast, '*Moi, je prends son bien là ou je trouve!*'[2]

A week later *Truth* published Wilde's reply:

> I can hardly imagine that the public are in the very smallest degree interested in the shrill shrieks of 'Plagiarism' that proceed from time to time out of the lips of silly vanity or incompetent mediocrity.
>
> However, as Mr James Whistler has had the impertinence to attack me with venom and vulgarity in your columns, I hope you will allow me to state that the assertions contained in his letters are as deliberately untrue as they are deliberately offensive.
>
> The definition of a disciple as one who has the courage of the opinions of his master is really too old even for Mr Whistler to be allowed to claim it, and as for borrowing Mr Whistler's ideas about Art, the only thoroughly original ideas I have ever heard him express have had reference to his own supriority as a painter over painters greater than himself.
>
> It is a trouble for any gentleman to have to notice the lucubrations of so ill-bred and ignorant a person as Mr Whistler, but your publication of his insolent letter left me no option in the matter.[3]

Whistler's retort, in *Truth* for 16 January, contained the last words to pass

between them. 'Cowed and humiliated,' he acknowledged that 'our Oscar is at last original,' and 'sublime in his agony, he certainly has, for once, borrowed from no living author.'

'In all humility' Whistler admitted that 'the outcome of my "silly vanity and incompetent mediocrity" must be the incarnation: "Oscar Wilde."' [4]

* * * *

Shortly after the *Truth* episode, the Whistlers moved into a Queen Anne studio house, downstream from Lindsey Row at 21 Cheyne Walk. It had four stories, six bedrooms, a large rear garden, and a magnificent view of the river.

Jimmy and Trixie lived here for just over two years. Their parlormaid for most of this period recollected life at 21 Cheyne Walk in a letter to *The Times*:

The house seemed very large. On the top floor was Mr and Mrs Whistler's bed-sitting room, Mrs Whistler's studio, my own bedroom, and Miss Philip's room. She was Mrs Whistler's sister and acted as housekeeper. Mr and Mrs Whistler's bedroom was very pretty. The whole effect was white with beautiful butterflies here and there on everything. Mr Whistler set great store by his butterflies, and had all the house linen and his own personal linen marked with them.

The whole of the drawing-room floor [American second floor] was his studio. He had another studio not far away, and I often used to take his luncheon there in a big breakfast tray, very carefully arranged with pretty, dainty china.

They lived in the foreign manner, having breakfast on a tray taken upstairs to their room, and never more than bread, butter, and watercress. They liked 'dejeuner,' as it was called, at 12 o'clock, and then dined in the evening. They were quiet people, with not much entertaining, and then only artists. . . .

Mr Whistler could be quick-tempered, and once he was very angry with me. There was on the dining-room table a small table of china that stood on four legs on a mat with a vase on the top with a perforated lid for flowers. Cleaning under the mat one day, I unfortunately upset and broke the vase.

Mr Whistler was very angry and threatened to send me to prison. Mrs Whistler told him gently not to be silly, and so I never went to prison! [5]

Nor was she sacked. When the Whistlers moved to Paris, they wanted to take her with them, but she didn't go only because she preferred to stay in England.

* * * *

The one major book with Whistler's name on the title page appeared during his residence at 21 Cheyne Walk.

In 1889, Sheridan Ford, a young American correspondent for the New York *Herald* who had written several articles on Whistler, approached him on Tite Street with an idea for a book of documents – *Ten O'Clock*, the Ruskin trial

record, letters to editors, statements in catalogues, reviews of his work – anything relevant to his career. Ford even had a title: *The Gentle Art of Making Enemies.*

Whistler encouraged him to proceed and gave him cuttings from his own file.

Ford spent many days in the reading room of the British Museum, gathering, organizing, and editing materials. When the work was almost completed, out of the blue he received a terse note from Whistler, withdrawing authorization for the project. To compensate Ford for his weeks of labor, he had enclosed a check for ten pounds.

Whistler had written this note at the urging of Trixie, who realized that money, perhaps a great deal of it, might be realized from the book.

Ford tried to publish the book that he had put together, in England, the United States, and Belgium, but he was pursued by Whistler's lawyers, and since Whistler owned the copyright to his own letters, they could and did block distribution of the book. They also could and did ruin Ford financially.

Meanwhile in mid-1890 William Heinemann brought out Whistler's version of what Ford had compiled. The title was enlarged to *The Gentle Art of Making Enemies, as pleasingly exemplified in many instances, wherein the serious ones of this earth, carefully exasperated, have been prettily spurred on to unseemliness and indiscretion, while overcome by an undue sense of right.* Whistler added a few items to, and discarded a few from, the Ford anthology. He also provided a three-word frontispiece – '*Messieurs Les Ennemis!*' – and throughout the 286 pages he inserted his own marginal, usually sarcastic comments.

The book opens with documents on the Ruskin trial and closes with '*l'Envoi*' (the word now correctly spelled and properly used), Whistler's remarks at the 1889 complimentary dinner. The intervening pages contain letters to papers, especially the *World*; reviews, mainly unfavorable; pamphlets and statements; catalogues; the Ten O'Clock lecture; and miscellaneous items. The earliest document was the comment in 1867 on Philip Hamerton's critique of the *Symphony in White, No. 3.* The latest was a letter published in the *Scots Observer* on 19 April 1890.

Whistler loved this book. Soon after their first meeting in 1890, Graham Robertson related, 'Whistler read nearly the whole of it aloud to me at one sitting with the greatest enjoyment.' 'To the Pennells, he repeatedly referred to it as his 'Bible.'[7]

A present-day reader with an interest in Whistler will probably find the book to be idiosyncratic, moderately witty, and exceedingly dated.

<div align="center">* * * *</div>

A couple of months after the publication of *The Gentle Art*, a comic episode added a name to Whistler's list of enemies, that of Augustus Moore, younger brother of novelist–essayist George Moore.

A man in his early thirties, he was known as 'Masher' Moore. ('Masher' was a name given to dandies who dressed in an exaggerated manner, spoke and acted affectedly, and regarded themselves as 'ladies' men.') As a high-spirited, brilliant conversationalist who had been a mediocre student, he resembled Whistler.

In the late eighties, Moore founded a weekly newspaper, *The Hawk*, which he called 'a smart journal for young men about town' but was in fact a scandal sheet. Late in the summer of 1890 it contained an item, already published and denied, that Degas had reprimanded Whistler for 'behaving as if you had no talent.' Whistler found this to be offensive and decided to retaliate in a forthright manner.

Moore was a habitual 'first-nighter,' and Whistler went looking for him at the opening of 'a new military, sporting, and spectacular drama in five acts,' '*A Million of Money*, on 6 September at the Drury Lane. Since he had never met Moore, he brought along a friend to identify him. In the foyer, the friend pointed to Moore, about nine inches taller than Whistler. What happened after that is a matter of dispute. According to one account, Whistler shouted 'Hawk! Hawk!' and then struck Moore across the face with his cane. Another version has Whistler running toward Moore with his hand uplifted, shouting, 'This is the way a hawk strikes!' and then, before reaching his target, slipping and falling to the ground.

The *Athenaeum*, which gave *A Million of Money* only a lukewarm review, said in its 'Dramatic Gossip' column that:

> An unrehearsed drama, leaning to farce and more interesting than that on the stage, was witnessed in the lobby of the Drury Lane when a well-known artist struck a journalist with his cane. Mr Harris [manager of the theater] is a most enterprising man, and we are curious to know whether this entertainment for his visitors was not of his providing.

* * * *

Not long after the Drury Lane escapade, Whistler became acquainted with a young man who had recently bought *Rosa Corder* and another of his paintings, W. Graham Robertson, who recalled the meeting:

> I received a letter from Whistler. 'I am told,' he wrote, 'that you have acquired two paintings of mine. This being the case, you will perhaps pardon my curiosity to see them hanging on your walls and my desire to know the collector who ventures to brave popular prejudice in this country.'
>
> 'The collector' – it sounded so important – and elderly. I felt very young and uninteresting and quite sure of proving a disappointment.
>
> But I was in for it; Whistler was coming to luncheon, my mother had taken to

her bed in a sudden attack of shyness which she called a slight chill, and I was left alone to face the Great Man.

I had heard tales of his sarcasm, his pitiless wit, his freakish temper, and by the time he arrived I was on the point of developing a slight chill myself.

But behold, instead of the Whistler of legend entered a wholly delightful personage, an *homme du monde* whose old-world courtesy smoothed away all awkwardness and who exercised an almost hypnotic fascination such as I have met with in no one else.

I knew him for Whistler by the restless vitality of the dark eyes; there was the dapper figure, the black curls, the far-famed white lock, but of the scoffer, the *papilio mordens*, not a trace. He was courteous and kind and showed a lovable side to his nature with which he is not often credited.[8]

After 1891 a person did not have to be courageous or foolhardy to buy a Whistler painting; in that *annus mirabilis* there were successive sales of the portraits that for nearly two decades had been unmarketable, *Thomas Carlyle* and the *Mother*.

Carlyle had made the rounds of exhibition galleries: the one-man show of 1874; the Grosvenor, 1877; the Salon, 1884; Edinburgh, 1884; Dublin, 1884; Glasgow, 1888; and London's College of Men and Women, 1889.

It was almost sold in Edinburgh in 1884. A subscription list to purchase it for the asking price, 500 guineas, had almost reached its goal when Whistler learned that some subscribers didn't really like the painting. He telegraphed the managers of the subscription, 'The price has advanced to one thousand guineas. Dinna ye hear the bagpipes?' There was no sale.

After the Edinburgh fizzle, interest in the painting dropped off until 1891, when a group of artists in Glasgow urged city officials to buy it at the current asking price, 1000 guineas. The city council sent a delegation of its members down to London to examine the portrait and to discuss the matter with the artist.

'Mr Whistler received us,' one of them said, 'with great ceremonial, cordiality, and impressiveness. He wore a brown velveteen jacket and a loose neck-tie, with hanging ends, reminiscent of the Boul' Mich. His hair was oiled and curled and worn well down toward the shoulders. He walked as if on tiptoes, his head daintily turned sideways.'

After preliminary eating, drinking, and smoking, he escorted them up to his studio to see the painting.

'Mr Whistler,' one of his guests asked when they were in the studio, 'do you call this life size?'

'No, I don't,' he answered calmly, exercising admirable self-control. 'There is really no such thing as "life size." If I put you up against that canvas and measured you, you would be a monster.'

'The tones of this portrait are rather dull, are they not?' he was asked. 'Not very brilliant, are they?'

'Not brilliant! No, why should they be? Are you brilliant? Am I brilliant? Not at all. We are not "highly colored" are we? We are very ordinary looking people. The picture says that and no more.'

After more questions had been asked and answered, the leader of the group wondered if the price might be reduced to 800 guineas.

'Gentlemen,' Whistler said, 'you and I will never haggle over money. If it were in my power to bestow this picture on the people of Glasgow as a gift, I would gladly do so, as proof of my appreciation of their good judgment in desiring to have it. But alas, I cannot make it a gift, and I wish you to have it. What need, then, to discuss the question of money?'[9]

Soon after the men had returned to Glasgow, he received a check for 1000 guineas.

* * * *

From 1872 until 1891, the *Mother* was exhibited at least ten times: four times in London and once in Philadelphia, New York, Paris, Dublin, Munich, and Amsterdam. Even though no one had made a serious offer, David Croal Thomson, art critic and manager of the Goupil Gallery, thought that the French government might be interested in acquiring it for the Musée du Luxembourg. This was the relatively new home for contemporary works of art, the best of which would eventually be transferred to the Louvre.

Thomson suggested that it be shown in the Goupil's Paris branch, where it could be seen by the right people. Game for anything, Whistler agreed.

The authority for purchasing pictures for the Luxembourg rested with the Minister of the Interior, who was escorted to the Goupil Gallery by the famed poet Stéphane Mallarmé, an admirer of Whistler's work and recent translator of the Ten O'Clock lecture. The Minister liked the portrait, and, Mallarmé told Whistler, would probably make an offer.

Whistler's correspondence with Mallarmé shows how important this matter was to him.

'You know, *mon cher ami*,' he wrote on 13 November, 'that I don't want to cause any problems regarding the price. I just want to see the portrait in the "Luxembourg," and I am prepared to accept any price that the government will offer.'*

Three days later he wrote,

You surely know how sweet this artistic triumph in the world capital of Art would be for me! All of my past sufferings in this country – 'insults and ribald misunderstandings' [written in English] – would then become insignificant. I

271

would even find poetic justice in the severe trials which I have undergone before achieving such recompense and honor in my lifetime.* 10

On 24 November, Mallarmé informed Whistler that the Minister was willing to buy the picture for 4000 francs (about £160 or $800). 'I believe,' he said, 'that you should accept it at once, without losing even an hour, for a thousand reasons which we shall talk about later. Please wire me at once as follows: "Yes, I accept 4000 francs."' * 11

Whistler immediately sent this telegram: 'Accept sum agreed upon.'

He did not want the people in the telegraph office to know how much was being paid.

Since the French government rarely gave more than £200 for a picture to hang in the Luxembourg, it was a good price, and in any event, as the *Art Journal* said, 'It was an honor that presumably outweighs all monetary considerations.'

On 27 November 1891, the Government of France officially took possession of Whistler's *Mother*. (As almost every reader of this book surely must know, for many years it has been one of the most popular works in the Louvre.)

43

Living Again in Paris

[1892–94]

George Smalley, London correspondent for the New York *Tribune*, had occasionally contributed pieces on Whistler for his paper, and early in 1892 Whistler wrote to him about the sale of the *Mother*, rightly surmising that an article would follow.

> The highest honor that can be conferred upon an artist by the French Government, [he said,] has been conferred upon me. What has occurred is without precedent, in that the French Government took the initiative and le Ministre de l'Instruction Publique et des Beaux Arts wrote himself *direct* to me personally, asking if I would '*cedar ce tableau au Government Français*,' and trusting that my conditions might not prove an obstacle to its purchase. Such a démarche on the part of the Government is openly acknowledged to be quite unheard of, and is universally accepted as an official engagement that the picture goes to the Louvre. This is simply the greatest honor that can be conferred upon an Artist, and it occurs in my lifetime![1]

His other recently sold portrait, on loan from Glasgow, was at the New Gallery, in Regent Street, in an exhibition of 'dead heroes and notables,' where it had been 'skied' just under the ceiling.

> Could anything, [Whistler told Smalley,] be more perfect as a resumé of all the past! Was ever revenge more complete! One work received with high honors in the Luxembourg [where it had been exhibited, for two weeks, well positioned in the *salon d'honneur*] on its way to the Louvre, at the *very moment* that another is hoisted with equally high disrespect in a gallery in Regent Street!'

※　　※　　※　　※

Recognizing a changed attitude toward Whistler, the Goupil Gallery's Thomson

went to him late in 1891 and proposed a retrospective exhibition of oils. Whistler liked the idea, and they began preparing for an early spring opening.

Thomson described Whistler's efforts: 'He corresponded with the owners and cajoled the unwilling into letting him have their treasures. He worked day and night, and his example of intense application I can never forget.'[2]

Forty-three paintings and a photograph of the *Mother* were included in the show, representing all types and periods, ranging from *Carlyle* to *The Fire Wheel*, from *Cicely Alexander* to *Symphony in White, No. 3*, from *Rosa Corder* to *Old Battersea Bridge*, from *The Blue Wave* to *The Balcony*. The exhibition was called 'Nocturnes, Marines and Chevalet Pieces' and ran from 21 March until 9 April.

On the day before the private view, Whistler was interviewed by someone from the *Illustrated London News*:

'Well, Mr Whistler,' he asked, 'have you any surprises for us? Any dainty delights in drapery?'

'Aha! The catalogue is the thing to catch the conscience of the critic.'

'The catalogue?'

'Well, here, you see are all these beautiful things they've said about me from time to time, don't you know, and the moral of it all is, you see, that they, and the rest of them, are going along in the old way, while we are on our road to the Louvre! Ha, ha, ha!'[3]

Again he had a brown-covered catalogue with each entry followed by negative statements by Ruskin, Hamerton, Wedmore, and others. He couldn't resist repeating an old joke.

He was questioned on what he was currently painting.

'Well! I am at work on a full-length portrait of a distinguished man, the Comte Robert de Montesquiou. It is a standing figure, and those who have seen it declare it quite the best thing I have ever done.'

The subject was well known to Parisian society, an eccentric poet and art patron, who would be Proust's model for the Baron de Charlus. Whistler had begun the picture late in 1891 in London, with some 17 sittings in one month, and was now carrying on with it in Paris.

* * * *

The Goupil Gallery show was an immense success.

The *Pall Mall Gazette's* reviewer spoke for his compeers when he wrote that 'the time has long passed when Mr Whistler's Nocturnes and Harmonies could be received with shouts of laughter.'

Nothing more cogently epitomizes this changed attitude than the *Saturday Review's* evaluation of the picture that had been the thorn in Ruskin's flesh: 'To the notorious "Falling Rocket" we have nothing to offer but admiration. This,

it appears to us, is a previously unrecorded aspect of modern life, caught with exquisite exactitude, and painted in tones of the richest harmony.'

Numerous writers acknowledged Whistler's healthy influence. The *Graphic's* critic, for one, observed, 'He has taught painters how much better it is to look at Nature with their own eyes than with the spectacles of tradition. He has shown that simple subjects can become picturesque by skilful treatment, and he has shown that art is more important than subject.'

As a result of the show, the *Scotsman* was certain that Whistler's 'reputation will stand higher than ever before.' And not because of new pictures. 'The art remains where it was twenty years ago,' the *National Observer* remarked, 'but public opinion is creeping up. In the critic's vocabulary originality has usurped the place of eccentricity.'

The *Echo's* review of the Goupil show was headed 'The Vengeance of Mr Whistler.' He was basking in it. 'It was amazing, wasn't it,' he wrote to his brother and sister-in-law. 'The great triumph of this Exhibition crowned all my past victories.'[4]

In addition to the excellent reviews, more than 10,000 visitors saw his pictures. In a letter to Thomson, Whistler said, 'the papers acknowledge that in numbers at the door we have "beaten the record"!'[5] It is not clear just what record was broken, but with an average daily attendance of 575 the small gallery must have been congested most of the time.

Whistler wrote these letters from Paris, where he and his wife had arrived on the day after the Goupil opening, not for a visit but to settle, perhaps permanently.

* * * *

'Our address is, as you see, Paris, and I am delighted with the place!' Whistler wrote early in 1892 to Sidney Starr, one of his S.B.A. supporters. 'The dreariness of London was at last too depressing for anything, and after the exhibition there was nothing to stay for. No further fighting necessary, I could at last come away to this land of light and joy where honors are heaped upon me.'[6]

He repeatedly expressed this notion that he had been appreciated more in Paris than in London. He told his brother,

> Everybody is determined to do us honour! And after all those black and foolish years in London among the Pecksniffs and Podsnaps with whom it's peopled, you can fancy the joyous change! Amazing! To look at *one's own* picture hanging on the walls of the Luxembourg – remembering how it was treated in England – to be met everywhere with respect – to be covered with distinction, and to know that all this is gall and bitterness and a tremendous slap to the Academy and the rest! It's like a dream – a sort of fairy tale. It's a pity you have to stick in that dark London.[7]

The truth of course was that in the earlier years his work had been better treated in London, and that the response to the *Mother* at the Academy had been predominantly favorable. But he wouldn't give London credit for anything, not even the good reviews at the Goupil, which Trixie explained in a letter to an American friend: 'Since the sale of the Mother to the French government, it is wonderful to note the different tone his pictures are spoken of by the London press.'

<p style="text-align:center">* * * *</p>

After a few weeks on the Rue de Tournon, the Whistlers moved into their only fixed place of residence in Paris, on the Rue du Bac, which leads up from Pont Royal through the ancient, once aristocratic Quartier St Germain. Their address, number 110, was two streets above Boulevard St Germain des Pres. An ideal location, close to the Latin Quarter, but not too close, it provided seclusion in the heart of the old city.

They had a flat in a two-story seventh-century house. To reach it, one passed through a narrow passage beneath an archway into a small paved courtyard. Their door, painted peacock blue soon after their arrival, was opposite the entrance to the court. From the door several steps led down into a small vestibule which opened into the drawing room, described by an early visitor:

> It was restful and charming to the last degree. The floor was covered with a coarse, dark-blue matting; the panelled walls were in pure white and blue, while the ceiling was in a light shade of blue. The few pieces of furniture were of an old pattern, graceful almost to fragility, and covered with some light stuff which harmonized with the tone of the walls. There were but two pictures in the room, at each end, 'harmonies' by Whistler. The 'key' being blue, the pictures blended with the walls. Near the fireplace, at one end of the room, was a little old-fashioned table covered with writing materials – paper of the smallest size, a dainty ink-stand, and several quill pens.[8]

On one side of the room large windows opened onto a garden, where on Sundays Whistler presided over tea parties and was an exemplar of good manners and conviviality.

Arthur Eddy, a lawyer and an art connoisseur from Chicago said,

> It is difficult to describe the charm of his manner, so different from the notion that prevails generally. He was far more easy of approach than most celebrities, and he was the most agreeable and companionable of men. He would make the diffident feel instantly at ease, and he would exert himself to interest even a stupid visitor, but he would not encourage him to come again.[9]

<p style="text-align:center">276</p>

Eddy said that Whistler 'did not monopolize the conversation,' but 'was the keenest of listeners at a dinner-table, and if someone said a good thing he was the first to applaud.'

Another American in Paris was an art student who would become Director of the St Louis School of Fine Art, Edmund Wuerpel. Whistler saw him copying the *Mother* and began a conversation.

It was not so much what he said, [Wuerpel recalled,] as the way in which he said it, that made such an impression upon me. There was not the slightest suggestion of patronage, hauteur, or condescension, no show of superiority or greatness. Had he been a family physician giving me friendly advice concerning my health, he could not have talked more gently, more sympathetically, or more earnestly to me, an utter stranger.[10]

Wuerpel became a frequent guest at 110 Rue du Bac, where, he said, 'I was always taken in by them in the most charming manner and made to feel that I was conferring a pleasure upon them by being there.'

That Wuerpel was entertained by 'them' is a tip-off on Whistler's current conduct. He had come strongly under the influence of his wife.

Trixie was calm, cheerful, tactful and knew just how to handle her husband.

She was so full of sympathy and understanding for his genius, [Wuerpel said,] that no mood of his was ever misunderstood by her. When after a long strenuous day's work he came home tired and discouraged she would have all sorts of small troubles to relate in order to make him forget his. It was either the cook or the canaries or the roses that worried her.

'Jimmy,' she once said, 'I want you to come out and see what is the matter with the rose-bush – it looks droopy.'

'But Trixie,' he protested, 'I am so tired.'

'Yes, I know, but the bush may die if you don't look at it at once and tell me what to do.'

Child-like, he followed her into the garden, and they walked back and forth, arm in arm, until his mood changed. Mrs Whistler humored him as she would a child and managed him so skillfully that he never suspected it.[11]

* * * *

When Whistler came home from 'a long, strenuous day's work,' he came from a building unconnected with his home. The artist and the husband led separate lives.

His studio was located about three-quarters of a mile away, just south of the Jardin du Luxembourg, at 86 Rue Notre Dame des Champs. Large enough to have a gallery along one wall, and with a fine skylight, this was, he said, his all-

time best studio. But to reach it he had to climb six steep flights of winding stairs. Because of the tiring ascent, he always carried his lunch with him. He took control of his studio just before the opening of the 1892 Salon, where he was represented by five nocturnes and the portrait of Mrs Meux, now Lady Meux, in the pink dress and big hat.

'My success is *complete*, all along he line!' he wrote to Thomson. 'In this morning's *Figaro* – the *first* article – *Whistler* was the first mentioned! Lady Meux's picture is an *enormous* success! Also the Nocturnes.'[12]

The Parisian notices for *Lady Meux* were indeed superlative. Typically, Edmund Potur in the *Gazette des Beaux-Arts* called it 'a masterpiece of taste and arrogant simplicity.'*

British reviewers were less enthusiastic because they had seen the pictures six weeks earlier in Bond Street. As Claude Phillips said in the *Art Journal*, 'None of these contributions is new, or anything like new, and their presence at the Salon is something of an anomaly.'

Nor were they new when in the Goupil Gallery. Camille Pissarro had been in London and wrote to his son, 'I supposed that Whistler would show his new works. It's strange that he doesn't want to show new canvases. Perhaps he hasn't any! For years I have seen the same works again and again! Why?'[13]

Why indeed? The question might continue to be asked. For two and one-half years, until the end of 1894, Whistler worked steadily in his sixth-floor studio but didn't complete anything even to approach his best works of the past. After his success in London, he received numerous commissions, especially from wealthy Americans, to do portraits, for which they paid from 1000 guineas for full lengths down 300 for very small ones. All of them, even *Montesquiou*, were minor efforts of no great significance.

<p style="text-align:center">* * * *</p>

Whistler, 60 years old in 1894, realizing that he was no longer as creative as he once had been, may have been doing this work primarily for money. Certainly at this time monetary matters of one sort or another were of more than usual concern to him.

In the first place, there were checks that he posted periodically with annoyance, usually 'in great haste': 10 March 1992, £5; 11 April 1892, £5; 5 May 1892, £5; 10 August 1892, £5; 12 September, 1892, £5; 27 September, 1892, £8; 14 December 1892, £10; 15 May 1893, £5; 30 June 1893, £6; 13 December 1893, £5; 24 January 1894, £5, 'which I can ill afford'; 5 March 1894, £5; 5 July 1894, £10.[14] They went to 16 Featherstone Buildings, Holborn, and were made out to Charles James Hanson. Who was Charles James Hanson? The son of James Abbott Whistler, that's who.

Charles Hanson's name does not appear in the Pennells's 643-page biography, nor in their 339-page *Whistler Journal*, a record of their personal relationships

with the artist. Nor is he referred to in any biography published before 1974. (In one of the two books of 1974, he is allotted three sentences; in the other, he is given an incorrect first name.)

Hanson's absence from the literature is due to prudery, to a scarcity of documentary materials, and to his relative unimportance. But as the only one of Whistler's children about whom we know anything, he deserves some mention.

Charles was born on 10 June 1870. Whistler is alleged to have called him 'an infidelity to Jo,' because he was presumably the son of a parlormaid, Louisa Fanny Hanson. I say 'presumably' because the maid soon disappeared, and Charles was adopted and raised by Jo, whom he called 'Aunty.' This is admittedly speculative, but would it really be preposterous to suggest that for reasons best known to themselves Whistler and Jo gave the boy a chambermaid's name to conceal the identity of his real mother, none other than Jo herself? In this connection, it may be significant that when the two of them parted, Jo at once took over as guardian of the lad, who was then four years old.

Regardless of who his mother was, Whistler had very little personal contact with Charles until his graduation on 9 June 1888 from the King's College day school, in London's Strand. A 'chip off the old block,' he finished at the bottom of his class.

Immediately afterwards, he became his father's secretary, a job he held until the Whistlers moved to Paris. He acknowledged letters, answered inquiries, kept an appointment book, posted price lists, delivered messages, and performed a variety of menial tasks for his father and his stepmother.

The relationship between father and son was cool and formal, with letters beginning 'Dear Mr Hanson' and ending 'J. McNeill Whistler.'[15] When speaking or writing to others about his son, Whistler always referred to him as 'Mr Hanson,' and most people were not cognizant of their biological connection.

Sometimes Whistler became extremely angry with the young man, usually because of money.

Once when Hanson asked for an 'indulgence' concerning a debt, his father replied, 'If you look over your past record you will perhaps understand how offensive must seem to me the glib tone in which you ask for indulgences.'[16]

Then there is this revealing letter from Hanson to Whistler:

I am more than wounded by your harsh treatment of me. When I went to you it was with a good feeling. I never thought that you could have treated me – your own son – by ordering me out of the house and shutting the door against me.

Perhaps you think you have treated me right – even though I was in the wrong – to send me away without a penny in my pocket to do the best I could. . . .[17]

On another occasion Whistler asked Hanson, 'Why should you be furnished

with money beyond your salary so that your friends may believe in your pose of ease and affluence?'

And so it went, in London and in Paris, the continuing requests for money and the continuing reluctant posting of small checks, rarely accompanied by a message of any kind. Whistler regarded Charles Hanson as simply a cross that he had to bear.

* * * *

Whistler was irritated by Hanson's repeated requests for money, but what really incensed him was profiteering from sales of his pictures. He hadn't always been resentful of this. On 7 May 1892, just after the opening of the Salon, he wrote to Thomson, 'The superb success here on top of the heroic kick in Bond Street must from your point of view open up an amazing prospect in the way of prices!!!'[18]

The triple exclamation points suggest that he would have enjoyed seeing his pictures doing well in sales-rooms.

Three weeks later, Christie's sold the paintings from Leyland's estate. *La Princesse du Pays* fetched £441, four times its purchase price, but after 27 years not an unreasonably inflated price. And consider the amounts given for some other pictures at the sale. Rossetti's *Veronica Veronese* was sold for £1050, and Millais's *Eve of St Agnes* went for £2205, and they weren't the *pièces de résistance*.

'The chief feature of the sale,' the *Athenaeum* reported, 'was the high prices fetched by Mr Burne Jones's pictures.' Seven of his paintings were sold. One went for £3750, another for £3570, and the least of them brought in £850, nearly double the price of *La Princesse*.

Only after hearing about what had been paid for the Burne-Joneses, did Whistler begin to grumble about profits from the sales of *his own* pictures.

In mid-1892, before moving into the Rue du Bac flat, he complained to his sister-in-law, for the first time, about 'the way in which all of them [owners of his pictures] have been coming out in their true colors as mere dealers!' Pictures which 'they got for about thirty pounds each they are rushing about to hawk and sell. They are in such haste that under their very noses the pictures are turned over two or three times for double and treble the gold they got for them themselves!' Since the Goupil show, 'six of my pictures have been sold by their "Owners," "Patrons," and "Gentlemen" for 7, 8, 10, in one case 14 times the sums that they gave me!!'[19]

He continued to harp on this topic throughout the early and middle nineties, as in a lament to Thomson in 1895 about Alexander Ionides, the man who had been extremely generous to him at a time when he greatly needed encouragement:

'That Mr Ionides should ask 700 for the work for which he gave me fifty

pounds is monstrous shamelessness – and you can tell him so from me. What right has he or any of the others to make one penny out of my brain and my battle!'[20]

Why, he was asked, shouldn't the owner of a painting be free to sell it at a profit? Because 'It's the dealer's business to sell – it's the gentleman's privilege to preserve, care for, and take pride in works he has acquired.'

He told an American patron that he could never get used to the idea of 'hawking scoundrels, in the guise of connoisseurs, collectors, and protectors of Art, taking their families to the Riviera on *my* labor.' (How would he have reacted to the sale of a Van Gogh painting for 83 million dollars, a painting from which the artist had earned nothing?)

* * * *

It was not entirely true that Whistler did not personally gain from the higher prices being paid for his earlier pictures.

On 6 November, he wrote to Thomson, who had lately become editor of the *Art Journal*, 'You'll be pleased to hear that I've sold "The Falling Rocket" for 800 guineas. Wherefore you can now make known the fact that the "Pot of paint flung into the face of the British Public for 200 guineas" has been sold for four pots of paint, and Ruskin has lived to see it!'[21]

A few days later, Trixie sent Thomson a note: 'Mr Whistler wishes me to tell you that the "Falling Rocket" was not sold through any dealer at all. He got the 800 guineas net – himself.'[22]

Thomson sent the information to the *Pall Mall Gazette*, which ran one brief paragraph, straightforward without comment, on the sale of 'The Falling of the Rocket' for 800 pounds to 'a friend in America.'

Thomson cut and sent the item to Whistler, who thereupon exploded in a letter by return mail:

> The paragraph in the Pall Mall was, I am sure, very nicely meant and you sent it with a certain sense of triumph, but a more ingenious method of stultifying absolutely the *real* bitter truth to the enemy could not have been devised! Not a word that could possibly offend! Instead of proclaiming boldly the fact that the famous picture which Mr Ruskin had vilified as a *pot of paint flung in the face of the public* – for which the imposter, charlatan, and coxcomb-painter had dared to ask 200 guineas was now bought 'without the aid of a middleman' for *eight hundred guineas* (not pounds, by the way, as you have it) and that Professor Ruskin *had lived* to receive this commercial slap in the face, the only rebuff understood or appreciated in this country – instead of making clear that the 'pot of paint' has become in value four Pots (!) – instead of all this, you have allowed a mere dull statement of sale to find its way into the papers, in which under the new name of 'The Falling of the Rocket' (!) the original *Nocturne* in Black and

Gold' harmlessly disguised is supposed finally to have been bought by some '*friend*' in America for a larger price than Mr Whistler could obtain for it in London! (The collector is an absolute stranger – I have never seen him in my life.) In short you have 'knocked the bottom out of the whole thing.'[23]

(With 163 words, the third sentence from the end was probably the longest that Whistler ever wrote.)

<p style="text-align:center">* * * *</p>

Because he wasn't making much progress with his paintings, Whistler returned to a medium in which he had dabbled in the past, lithography.

This was Trixie's idea. Because he would come back from his studio exhausted and frustrated, she encouraged him to concentrate on an art which he could practice almost anywhere. He went along with her suggestion, and most of his lithographic work was done while he was married, when he regularly carried a supply of chalk and a case of lithographic paper.

As with everything else, he began this venture with enthusiasm and optimism. 'I am sure to make lithography a roaring fashion,' he told Thomas Way, Jr. 'I expect to get amazing things out of this business – I am enchanted with it.'[24]

Again and again Whistler wrote from Paris about his lithographs, and lithography generally, to the younger Way, who since his father's retirement had taken charge of the Wellington Street firm. (The Library of Congress has 21 letters from Whistler to Way during the second half of 1893 and 32 written during 1894. All of them have the butterfly signature.)

In his lithographic work, Whistler had always collaborated with the Ways, the only printers of his work.

'As to thanking your father and yourself,' he said in one letter, 'I don't suppose I shall ever be able to do that.'[25]

He was uncompromisingly loyal to them, as he demonstrated in the middle of 1894. He had been preparing some drawings for the *Art Journal*, with the understanding that they would be printed by Way and Son. In July, Thomson informed him that the publishers wanted another man to share in the printing. This was Whistler's response:

> You really are grieving me greatly about this unhappy business of the lithographs for the Art Journal!
>
> You must know that I could not possibly allow my work to be treated by any one but Mr Way.
>
> These things are of great delicacy, and I could not dream of running risks in other hands.
>
> Mr Way has for years not only acquired the experience that is beyond doubt,

<p style="text-align:center">282</p>

but he brings to this work of mine the appreciation and complete understanding of the connoisseur and artist that he is.

For ages he has made this matter of art printing his particular affair – and it is to him entirely that is due the revival of artistic lithography in England. I certainly owe all the encouragement I may have received in my work to his exquisite interpretation.

Besides which he is one of my oldest and best friends – and you know me well enough to make it unlikely to suppose that I should mortify him by taking out of his hands the work to which he has given such tender care.

If Messrs Virtue [publishers of the *Art Journal*] are not pleased that Mr Way should do for them the printing absolutely, I am afraid that it all falls to the ground – and that is the end of *that*.[26]

The Messrs Virtue yielded and – really with no pun intended! – Whistler had his way.

* * * *

'I am doing a lot of the most wonderful work!' Whistler wrote to Thomson, with regard to his lithographs. 'I am rapidly developing something in that "Art," as the critics call everything that they fancy a speciality (as though it were not all one – with the same man) that has scarcely been done before.'[27]

But he wasn't always pleased. In June 1894 he did a lithographic copy of his oil painting *Montesquiou* for the *Gazette des Beaux-Arts*. He sent it to the Ways to be printed, who in turn sent him the print for approval. He voiced his reaction to the younger Way:

The portrait is damnable! I don't mean the print, which is ever so good as the thing to be printed was bad! And that is saying a lot! My drawing or sketch or whatever you choose to call it is damnable – and no more like the superb original than if it had been done by my worst and most incompetent enemy!

I hope to Heavens that no one has seen it. Now wipe off the stone *at once*!! sending me one proof on the commonest of paper of its destroyed state – and also every other trial proof you may have taken – that I myself may burn all – there must be no record of this abomination! It only proves what other people would never understand – the folly of proposing the same masterpiece *twice* over!![28]

He explained to Thomson why he couldn't do the same thing twice: 'I had no inspiration – and not working at a *new* thing from nature, I found it impossible to apply myself!'

* * * *

Because lithography was a popular art, utilized by magazines and newspapers, at last, Whistler thought, he might make some money from his work.

Late in 1893, he wrote to the junior Way, 'I have always been so beastly poor – only now I fancy I see fortune looming on the horizon! And I might really be rich! It would be amazing fun – and what wonderful things we would do then – I think I should bring you over to Paris and make you set up a press of my own for my trial proofs.'[29]

The daydreams soon came to an end. Just one year later, he wrote to Ernest Brown, of the Fine Art Society:

> I find that the clientelle [sic] for lithographs is in no way larger than the old one for the etchings – if it be not absolutely the same one.
>
> I tried to put these works before the people for a very small price – two guineas each – being urged to this by the hopes of some enthusiasts that the masses would rise in extasy and that hundreds who could not afford etchings would be only too glad to possess the lithographs, which would consequently go by the thousands and I should make endless moneys!!! All nonsense! . . . I cannot afford to give these works in their luxurious conditions – beautiful proofs on the most precious old Dutch paper – or Japanese of the rarest quality – for the foolish prices supposed to be addressed to the crowd. My works after all are not for them. I have nothing in common with them and can only go on becoming less and less in touch with them as the works themselves improve.[30]
>
> Popularity is not my affaire [sic], for of course if *you* cannot make a two guinea work possible, who can?[31]

It was not that Whistler didn't *want* to be popular; it was simply that he *couldn't* be popular.

44

Joe Sibley and the Baronet

[1894–95]

In 1891, after a lifetime as a visual artist, George Du Maurier, aged 55, became a novelist. An American periodical, *Harper's New Monthly Magazine*, published his initial literary work, *Peter Ibbetson*. It was successful enough for *Harper's* to ask for another book-length contribution from Du Maurier, and the January 1894 issue began with the opening section of his second, penultimate novel, *Trilby*. The action was set in Paris's Latin Quarter of 35 years earlier, with Du Maurier looking nostalgically at his student days. The seven magazine installments were much talked-about, and later in the year the book itself became an American best seller. Its popularity was primarily due to the main plot, involving the delightful young artist's model Trilby O'Farrall and the sinister musician–hypnotist Svengali. Additionally, readers enjoyed Du Maurier's recreation of the earlier Latin Quarter. This part of the book is a *roman à clef*, with no doubt about the characters' prototypes.

In Chapter 7, we dealt with one of the students in *Trilby*, Joe Sibley, who was modelled upon Whistler. He is hardly a major personage. In all of its installments, the novel extends over 150 of *Harper's* double-columned pages. Everything said about Joe Sibley is contained in one and a half pages of the third portion, published in March, and one-half of one column in the April segment, slightly more than one per cent of the book.

Earlier when quoting passages from *Trilby*, I said that Whistler could not reasonably have complained about any of them. But I didn't include everything that Du Maurier said about Joe Sibley. Consider these lines:

Joe Sibley was a monotheist, and had but one god. He is so still – and his god is the same – no stodgy old master this divinity, but a modern of the moderns! For forty years the cosmopolite Joe has been singing his one god's praise in every tongue he knows and every country – and also contempt for all rivals to this

godhead. . . . For Sibley himself was the god of Joe's worship, and none other! and he would hear of no other genius in the world.[1]

Then there was this paragraph:

> The moment his friendship left off, his enmity began at once. Sometimes this enmity would take the simple and straightforward form of trying to punch his ex-friend's head; and when the ex-friend was too big, he would get some new friend to help him. And much bad blood would be caused, though very little was spilt. His bark was worse than his bite – he was better with his tongue than with his fists.[2]

This last passage is unfair and untrue. During his student days, Whistler was always good-natured, never pugnacious, when later he engaged in fisticuffs, he took care of matters himself. He never needed anyone else's help.

Du Maurier apparently had qualms about what he had written, and he ended his portrayal of Sibley by referring to him as a 'tall' man with 'white hair like an Albino's.' This didn't fool anybody. Joe Sibley was obviously James Whistler.

The unflattering details are wholly unnecessary because Sibley is a peripheral character. Du Maurier's digs were purely gratuitous.

He probably had two reasons for doing this. In the first place, he may have been envious. Whistler, his Newman Street roommate, was a famous artist whereas he, Du Maurier, was just an illustrator, and to some people, including Whistler, he was a hack. Then, too, Du Maurier had been the victim of a published barb. At the first exhibition of Venetian etchings, Whistler had encountered Du Maurier and Wilde together. 'I say,' he asked, 'which one of you invented the other?' The implication was that Wilde's fame had come from Du Maurier's cartoons and Du Maurier's fame had come from drawings of Postlethwaite.

The witticism was then included in *The Gentle Art*.

Because, he said, 'he had been drawing for *Punch* twenty years before the invention of Postlethwaite,'[3] Du Maurier was rightly annoyed.

Harper's was not commonly found in Paris, and Whistler didn't see the March installment until May, when it was cut out and sent to him.

After reading it, he posted a letter to the *Pall Mall Gazette*, where it appeared on 15 May under the title 'Mr Whistler on Friendship:

> It would seem as if I had not, before leaving England, completely rid myself of that abomination – 'the friend.'!
>
> One solitary unheeded one – Mr George Du Maurier – still remained, hidden away in Hampstead [where he then lived].

On that healthy heath, he has been harbouring, for nearly half a life, every villainy of good fellowship, that could be perfected by the careless frequentation of our early intimacy and my unsuspecting camaraderie. Of this pent-up envy, malice, and furtive intent, he never at any moment, during all that time, allowed me, while affectionately grasping his honest Anglo-French fist, to detect the faintest indication.

Now that my back is turned the old *marmite* of our *pot au feu* he fills with picric acid of thirty years' spite, and, in an American magazine, fires off his bomb of mendacious recollection and poisoned rancune. [The implication is that Du Maurier went to an American magazine to escape detection.]

In his present unseemly state, he furnishes an excellent example of all those others who, like himself, have thought a foul friend a finer fellow than an open enemy.

Four days later the *Pall Mall* reported on an interview with the other party to the dispute:

Mr Du Maurier was not disposed at first to vouchsafe an answer. 'If a bargee insults one in the street,' he said, 'one can only pass on. One cannot stop to argue.' But on second thought, he added a few words. 'I should,' he said, 'have avoided all reference to Mr Whistler if I had imagined it would have pained him. I should have written privately to him to say so if his letter had been less violent and brutal.

'Certainly in the character of Sibley I have drawn certain lines with Mr Whistler in mind. I thought that this would have recalled some of the good times we had in Paris in the old days. But he has taken the matter so terribly seriously. It is so unlike him . . . His letter is incomprehensible to me. Of course he has been embittered by reason of his genius not being recognised at its full value. This circumstance, and possibly illness, may account for the leave he has taken of good manners.'

Du Maurier then recalled the quip involving himself and Oscar Wilde: 'I did what I did in a playful spirit of retaliation for his little joke about me. A man so sensitive as Mr Whistler seems to be should beware of how he goes about joking at others.'

For Du Maurier it was simply an instance of tit for tat, but he should have known how much easier it was for Whistler to deliver jokes than to receive them.

The *Pall Mall* letter was only the beginning of Whistler's onslaught. Next he wrote to the president of the Beefsteak Club, demanding Du Maurier's expulsion. 'It becomes clear,' he wrote, 'that he and I cannot both be members. Either I am a coward, or he is a liar.'[4] For other reasons, Du Maurier had already resigned.

After writing the Beefsteak letter, Whistler decided upon demanding legal redress from Du Maurier and *Harper's*.

<p style="text-align:center">❋ ❋ ❋ ❋</p>

A few days after his *Pall Mall* interview, Du Maurier asked the publisher of the forthcoming book edition if there was 'still time for a small alteration,' the replacement of 'the character of "Joe Sibley" by another (& better one).'[5]

This would not have appeased Whistler, who asked George Lewis, the most famous solicitor of the century, to represent him in a suit against Du Maurier. Because 'he is one of my oldest friends,' Lewis said, 'it is impossible for me to act against him.'[6] He also implied that the suit would be as ill advised as the one against Ruskin.

Others agreed with Lewis and tried to get Whistler to drop the whole thing, but he was determined to forge on. John Singer Sargent, who saw him at this time, told Du Maurier that 'he was quite furious and stung beyond description.'[7]

After Lewis had turned him down, Whistler consulted another solicitor, William Webb, who agreed to represent him, but because his reputation had not been damaged, he said it was unrealistic to seek a financial settlement. The most that they could hope for was a retraction and an apology, which could be obtained out of court. Whistler agreed to this line of attack.

At first, when the question of an apology was raised, Du Maurier told his publisher's solicitor that this would be impossible because of 'Whistler's abusive letter to the *Pall Mall Gazette*.' Later he modified his position: 'I don't like the idea of a public apology, but if I must I must, I suppose. It would be cold and formal – very different to what I should have written if he had written to me instead of to the Pall Mall.'[8]

Whistler's real motive underlying all of this, Du Maurier said, was his desire for 'notoriety, an advertisement – he has always been *mad* for that sort of thing – rather than not advertise he would almost advertise "Trilby." '[9]

It was not clear if Du Maurier ever did apologize, but he told Armstrong how he would like to go about it: 'I shall tell Jimmy in the most abjectly fulsome terms of adulation I can invent that he's the damned'st ass and squirt I ever met.'[10]

Whether or not he heard from Du Maurier, Whistler did get a letter, dated 8 September, from *Harper's*:

> Our attention has been called to the attack upon you in the novel *Trilby*. If we had any knowledge of personal reference to yourself being intended, we should not have permitted the publication of passages that could be offensive to you. As it is, we agree to stop future sales of the March number of *Harper's* Magazine, and we undertake that when the story appears in the form of a book the March number shall be so written as to omit every mention of the offensive character,

<p style="text-align:center">288</p>

and that the illustration which represents the idle apprentice shall be excised and the portraits of 'Joe Sibley' in the general scenes shall be so altered so as to give no clue to your identity. Moreover we engaged to insert in the foreign edition of our magazine for the month of October this letter of apology.[11]

For Whistler this was a total victory. 'I have wiped up Hampstead,' he told William Heinemann, publisher of *The Gentle Art*, 'and manured the heath with Dumaurier.'[12]

 * * * *

In the early nineties, Whistler engaged in a legal battle with a second antagonist, a baronet, Sir William Eden.

Eden had a remarkably beautiful wife, and after the Goupil Gallery show, he wanted Whistler to paint her portrait. He inquired at the Goupil about prices and was advised to expect to pay about 500 guineas, which would seem within the means of a gentleman of leisure who owned 8000 acres of land, and whose 'recreations' were listed in *Who's Who* as 'hunting, shooting, driving, and travelling.'

But Eden felt that this was too much to pay, and he asked a mutual friend, the writer George Moore, to intercede on his behalf with the artist.

Whistler told an interviewer from the French newspaper *Le Journal*, 'Mr Moore, first with a letter, then with a visit, addressed my friendship, begged me to put aside for once my ordinary "tariffs" and, for his friend Sir William Eden, a "kind gentleman," he beseeched me to make a little sketch, in pastels, water-colors, or whatever I preferred. He concluded, "Please consent to do this, for God's sake, for a pittance, for something between 100 and 150 pounds.' *[13]

Because he 'didn't know how to resist such a sentimental attack,' and could be casual about a price so long as the other party was similarly unceremonious, Whistler agreed to do this portrait of the wife of a friend of a friend for much less than he usually charged. But nothing was said about the precise price, the size of the picture, the medium, or the type of portrait it would be.

Late in 1893, Eden wrote to Whistler and asked about the price. On 6 January 1894, Whistler replied, 'The only really interesting point is that I should be able to produce the charming picture, which, with the aid of Lady Eden, ought to be expected. . . . As for the moment, Moore, I fancy, spoke of one hundred to one hundred and fifty pounds.'[14]

Three days later the Edens were in Paris, and Lady Eden had her first sitting for a fourteen by eight inch full-length oil portrait of her in a brown dress seated on a brown sofa.

'Your friends the Edens are charming,' Whistler told George Moore. 'I shall be delighted to know them.'[15]

He got to know both of them because Eden frequently accompanied his wife

to the studio, always expressing total satisfaction with what was being done. After five weeks, when the painting was almost complete and no more sittings seemed necessary, Eden arrived alone and informed Whistler that he and his wife were about to leave for India. He was 'perfectly satisfied' with the 'charming' portrait, which looks 'more delightful every time I see it.'[16]

He gave Whistler an address to which to send it and handed him a sealed envelope. Since the date was 14 February, he said, 'Here's a Valentine present, but please don't open it until you are home.'

The envelope contained this note: 'Here is your valentine. The picture will always be of inestimable value to me and will be handed down as an heirloom as long as heirlooms last! I will always remember with pleasure the time during which it was painted. My thanks.'[17]

Accompanying the note was Eden's 'valentine,' a check for 100 pounds.

All of a sudden, [Whistler told the interviewer from *Le Journal*,] the sportsman's intention was revealed. Not content with an introduction under the auspices of friendship, and then acquiring a work under exceptional circumstances, the baronet, who saw his portrait growing in value day by day, instead of trying to find a proper means of showing his gratitude, conceived the idea of the 'valentine.'

I was offended by this attempt to dupe me and to force my hand. Despite the conditions of cordial understanding upon which the affair had been founded, I had the right to fix the price at 100, 110, 120, 130, 140, or 150 guineas. But the clever sportsman forestalled me, and by an ingenious trick hoped to obtain the painting for the lowest possible amount. Under color of graciousness and flattery he tried to create a situation of false courtesy, hoping that I would be unable to extricate myself. The baronet had the wrong man.*[18]

This was the Frederick Leyland affair all over again.

'I resolved to play it cool,' Whistler continued for *Le Journal*. 'I kept the valentine, and immediately sent the baronet a little letter of ironic felicitations.'*

This is the text of Whistler's note to Eden:

My Dear Sir William – I have your valentine. You really are magnificent – and have scored all round.

I can only hope that the little picture will prove even slightly worthy of all of us, and I rely on Lady Eden's presence for one more sitting to let me add the few last touches we know of. She has been so courageous and kind all along in doing her part.

With best wishes for your journey.[19]

* * * *

On the next morning, Eden appeared at the door of Whistler's studio. He was not invited to enter, and this conversation took place on either side of the entranceway:

'I have received a very rude letter from you.'

'Impossible. I never write rude letters.'

'But I don't understand it.'

'There are those who spend their lives in not understanding my letters.'

'You have written, "I have your valentine."'

'Yes. You sent me a valentine, and I sent you a graceful acknowledgment.'

'But you say, "You really are magnificent."'

'Well, aren't you?'

'"And you have scored all round." I had no desire to score.'

'But as a sportsman, my dear Sir William, that's your luck!'

'You seem to be insinuating, sir, that I have been mean in my dealing with you. If you tear up that cheque, I will give you this one for one hundred and fifty guineas.'

'Put away your papers, my dear man. I can't be wearied with more business details. The time has gone by for that.'

'Well, I know that the picture is a beautiful one, and that I am lucky to have it. But a man is a damned fool to pay a larger price for anything he can get for a smaller one.'

'Good day, Sir William.'[20]

On the next day the Edens left for India.

Whistler deposited Eden's check, and he also kept the painting, which, he told *Le Figaro*, was 'a little masterpiece.'* He exhibited it at the Salon as *Portrait of Lady Eden: Brown and Gold.*

At the end of the year, the Edens returned to Paris, and Sir William legally summoned Whistler 'to give up, within 24 hours, the portrait which had been ordered and paid for.'

When Whistler did not respond, Eden filed a suit in the Civil Tribunal of the Seine, asking for delivery of the picture, return of the check, and 1000 francs (£50) as compensation for living expenses in Paris while the portrait was being painted.

＊　　＊　　＊　　＊

'Why did you keep the check' Whistler was asked at the trial, 'if you didn't intend to deliver the picture?'

'I didn't intend to keep it permanently. I only temporarily withheld it in order to force him to take me to court. If I had not kept it, I would not have had an opportunity to tell my story to the world.'[22]

He told his story, and in the telling publicly promoted himself, but there was

more to this episode than the gratification of James Whistler's ego. An artistic principle was at stake, articulated in court:

'The transmission of a work of art does not take place except by formal consent of the artist, who continues to be the owner of his work until he is ready to let it go. In this case there was no act which would lead one to suppose that Mr Whistler was willing to transmit his property to Sir William Eden.'[23]

The trial judges did not agree. Ruling that a contract had been ratified by his acceptance of Eden's check, they ordered Whistler to hand over the portrait, return the check (which he had already done), and pay 1000 francs damages and court costs.

Asked if he was disappointed, Whistler answered, 'No! Why should I be? There was a misunderstanding. I am confident I will win on appeal.'

<div align="center">* * * *</div>

When the trial court handed down its decision, the first stage of this affair should have come to an end. But in fact there was a postscript which *Punch* called 'an incident that should be relegated to the realms of comic opera.' It involved the man who had brought Whistler and Eden together, George Moore.

Moore had studied painting in Paris and for a number of years was art critic for the weekly *Speaker*. A faithful reader of his column was Whistler, who told him in December 1893, 'I have been buying the *Speaker* for your sake only.'[24] This isn't surprising. In his review of the 1892 retrospective exhibition, Moore said that 'the exquisite drawing of the shower of falling fire' in *The Falling Rocket* 'would arouse the envy of Rembrandt,' and he reckoned that 'nothing in his world ever seemed to be so perfect as *Cicely Alexander*.' Moore had judged Whistler to be 'the greatest painter of the nineteenth century.'[25]

But now all of this meant nothing because Moore had supported Eden by saying that £100 was a reasonable price for a small portrait.

After the trial was over, Whistler sent Moore one of his typical denunciatory letters, which drew this response:

> I have no time to consider the senile little squalls which you are obliging enough to send to me. There is so much else in life to interest one. Yesterday I was touched by the spectacle of an elderly eccentric hooping about on the edge of the pavement; his hat was in the gutter, and his clothes were covered with mud. The pity of the thing was that the poor old chap fancied that everyone was admiring him.
>
> [There was a postscript:] If a man sent me a cheque for a MS., and I cashed it, I should consider myself bound to deliver the MS., and if I decline to do so I should consider that I was acting dishonourably. But, then, every one has his own code of honour.

Moore sent a copy of his letter to the *Pall Mall Gazette*, where it was published on 12 March 1896.

Although his own letters had repeatedly appeared in the *World*, Whistler was fuming because of Moore's action.

On the day after he had seen Moore's communication in print, Whistler wrote to him,

> If the literary incarnation of the 'eccentric' person on the curbstone is supposed to represent Mr Moore, Mr Whistler thinks the likeness exaggerated – as it is absurd to suppose that Mr Moore can really imagine that anyone admires him. If, however, Mr Moore means to indicate Mr Whistler, the latter is willing to accept Mr Moore's circuitous and coarse attempt to convey a gross insult – and, upon the whole, will perhaps think the better of him for an intention to make himself at last responsible.
>
> In such case Mr Whistler will ask a friend to meet any gentleman Mr Moore may appoint to represent him. . . .[26]

Yes, in this year of 1895, James Whistler, 60, was seriously challenging George Moore, 43, to fight a duel.

This was the answer: 'Mr Moore begs to acknowledge the receipt of Mr Whistler's letter. In Mr Moore's opinion Mr Whistler's conduct grows daily more absurd.'

Four days later Moore received a note from the two Frenchmen who were serving as Whistler's seconds. They presented a demand for a public retraction of his letter or satisfaction on the field of combat.

The challenge was naturally ignored, and on 23 March Whistler's seconds wrote to him, 'Mr Moore, having preferred silence to an answer for which we have waited a week, we must consider our mission as ended.'

Whistler told them, 'I profoundly regret placing you in any relation whatsoever to Mr George Moore. I am completely mortified at having wasted your precious time for the contemplation of this poor character who has conducted himself in a fit of panic.'[27]

British humor magazines had a field day with this bizarre episode. 'It is reported,' *Punch* said, 'that the impressionist artist, animated by the sportsman-like desire of getting a shot at something or somebody, would like to engage a Moore for the shooting season. The most recent wire reports, "No Moore at present. J. McN. W."'

45

A Painful Death

[1895–96]

I was with Whistler constantly during the unfortunate Du Maurier and Lady Eden episodes, [Edmund Wuerpel related,] and I can never sufficiently admire the tact and patience with which Mrs Whistler controlled the poor, worried, irresponsible little man. He would come home with a harrassed and worn look in his face which she would instantly observe. Never at a loss for expedients she averted many an avalanche of anger and abuse by a timely well-chosen word or act.[1]

While 'Chinkie' was doing her best to comfort her husband, she had problems of her own. Beginning in mid-1894, this animated, outgoing woman, noted for her *joie de vivre*, was becoming increasingly lethargic, spending most of her time sitting and reading. Whistler did several sketches of her in her chair, one of which he called *The Convalescent*. This title epitomizes his attitude toward her condition: she was convalescing from something not really serious. He wasn't insensitive; he just wouldn't face up to the truth, which his doctor-brother told him when they were briefly in London, that she was suffering from abdominal cancer.

'Never!' James Whistler shouted.

He and his wife immediately returned to Paris, where he took her to a quack, who recommended a useless, perhaps harmful operation. William then suddenly appeared and pleaded with his brother not to go through with it. Reluctantly James agreed but not without an exchange of words that forever ended their intimate relationship.

* * * *

Late in the summer of 1895, they left Paris, never to return.

In mid-September they went to a coastal health resort in Dorset, the town of Lyme Regis. A secluded harbor, surrounded on three sides by chalky cliffs, it was

quaint, bucolic, and dreadfully dull. After five weeks, Trixie had had all that she could take. She departed for London, but, despite her illness, she travelled alone. Jimmy stayed on for another five weeks to finish some pictures that he had started. He did a fair amount of work: his first sketches of animals, horses in a blacksmith's shop; a large landscape; an oil portrait of a blacksmith; and his last portrait of a young girl, *The Little Rose of Lyme Regis*. And, 'just to keep my hand in,' he told the younger Way, he worked on some lithographs.[2]

He had written to Way mainly to chastise him for sending some of his lithographs to Frederick Wedmore to be used as illustrations in an article: 'How could you give anything to that conceited, empty, pilfering ass Wedmore! I refused point blank when Mr Thomson asked me to allow anything of mine to appear in any article of Wedmore's.'

* * * *

Soon after returning to London at the end of November, Whistler exhibited 75 lithographs at the Fine Art Society. 'Its success,' he told a friend early in 1896, 'was quite stupendous. They sold £600 right off the first two or three weeks and we expect to run over the 1000 mark directly. The Ways have been hard at working printing by the stone as called for – many of them in the gallery have been marked "Sold Out"!!'[3]

The letter was written on the stationery of the Savoy Hotel, the Whistlers' residence since the first of the year.

The seven-story Savoy had opened in August 1889, the latest in luxury hotels, the first to be equipped with lifts. There were 520 bedrooms, and, remarkable for the time, 70 bathrooms (the recently opened Hotel Victoria, in Northumberland Street, had 500 guest rooms and 4 bathrooms). Also innovative, most rooms had telephones. The rates were 7/6 (38 pence in today's money) for a single room and 12 shillings (60 pence) for what the Whistlers had, a double room with a private bath.

Their room was on the top floor, with a splendid view of the river and much of London. Seated by a window, Whistler turned out eight lithographs which the younger Way called 'the climax of all his black and white work.' Six depicted views of the city, and two were portraits of his dying wife.

Soon after the last of the drawings had been done, in late March, they moved to what he felt would be more comfortable quarters for Trixie in a house near to Hampstead Heath, where he watched her, day by day, waste away, until at last, on 10 May, the end came.

* * * *

There can be no doubt about it. Whistler was temporarily devastated. His eight-year marriage had embodied the most halcyon period of his life, when, uniquely as an adult, his day-to-day existence was orderly. He needed this, not only

because of advancing age but also because of the status of his art. No longer a major figure in the art world, except in retrospect, he was producing second-rate work and living in the past. Alone, he might not have been able to cope with this state of affairs, and, as with certain other artists in similar circumstances, suicide would not have been out of the question. But fortunately 'Chinkie' was always there with cheer and comfort and nourishment for his ego. She even gave him good artistic advice, to return to lithography.

She was his booster and prop, the person who kept him, artistically, perhaps even literally alive. Now she was gone.

After her burial on 18 May 1896 in Chiswick Cemetery, near the tomb of Hogarth, he plaintively asked his sister, 'What is to become of me?'[4]

Without a replacement for Trixie, one can only wonder what might have happened. Luckily, he did not have to look far for a successor. She was present at the Chiswick burial. Born in 1855, she was almost exactly Trixie's age. Her name was Elizabeth Pennell.

Although Joseph was responsible for many of the ideas in their indispensable two-volume biography and their invaluable journal, the actual writing was done by Elizabeth. Whereas Joseph was a visual artist, Elizabeth was a professional writer. At the time of Trixie's death, she was the author of ten published books, including a biography of Mary Wollstonecraft and numerous delightful travel volumes.

In her own right, Elizabeth Pennell was a fascinating person. Born of wealthy, snobbish parents in what once was, and may still be, America's most snobbish city, Philadelphia, she was educated in expensive, exclusive schools in Philadelphia and Paris. In 1884 she and Joseph, also a Philadelphian, married and then crossed the Atlantic to spend more than twenty years as expatriates in London.

They met Whistler in the late 1880s, and from the beginning he and Elizabeth cottoned to one another and began a friendship that was ended by death. Like Trixie, Elizabeth had a fine sense of humor and a high opinion of his work. Unlike Trixie, she was slender and attractive. Her travel books, like all others, were the outgrowth of personal visits to the places described, but she relied on an uncommon mode of long-distance locomotion. Her journeys throughout Britain and Europe were conducted almost exclusively on a bicycle. It once was said that she had ridden more miles on a bicycle than any other woman in history. In the latter days of Whistler's marriage, the physical contrast between Elizabeth and Trixie must have been striking.

Once Whistler would have shied away from a woman like Elizabeth Pennell, but not now, and for the rest of his life she was his closest companion. He travelled a great deal during his final years, but when he was at home in London, she constantly saw him, sometimes on a daily basis. Perhaps no other person, not even his wife, ever knew him as well as she did. (Although I cannot speak with

finality, I do not for a moment believe that the relationship was strictly platonic. But does it matter?)

Elizabeth's closeness to her subject is the main reason for the singular value of all books and articles on Whistler whose title page contains the name 'Pennell.'

46

Post-Marital Controversies

[1896–98]

Only hours after his wife's burial, Whistler posted his first post-marital epistle of venom. The recipient was Frederick Keppel, the American who a few years earlier had brought him a painting from Paris and had been his guest for a day.

Keppel became an object of vilification because of a pamphlet, *Guide to the Study of James Abbott Whistler*, by Walter Forsyth and Joseph L. Harrison, published in May 1895 by the University of the State of New York. The authors, librarians at the university, sent three copies to Keppel, who kept one for himself and passed the others on to Joseph Pennell and the Fine Art Society's Ernest Brown.

Keppel felt sure, he told Pennell, that the booklet 'would give Whistler pleasure' because 'the sole motive' of the authors had been 'to do him honor.'[1]

When Keppel arrived on his second visit to London, he went to Deborah Haden's home to inquire about her brother's whereabouts. He learned of Trixie's death, and her burial on that very day.

Immediately he sent off a message of condolence, a note which, he said, 'mentioned nothing else.'

On the next day he received a registered letter from Whistler. After reading it, he 'stared at it in amazement.' This is what he read:

Sir: I must not let the occasion of your being in town pass without acknowledging the gratuitous zeal with which you did your best to further the circulation of one of the most curiously malignant innuendoes, in the way of scurrilous half-assertions, it has been my fate to meet.

Mr Brown very properly sent on to me the pamphlet you had promptly posted to him.

Mr Pennell also, I find, you had carefully supplied with a copy – and I have no doubt that, with the untiring energy of the 'busy' one, you have smartly placed the pretty work in the hands of many another.

Personally I am grateful to this activity of yours – for there is no obscurity into which the journalist will not, in time, pry for his paragraph – and thanks to your unexampled perseverance, I have, though in a circuitous and doubtless unintended way, been enabled to deal with the authorities of the American college upon whose shelves is allowed to be officially catalogued this grotesque slander of a distinguished and absent countryman.

Had you sent *me direct*, and to *me alone*, the libellous little book, it would have been my pleasant duty to have thanked you for the kind courtesy – and to have recognized, in the warning given, the right impulse of an honorable man.[2]

The booklet that generated this letter contains only twelve small pages, four of which are a catalogue of pictures and two and one-half of which include nothing but highly favorable quotations. The text thus takes up only five and one-half pages, which contain no opinions, only facts. There's the rub. Two factual recitals – only two – probably were embarrassing.

In the first paragraph, Forsyth and Harrison say that Whistler was born in 1834, 'according to his own statement' in St Petersburg. They note, however, that according to other sources he was born in the United States – in Lowell, Stonington, or Baltimore. 'It is said,' they observe, 'that Whistler delights in keeping up a mystery of his nativity.'[3]

This may seem innocuous, but Whistler was abnormally sensitive about the time and place of his birth. As we have seen, he would not admit to being born in Lowell. It was now even more difficult for him to acknowledge that he was 61 years old.

Disturbing though they doubtlessly were, the details on his birth could not have been as distressing as this passage: 'His career at West Point was unsuccessful. At the end of his first year his rank was 42 in a class of 60. At the June examinations in 1854, he was found deficient and recommended for discharge. Throughout his three years at West Point, Whistler's name appears very near the foot of the general merit and conduct rolls of his class.'[4]

Whistler had never been more proud of anything than of his association with the United States Military Academy. He constantly talked about West Point, but never about how and why his army career had ended. So it is not hard to imagine his probable reaction to this revelation by a pair of librarians.

He never again spoke to Frederick Keppel.

* * * *

On 19 June 1896, Whistler received a letter from Charles Hanson which had been delayed in transit. This was his reply:

It is very clear that you could have wanted neither advice or counsel – for when

a man writes on the 11th to say that he is going to be married on the 20th nothing can be done but congratulate him and wish him every possible happiness.

Had there been more time – say a year or two – in which to reflect, one might have suggested that you are rather young – and not well enough off – to take upon yourself the proper care of a wife, especially since you have scarcely shown any great capacity for taking care of yourself.[5]

The wedding of Charles James Whistler Hanson (as his name appears on the marriage certificate), aged 26, and Sarah Ann Murray, aged 21, took place on 25 June at the Sardinian Chapel, in the District of St Giles, in accordance with the rites of the Roman Catholic Church. The certificate identifies the father of the groom as 'James McNeill Whistler, Artist,' and the father of the bride as 'Benjamin Patrick Murray, Gentleman.'

On the 24 June, the father of the groom sent his son a two-sentence letter: 'Don't trouble about me tomorrow. I would not disturb you on your wedding day.'[6]

Whistler was not present for the ceremonies, nor did he ever see his son again.

* * * *

On his son's wedding day, Whistler was undoubtedly working. Beginning soon after his wife's burial and continuing for the remainder of this final decade of the century, the Pennells said, he 'worked harder than ever.' When he was in London, they were 'distressed by his fatigue at the end of a long day in his studio.' When he was in Paris, he would write to them about the 'amazing things' he was doing.

As usual, he was enthusiastic about whatever his current project might be. A little over two months after his wife's death, he told Edward Kennedy, visiting London, that the portrait he was painting of an American woman named Louise Kinsella was 'one of the most important, if not *the* most important, portrait I have ever undertaken. Therefore I have put everything else aside.'[8] The painting was never finished. Early in 1897, he wrote from Paris to Heinemann, 'I am doing work that is far beyond anything I have ever done before. I sit in the studio and could almost laugh at the extraordinary progress I am making and the lovely things I am *inventing*!' Then came this sentence: 'I see excellent business if I can only hold on!'[9] In another letter to Heinemann, he said, 'I don't know what really is the matter with me – but I am *so tired*!! I who am *never* tired!'

In Paris he was exhausted after climbing the six flights of stairs in the Rue Notre Dame des Champs, and in London he became tired after working in a ground-floor studio. Sometimes, the Pennells said, 'he was dull and listless as never before.'[10]

His work during these last years of the century was mainly small-scale; lithographs of London, including a series on churches; pastels of London people

and scenes; seascapes done on a visit to Pourville; and small oil portraits, mostly of children.

Perhaps his best single picture of the late nineties was the portrait of a young girl, *The Little Lady Sophie of Soho*, which brought out an interesting facet of his personality.

For a number of weeks little Sophie went almost daily to his studio, which was then in Fitzroy Street, and when the portrait was virtually complete Whistler returned to his Rue du Bac flat, which he shared with his mother-in-law. Soon he wrote to Sophie's mother and asked if her daughter might be permitted to go to Paris so that he could add some finishing touches to her portrait. Her mother agreed, and Sophie spent six weeks as Whistler's guest. But she made only three brief appearances in his studio. He didn't really need her; he was providing her with a Parisian holiday as recompense for her patience during the prolonged sessions in London. Years later, her sister told of how she had been treated in Paris:

> She was extended every delightful courtesy and hospitality that could be thought of by Mr Whistler. She told us that she had been treated like a royal person during the entire visit and was quite sad at having to leave. Miss Philip, Mr Whistler's sister-in-law, took her out almost every day to some place of interest, always accompanied by a maid. In the evening at dinner, when the table was lighted by candles, she met such friends as William Heinemann, the publisher, and the Vanderbilts.
>
> At the time she had a red dress with a raised satin design, and Mr Whistler had a small, round felt hat dyed for her to wear with it. He also bought the longest black quill available for its only trimming. Miss Philip bought her a length of summer dress material in a beautiful blue, with small lace panels. Soon after her return home, Mr Whistler wrote to Mother expressing his pleasure at having had her with them.[11]

* * * *

When Trixie died, Walter Sickert was in Venice. Immediately upon hearing about it, he wrote to Whistler,

> You must always remember how you made her life, from the moment you took it up, absolutely perfect and happy. Your love has been as perfect and whole as your work, and that is the utmost that can be achieved. Nor has her exquisite comprehension of you, and companionship with you, ceased now. Never let yourself forget that her spirit is at your side, and will always be, for sanity, and gaiety, and work; and you must not fail her now in your hardest peril.[12]

Whistler thanked Sickert for his letter, but he was not 'eternally grateful.'

One afternoon, not long before the sessions with Sophie had ended in London, he entered a Bond Street gallery to be met by the manager, who said excitedly, 'Who do you think just left? Sir William Eden. And you'll never guess who was with him. Walter Sickert!'[13]

A few days later, Sickert, called on Whistler, and finding him absent left his card. Whistler mailed it to Sickert after writing on the back, 'so like André you have gone over to the enemy.'[14] This was a reference to Major John André, who conspired with Benedict Arnold to deliver military secrets to the British during the Revolutionary War and was hanged for being a spy. Being seen with Eden was an act of treason for which there could be neither explanation nor forgiveness.

Whistler's personal relationship with Sickert ended with this incident, but he soon had a chance to strike back, professionally and financially.

<p align="center">* * * *</p>

Punch for 27 April 1897 included a feature entitled 'Some Favourite Recreations (omitted from Who's Who).' Listed were 'recreations' of some well-known persons, including two Americans:

'President McKinley. Shaking 2500 free and independent hands per hour.'

'Mr Whistler. The gentle art of appearing in a witness box.'

Earlier in that month, Whistler had again stepped into a witness box, but not as a litigant. Joseph Pennell was suing Walter Sickert, and Whistler was a willing, indeed an eager, witness for the plaintiff.

Pennell, 23 years younger than Whistler, a prolific illustrator and a lecturer in illustration at the Slade School of University College, had recently had an exhibition at the Fine Art Society of 'Lithographs Illustrating Scenes and Places Described in Washington Irving's *Alhambra*.' The catalogue included a brief prefect by Whistler.

The Alhambra is a book of Spanish sketches resulting from Irving's residence in Spain, and Pennell did his drawings 'on location.' Lithographs are created on a stone, but because stones are too heavy to carry about easily, he resorted to a method regularly used by many artists, including Whistler. He did the drawings on what is known as transfer paper, and upon returning to London he had a lithographer transfer the drawings to a stone. They were printed, exhibited, and described as 'lithographs.'

Gratuitously, Walter Sickert objected to what Pennell had done. In an article published on 26 December 1896 in the *Saturday Review*, Sickert charged Pennell with 'looseness of statement' in referring to his drawings as lithographs. 'If we are to keep our artistic diction pure,' he said, 'a lithograph by Mr Pennell must be made to mean a drawing done on the stone by Mr Pennell and then printed. It does not mean a drawing done by Mr Pennell on transfer paper, transferred by the lithographer on to the stone, and then printed.' Sickert maintained that

'an artist who does transfer lithographs' is using 'a debased instrument' and is defrauding the public by selling them as lithographs.

In the last paragraph of his essay, Sickert brought in his former master, whose catalogue preface warmly praised Pennell's work: 'Mr Whistler is a genius. His lightest utterance is inspired. His smallest change is golden. But he must not help Mr Pennell to debase the currency.'[15]

When Sickert refused to issue a retraction or an apology, Pennell sued him for libel, and Whistler immediately pledged his support. Sickert's response was that even if he was wrong, he had written fair and honest criticism. Here we go again!

The case was heard on 5 and 6 April 1897 by Mr Justice Mathew and a special jury in the Queen's Bench Division of the High Court of Justice. The principal advocates were famous, highly paid members of the British bar, Sir Edward Clarke, QC for the plaintiff, and John Charles Bigham, QC for the defendant.

(Clarke had represented Oscar Wilde in the trials that had led to his prison sentence. In late 1895 and early 1896 petitions had circulated in Paris and London urging clemency for Wilde. Whistler refused to sign, along with such enlightened figures as Emile Zola, Victorien Sardou, Henry James, George Meredith, and the Pre-Raphaelite painter Holman Hunt, who felt that 'the law had treated Oscar Wilde with exceeding leniency,' by demanding of him a mere two years at hard labor for performing a sexual act in private with a consenting adult.)

Clarke easily obtained expert witnesses. Among those who testified that Pennell had used a legitimate, well-established method to create genuine lithographs were the Keeper of Prints and Drawings at the British Museum; the Assistant Keeper of the National Art Library at Kensington; the official printer of the Royal Society of Painter-Etchers; the editor of the *Art Journal*; the editor of *Studio*; the printer of lithographs Thomas Way, Sr.; and James Whistler.

Whistler's presence guaranteed a full house of spectators and reporters. This is how he appeared in the *Daily Mail*:

'Monsieur Vistlaire' drew off black gloves on entering the witness-box, and he was ready, a warrior bold fearing no foe. His keen and merry eyes twinkled and sparkled beneath bushy eye brows; the eye-glass escaped impressively from its position; the white forelock posed gracefully on the rebellious head of hair; the moustache maintained aggressively its pride of place; and with a nonchalant southern drawl the many-sided master poured out self-complaisant witticisms before an expectant audience. Altogether he seemed as pleased with himself as a Florida belle.[16]

None of the witticisms came out during the routine direct examination, in which he stated that there is no limit to what can be done by the transfer paper process, that the artist on transfer paper is at no disadvantage as compared to the artist

on stone, and that there is no distinction between the two processes so long as the work is that of the artist himself.

Then came what everyone had been waiting for, Bigham's cross-examination of Whistler. Here is a sampling of the exchange:

Bigham: 'Are you very angry with Mr Sickert?'

Whistler: 'Not in the smallest degree. (Loud laughter) If any one could be vexed at all it is because distinguished people should be brought here by a gentleman whose authority has never before been recognised.'

Bigham: 'Then Mr Sickert is a very insignificant and irresponsible person who cannot do any one harm?'

Whistler: 'Oh, I think a fool may do harm.' (Laughter)

Bigham: 'Has he done you any harm?'

Whistler: 'Oh, I don't know how I shall survive.' (Laughter)

Bigham: 'Do you object to Mr Sickert calling you a genius?'

Whistler: 'That is a very proper observation, and I have no objection to it.' (Loud laughter)

Bigham: 'Are you helping Mr Pennell in bringing this action?'

Whistler: 'I don't know that I am, but of course I should be quite willing to do so.'

Re-examining, Clarke asked, 'Is there anything in this suggestion that you have borne some part of the expense of the case?'

'Nothing,' Whistler answered, 'but the delicacy of the question itself.'

Even Mr Justice Mathew joined in the laughter that greeted the sarcasm in this reply.

Whistler's testimony must have been helpful. The jury returned a verdict for the plaintiff, with a damages award of £50.

Whistler couldn't have been more elated if he himself had been the victor. 'It was simply amazing,' he wrote to his sister. 'Really, the whole thing would seem to amount to a sort of involuntary public recognition of the position of your brother. You can see from the papers how wonderfully I was reported.[17]

George Moore had appeared for Sickert and under cross-examination admitted that he didn't know much about lithography. 'Moore in the box,' Whistler gloated, 'was really my revanche for all the past! A poor smiling imbecile!'[18]

Later in the year he would celebrate his own legal triumph.

* * * *

As he had said he would, Whistler appealed the Eden verdict. Late in November 1897, the Court of Appeals issued its decision:

'Inasmuch as the agreement between the parties was in no sense a contract to sell, but merely an obligation to execute, the portrait never ceased to be the artist's property and cannot be taken from him without his consent.'[19]

Although Whistler did not have to turn over the painting, the court also decided that 'an artist's right to a picture is not absolute,' and thus he 'may not make any use of it, public or private.'

Further, the court instructed Whistler to return Eden's money, with five per cent interest payable from the day of payment; to pay damages of £40; and to cover the costs of the trial. (The expense of the appeal was Eden's responsibility.)

It might have seemed like a Pyrrhic victory, but Whistler didn't see it as such. He was in Paris at the time, and within minutes of learning about the decision he wrote to Thomson,

> Well I fancy the floor has been wiped up with the Baronet! What an awful state it has left him in – none but his own lot could possibly make any further use of him!
>
> As yet, though, in England it is not even distantly perceived the great importance of what has taken place. What has happened is that a *new* law has been made! I indeed have added to the Code Napoleon. What do you think of that! It is now established once and for all that the work of the artist belongs absolutely to himself – even be he *paid for it in full* – and that at any moment he may refuse to deliver it into hands that he thinks unworthy. This establishes the difference between an ordinary object of commerce and a work of art. All of this will be understood when the case is fully published, as it will be shortly, and it then will become a book of reference![20]

In this instance there was some basis for Whistler's bluster. As the first person to legitimatize in a court of law an artist's absolute right of ownership of his creative work, he had in fact added to the Code Napoleon. For this he has frequently been acclaimed. As recently as 1988 an art journal article referred to him as 'one of the unlikely heroes in the history of artists' freedom' because he 'codified the artist's moral right . . . to decide when a work of art is finished and when it may be delivered.'[21]

It is true that for the first time this particular right was 'codified.' But even without codification the right existed in fact. The painter, the writer, the composer have always decided when to deliver a picture, a book, a piece of music. How could it be otherwise? Who could force an artist to hand over something against his or her will?

But because his appeal legally ratified a basic right, it was a victory for Whistler. A small victory.

When he told Thomson that the Eden case would be 'fully published,' he had in mind a book of his own.

He wrote to Heinemann about doing a volume on the dispute:

'The form will be the same as the little brown Ten O'Clock, and the other

pamphlets, with the intention that it shall be considered a text book or a reference.'[22]

Against his better judgment, Heinemann agreed, and at once Whistler began to collect pertinent documents. According to the Pennells, he took as much care with this as with anything else. While it was in progress, he would read passages to them and would repeatedly pause to ask, 'Isn't that beautiful?'[23] They didn't really think so, but they wouldn't dampen his spirits.

The upshot was the appearance, early in 1899, of an 80-page volume, *Eden v. Whistler: The Baronet and the Butterfly*.

After he had received his personal copy, Whistler wrote to Heinemann, 'It is simply stupendous!'[24]

In holding this opinion, he probably stood alone. In every way *Eden v. Whistler* was a failure. Consisting of tedious speeches by lawyers and judges, it is unbearably dull; very few copies were sold; it was demolished by a few reviewers and ignored by the others.

After reading particularly painful comments in the *Pall Mall Gazette*, Whistler wrote to Heinemann, 'What ought to be done is to get a really good article written at once – taking the statement of the Pall Mall and showing how, on the contrary, the book is important, etc., etc.'[25]

When Heinemann did nothing, Whistler wondered if he too had 'gone over to the enemy?'

He did not, however, have to wait forever for something that he liked. Late in the year he told his publisher, 'Julian Hawthorne has written an article that is really delightful! beautifully done! so crisp and bright and in such perfect taste! The *prettiest* piece of work you have seen for a long time.'[26]

Julian Hawthorne, son of Nathaniel, was a popular novelist and essayist who had lived in London and had known Whistler rather well. His latest essay, 'A Champion of Art,' appeared in the American weekly *Independent*, seven tightly packed double-columned pages of unmitigated praise, a total panegyric.

As a person, Whistler, according to Hawthorne, was noted for 'exquisite keenness and delicacy of perceptions,' for 'quickness and breadth of sympathies,' for an 'immense and sweet good nature' (!), for 'tender, human feelings for all that is good and true in mankind,' and – in all seriousness – for 'flawless personal modesty.'

As a painter he was likened to the greatest of composers: 'The impression produced upon a competent mind by a picture by Whistler can no more be reproduced by verbal speech than can a symphony by Beethoven.'

Hawthorne then produced several pages of verbal speech on Whistler's paintings.

The article ends with a discussion of *The Baronet and the Butterfly*, whose 'contents are delectable.' Eden was 'an amateur Shylock' and 'a titled

306

freebooter,' and the final result of the case 'confirmed Whistler's undivided claim to wear the proud title which stands at the head of the essay.'[27]

To a friend, Whistler wrote, 'Believe me, Julian Hawthorne is right. I *am* charming.'[28]

47

Two Final Ventures

[1898–1901]

When Julian Hawthorne's essay appeared, Whistler was enjoying early reports of the Boer War.

He read the war dispatches with zest, and reveled in reports of British defeats during the winter and spring of 1899–1900.

'The Boers are as fine as Southerners,' he told a friend. 'Their fighting would be no discredit to West Point.'

When his friend referred to 'the athletic character of the British army,' Whistler laughed. 'Athletics!' he responded. 'Yes, to be sure! If it weren't for athletics, how could they run forty miles away from the Boers?'[1]

Joseph Pennell was away from London for a while during the early days of the war, and Whistler and Elizabeth would spend long evenings together by themselves.

'He would come and dine with me alone,' Elizabeth related, 'his pockets stuffed with newspaper clippings. He would put them by his plate, and after dinner he would read every one to me, with that gay laugh.'[2]

One might think that it would have been boring to spend night after night reading war reports.

Many of his cuttings went off to America with underlined passages dealing with British capitulations. On one of them he wrote, 'The same old story! outfought, outwitted and outmaneuvered – your boasting Britons can only *outnumber*! Else he surrenders!'[3]

The Boer War was a diversion, and Whistler lost interest when the tide turned. Two other matters of greater importance were the last enterprises of his life, an art society and a school.

* * * *

At the beginning of 1898 a group of young artists in London formed an International Society of Sculptors, Painters, and Gravers, a cosmopolitan

organization without geographic, philosophical, or doctrinal limitations. Unsurprisingly, they chose as their first presiding officer, Chairman of the Executive Committee, James Whistler, who accepted the offer with pleasure.

Their first exhibition was in 1898, and, in defiance of established societies, it opened in late spring. It was in an uncommon locale. Hitherto virtually all of London's art shows of any consequence had been held somewhere between Trafalgar Square and Mayfair, but nothing in that area was available to the International Society except small dealers' showrooms. And so, in the words of *The Times*, this new coterie went to 'faraway Knightsbridge' into 'a building as yet innocent of all associations with art,' the popular Prince's Skating Rink.

The ice floor was boarded over, partitions were brought in to intersect three sizable galleries, and the walls were lined with greenish-gray canvas. The rooms were well lighted and provided space for more than 500 pictures and pieces of sculpture.

The society had a liberal hanging policy. Its art would not be confined to any time, country, or school. Exhibitors could enter works from any stage of their career. Whistler's had been done more than 35 years earlier: a Valparaiso seascape, *La Princesse du Pays*, *The Thames in Ice*, and his first Royal Academy picture, *At the Piano*. Manet's principal submission was more than 30 years old, the celebrated *Execution of Maximilian*.

Manet was joined by most of the other Impressionists – Monet, Degas, Renoir, Sisley, Cézanne, and Pissarro.

Because of Whistler and the Impressionists, the show was widely noticed, with reviews that were generally friendly, but with a note of caution. The *Saturday Review*, for example, while acknowledging the good work, said that there was also 'far too much rubbish.'

The warning was not heeded. The 1899 show, opening again in May at the Prince's Skating Rink, had less good work and more rubbish. Whistler set the tone with five entries that were negligible. And most of the Impressionists stayed away.

'There are no risky pictures here,' *International Studio* said. 'There is scarcely one that would fail to pass muster before the bar of Mrs Grundy.'

Ostensibly because Paris was holding an International Exhibition, in 1900 there would be no art show in the Prince's Skating Rink.

<p style="text-align:center">* * * *</p>

Early in 1900, within a space of five days, two of *The Times's* obituaries reported on men who had played roles in Whistler's life.

On 1 March, it disclosed the death of William Stott, 42. The notice, handed to Whistler by an acquaintance, began 'William Stott "of Oldham" has died at sea . . .' He looked up and said, 'So he died at sea, just where he always was.'

Seeing a look of surprise on his companion's face, he remarked, 'I forgive when I forget.'[4]

Four days later, he read in *The Times*, 'Dr William McNeill Whistler, senior physician to the London Throat Hospital . . .' (He had acquired his middle name in the early seventies.) James Whistler wasn't sent into a paroxysm of grief. Recently the two brothers hadn't seen much of each other. A longtime member of the Royal College of Physicians, and past president of the British Laryngolical Association, William had been part of the medical establishment, and as an entrenched resident of Mayfair, he had moved in circles very different from those of James, who took the death in his stride.

When Nellie asked for advice on what should be included in a medical journal obituary notice, James said, 'Let Baltimore be his home, and generally the South be his country – and say that he distinguished himself in the War as a Surgeon in General Lee's Army . . .'[5]

<p style="text-align:center">❉ ❉ ❉ ❉</p>

Whistler would never lose his zest for a fight, and despite advancing age he continued to engage in hostilities of one kind or another. One of his disputes, begun in 1896, reached a painful climax in 1900. It involved the men to whom he had so often expressed undying gratitude, the Thomas Ways, father and son.

In June 1896, the younger Way had issued a catalogue of Whistler's lithographs, to which no objection was raised until the publication of one sentence, on 29 June, in the 'World of Art' column of the Glasgow *Herald*: 'Mr Whistler has executed a portrait of himself in what is known as "stump lithography" to serve as the frontispiece [to the catalogue.].'

When he read this, Whistler, inexplicably, flew into a rage. He addressed a letter to his solicitor:

> I wish you would write to Mr Way. Say that Mr Whistler is very greatly amazed at the note which says that he supplied the photograph for the frontispiece and has worked upon it himself. The papers are taking great notice of this, and the impression given is that I am so anxious to thrust my likeness upon the public on the occasion of this catalogue that I urged it upon Mr Thomas Way and furnished the photograph. . . . I didn't want any portrait at all, and I ought not to have allowed it. But I yielded to the pertinacity of young Mr Way as he had set his heart upon the portrait.[6]

Way was at a loss on how to respond to an attack on himself because of a note in a newspaper. Whistler refused to discuss the matter with him and his assault through his solicitor until finally he refused to have anything more to do with Thomas Way, Jr.

Amazingly, another person personally blackballed by Whistler was Thomas

Way, Sr., to whom he wrote a letter 'of such a character,' his son said, 'that I trust it has been destroyed.'[7] [Apparently it was destroyed.]

Whistler never saw either of them again until an evening in the spring of 1900, when he and Elizabeth Pennell attended a lecture by her husband. Thomas Way, Sr., sat down behind them, leaned over, stretched out a hand, and said, 'Come now, Mr Whistler, be a gentleman and shake hands with me.'

Whistler drew himself up stiffly and said, 'It is because I am a gentleman that I refuse to shake hands with you.'[8]

This was his last contact with father or son.

* * * *

As soon as one unilateral altercation ended, another one began.

Whistler had three paintings at the Paris International Exhibition, including a prize-winner, *The Little White Girl*. Marion Spielmann, editor of the *Magazine of Art*, called attention to one of the rules of the show, that no picture more than ten years old should be considered for an award, which should have ruled out *The Little White Girl*, which had been exhibited at the Royal Academy in 1865.

Whistler was livid. 'Spielmann became an art critic,' he told Pennell, 'by running to fires and reporting on them. The last time I saw him he was walking down Piccadilly carrying a nude picture and trying to explain *Horsley soit qui mal y pense*.'[9]

He wrote letters to Spielmann. His solicitor wrote letters to Spielmann. They demanded a retraction and an apology, copies of which were to be personally delivered to every paper and magazine that reviewed art exhibitions. Otherwise he would be sued for libel.

For weeks, the Pennells reported, Whistler 'talked little of anything but Spielmann.'[10] But what began with a bang ended with a whimper.

'In view of our resistance to their absurd demand,' Spielmann said, 'they wisely let the matter drop.'[11]

* * * *

In its 1898 International Society review, the *Spectator* expressed 'a sincere hope that this exhibition is the first of many.' It was in fact the first of three.

In 1901, the show opened in October, when there was very little competition, and was moved from Knightsbridge to the more centrally located Royal Institute, in Piccadilly.

The pictures were well hung, but that is about all that could be said for them. Whistler entered five small, trivial works, which, in his terminology, were no more than 'notes.' Most of the other well-known former exhibitors didn't appear at all, and the *Art Journal*, until now a champion of the society, agreed that 'few of the works rise above mediocrity.'

Like Whistler's threatened suit against Marion Spielmann, the International Society of Sculptors, Painters, and Gravers just faded away.

<div align="center">* * * *</div>

In September 1898, soon after the first exhibition of the International Society had closed, a circular appeared in Paris and drifted over to London, which, the Pennells said, 'created a sensation in the studios.'[12] A former model, Carmen Rossi, announced that an art school would open in the Passage Stanislas and would be called the Académie Whistler.

James Whistler was going to be a professor of painting!

The Passage Stanislas is a narrow, block-long alley, facing Rue Notre Dame des Champs across from Boulevard Raspail. The building for the school, number 6, was described by one of the first students:

> It was an old three-storied house that contained a stable on the ground floor, ingeniously adapted to a studio, and another atelier at the top of the house. Whistler purchased some fine old carved oak from a château in the south of France, which he presented to the school. He had the handsome staircase fitted in bodily, with wainscot and hand-rail complete, and one mounted these magnificent stairs to gain the studio on the third floor. The door leading into this room was of beautiful black oak, with iron latch and hinges; and in this room was a fireplace which, for the dignified simplicity of its carving, was worthy of a home in any museum. On the landings and in the studios were simple draperies and divans with cushions, and at a glance one felt the presence of Whistler. In every sense the school was a distinct innovation from the ordinary French academy.[13]

It was commonly referred to as 'the Whistler school,' and for a time a sign proclaimed it to be the 'Académie Whistler.'

A code of conduct was drawn up by Whistler. As he told the Pennells, 'there was to be no [informal] talking; smoking was not to be allowed; the walls were not to be decorated with charcoal; and the usual "studio cackle" was forbidden.' Prospective students, whom he called 'candidates for admission,' were informed that 'Mr Whistler begs it to be understood that he cannot entertain any discussion of these regulations.' Additionally, 'Mr Whistler expects complete acquiescence in his wishes – and perfect loyalty.'[14]

The upper studio was for male students, while the lower one was for the women. Each studio was furnished with one poster, conspicuously placed with printing in large letters. This was the statement included in the 1884 'Notes – Harmonies – Nocturnes' catalogue, erroneously called *l'Envoie*. (See chapter 37, page 237.) It would be the guiding light of his students.

Despite the rules and pronouncements, Whistler had nothing to do with the day-to-day operations. The real director was Carmen Rossi, a thirty-year-old

<div align="center">312</div>

woman who had been one of Whistler's child models, and for whom, he said, he had established the academy. 'He confided to us over tea and brioche,' a student recalled, 'that 'it was for Carmen, poor little Carmen, a mere child with no money, and saddled with the usual Italian burden of a large, disreputable family – banditti brothers, a trifling husband, and all the rest of it.'' [15]

Carmen and her husband operated the school, and Whistler was a visiting professor. Since he charged nothing for his services, they kept all the profits from the tuition, which, because of his name, was double that of the usual school. The enrollment was limited to forty, and despite the high fees, the school opened with a full complement of French, British, and American pupils.

Unlike most masters of ateliers, Whistler did not make regularly scheduled visits. He came, a student said, 'whenever the spirit moved him,'[16] usually once or twice a week.

He put in his first appearance early in 1899, and, as would become his custom, he went first to the women's studio. This visit was described by someone who was there, a young woman distantly related to him on the maternal side of his family (although until this day they had never seen each other):

Very young, ecstatic, inexpressibly nervy, I joined the students who had assembled for the opening of the Académie Whistler. On that day there was tension in the air.

One entered the enormous, high-ceiled room from the corridor by a door at the top of a short flight of steps. This door was flung open. Every one held her breath; I could hear the whistling intake as they stopped breathing.

Carmen, with a grand gesture, appeared against banked shadows. With her great Italian chest flung back, her still beautiful head high in the air, in her deep voice the roll of drums, she announced,

'Monsieur Whistlaire!'

She stood aside. The pride of an impressario in her majestic mien, she made way for a man clothed in black from head to foot, very slim, very odd, about whom there was no color except the red of the cheeks and the stubborn under lip and the amazing blue of the deep-set blue eyes. These eyes swept the room in a rapid glance. There was a light behind the blue, a sparkling malice. He was laughing at us!

He handed Carmen the great coat which had hung over his arms, the high hat which he had held in his hand. Into his right eye he screwed a monocle. He took a long time about it. He stood on that upper step like a *premiere danseuse*, the impression of being on his toes before a thrilled audience.

The black figure, who seemed immensely tall, came down the steps to the floor of the atelier.

'Goodness!' I said to myself, behind my easel, 'he's not much taller than I am!'

My turn at criticism came. I knew that a Mephistophelian terror was standing

behind me. I knew that he looked like the devil, but I kept my eyes fixed on the daub I had spread upon my canvas.

'Marvellous! Mademoiselle, do you call this a painting?' demanded the rasping voice. 'The violence of youth is in these colors.' The sparkling eyes were turned full upon me; they looked me over from head to foot. The malice died, and the laugh grew back behind the cobalt.

'Finish your education, mademoiselle. Enlarge your brain. No one starts at your tender age with a brain. One cultivates it, coaxes it, helps it along, as one waters a flower which is to grow into a beautiful thing.'

His long fingers were painting in the air the growth of the beautiful thing.

'Some people do start with brains,' I replied stubbornly. 'Besides, I am your cousin.'

Raucous laughter from the master, and stares from the students.

'Mademoiselle, my cousin!' said he, with an exaggerated bow. 'I should have known it from your amazing cheek! Only "de fambly" could produce cheek of a quality so rare.'[17]

Unlike most art instructors, who dressed casually, Whistler always arrived in a black suit, wearing a monocle, holding a kid glove, and carrying a high hat.

His studio procedure also deviated from the norm. The typical French art teacher went methodically from pupil to pupil, stopping to comment on each one's work. Whistler would wander about haphazardly, ignoring some, making brief comments to others, and stopping to examine whatever caught his eye.

He might deliver such off-hand remarks as 'Yes, yes. Continue, continue,' or 'I see you're beginning to understand,' or 'Rather dirty, you know – dirty, muddy in colour.' Sometimes he would paint a few strokes on a student's picture.

To European pupils he spoke in French. To British and Americans he spoke in their language, but, one American observed, he employed two kinds of English:

'I often remarked a whimsical affectation of Mr Whistler in his manner of speech with different pupils. If criticising an American, his choice of language, and in some cases his accent, would become markedly English in form; while in addressing an Englishman he would adopt the Yankee drawl, sometimes adding a touch of American slang.'[18]

An American who visited his studio at this time, with a letter of introduction from a man named Pendleton, commented on this particular mannerism:

'In an exaggerated and affected English tone, he said, "I'm chawmed to meet you. Deah old Pendleton, how is he? Fine old chap."

'He paused and then asked, "Are you a painter?"

'"No, I'm only a newspaper man."

'"Reahly!"'[19]

Regardless of his language and diction, 'his criticisms,' one student said, 'were often foggy and uncertain, and he couldn't find words with which to express himself.'[20]

But occasionally he would come out with one of those *bons mots* for which he was famous.

Once he stood beside a newly arrived female student.

After looking at her work for a few moments, he said, 'You're from New York?'

'Yes, sir.'

'You were a pupil of Chase?'

'Yes, sir.'

'Um–m! I thought so. Why did you paint a red elbow with green shadows?'

'I am sure I just paint what I see.'

'Yes. The shock will come when you see what you paint.'[21]

After he had spoken critically of another young woman's work, she said, 'But I painted it in only two hours.'

'You had no business to paint it in only two hours.'

'I intended to work longer.'

'Intentions are never a virtue.'[22]

Then there was the American woman who, asked under whom she had studied, said, 'I never studied with anybody.'

Unhesitatingly, Whistler said, 'You couldn't have done better.'

He spent more time with the women than with the men, and when he was with the women, men were forbidden to enter their studio. Once, however, a male student momentarily penetrated the hallowed sanctum, and he reported on the experience:

> By mistake one day I opened the door to the girls' studio, and I was at once stopped short by many angry eyes turned on me. I fled out of the room as soon as I became aware that Mr Whistler was criticising.
>
> The picture made an indelible impression on me: Whistler in his tightly buttoned black frock-coat, his monocle gleaming in his eye, surrounded by a bevy of girls who hung on his slightest word. He was daintily wiping his finger-tips on a snowy handkerchief which the *massiere* held before him. I heard him say, 'And is this what they taught you at the Slade?'[23]

Because of weakening health, Whistler left Paris for warmer climes late in 1900. In January 1901 he sent a message to his school, with a new name, from Ajaccio, Corsica:

> Mr Whistler presents his compliments to the ladies and gentlemen of the Académie Carmen.

315

He regrets that his pleasant relations with them should be, for a time, interfered with – by his doctor's abrupt devotion and authority!

To his distinguished pupils he would say, in all kindliness, that the great and simple truths they have together been permitted to approach may well occupy them during his absence. So it is again sadly undeniable that 'nothing matters!' – and, in their absorbed ardour, he may not even be missed![24]

Actually he was very much missed. The Académie Whistler without Whistler was somewhat like *Hamlet* without Hamlet, and it closed down for good in April 1901.

* * * *

Although some pupils were bedazzled and inspired, Whistler wasn't a good teacher. He was too impatient, and his own working methods were too highly individualized to be easily transmitted. If by his fruits we shall know him, his school was not a success. There doesn't seem to have been a single gifted artist who was influenced by his instruction. But it was something he had to do. And it was almost the last thing of consequence that he did.

48

The Last Days

[1901–03]

Early in 1901, Whistler wrote from Ajaccio, Corsica, to Heinemann, 'I have been drifting about from hot glare into icy shade! Tangiers! Algiers! The Mediterranean! *Que sais-je?* Catching colds that I never had in blank, black London! (Gibraltar, by the way, is really ridiculous!)'[1]

His last two and one-half years were spent mainly in drifting about – from Paris to Gibraltar to Algiers to Tangiers to Marseilles to Corsica to Marseilles to London to Dieppe to London to Bath to London to The Hague to London to Bath to London.

* * * *

Whistler was 66 when he went to Corsica, but he looked and acted older than his age.

In July of 1900, when he was still involved with his school, he had briefly visited London and had dinner with the Pennells. Later that night Elizabeth described his appearance: 'He seemed suddenly to have grown old. His hair lay flat, his forehead was a network of wrinkles, his cheeks had fallen and were flabby and pale, and when he talked, all life and gaiety and fun had gone.'[2] For the first time ever in their presence, she noted, he had complained about the heat.

In some ways he mellowed with advancing age. Soon after his death, an American woman named Mary Thompson was a guest at a hotel in Ajaccio, and she got into a conversation with her chambermaid, a Swiss woman named Marie. 'Imagine my astonishment,' she related, 'when Marie asked me if I knew "Monsieur Whistler." Sadly I replied, "I have never had the honor," and told her that he no longer lived. Marie's face became sad, and she immediately began to tell me how good "Monsieur Whistler" was; how gay, never angry, always *"un bonhomme."* '

'What an honor for you to attend his room!' I said.

'Oh,' replied Marie, 'I did not know for ever so long that he was a great man. He was so simple! Always painting, always out of doors in all weathers, wearing his great fur-lined coat. Always the *bonjour*, and some pleasant words. Always a smile. I tried to keep his room so clean, because it was full of all kinds of things. Sometimes he would say, on his return, "Are you sure, Marie, that this is my room? It is so tidy."' Marie's face glowed with pride during this part of her description.

'Then I used to make his paint brushes so white and clean.'

'But Marie,' I asked, 'did Mr Whistler like you to do that? Was he never cross when you mislaid one?'

'Oh, no, mademoiselle, *ce cher* Monsieur Whistler, he only said, "Never mind, Marie, we will search for it."'

I asked her how she found out that he was a distinguished artist. 'The mistress told me,' she said. 'Someone had told her.'

Mr Whistler and the chambermaid left the island by the same boat. He called her to stand near him, and he said, 'I will speak to the men at the douane for you. Then you will have no trouble.'

Marie, almost with tears of pride in her eyes, said, 'He did, and I had not a minute to stand anywhere because Monsieur Whistler said, "I know her, and she has not anything to declare. Let her pass."'

Then Marie added, 'You see, mademoiselle, they knew he was a great man.'[3]

* * * *

Whistler was not very productive in Corsica. He started a couple of oil paintings, but both of them remained unfinished. He did, however, complete a few water colors, the best known of which is called *The Gossips, Ajaccio*, showing his never-ending interest in ordinary life. The picture depicts two middle-aged women standing and conversing in a doorway, with several children playing in the background.

His output in Corsica was limited, partly because, he told Heinemann, 'I have *at last* learned how to "rest" – and I have discovered that for years and years I have *never* rested – never taken off even a Saturday afternoon!!'[4]

He also learned how to enjoy activities for which in the past he would not have had time. He took up dominoes. He acquired a cat, and 'his devotion to her,' the Pennells said, 'was something to remember. We have seen him get up, when probably he would not have stirred for any human being, just to empty the stale milk from her saucer and fill it up with fresh.'[5]

* * * *

After his wife's death, when Whistler was in London he would usually stay in Garlant's hotel, a small, inexpensive 'family' establishment in Suffolk Street, a

couple of doors from the galleries of the British Artists. Then in April 1902 he took a lease on his last place of residence, 74 Cheyne Walk. The embankment had been in place for more than 25 years, and there was a commercial building next door, with a savings bank, a post office, and a bakery shop, but he could still look out and see his river.

In that spring of 1902, the second edition of *Who's Who in America* was published. The first edition had appeared in 1900, and it is instructive to juxtapose Whistler's entries in the two volumes. (The data fed into *Who's Who* has generally been supplied by the subjects themselves, and at that time the editorial board rarely altered anything given to them.)

When information was collected for the first edition of *Who's Who*, Whistler was in relatively good health, actively involved with the International Society and his Parisian academy. When he provided material for the second edition, his health had deteriorated alarmingly, his art society and his school had foundered, and he may have wondered if he would be listed in the third edition. It would seem as if he was now writing his obituary notice as he wanted it to be. For this reason it is interesting to note how he modified his biography as it had been written two years earlier.

In the first edition he appears as 'Whistler, James Abbott McNeill, portrait painter.' In the second edition, he is 'Whistler, James McNeill, painter.'

In the first edition, he was 'born in Lowell, Mass., 1834.' In the second edition, he is 'of Baltimore,' without a date.

In the first edition, his parents are unmentioned. In the second edition, he is the 'son of Maj. George Washington Whistler,' and his 'mother's family' are the 'McNeills of South Carolina.' He understandably gave his father the rank which he was popularly believed to have had, and he probably moved the McNeills from North to South Carolina because South Carolina was, and is, the most aristocratically Southern of all the American States.

In both editions, he was 'educated at West Point,' the only school mentioned.

In the first edition, he 'studied in Paris under Gleyre, 1857.' In the second edition, he was a 'pupil of Gleyre in Paris.' The first entry was, of course, more accurate, but because of Sisley, Renoir, and Monet, it had become fashionable to have been a 'pupil of Gleyre.'

According to the first edition he 'began to exhibit at the Royal Academy in 1859,' he held his own exhibitions in London in 1874 and 1892, and he had been 'President of the British Artists.' For the second edition this was all discarded and replaced by the following: 'Knight of the Order of St Michael, Bavaria; Hon. Member, Royal Academy of St Luke, Rome; Hon. Member, Royal Academy of Bavaria, Munich; Member, Société Nationale des Beaux Arts, France; President, International Society of Painters, Sculptors, and Etchers.' He wanted to be remembered as an international artist.

The first edition notes that he had 'sued Ruskin and was awarded a judgment

against him for an attack on him and his art in "Fors Clavigera." ' For the second edition, this was entirely dispensed with; Whistler did not want in any way to be linked with Ruskin.

In both editions he is the 'Author of *Ten O'Clock* and *The Gentle Art of Making Enemies*'; the second edition also includes *The Butterfly and the Baronet*.

The entry in the first edition does not refer, specifically or generally, to pictures. The second edition includes the following: 'Portrait of his Mother, Luxembourg Gallery; Carlyle, Glasgow Gallery; and others. Etchings: British Museum, Venice Academia, Dresden Galleries; Biblioteque Nationale, etc.'

The entry in the second edition listed his address as 110 Rue du Bac, although he hadn't lived there for several years and no longer held the lease to the flat.

<p style="text-align:center">* * * *</p>

In June 1902, accompanied by an American patron, Charles Freer, Whistler went for the fourth time to Holland for what was to be a holiday. Almost immediately upon arriving in The Hague, he collapsed and had barely enough energy to scribble this paragraph on a sheet of hotel stationery:

> I give and bequeath unto my ward and sister-in-law Rosalind Birnie Philip, of 36 Tite Street, Chelsea, London, all of my real and personal property of every kind and nature, wherever located. I declare this to be my last will and testament written briefly, fearing because of the great heart strain upon me the cord might at any moment snap.[6]

After he had been confined to his hotel room for several weeks, the *Morning Post* in its 'Art and Artists' column for 31 July paid him a lengthy, if premature, tribute:

> Mr Whistler is so young in spirit that his friends must have read with surprise the Dutch physician's pronouncement that his present illness is due to 'advanced age.' In England 67 is not exactly regarded as 'advanced age,' but even for the gay 'butterfly' time does not stand still, and some who are unacquainted with the details of Mr Whistler's career will be surprised to hear that he was exhibiting at the Academy 43 years ago. His contributions to the exhibition of 1859 were 'Two Etchings from Nature,' and at intervals during the following fourteen or fifteen years he was represented at the Academy by a number of works. . . . Among his pictures of 1865 was the famous 'Little White Girl,' which was rejected at the Salon of 1863 and was inspired by a poem of Swinburne . . .

Someone posted the column to Whistler, who immediately responded with a letter which the *Post* published on 6 August:

<p style="text-align:center">320</p>

May I acknowledge the tender little glow of health induced by reading, as I sat here in the morning sun, the flattering attention paid me by your gentleman of ready wreath and quick biography!

I cannot, as I look at my improving self with daily satisfaction, really believe it all – still it has helped to do me good! and it is with almost sorrow that I must beg you to put back into its pigeon-hole, for later on, this present summary.

This will give you time, moreover, for some correction. The 'Little White Girl,' which was not rejected at the Salon, was, I am forced to say, not 'inspired by a poem of Swinburne' for the simple reason that his poem was only written in my studio after the picture was painted. . . .

It is my marvellous privilege to come back while the air is still warm with appreciation, affection, and regret, and to learn how little I had offended!

The continuing to wear my own hair and eyebrows, after distinguished confreres and eminent persons had long ceased their habit, has, I gather, clearly given pain. It is even found inconsiderate and unseemly in me, as hinting at affectation.

Protesting, with full enjoyment of its unmerited eulogy, against your premature tablet, I ask you again to contradict it, and appeal to your sense of kind sympathy when I tell you that I have, lurking in London still 'a friend' – though for the life of me I cannot remember his name.

<p style="text-align:center">* * * *</p>

'Surely this letter,' the *Morning Post* editorialized, 'cannot be taken as other than a sign of robust health.'

This was an overstatement. Whistler was not near death, but when he returned to London in September he was not in 'robust health.'

He was still energetically spirited, as he demonstrated by a couple of letters written in November 1902.

After hearing that Montesquiou had sold his own portrait and was using the proceeds to pay for an American tour, he wrote to a friend, 'The portrait acquired as the Poet, for a song, is sold again as the Jew of the rue Lafitte for ten times that first air: felicitations. We *nous autres* have waited to see if M. Montesquiou would in his confidences to America reveal his own great talent in their God gifted specialty – business!'[7]

A few days later he wrote his last 'letter to the editor.' It went to the *Standard*, whose art critic, Frederick Wedmore, had complained of having seen one of his exhibited pictures more than once:

Sir – If there be any wit or intention in your expert's complaint that he had seen 'the small Whistler' in the New Gallery before, it is the conveyed insinuation that the work is an old one, and has been continually thrust upon him in the many shows he, in watchful duty, frequents – in short, that he recognises the picture as

a species of Exhibition hack, and, no longer able to tolerate such fraud, exposes it . . .

Now, as a matter of mere fact, the little Cardinal [the picture of a small child, the one mentioned by Wedmore] is only yesterday morning returning from the Paris Salon, where, in brilliant company, she received her baptism. And this is the first Gallery in the Island in which she makes her appearance, and the busy and correct one has hitherto never laid eyes on her! For to frankly say that it was his privilege to be presented to her in her cradle the other day, in the Champs de Mars, was certainly not the intention of this upright and unhesitating Master Podsnap – and surely Podsnap it is, with his convinced emphasis and angry innuendo. Oh, but Podsnap is beautiful! Podsnap General, Podsnap Financier, Podsnap Statesman we know, but it is my joy to have perceived our old friend in his last incarnation, and I nearly felt the apple of Newton thump upon my head in the delightful abruptness of discovery.

Podsnap then, Podsnap in crimson tie of The Schools, but Podsnap still, pervades the Press, and, determined that a trick is being played, appeals to his memory, and his memory does not serve him better than do his eyes! And so he commits perfidious little Podsnap paragraphs, and hints at a funny sort of unfairness in the reappearance of a painting he has placed in former Galleries, and from a parochial point of view, Podsnap indignantly holds that this is 'not the game – not cricket!' and that a picture once seen should never be looked at again. This is sometimes monstrously true.

As intimated in his letter to the *Standard*, Whistler was working almost to the end. Among his last pictures, a couple of portraits are worth noting, those of Richard Canfield and Dorothy Seton.

Canfield was a curiously contradictory man. A Harvard graduate who quoted Latin poetry and patronized the arts, he owned a gambling house in New York City, recently raided by the police, and his friends included several notorious gangsters.

At the end of 1901, Canfield came to London, allegedly to avoid prosecution in America. He sought out Whistler and commissioned a portrait of himself. He became not just the subject of a picture but also a personal companion of the painter. 'He was always welcome as a friend,' the Pennells recalled, 'and seemed almost to have hypnotized Whistler.'[8]

Ignoring the advice of several Americans not to associate with this disreputable man, Whistler was elaborately courteous, almost deferential, toward him. (Because of a disagreement over Canfield, he broke off all ties with his benefactor Edward Kennedy.)

For two and a half months Whistler, and the tall, corpulent Canfield were together almost every afternoon. For a couple of hours Whistler would work on

the portrait, which had the ironic title *His Reverence*. Then for two or three hours they would chat over cocktails.

Canfield's final sitting took place on 14 May, the day before he returned home. He described this last meeting with Whistler:

> I went around to his studio, and he painted until well into the afternoon. When he was done, he said that with a touch or two here and there the picture might be considered finished. He then said,
>
> 'You are going home tomorrow, to my home as well as yours, and you won't be coming back till autumn. I've been thinking that maybe you had better take the picture with you. His Reverence will do very well as he is, and maybe there won't be any work in me when you come back. I like to think of you having this clerical gentleman in your collection, for I have a notion that it's the best work I have ever done.'
>
> He had never talked that way before, and I have since thought that he was thinking that the end was not far away. I told him that I would not think of taking the picture, and that if he didn't put on the finishing touches until I got back so much the better, for then I could see him work. That seemed to bring him back to himself, and he said,
>
> 'So be it, your Reverence. Now we'll say *au revoir* with a couple of mint-juleps.' He sent for the materials, made the cups, and just as the sun was setting, we drank to each other and the homeland.[9]

Canfield did not return, and the two men did not see each otherr again.

Canfield's portrait was painted before Whistler's illness in Holland. Dorothy Seton's was done afterwards, his last picture.

Calling to mind Jo Hiffernan, Dorothy Seton was a red haired Irish woman. She is portrayed with her hair dropping down over her shoulders as she stands with an apple in her hand. Her portrait was called *Daughter of Eve*.

Pointing to the small portrait, he asked Pennell, 'How long do you think it took me to paint that?'

'I don't know. How long did it take?'

'I did it in a couple of hours this very morning!'

'Not for many weeks,' Pennell said, 'had he shown such animation as when he made this comment.'[10]

Daughter of Eve is nothing to be ashamed of. As the present-day critic Denys Sutton said, it is 'particularly full-blooded and handsome.'[11]

Elizabeth Pennell, incidentally, recalled entering one afternoon just as Miss Seton was leaving.

'Most people think she isn't pretty,' he said, 'but I find hers a remarkable face. It reminds me of Hogarth's *Shrimp Girl*.'[12]

And so Whistler ended his career under the influence of the man who had

provided him with his first ephiphany as a twelve-year-old convalescent in St Petersburg.

<div align="center">* * * *</div>

Whistler painted Dorothy Seton's portrait during one of his infrequent periods of animation following his return from The Hague.

Most of the time, his constant companion Elizabeth Pennell said, he was

> the ghost of the Whistler who had laughed his troubles away and scattered his enemies with the first dart of the Butterfly's sting. A Whistler with shrunken face and eyes that, through this long last winter, were ready to shut in sleep after a few minutes' walk – a Whistler disdaining a dressing gown, symbol of illness, and tottering about the studio in an old brown fur-lined overcoat which reached to his heels and was always buttoned up.[13]

Only rarely did he go out, as on a last visit to Agnew's showroom. George Boughton was there and described him as,

> the shadow of what was once 'our Jimmie.' The poor dear was muffled up in a thick black ulster, and what could be seen of him was shrivelled and white-grey. The white lock had been merged into the scant white-grey hair, and the light seemed dim and furtive in the once gleaming eye. But after a little talk he seemed to expand, and the laugh had an echo of that old ring in it.[14]

<div align="center">* * * *</div>

In the spring of 1903, Whistler was informed by the Rev. Dr Story, Principal of the University of Glasgow, that the university wished to award him an honorary doctor of laws degree. He responded with the last letter of his life:

> My Dear Sir,
> I beg to acknowledge your personally kind letter, and I trust that you will convey to the Senate my keen sense of the rare indulgence they are extending to me, in yielding to the peculiar circumstances, and so graciously conferring this high honor in my enforced absence.
> Pray present my thanks, accept them yourself, together with my regrets to the distinguished body who have chosen me as their confrère – than which there can be no greater compliment.
> I would like to have said to these gentlemen as a reassurance, in their generosity, that in one way the gods have prepared me for the reception of such dignity, in as much as they have kept for me the purest possible strain of Scotch blood – for am I not a McNeill – a McNeill of Bara?[15]

He received the diploma in June. The man who had never earned an academic degree was now Dr James McNeill Whistler.

A month later, somewhat rejuvenated, he went out riding for several days running. On 17 July, Charles Freer stopped by to keep a date they had made for a ride. Only moments earlier Whistler had sat down in a chair and closed his eyes for the last time.

<center>＊　　＊　　＊　　＊</center>

Even in death Whistler couldn't avoid controversy. On 19 July, Elizabeth Pennell noted in her journal that 'other people besides ourselves think the notice in the *Times* is shocking. Abbey is indignant. Heinemann answered it but thought it best to tear up his letter.'[16]

The Times's obituary notice was quite long, two full columns. These were surely some of the statements that incensed Whistler's friends:

> To Whistler the world was divided into two classes only – the artists and the not artists; and the latter was a class whose chief function was to provide for the wants of the former, to accept in a grateful spirit what the artists were pleased to give it, and to be heartily despised in return.

> An American admirer, Julian Hawthorne, once wrote, 'There is an immense and sweet good nature in Whistler.' Frederick Leyland's experience of this immense and sweet good nature was a savage life-size portrait of himself as a devil with horns and hoofs.

> Whistler was an extremely irritating controversialist. His sharp tongue and caustic pen were always ready to prove that the man – especially if he happened to paint or write – who did not fall at once into line as a worshipper was an idiot, or worse. The painful thing was that Whistler, who did not mind how much his own epigrams might hurt others, could not himself stand criticism.

> One wonders what might have happened if the Academy in the early seventies had chosen to elect Whistler an A.R.A. The irreconcilable might have been reconciled; he might have encountered what a rival wit called 'the last insult – popularity'; and we might never have chuckled over that crowning production of a big man's small vanity – 'The Gentle Art of Making Enemies.'

> Whistler's book [*The Gentle Art*] is full of evidence of his colossal vanity.

All of London's daily newspapers had full acounts of Whistler's funeral, on 22 July. This report appeared in the *Daily News*:

> Yesterday afternoon, shortly after midday, the mortal remains of James Abbott McNeill Whistler were interred at Chiswick. The preliminary service was held at

<center>325</center>

the old church of Chelsea, a few minutes after eleven o'clock. The famous old church is only a few minutes' walk from Mr Whistler's house, 74 Cheyne Walk. . . .

The Old Church took a long time to fill. Half an hour before the arrival of the procession from Mr Whistler's house, there were not a half-a-dozen visitors present. But by the time the funeral procession reached the church, shortly after eleven o'clock, where it was met by the Rev. Mr Thompson, who conducted the service, the little church was nearly full.

There was no music, vocal or instrumental. The service was as plain as could be. After its conclusion, the procession resumed its course to Chiswick Cemetery. At its head was a carriage filled with wreaths sent by relatives and personal friends of Mr Whistler, and by various clubs and art societies.

Under a tree, close to the wall, in a quiet corner of Chiswick Cemetery, facing the radiant mid-day sun, the dead artist was laid to his rest. Few were present besides those who had already attended the services at Chelsea Church. To judge from the indifference, or ignorance, of the public, one would not have imagined that the new comer to Chiswick Cemetery was one of the most gifted and famous men of his time. Two ladies remarked that the people of Paris would have signalised the event differently. Said one of them, 'The artists, the musicians, the men of letters, the statesmen of Paris would have followed to the graveside a man of his eminence; and in the streets through which the procession passed traffic would have spontaneously stopped, and every man would have stood still with bared head.' All of which is literally true. This popular reverence paid to the dead is one of the most impressive differences between 'frivolous' Paris and serious London.

So did James Whistler become an eternal neighbor of William Hogarth.

Notes

After the first full citation, books and articles are referred to by author only or by author and short title. The following abbreviations are used for five principal sources of material:

AWD Anna Whistler Diary (New York Public Library)
GUL Glasgow University Library, Special Collections
LC Library of Congress, Manuscript Division
NYPL New York Public Library, Manuscript Division
PEN Elizabeth and Joseph Pennell, *The Life of James McNeill Whistler*

CHAPTER 1

1 Carlisle Allen, 'The Husband of Mrs Whistler,' New York *Herald Tribune*, 6 May 1934, p. 5
2 NYPL
3 NYPL
4 NYPL
5 NYPL
6 From a letter to his brother, Freer Gallery of Art
7 Manuscript letter, Massachusetts Historical Society
8 AWD

CHAPTER 2

1 AWD
2 Bayard Taylor, manuscript letter, LC
3 Charles Dickens, *American Notes*, chapter 1
4 AWD
5 AWD

6 AWD
7 AWD
8 AWD
9 John S. Maxwell, *The Czar, His Court and People* (New York, Scribner's, 1854), 162
10 AWD
11 NYPL
12 NYPL
13 AWD
14 See J. G. Kohl, *Russia* (London, Chapman & Hall, 1844), 105
15 AWD
16 AWD
17 GUL
18 GUL
19 GUL
20 AWD
21 AWD
22 NYPL
23 AWD
24 Peter Cunningham, *Handbook of London* (London, Murray, 1850), 450

CHAPTER 3

1 AWD
2 AWD
3 GUL
4 GUL
5 GUL
6 GUL
7 GUL
8 GUL
9 GUL
10 GUL
11 GUL
12 GUL
13 LC

CHAPTER 4

1 LC
2 PEN, I, 27
3 Nancy Dorfman Pressly, 'Whistler in America,' *Metropolitan Museum Journal*, 5 (1972), 129
4 PEN, I, 28

5 Lilian Whiting, *Louise Chandler Moulton* (Boston, Little Brown, 1934), 9–10
6 LC
7 LC
8 LC
9 LC (Anna's Pomfret diary was different from the one she kept in St Petersburg)
10 LC
11 NYPL
12 Joseph Gardner Swift, *Memoirs* (privately printed, 1890), 267–68

CHAPTER 5

1 Samuel Bayard, *The Life of George D. Bayard* (New York, Putnam, 1874), 21
2 GUL
3 Morris Schaff, *The Spirit of Old West Point* (Boston, Houghton, Mifflin, 1907), 33
4 LC
5 H. M. Lazelle, 'Whistler at West Point,' *Century*, 90 (1915), 710
6 Thomas Wilson, 'Whistler at West Point,' *Book-Buyer*, 17 (1898), 113
7 Lazelle, 710
8 GUL
9 William S. Myers, *General George B. McClellan* (New York, Appleton-Century, 1934), 12
10 Lazelle, 710
11 Luke Ionides, 'Memories,' *Transatlantic Review*, 1 (1924), 52
12 Mortimer Menpes, *Whistler as I Knew Him* (London, Black, 1904), 65
13 Lazelle, 710
14 Herman Herst, Jr., 'Manuscripts Gone Forever?' *Manuscripts*, 17 (1965), 4
15 LC
16 GUL
17 Gustav Kobbé, 'Whistler at West Point,' *Chap-Book*, 8 (1898), 440
18 Wilson, 114
19 Kobbé, 442
20 Wilson, 113
21 Kobbé, 442
22 Joseph William Carr, *Some Eminent Victorians* (London, Duckworth, 1908), 137
23 West Point Superintendent's Letterbook, Number 3, 29
24 Irene Weir, *Robert S. Weir* (New York, Doubleday, 1947), 73
25 Metropolitan Museum of Art, manuscript collection
26 GUL
27 Douglas Southall Freeman, *Robert E. Lee* (New York, Modern Library, 1928), 337

CHAPTER 6

1 PEN, I, 36
2 Elizabeth Mumford, *Whistler's Mother* (Boston, Little, Brown, 1939), 202
3 GUL
4 PEN, I, 39
5 Pressly, 134
6 Thomas Winans's manuscript journal, Maryland Historical Society, Baltimore
7 John Ross Key, 'Recollections of Whistler,' *Century*, 75 (1908), 929
8 Gustav Kobbé, 'Whistler in the U.S. Coast Survey,' *Chap-book*, 8 (1898), 479–80
9 Key, 929
10 Key, 911
11 Kobbé, 'Coast Survey,' 480
12 GUL
13 Henry S. Pritchett, manuscript letter to Howard Mansfield, NYPL
14 Unpublished memorandum by colleague of Whistler, NYPL
15 Kobbé, 'Coast Survey,' 480
16 Key, 931
17 Ibid.
18 PEN, I, 42
19 Pressly, 134
20 GUL

CHAPTER 7

1 GUL
2 Lawrence and Elizabeth Hansen, *Impressionism* (New York, Holt, Rinehart & Winston, 1961), 454
3 Ernst Scheyer, 'Far Eastern Art and French Impressionism,' *Art Quarterly*, 6 (1943), 59
4 John Rewald, *The History of Impressionism* (New York, The Museum of Modern Art, 1961), 20
5 Marcel Zahar, *Courbet* (London, Longmans, Green, 1950), 8
6 François Fournel, *Les Artistes Français Contemporains* (Tours, Alfred Mame, 1884), 222
7 George Du Maurier, 'Trilby,' Part II, *Harper's Monthly*, 88 (1894), 337
8 PEN, I, 51
9 Thomas Armstrong, *A Memoir* (London, Martin Secker, 1912), 183
10 G. H. Boughton, 'A Few Of the Various Whistlers I Have Known,' *Studio*, 30 (1903), 211
11 'The Grisette,' *Putnam's Monthly Magazine*, 10 (1857), 208
12 Mrs Russell Barrington, *Life, Letters, and Work of Frederick Leighton* (London, George Allen, 1906), I, 236
13 NYPL

14 Armstrong, 174
15 PEN, I, 38
16 Henri Fantin-Latour, manuscript letter, LC
17 Armstrong, 14
18 Ibid., 140
19 Ibid., 121
20 Leonée Ormond, *George Du Maurier* (University of Pittsburgh Press, 1969), 45–6
21 Dougald S. MacColl, 'The Industrious and Idle Apprentices,' *Saturday Review*, 96 (1903), 608

CHAPTER 8

1 Joshua Reynolds, *Discourses*, Twelfth Discourse
2 Fournel, 224
3 PEN, I, 67
4 Ibid., 61
5 Alfred Stevens, *A Painter's Philosophy* (London, Elkin Mathews, 1904), section xv
6 Fournel, 356
7 Ibid., 354–55
8 Lecoq de Boisbaudran, *The Training of Memory in Art* (London, Macmillan, 1911), 4
9 PEN, I, 63
10 LC
11 'The Lady of the Portrait,' *Atlantic Monthly*, 136 (1925), 322
12 Armstrong, 25
13 Stevens, section cxxvi
14 Rewald, 20
15 NYPL
16 Charles Baudelaire, *Art in Paris* (London, Phaidon, 1965), 146
17 PEN, I, 69
18 Armstrong, 211

CHAPTER 9

1 GUL
2 William Rossetti, *Fine Art* (London, Macmillan, 1867), 97
3 'Art and the Royal Academy,' *Fraser's Magazine*, 46 (1852), 230
4 'The Art Exhibition of 1859,' *Bentley's Quarterly Review*, 1 (1859), 586
5 Daphne Du Maurier, *The Young George Du Maurier* (London, Peter Davies, 1951), 6
6 Ibid., 11
7 Armstrong, 151
8 Boughton, 87
9 PEN, I, 79

10 Daphne Du Maurier, 7
11 Ibid., 66
12 LC
13 Daphne Du Maurier, 27
14 Nathaniel Hawthorne, 'Up the Thames,' *Atlantic Monthly*, 11 (1863), 599
15 Richard Rowe, 'Down by the Docks,' *Argosy*, 3 (1866), 430
16 Daphne Du Maurier, 27
17 Rossetti, 272
18 LC
19 PEN, I, 90
20 [Margaret Oliphant], 'The Royal Academy,' *Blackwood's Magazine*, 119 (1876), 753–54
21 William Holman Hunt, *Pre-Raphaelitism and the Pre-Raphaelite Brotherhood* (London, Chapman & Hall, 1913), I, 360
22 Daphne Du Maurier, 4
23 Ionides, 40
24 Freely adapted from PEN, I, 82
25 Armstrong, 203
26 Boughton, 112
27 Daphne Du Maurier, 38
28 Martin Hardie, *Frederick Goulding* (Stirling, England, E. Mackey, 1910), 4231
29 James Laver, *Whistler* (London, Faber & Faber, 1930), 340
30 Edward G. Kennedy, *The Etched Work of Whistler* (New York, The Grolier Club, 1910), 24
31 PEN, I, 89

CHAPTER 10

1 LC
2 Daphne Du Maurier, 105
3 NYPL
4 GUL
5 Daphne Du Maurier, 118
6 Ibid., 105
7 John A. Mahey, 'The Letters of James McNeill Whistler to George A. Lucas,' *Art Bulletin*, 49 (1967), 416
8 LC
9 Baudelaire, 225
10 LC
11 George Boyce, *Diary* (London, Old Water Color Society, 1941), 55
12 PEN, I, 118
13 Manuscript letter, Fitzwilliam Museum
14 LC
15 LC

16 LC
17 LC
18 LC
19 PEN, I, 101

CHAPTER 11

1 Thomas Burke, *Nights in Town* (New York, Holt, 1916), 363
2 Manuscript letter, University of British Columbia Library
3 LC
4 LC
5 LC
6 LC
7 Theodore Duret, *Whistler* (Philadelphia, Lippincott, 1917), 24
8 Ibid.
9 J. K. Huysmans, *Certains* (Paris, Tresse & Stock, 1889), 345
10 Paul Mantz, 'Salon de 1863,' *Gazette des Beaux-Arts*, 15 (1863), 60
11 Louis Étienne, *Le Jury et Les Exposants, Salon des Refusés* (Paris, Dentu, 1863), 30
12 LC
13 John Rothenstein, *The Artists of the 1890's* (London, Routledge, 1928), 127
14 Elizabeth and Joseph Pennell, *The Whistler Journal* (Philadelphia, Lippincott, 1908), 124
15 Daphne Du Maurier, 106
16 Boyce, 38
17 'The Lady of the Portrait,' 324
18 LC
19 Pennell, *Journal*, 124, 163
20 Daphne Du Maurier, 227
21 Pennell, *Journal*, 224
22 'The Lady of the Portrait,' 322
23 *The Times*, 18 February 1870
24 *Golden Guide to London* (London, Sampson, Low, 1875), 62
25 George Bryan, *Chelsea in the Olden and Present Times* (London, George Bryan, 1869), 39
26 Katharine Macquoid, 'Old Battersea Bridge,' *Art Journal*, 33, (1881), 35
27 Manuscript letter, University of British Columbia Library
28 Ibid.
29 Ibid.
30 Armstrong, 199

CHAPTER 12

1 LC
2 LC

3 'The Lady of the Portrait,' 503
4 Jeremy Maas, in a letter to the author
5 Freely adapted from PEN, I, 124
6 LC
7 Manuscript letter, University of British Columbia Library
8 Daphne Du Maurier, 216
9 LC
10 LC
11 Daphne Du Maurier, 218
12 Ibid., 248
13 LC
14 Daphne Du Maurier, 216
15 LC

CHAPTER 13

1 GUL
2 GUL
3 LC
4 Elizabeth Pennell, 'Whistler Makes a Will,' *The Colyphon* (1934) [unnumbered pages]
5 Manuscript letter, Fitzwilliam Museum
6 Pennell, 'Whistler makes a Will'
7 Pennell, *Journal*, 43
8 Freely adapted from Whistler's letter to the president of the Burlington Club, GUL
9 PEN, I, 135
10 Frederick Sweet, *Sargent, Whistler, and Mary Cassatt* (Chicago Art Institute, 1954), 12

CHAPTER 14

1 Boyce diary, 11 November 1866
2 'Fine Arts Gossip,' *Athenaeum*, 5 January 1867
3 LC
4 LC
5 Ionides, 45

CHAPTER 15

1 *l'Illustration*, 18 May 1867, 309
2 *Galignari*, 14 May 1869
3 Mahey, 251
4 LC
5 GUL

6 GUL
7 GUL
8 Freely adapted from a letter from Whistler to Haden, GUL
9 GUL
10 GUL
11 GUL
12 William Rossetti, *Rossetti Papers* (London, Sands, 1903), 495

CHAPTER 16

1 LC
2 Rough draft of letter to unidentified recipient, GUL
3 Philip Hamerton, 'Pictures of the Year,' *Saturday Review*, 23 (1867), 690
4 James Whistler, *The Gentle Art of Making Enemies* (London, Heinemann, 1890), 45

CHAPTER 17

1 GUL
2 GUL
3 GUL
4 Mahey, 252
5 Rossetti, Diary, 24 July 1868
6 Manuscript letter by Henry Edenborough, GUL
7 GUL
8 Manuscript letter, University of British Columbia Library
9 GUL
10 GUL
11 GUL
12 Hamerton, *Etchers and Etchings* (London, Macmillan, 1868), ix
13 GUL
14 GUL

CHAPTER 18

1 Whistler, *Gentle Art*, 78
2 LC
3 Mahey, 251
4 Ibid.
5 LC
6 LC
7 PEN, I, 148
8 Mahey, 252
9 LC

10 Humanities Research Center, University of Texas
11 GUL

[No notes for Chapter 19]

CHAPTER 20

1 LC
2 *Punch*, 17 June 1871
3 LC
4 GUL
5 LC

CHAPTER 21

1 LC
2 LC
3 Val Prinsep, 'James A. McNeill Whistler. Personal Recollections,' *Magazine of Art*, n.s. 1 (1903), 578
4 Ibid., 579
5 Ibid.
6 PEN, I, 123
7 'The Lady of the Portrait,' 326
8 LC
9 LC
10 LC
11 Boughton, 215
12 Whistler, *Gentle Art*, 128
13 Sidney Colvin, 'Pictures in London and Paris,' *Cornhill Magazine*, 26 (1872), 39

CHAPTER 22

1 Marion Spielmann, 'James McNeill Whistler,' *Magazine of Art*, 27 (1903), 14
2 R. R. Tatlock, 'Walter Greaves,' *Burlington Magazine*, 59 (1931), 261
3 LC
4 Mahey, 253

CHAPTER 23

1 LC
2 GUL
3 GUL
4 Bernard Sickert, *Whistler* (London, Duckworth, 1908), 24

5 PEN, I, 173–74
6 LC
7 PEN, I, 170
8 William Allingham, *Diary* (London, Macmillan, 1907), 84
9 GUL
10 Manuscript letter to Charles Eliot Norton, Houghton Library, Harvard University

CHAPTER 24

1 GUL
2 Colvin, 'Exhibition of Mr Whistler's Pictures,' *Academy*, 5 (1874), 672
3 William Chase, 'The Two Whistlers,' *Century*, 80 (1910), 223
4 LC
5 Brighton Gazette, 9 September 1875
6 GUL

CHAPTER 25

1 PEN, I, 189
2 A. Henry Savage-Landor, *Everywhere*, (London, Unwin, 1924), 202
3 Edith Shaw, 'Four Years with Whistler,' *Apollo*, 87 (1968), 198
4 Pennell, *Whistler Journal*, 231
5 GUL
6 Boughton, 215
7 Edmund Wuerpel, 'Whistler the Man,' *American Magazine of Art*, 27 (1935), 315
8 Lily Langtry, *The Days That I Knew* (New York, Doran, 1925), 62
9 Mortimer Menpes, *Whistler as I Knew Him* (London, Black, 1904), 33–5
10 GUL
11 GUL
12 GUL
13 PEN, I, 182
14 GUL
15 GUL
16 Manuscript letter, Freer Gallery of Art
17 Peter Ferriday, 'The Peacock Room,' *Architectural Review*, 125 (1959), 412
18 GUL
19 GUL
20 Unpublished manuscript, Humanities Research Center, University of Texas
21 LC
22 GUL
23 GUL
24 GUL
25 GUL
26 GUL

27 GUL
28 *Nine Whistler Letters* [to Theodore Watts-Dunton] (privately printed, 1922), unnumbered pages
29 Denys Sutton, *Nocturne* (London, Country Life, 1963), 95

CHAPTER 26

1 Henry Huntington Library
2 Dorothy Weir Young, *Life and Letters of J. Alden Weir* (Yale University Press, 1960), 133
3 Ibid., 134
4 John Lloyd Balderston, 'The Dusk of the Gods: A Conversation with George Moore,' *Atlantic Monthly*, 118 (1916), 171
5 Ellen Terry, *Memoirs* (New York, Putnam, 1932), 101
6 PEN, I, 199
7 PEN, I, 135
8 Oscar Wilde, 'The Grosvenor Gallery,' *Dublin University Magazine*, 90 (1877), 121
9 *The Works of Ruskin*, ed. by E. T. Cook and A. Weddeburn (London, George Allen, 1907), vol. 29

CHAPTER 27

1 John Ruskin, *Modern Painters*, vol. I, chap. 2, parag. 1
2 Boughton, 213
3 GUL
4 GUL
5 Henry Huntington Library

CHAPTER 28

1 Unpublished manuscript, Humanities Research Center, University of Texas
2 W. Graham Robertson, *Time Was* (London, Hamish Hamilton, 1931), 191–92
3 Thomas R. Way, *Memories of James McNeill Whistler* (London, John Lane, 1912), 7
4 GUL
5 GUL
6 Pennell, *Whistler Journal*, 69
7 Manuscript memorandum, Chelsea District Library
8 'A Harmony in Yellow and Gold,' *American Architect and Building News*, 4 (1878), 36

CHAPTER 29

1 Georgiana Burne-Jones, *Memorials of Edward Burne-Jones*, (London, Macmillan, 1904), 87
2 The *Referee*, 2 February 1878, p. 8
3 GUL
4 GUL
5 Burne-Jones, 87
6 Helen Viljoen, *The Brantwood Diary of John Ruskin* (Yale University Press, 1971), 423
7 LC
8 GUL
9 LC
10 Fitzwilliam Museum
11 LC
12 GUL
13 *The Works of Ruskin*, 37, p. 266

CHAPTER 30

1 Henry James, *The Painter's Eye* (Harvard University Press, 1956), 173

CHAPTER 31

1 LC
2 LC
3 Armstrong, 209

CHAPTER 32

1 GUL
2 *The Works of Ruskin*, vol. 37, p. 274
3 GUL
4 LC
5 Elizabeth Pennell, *The Art of Whistler* (New York, Modern Library, 1928), 164
6 Whistler, *The Gentle Art*, 35–6
7 Ibid., 37
8 Ibid., 38
9 *Spectator*, 52 (1879), 44
10 *Saturday Review*, 46 (1878), 687
11 *Art Journal*, n.s. 18 (1879), 63
12 James, 175
13 LC
14 GUL

15 GUL
16 E. V. Lucas, *Edwin Austin Abbey* (London, Methuen, 1921), 192
17 Ibid., 193
18 Mahey, 137
19 Dante Gabriel Rossetti, *Collected Letters*, ed. by O. Doughty and J. R. Wahl (Oxford, Clarendon Press, 1947), iv, 1663
20 PEN, I, 257

CHAPTER 33

1 GUL
2 GUL
3 LC
4 Julian Hawthorne, *Shapes that Pass* (Boston, Houghton Mifflin, 1928), 249
5 LC
6 Otto Bacher, *With Whistler in Venice* (New York, Century, 1908), 12–3
7 Ibid., 17
8 Ibid., 7
9 Denys Sutton, *Nocturne* (London, Country Life, 1963), 92
10 Bacher, 31
11 'How Whistler Posed for John W. Alexander,' *The World's Work*, 9 (1905), 5993
12 Manuscript letter, Freer Gallery of Art
13 Sutton, 93
14 Arthur J. Eddy, *Recollections and Impressions of James A. McNeill Whistler* (Philadelphia, Lippincott, 1903), 93
15 Bacher, 25
16 Ibid., 19–20
17 LC
18 Harry Quilter, 'James Abbott McNeill Whistler,' *Chambers' Journal*, 76 (1903), 695
19 Bacher, 152
20 Ibid., 265
21 GUL
22 GUL
23 GUL
24 GUL
25 GUL
26 LC

CHAPTER 34

1 LC
2 'Mr Whistler on His Works,' *Illustrated London News*, 100 (1892), 384
3 Quilter, 693

4 Leon Edel, *Writing Lives* (New York, Norton, 1959), 13
5 *The Paris Interviews*, ed. by Malcolm Cowley (New York, Viking, 1959), 141
6 Bacher, 207
7 The *World*, 8 December 1880, p. 6

CHAPTER 35

1 PEN, I, 195
2 'What the World Says,' *World*, 9 March 1881
3 Julian Hawthorne, 149
4 Richard Ellmann, *Oscar Wilde* (New York, Knopf, 1988), 271

CHAPTER 36

1 *The Letters of Oscar Wilde*, ed. by Rupert Hart-Davis (London, Hart-Davis, 1962), 121
2 Kerrison Preston, *Letters of W. Graham Robertson* (London, H. Hamilton, 1903), 124
3 LC
4 Camille Pissarro, *Letters to Lucien Pissarro*, ed. by John Rewald (London, Kegan Paul, 1943), 22
5 LC
6 Frederick Wedmore, 'The Place of Whistler,' *Nineteenth Century*, 55 (1904), 668
7 Wedmore, 'Mr Whistler's Exhibition,' *Academy*, 23 (1883), 139
8 LC
9 Wilde, 'Lecture to Art Students,' *Complete Works of Oscar Wilde*, vol. 11 (New York, Doubleday Page, 1923)
10 Frank Harris, 'Whistler, Artist and Bantam,' *Forum*, 52 (1914), 67

CHAPTER 37

1 Menpes, 23–4
2 GUL
3 Menpes, 135–6
4 GUL
5 Menpes, 137–38
6 Menpes, 56
7 'Senior Sarasate,' *Saturday Review*, 59 (1885), 754
8 Frederick Keppel, *One Day with Whistler* (New York, Keppel, 1904), 7–9
9 Manuscript letter, Henry Huntington Library

CHAPTER 38

1 PEN, II, 34

2 The lecture was privately published in 1885 and reprinted in *The Gentle Art*, 131–59

3 *Wilde v. Whistler* (London, privately printed, 1906), 10

4 Ibid.

5 Ibid., 11

CHAPTER 39

1 Albert Ludovici, 'The Whistlerian Dynasty at Suffolk Street,' *Art Journal* (1906), 195

2 When the author saw the diary, it was in the possession of Rosamund Haden's granddaughter, the late Mrs Nancy Strode.

CHAPTER 40

1 Whistler, *The Gentle Art*, 164

2 Menpes, 105

3 Ibid., 106

4 LC

5 G[eorge] B[ernard] S[haw], 'Picture Shows,' the *World*, 13 April 1887, 5

6 *Fun*, 8 December 1886

7 Menpes, 146–49

8 Ibid., 149–52

9 PEN, II, 140

10 LC

11 LC

12 'The Rise and Fall of the Whistler Dynasty,' *Pall Mall Gazette*, 11 June 1888

CHAPTER 41

1 *Pall Mall Gazette*, 5 September 1888, 13

2 Interview with Henry Labouchere, *Truth*, 28 July 1903

3 LC

4 GUL

5 Letter to Alfred Stevens, LC

6 LC

7 'The Dinner to Mr Whistler,' *Sunday Times*, 4 May 1889

CHAPTER 42

1 Wilde, 'The Decay of Lying,' *Nineteenth Century*, 25 (1889), d35–56

2 *Wilde v. Whistler*, 14–5

3 Ibid., 15

4 Ibid., 16

5 *The Times*, 17 July 1934, p. 10
6 Robertson, 189
7 PEN, II, 107
8 Robertson, 188–89
9 Robert Crawford, 'How We Bought the Whistler Carlyle,' Glasgow *Evening Herald*, 23 March, 21–2
10 *Mallarmé-Whistler Correspondence*, ed. by C. P. Barbier (Paris, Nizet, 1964), 117
11 Ibid., 120

CHAPTER 43

1 LC
2 David Croal Thomson, 'Mr Whistler and His London Exhibitions,' *Art Journal* (1903), 266
3 'Mr Whistler on His Works,' *Illustrated London News*, 100 (1892), 384
4 Manuscript letter, Freer Gallery of Art
5 LC
6 Manuscript letter, Freer Gallery of Art
7 Ibid.
8 Eddy, 220–21
9 Ibid., 222
10 Edmund H. Wuerpel, 'Whistler the Man,' *American Magazine of Art*, 27 (1935), 316
11 Ibid.
12 LC
13 Pissarro, 195
14 GUL
15 GUL
16 GUL
17 GUL
18 LC
19 LC
20 LC
21 Manuscript letter to Edward Kennedy, NYPL
22 LC
23 LC
24 LC
25 LC
26 LC
27 LC
28 LC
29 LC
30 LC
31 LC

CHAPTER 44

1 George Du Maurier, 578
2 Ibid., 577
3 Ormond, 469
4 Ibid., 467
5 Ibid., 471
6 Ibid., 477
7 Ibid.
8 Manuscript letter, Pierpont Morgan Library
9 Ibid.
10 Ormond, 478
11 Ibid., 476
12 Manuscript letter, Pierpont Morgan Library
13 'Brun et Or,' *Le Journal*, 15 April 1895
14 Timothy Eden, *The Tribulations of a Baronet* (London, Macmillan, 1933), 56
15 GUL
16 Eden, 58
17 Ibid., 60
18 'Brun et Or'
19 Whistler, *Eden versus Whistler. The Baronet and the Butterfly*, 10
20 Ibid., 11–12
21 Ibid., 73
22 'Mr Whistler: The Strange Story of the Baronet,' the *Realm*, 26 April 1895, 894
23 Whistler, *Eden*, 31
24 GUL
25 George Moore, *Modern Painting* (New York, Scribner's, 1893), 11, 23
26 *Daily Chronicle*, 29 March 1895
27 *Pall Mall Gazette*, 25 March 1895

CHAPTER 45

1 Wuerpel, 329
2 LC
3 Letter to Edward Kennedy, NYPL
4 Manuscript letter, Freer Gallery of Art

CHAPTER 46

1 Keppel, 20
2 Ibid., 20–22
3 Walter Forsyth and J. L. Harrison, *Guide to the Study of James A. McNeill Whistler* (Albany, University of the State of New York, 1895), 1
4 Ibid., 1–2

5 GUL
6 GUL
7 PEN, II, 203
8 NYPL
9 Manuscript letter, Pierpont Morgan Library
10 PEN, II, 202
11 Andrew Causey, 'Whistler's British Friends,' *Illustrated London News*, 249 (1966), 24
12 GUL
13 Andrew Dempsey, 'Whistler and Sickert,' *Apollo*, 83 (1966), 34
14 Ibid.
15 Walter Sickert, 'Transfer Lithography,' *Saturday Review*, 82 (1896), 667
16 'A Day with Mr Whistler,' London *Daily Mail*, 6 April 1897
17 Manuscript letter, Freer Gallery of Art
18 Ibid.
19 Whistler, *Eden*, 76
20 LC
21 Albert Elsen, 'The Artist's Oldest Right,' *Art History*, 11 (1988), 217
22 Pierpont Morgan Library
23 PEN, II, 198
24 LC
25 Pierpont Morgan Library
26 Ibid.
27 Julian Hawthorne, 'A Champion of Art,' the *Independent*, 51 (1899), 384–87
28 Manuscript letter to May Morris, Freer Gallery of Art

CHAPTER 47

1 Harrison Morris, *Confessions in Art* (New York, Sears, 1930), 80
2 PEN, II, 254
3 NYPL
4 C. J. Bulliet, *The Courtesan Olympia* (New York, Covici Friede, 1930), 116
5 LC
6 LC
7 Way, 141
8 Elizabeth Pennell, 'Whistler as I Knew Him,' New York *Herald Tribune*, 8 July 1934, 13
9 Pennell, *Whistler Journal*, 199
10 Ibid.
11 Marion H. Spielmann, 'The Man and the Artist,' *Magazine of Art*, 27 (1903), 12
12 PEN, II, 254
13 Cyrus Cuneo, 'Whistler's Academy of Painting,' *Century*, 73 (1906), 19
14 PEN, II, 230
15 Amulet Andrews, 'Cousin Butterfly,' *Lippincott's Monthly*, 73 (1904), 320

16 Cuneo, 19
17 Andrews, 321
18 Earl Stetson Crawford, 'The Gentler Side of Mr Whistler,' the *Reader*, 2 (1903), 387
19 Henry Russell Wray, 'An Afternoon with James Whistler,' *International Studio*, 56 (1915), xl
20 Cuneo, 20
21 M. A. Mulliken, 'Reminiscences of the Whistler Academy,' *Studio*, 34 (1905), 237
22 Ibid., 238
23 Cuneo, 22
24 GUL

CHAPTER 48

1 Manuscript letter, Freer Gallery of Art
2 Pennell, *Whistler Journal*, 153
3 'Whistler,' *T.P.'s Weekly*, 6 (1905), 52
4 LC
5 PEN, II, 290
6 Freer Gallery of Art
7 GUL
8 PEN, II, 292
9 Don Carlos Seitz, *Whistler Stories* (New York, Harper's, 1913), 111–12
10 PEN, II, 291
11 Sutton, 135
12 Pennell, *Whistler Journal*, 257
13 Pennell, *Art of Whistler*, 200
14 Boughton, 217
15 Tom Honeyman, *Whistler: Arrangements in Grey and Black* (Glasgow Art Gallery, 1951), 9
16 Pennell, *Whistler Journal*, 295

Select Bibliography

Principal published works cited or quoted.

Allen, Carlisle. 'The Husband of Mrs Whistler,' New York *Herald Tribune*, 6 May 1934, 5

Allingham, William. *Diary* (London, Macmillan, 1907)

Andrews, Annulet. 'Cousin Butterfly,' *Lippincott's Monthly*, 73 (1904), 318–27

Armstrong, Thomas. *A Memoir* (London, Martin Secker, 1912)

'Art and the Royal Academy,' *Fraser's Magazine*, 46 (1852), 228–36

Bacher, Otto. *With Whistler in Venice* (New York, Century, 1908)

Balderston, John Lloyd. 'The Dusk of the Gods: A Conversation with George Moore,' *Atlantic Monthly*, 118 (1916), 165–75

Baudelaire, Charles. *Art in Paris* (London, Phaidon, 1965)

Boisbaudran, Lecoq de. *The Training of Memory in Art* (London, Macmillan, 1911)

Boughton, G. H. 'A Few of the Various Whistlers I Have Known', *Studio*, 30 (1903), 208–18

Boyce, George. *Diary* (London, Old Water Colour Society, 1941)

'Brun et Or,' *Le Journal*, 15 April 1895

Bryan, George. *Chelsea in the Olden and Present Times* (London: Bryan, 1869)

Bulliet, C. J. *The Courtesan Olympia* (New York, Covici Friede, 1930)

Burne-Jones, Georgiana. *Memorials of Edward Burne-Jones* (London, Macmillan, 1904)

Carr, Joseph W. *Some Eminent Victorians* (London, Duckworth, 1908)

Causey, Andrew. 'Whistler's British Friends,' *Illustrated London News*, 249 (1966), 24

Chase, William. 'The Two Whistlers,' *Century*, 80 (1910), 218–26

Colvin, Sidney. 'Exhibition of Mr Whistler's Pictures,' *Academy*, 5 (1874), 672–3

Colvin, Sidney. 'Pictures in London and Paris,' *Cornhill Magazine* 26 (1872), 33–47

Crawford, Earl Stetson. 'The Gentler Side of Mr Whistler,' the *Reader*, 2 (1903), 387

Crawford, Robert. 'How We Bought the Whistler Carlyle,' Glasgow *Evening News*, 23 March 1935, 21–2

Cullum, George W. *Biographical Register of the Officers and Graduates of the U.S. Military Academy* (New York, Van Nostrand, 1868)

Cuneo, Cyrus. 'Whistler's Academy of Painting,' *Century*, 73 (1906), 19–28

Cunningham, Peter. *Handbook of London.* (London, Murray, 1850)

Dempsey, Andrew. 'Whistler and Sickert,' *Apollo*, 83 (1966), 34; 'The Dinner to Mr Whistler,' *Sunday Times*, 4 May 1889

Du Maurier, Daphne. *The Young George Du Maurier* (London, Peter Davies, 1951)

Du Maurier, George. 'Trilby,' *Harper's Monthly*, 88–89 (1894)

Duret, Theodore. *Whistler* (Philadelphia: Lippincott, 1917)

Eddy, Arthur J. *Recollections and Impressions of James A. McNeill Whistler* (Philadelphia: Lippincott, 1903)

Eden, Timothy. *The Tribulations of a Baronet* (London: Macmillan, 1933)

Ellmann, Richard. *Oscar Wilde* (New York, Knopf, 1988)

Elsen, Albert. 'The Artist's Oldest Right,' *Art History*, 11 (1988), 217–30

Étienne, Louis, *Le Jury et Les Exposants, Salon des Refusés* (Paris, Denatu, 1863)

Ferriday, Peter. 'The Peacock Room,' *Architectural Review* 125 (1959), 407–414

Forsyth, Walter, and J. L. Harrison. *Guide to the Study of James A. McNeill Whistler* (Albany, University of the State of New York) 1895

Fournel, François. *Les Artistes Français Contemporains* (Tours, Alfred Mame, 1884)

Gettscher, Robert H. and Paul G. Marks. *James McNeill Whistler and John Singer Sargent* (New York, Garland, 1986)

Hamerton, Philip. *Etchers and Etchings* (London, Macmillan, 1868)

Hamerton, Philip. 'Pictures of the Year,' *Saturday Review*, 23 (1867), 690–1

Hardie, Martin. *Frederick Goulding* (Stirling, England, E. Mackey, 1910)

'A Harmony in Yellow and Gold,' *American Architect and Building News*, 4 (1878), 36

Harris, Frank. 'Whistler, Artist and Bantam,' *Forum*, 52 (1914), 338–55

Hawthorne, Julian. 'A Champion of Art,' the *Independent*, 51 (1899), 384–7

Hawthorne, Julian. *Shapes that Pass* (Boston: Houghton Mifflin, 1928)

Hawthorne, Nathaniel. 'Up the Thames,' *Atlantic Monthly*, 11 (1863), 598–614

Herst, Herman. 'Manuscripts Gone Forever?' *Manuscripts*, 17 (1965), 3–5

Honeyman, Tom. *Whistler: Arrangements in Grey and Black* (Glasgow Art Gallery, 1951)

'How Whistler Posed for John W. Alexander,' *World's Work*, 9 (1905), 5992–94

Huysmans, J. K. *Certains* (Paris, Tresse & Stock, 1889)

Ionides, Luke, 'Memories' *Transatlantic Review*, 1 (1924), 37–52

James, Henry. *The Painter's Eye* (Harvard University Press, 1956)

Jameson, Anna. *Memoirs of the Early Italian Painters* (London: Charles Knight, 1845)

'Japan in London,' *Punch*, 94 (1888), 184

Kennedy, Edward G., *The Etched Work of Whistler* (New York, The Grolier Club, 1910)

Keppel, Frederick. *One Day with Whistler* (New York, Keppel, 1904)

Key, John Ross. 'Recollections of Whistler', *Century*, 75 (1908), 928–32

Kobbé, Gustav, 'Whistler in the U.S. Coast Survey,' *Chap-Book*, 8 (1898), 479–80

Kobbé, Gustav. 'Whistler at West Point,' *Chap-Book*, 8 (1898), 439–42

Kohl, J. G., *Russia* (London, Chapman and Hall, 1844)

'The Lady of the Portrait.' *Atlantic Monthly*, 136 (1925), 151–6

Langtry, Lillie. *The Days That I Knew* (New York, Doran, 1925)

Laver, James. *Whistler* (London, Faber & Faber, 1930)

Lazelle, H. M. 'Whistler at West Point,' *Century*, 90 (1915), 710

Leslie, Charles Robert. 'Lectures on Painting,' *Athenaeum*, February–March 1848

'London Pictures,' *Builder*, 18 (1860), 348

Lucas, E. V. *Edwin Austin Abbey* (London, Methuen, 1921)

Ludovici, Albert. 'The Whistlerian Dynasty at Suffolk Street,' *Art Journal* (1906)

MacColl, Douglas S. 'The Industrious and Idle Apprentices,' *Saturday Review*, 96 (1903), 608–9

Mahey, John A. 'The Letters of James McNeill Whistler to George A. Lucas,' *Art Bulletin*, 49 (1967), 247–57

Mallarmé–Whistler Correspondence, ed. by C. P. Barbier (Paris, Nizet, 1964)

Mantz, Paul. 'Salon de 1863,' *Gazette des Beaux-Arts*, 15 (1863), 57–62

Marquoid, Katharine. 'Old Battersea Bridge,' *Art Journal*, 33 (1881), 35

Maxwell, John S. *The Czar, His Court and People* (New York, Scribners, 1854)

Menpes, Mortimer. *Whistler as I Knew Him* (London: Black, 1904)

Menpes, Mortimer. 'Whistler the Purist,' *Cornhill Magazine*, n.s. 15 (1903), 760–8

'Mr Whistler on His Works.' *Illustrated London News*, 100 (1892), 384

'Mr Whistler: The Strange Story of the Baronet,' *Realm*, 26 April 1895, 894

Moore, George, *Modern Painting* (London, Scott, 1893)

Morris, Harrison. *Confessions in Art* (New York: Sears, 1930)

Mulliken, M. A. 'Reminiscences of the Whistler Academy,' *Studio*, 34 (1905), 237–9

Mumford, Elizabeth, *Whistler's Mother* (Boston, Little, Brown, 1939)

Nine Whistler Letters (privately printed, 1922)

[Oliphant, Margaret.] 'The Royal Academy,' *Blackwood's Magazine*, 119 (1876), 753–9

Ormond, Leonée. *George Du Maurier* (University of Pittsburgh Press, 1969)

Pennell, Elizabeth. *The Art of Whistler* (New York, The Modern Library, 1928)

Pennell, Elizabeth. *Nights* (London, Heinemann, 1916)

Pennell, Elizabeth. 'Whistler as I Knew Him,' New York *Herald Tribune*, 8 July 1934, 13, 19

Pennell, Elizabeth, 'Whistler Makes a Will,' the *Colyphon*, 1934, part 17

Pennell, Elizabeth. *Whistler the Friend* (Philadelphia: Lippincott, 1930)

Pennell, Elizabeth and Joseph. *The Life of James McNeill Whistler* (Philadelphia: Lippincott, 1908)

Pennell, Elizabeth and Joseph. *The Whistler Journal* (Philadelphia: Lippincott, 1921)

Pissarro, Camille. *Letters to Lucien Pissarro* (London, Kegan Paul, 1943)

Pressly, Nancy Dorfman. 'Whistler in America,' *Metropolitan Museum Journal*, 5 (1972) 125–54

Preston, Kerrison. *Letters of W. Graham Robertson* (London: H. Hamilton, 1903)

Prinsep, Val, 'James McNeill Whistler Personal Recollections', *Magazine of Art*, N.5.1 (1903), 577–80

Quilter, Harry. 'James Abbott McNeill Whistler, *Chambers' Journal*, 76 (1903), 691–6

Rewald, John. *The History of Impressionism* (New York, Museum of Modern Art, 1961)

'The Rise and Fall of the Whistler Dynasty,' *Pall Mall Gazette*, 11 June 1888

Robertson, W. Graham. *Time Was* (London, Hamish Hamilton, 1937)

Rossetti, Dante Gabriel. *Collected Letters*, ed. by O. Doughty and J. R. Wahl, vol. 4 (Oxford, Clarendon Press, 1947)

Rossetti, William. *Fine Art* (London, Macmillan, 1867)

Rossetti, William. *Rossetti Papers* (London, Sands, 1903)

Rothenstein, John. *The Artists of the 1890's* (London, Routledge, 1928)

Ruskin, John. *Works*, ed. by E. T. Cook and A. Weddeburn (London, George Allen, 1907)

Savage-Landor, A. Henry. *Everywhere* (London, Unwin, 1924)

Schaff, Morris. *The Spirit of Old West Point* (Boston, Houghton Mifflin, 1907)

Seitz, Don Carlos. *Whistler Stories* (New York, Harper's, 1913)

Shaw, Edith. 'Four Years with Whistler,' *Apollo*, 87 (1868), 198–201

S[haw], G[eorge] B[ernard], 'Picture Shows,' the *World*, 11 April 1887

Sickert, Bernard. *Whistler* (London, Duckworth, 1908)

Sickert, Walter. 'Transfer Lithography,' *Saturday Review*, 82 (1896), 667–8

Sladen, Douglas. *Twenty Years of My Life* (New York, Dutton, 1915)

Spielmann, Marion. 'James McNeill Whistler,' *Magazine of Art*, 27 (1903), 14–8

Spielmann, Marion. 'The Man and the Artist,' *Magazine of Art*, 27 (1903), 580–4

Stevens, Alfred. *A Painter's Philosophy* (London, Elkin Mathews, 1904)

Sutton, Denys *Nocturne: The Art of James McNeill Whistler* (London, Country Life, 1963)

Sweet, Frederick. *Sargent, Whistler, and Mary Cassatt* (Chicago Art Institute, 1954)

Swift, Joseph Gardner. *Memoirs* (privately printed, 1890)

Swinburne, Algernon. 'Mr Whistler's Lecture on Art,' *Fortnightly Review*, 49 (1888), 745–51

Tatlock, R. R. 'Walter Greaves,' *Burlington Magazine*, 59 (1931), 261–2

Terry, Ellen. *Memoirs.* (New York: Putnam, 1932)

Thomson, David Croal. 'Mr Whistler and His London Exhibitions,' *Art Journal* (1903), 266

Viljoen, Helen. *The Brantwood Diary of John Ruskin* (Yale University Press, 1971)

Way, Thomas R. *Memories of James McNeill Whistler* (London, John Lane, 1912)

Wedmore, Frederick. 'Mr Whistler's Exhibition,' *Academy*, 23 (1883), 139–40

Wedmore, Frederick. 'The Place of Whistler,' *Nineteenth Century*, 55 (1904), 665–75

Weir, Irene. *Robert W. Weir* (New York, House of Field-Doubleday, 1947)

Whistler, James. *Eden versus Whistler. The Baronet and the Butterfly* (New York, R. H. Russell, 1899)

Whistler, James. *The Gentle Art of Making Enemies* (London, Heinemann, 1899)

Whiting, Lilian. *Louise Chandler Moulton* (Boston, Little, Brown, 1934)

Wilde, Oscar. 'Decay of Lying,' *Nineteenth Century*, 25 (1889), 35–56

Wilde, Oscar. 'The Grosvenor Gallery,' *Dublin University Magazine*, 90 (1877), 118–26

Wilde, Oscar. 'Lecture to Art Students' [23 June 1883, Golden Square], *Complete Works of Oscar Wilde*, vol. 11 (New York, Doubleday Page, 1923)

Wilde, Oscar. *Letters*, ed. by Rupert Hart-Davis (London, Hart-Davis, 1962)

Wilde, Oscar, 'Mr Whistler's Ten O'Clock,' *Pall Mall Gazette*, 21 February, 1885, 1–2

Wilde v. Whistler. (London, privately printed, 1906)

Wilson, Thomas. 'Whistler at West Point,' *Book-Buyer*, 17 (1898), 113–5

Wray, Henry Russell. 'An Afternoon with James Whistler,' *International Studio*, 56 (1915), xl-xlll

Wuerpel, Edmund. 'Whistler the Man,' *American Magazine of Art*, 27 (1935), 248–53, 312–21

Young, Andrew McLaren, Margaret MacDonald and Robin Spencer. *The Paintings of James McNeill Whistler* (Yale University Press, 1980)

Young, Dorothy Weir. *The Life and Letters of J. Alden Weir* (Yale University Press, 1963)

Zahar, Marcel. *Courbet* (London, Longmans, Green, 1950)

Index